aisthētikós

Panayotis A. Michelis

aisthētikós

ESSAYS IN ART, ARCHITECTURE, AND AESTHETICS

with an Introduction by John P. Anton, Emory University

Wayne State University Press Detroit 1977

A Note on the Illustrations

The illustrations were chosen by Mrs. Effie Michelis from those accompanying the essays on first publication, which were selected by the author. Grateful acknowledgment for her courtesy and assistance is hereby extended.

Library of Congress Cataloging in Publication Data

Michelēs, Panagiōtēs Andreou, 1903-1969.
 Aisthētikós.

 Bibliography: p.
 Includes index.
 1. Aesthetics—Addresses, essays, lectures. 2. Art, Modern—20th century—Addresses, essays, lectures.
3. Art, Byzantine—Addresses, essays, lectures.
4. Architecture—Addresses, essays, lectures.
I. Title.
N66.M48 701'.17 76-49970
ISBN 0-8143-1560-7

contents

introduction

The present collection of essays by the late Professor Panayotis A. Michelis (1903–1969), who taught philosophy of art and architecture at the Polytechnic University of Athens, Greece, is a significant addition to our literature. Professor Michelis was active in international aesthetics meetings, an honorary member of the American Society for Aesthetics, founder of the Hellenic Society for Aesthetics, and editor of the *Annales d'Esthétique (Chronika Aisthētikēs)*. Many of his articles and books have been translated into a number of languages, but to the English-speaking public he is known as the author of the original and insightful work *An Aesthetic Approach to Byzantine Art,* published in 1955 in England, with a foreword by Sir Herbert Read. Aside from his special monographs and articles, which opened new vistas to our understanding of Byzantine architecture, painting, and music, he addressed himself to the broader issues in the aesthetics of contemporary architecture, the function of aesthetic theory in the history of art, and the philosophy of art and culture. Roman Galeffi quite aptly characterized Michelis as combining "the sensibility of the artist, the technical learning of the architect, the deep insight of the historian, the sharp vision of the critic, and the synthetic power of the philosopher."[*]

The essays on architecture in this volume were conceived and worked out as special applications of his general theory of art. Given Michelis' defense of the autonomy of art, they show convincingly how modern architecture, far from having abandoned or minimized the

[*]"La Teoria architetturale di Panayotis A. Michelis," in the special volume *In Memoriam, Panayotis A. Michelis* (Athens,1972), p. 457: "se l'intuizione dell' artista, la compentenza tecnica dell' architetto, la profonda visione dello storico, l'acume del critico, la perspicacia e il potere de sintesi del filosofo."

language of images, has followed an ikonoplastic and cryptosymbolic direction. Yet its preoccupation with function has often led to the subordination of creative plasticity. What explains the aesthetic poverty of much recent architecture is precisely this compromise made by aesthetic autonomy to serve non-artistic demands. The aesthetic future and promise of architecture lies in the direction of its recovering and asserting its fundamentally autonomous character.

When Michelis speaks of the autonomy of art, he means its inherent power to assure the triumph of beauty. Beauty, apart from its most generic sense, is in each case an attainment, a concrete value which gives determinative embodiment to our aesthetic demands. This brings us to one of Michelis' basic themes. Recognizing that the ultimate nature of the aesthetic demand in all the arts, from architecture to poetry and music, is at once active and interpretive, he concludes that the history of art and aesthetics can reach its objectives only when it organizes its investigations accordingly. This principle, he declares, "we as historians of art can ignore only at our own risk." It is the approach which he applied with impressive success to Byzantine art and which enabled him to dissolve many age-old prejudices and misinterpretations and, more importantly, to illumine this most neglected period of Western art.

Michelis' bold views on the nature and function of the imagination are integral to his aesthetic theory. He defended a distinction between the abstractive and selective functions of the imagination. The former alone is genuinely creative. As the basic mode of the artistic activity, it concretizes the abstract and effects the symbolic form which our intelligence needs to create a style, the purest and best expression of the abstractive function. Both aspects of the imagination must be understood as pervasive traits of humanity, although it is the artistic person *par excellence* who exhibits both, and intensely so, as a creator who acts and a visionary who sees. Their dialectical interplay contains the solution to the problem of aesthetic value. Michelis argues against all solutions which place the issues exclusively either in a subjective or in a purely objective realm. He intends to avoid such solutions when he understands "the beautiful," in the inclusive sense of the term, as both being and becoming. The power of art is due to a vision which discloses an ideal world through the cast of identifiable styles, each of which expresses certain perennial principles of human consciousness. They emerge in art as the aesthetic categories of the sublime, the tragic, the comic, the graceful, and the ugly. To these he adds the basic concepts of

rhythm, harmony, and metaphor, which quicken the special awareness requisite to the appreciation of the artistic works of past periods, including contemporary but unfamiliar ones.

Michelis was always responsive to innovative elements and ready to appreciate stylistic changes in art, but never did he agree with the conventionalist theory of beauty. He regarded the arts and their historical changes as the record of human creativity whose ultimate source lay deeply rooted in the mind and in its archetypal principles of beauty, goodness, and truth. He came to hold that the epochal triumphs of the arts mark the highlights of monumental variations of the same quest and values of the human spirit. It would be unjust to see Michelis either as applying Platonic views to aesthetics, although he was highly conversant with Plato and Plotinus, or as following some version of Hegelianism in his understanding of art history. He had profound respect for empirical facts, and it was his conviction that what he called "aesthetic categories" or artistic archetypes are arrived at only inductively. The category of the beautiful which controlled the classical and Renaissance periods and the category of the sublime which dominated the Gothic and the Byzantine styles were basic forms guiding the imagination of the artists and were, in turn, furthered by their rich visions.

If the beautiful and the sublime seem to oppose each other, they are neither at war nor unequal in significance. For both share in the eternality of the human artistic *logos,* each with its own undeniable claims on truth and artistic authenticity. Both are partners in ideal fulfillment. The aesthetic categories as basic concepts of art history derive their validity from the genuineness of experience they express in concrete works. It is correct, then, to say that the sublime is what was best suited to express the religious aspirations of Christian culture, just as the beautiful became the proper category for the dominantly humanistic outlook of classical Greece and the man of the Renaissance.

The categories, Michelis taught, are not superimposed; rather, they are achieved as the shared and clarified artistic feeling of the age. The deep fonts of human art run in the constant streams of human sentiments, emotions, and thoughts, from which all historical periods draw in order for each one of them to give rise to a special characteristic form, a special style. Each period draws from the same reservoir of native human energy as the others and works with its own core of propensities and traditions. If a theocentric society gives prominence to

the sublime and an anthropocentric one to the beautiful, the experiences and valued tendencies sustaining them stand on their own right, have their own interpretive context, project their own evaluative standards, but together they constitute major landmarks in the history of mankind. From the artistic point of view, no period invalidates another and no category reigns supreme. Each affords a distinctive aesthetic joy and signals the completion of a style.

Michelis was careful to avoid the error of placing the artistic categories in some iron-clad temporal pattern of historical inevitability. In effect, he was able to offer a philosophy of art in the general context of a history of art by appealing to historically discoverable facts and concrete trends. His own procedure incorporated the best in the historical methods and utilized the psychology of emotions to substantiate his observations and generalizations in the morphology of art periods. That he arrived at the conclusion of an alternating dialectical interchange between periods of beauty and sublimity, between periods anthropocentric and theocentric, as the high points in Western civilization presents no difficulty to readers familiar with the scientific, literary, and philosophical developments of our culture. The struggle of man to understand himself and the powers beyond him has persisted down to our time and has indelibly marked the entire range of our institutions, from law and social theory to technology and space explorations. In fact, the texture of our theory of values has always been affected by our changing attitudes and vacillations between a balanced humanism and the passion for the divine.

The importance of Michelis' contribution to the understanding of the place of art in human life is more fully revealed in those of his writings which discuss the functional aspects of the categories of the sublime and the beautiful. Sir Herbert Read, in his Foreword to the English translation of Michelis' *An Aesthetic Approach to Byzantine Art*, remarks how "Professor Michelis brilliantly and convincingly restores the sublime to its status as an aesthetic category." Perhaps a few words on this category are in order to prevent misunderstanding, but more so to provide the reader with certain guideposts for the perusal of some of the essays in this volume.

It would help to bear in mind that Michelis was not attempting to offer what is now called a phenomenological description of the religious experience. His concern in discussing the sublime was to examine it as an aesthetic category in connection with the place and function of the religious attitude in art. In this context, the sublime is a quality to be

understood as the aesthetic analogue of the special character of the Christian religion as expressed through its artistic monuments. In his own words, "the aesthetic category of the sublime corresponds to the spirit of the Christian devotee and is the artistic reflection of his religious sentiment." As such it stands in contrast to the category of the beautiful, which presents itself as order and harmony, conveying a feeling of serenity and being received with delight. The sublime, on the other hand, presented as immeasurable in extent and power, transcends the limits of rational order, and is experienced as a revelation of supernatural forces. The feelings it evokes are those of wonder, amazement, and awe. Michelis has carefully distinguished between two types of the sublime, depending on the interrelations each exhibits between intensity and power. There is a sublime which is *external* and *concrete*, where size and power prevail throughout, as in the case of Western Christian art, best exemplified in Gothic cathedrals. When depth and power tend to predominate, as they do in Eastern art, the sublime is emphatically *esoteric* or inward and *spiritual*.

Michelis' contributions toward a more complete theory of this fundamental though neglected category have been gratefully received by the community of scholars. They deserve special attention for the promise they hold in providing excellent and fresh points of departure for further investigations in the history of art and aesthetic categories.

The gradual emergence of secular attitudes has succeeded in granting the divine a resting place *within* experience, but has hardly prevented its expression in artistic creation. Its disguise has many masks. Given this mixed mode of our modern consciousness, the quest for the meaning of the divine is still a dominant concern. In this regard, the category of the sublime still retains its significance even if it no longer enjoys the privileged status it once had in periods when theocentric outlooks defined the style of cultural expression.

Professor Michelis' thesis has much to recommend itself to the perceptive reader searching for alternatives as he works his way out of the polymorphous confusion of an age abounding in syncretic experiences, on-going revolutions in taste, high diversity in artistic pursuits, and, above all, the perplexities of an age anxiously hoping to bring order into a way of life that threatens us with chaos and meaninglessness. We can infer from Michelis' theory that our own cultural period with its uneven mixture of aesthetic categories is definitely one of transition. If so, its multifariousness is also a sign of instability. But insofar as our period necessarily partakes overtly or covertly of the sublime, Michelis'

ideas are more than relevant. They draw attention to what we habitually tend to ignore or inadvertently exclude. More than that, they are admirable lessons in the quest for cultural fulfillment and historical understanding.

John P. Anton
Emory University

I

general aesthetics and contemporary art

1

latent movement or the latent picturesque?

I. archaeology and aesthetics

Archaeology is a science of great intent, for it uncovers the remnants of the ancient world in order to interpret them historically, to evaluate them as art, and then to reconstruct the culture of each bygone age. It thus contributes to our knowledge of the ancient world and the historical march of man. But compelled, as it were, to deal with "dead languages" and to decipher them, archaeology becomes at times so deeply involved with linguistics, grammar, and syntax that it loses sight of the beauty of the content, precisely as happens much too often with literature. This accounts for the fact that literature and archaeology have gone astray in their evaluation of the art of the classical world. The works of the past are sometimes invested with the splendors of perfection, as in the case of the classical Greek works; at other times they are treated as a fusion of various influences, devoid of originality, as occurred with Byzantine art. The concept of the perfect governs the dynamism of classical art; its architecture is interpreted as a dry intellectual exercise in geometrical structure and its sculpture as a mere anatomical study. The passion for a genetic interpretation of Byzantine art, on the other

hand, saw this art as an amalgam of historical influences, sometimes traced to incredibly far-fetched origins. Similarly, history has proclaimed the ancient Greeks as an ideal race, and at the same time it has condemned the Byzantines as a semi-barbaric rabble of people.

It is true that such archaeological theories for the most part are linked to the general intellectual currents in vogue when the monumental structures are discovered. The idealization of the ancient Greek and his works dates from the rise of humanism in the Renaissance, which attempted to restore individualism and the anthropocentric concept as an ideal. The genetic interpretation of art derives from the approach of historical interpretation which has dominated thought in more recent times. It is unfortunate that archaeology, which is treated as a science in that it attempts to explain and justify a proposition, cannot free itself until it proves this proposition to be false and replaces it with other propositions. The man of letters who enjoys Homer as art is somewhat surprised to learn that in literary science there exists the problem of whether or not the Homeric epics are the works of a single poet or the compilation of smaller epics,[1] much in the way that the architect today is surprised to learn that archaeology at one time denied the polychromy and the curvature of the Parthenon, or that, in order to interpret a passage of Pausanius, it is still trying to discover how the sacred enclosure of the temple was illuminated through the roof. But to what end? The artist can believe in the unity of Homer, in the polychromy and the curvature of the Parthenon, but archaeology and literary scholarship are sciences, and therefore must show scientifically that Homer was a single poet and not several poets, and that the curvature of the Parthenon had aesthetic bases, not the practical ones of settling foundations, as Joseph Durm believed, or simply of draining the waters from the floor, as William Dörpfeld believed.

Thus, each time a new wind of interpretation blows, we find ourselves compelled to wait for scholars to disprove the fallacies of other scholars, and for archaeologists to prove that the theories of other archaeologists are unfounded, because the scientists see art in the light of their age. James Stuart, who first sketched the Parthenon, was unaware of the curves of the temple or of the entasis of the columns, for he saw the temple in a preconceived fashion simply as a work geometrically conceived. Artists too interpret art through the eyes of their ages. The painters of the Renaissance, themselves applying visual emendations in accordance with the style of their architectural works, as did Palladio in the contraction of the terminal axes of his basilica, had no

understanding of the corresponding sensitivity of classical architects. In fact, from the very beginning of the Renaissance, architects such as G. B. da Vignola and the "academicians" standardized five styles in such a way that later archaeologists considered any digressions from the Greek works and all polychromy as a fantasy of the classical texts. Architecture was taught as though it were not an art but a positive science with geometrical and mathematical foundations. Correspondingly, whereas the painters of the Renaissance violated traditional perspective, and despite the fact that in a subsequent age the significance of this perspective was disproved, art critics and archaeologists sought and still continue to seek basic laws, albeit imperfect ones, for a perspective within which the ancient architecture would neatly fit. In other words, they sought a basic origin from which it sprang, much in the way that a Darwin, were he an archaeologist, would, for the origin of architecture, have propounded a basic theory which would in his time have dominated all thought and which today would continue to survive.

It was only with the advent of the Romantic period that archaeologists first dared to reconsider their theories and turn to the Greek originals themselves so as to discover curvature and to verify the existence of polychromy. Then arose an age in which mediaeval art and generally all the anti-classical arts again began to be respected—that is to say, all those arts which in spirit conflicted with the classical, denying exactitude and regularity as a means of obtaining perfection in form, being replete with irregularities, and deriving not from an anthropocentric but from a theocentric spirit. Thus the Romantic movement brought enlightenment to classical art, and confronted it as a living expression of emotions, and not as a product of geometry. Aesthetic historians like John Ruskin, while almost totally rejecting classical art, nevertheless unconsciously influenced their contemporaries to see this art more through the eyes of the artist. Then the cleavage between science and classical art was for the moment bridged, and in fact sensitivity to art, which differed radically from the strictly academic interpretation and came closer to the truth, was strengthened through scientific argumentation in the direction of a more substantial understanding of the classical world.

And thus we note from time to time a unity alongside the cleavage between art and science. From this interplay of influences artistic contemplation acquires cause for inspiration and science is enriched at the same time. The scientific mind becomes convinced that the artistic evaluation of monumental works requires something beyond mere

17

grammar and syntax, something other than historical dating and archaeological interpretation. It is persuaded that a more important role must be given to the criteria of the senses and the feelings. More attention must be given to certain phenomena which contravene the dominant theories of the age, no matter how insignificant these may be, how symptomatic they may appear, or how irreconcilable they seem.

To revise a scientific theory from its very foundations because of phenomena artistically incompatible with it surely requires great effort, daring, and inspiration, since to do this in each instance means a referral by the researcher to first principles. Yet, though art demands such reference and accomplishes it through perception, science generally rejects it because, by nature coldly logical, it advances through additive processes. In other words, science continues to add further facts, and does not seek knowledge, or, rather, it approaches knowledge by calculation, from time to time adopting new propositions which explain a single aspect of the phenomena. Philosophy alone, without ceasing to be a science, always from the very start sets as its objective the problem of the whole. Aesthetics, which is a branch of philosophy, does the very same with the problem of what is good. For this reason, the archaeologist must essentially be grounded in aesthetics so that he can better evaluate the art theories which predominate in his age and be led to an evaluation of the importance of the works of the past. Unfortunately, however, whereas many archaeologists are by force of circumstance compelled to evaluate or to justify certain kinds of permanent works, they hasten to formulate new theories and proclaim new principles, as did Conrad Lange with his principle of frontality in ancient sculpture or Olaf Wulff with his inverse perspective in Byzantine painting, principles and theories, in other words, formulated without too much aesthetic effort, but which archaeologists, rarely equipped with an aesthetic training, cannot examine, challenge, and refute. Thus these theories remain like yellowed wrapping paper, readily at hand for a "wise and learned" interpretation (and a bad one at that) of the works of a certain era. But it is even more curious that, whereas aestheticians often examine and reject such theories, archaeologists continue to maintain them, perhaps because of their natural penchant for preservation, perhaps because it is difficult to find a substitute for these theories, but mainly, I believe, because they overlook the fact that certain principles of aesthetics lack a history. Moreover, many Byzantinists still speak of a stiffness in Byzantine art and of a distorted anatomy, whereas it is precisely these features that are so much admired

by aestheticians. Many archaeologists still speak of imperfect perspective in classical vase painting, whereas aesthetic critics have bypassed perspective, which they consider a technical means of painting not always needed, which at times can even be ignored. Indeed, they discover in unorthodox perspectives new and expressive artistic values. Is there, perhaps, a need for closer cooperation between more specialists for a complete study of the monumental structure of a past civilization?

At all events, at least in Greek archaeology, aesthetics is not a foreign science, and the academician K. A. Romaios has emerged on the contemporary scene to expound his views. He has noted the contradictions in certain archaeological theories for the evaluation of works of ancient art; for many years he has studied all aspects of the subject; and he makes a daring attempt to reject existing theories and replace them with new ones.

Thus, it is not altogether surprising that, upon becoming a member of the Academy of Athens, Romaios delivered a very significant talk entitled "Science and Art," in which he pointed out that "science will be imperfect, very incomplete, without the active participation of the aesthetic factor."[2] It is indeed discouraging to see how a trained archaeologist must struggle to use the aesthetic factor as part of his work in order to revise long-established views and to give substance and validity to the creations of his imagination. For without imagination no scientist can possibly create works of value.

II. the theory of latent movement

Romaios' book on Calydon is divided into two major parts. The first describes the results of his studies on the tile roofing of the temple at Calydon, and the second presents a contribution towards a more accurate interpretation of ancient Greek art.[3]

It was certainly well known that the roof tiling of the ancients was an unusually fine example of a practical solution for the protection of the temple from rain, and that the combination of sleepers and ridge tiles was a remarkable discovery, whose subtle technical elaboration made it a masterpiece of the human mind and at the same time a fine ornamental decoration. The perfection in the fitting of the tiles, which were initially of clay and later of marble, displayed an evolution in the technique for exactness which dazzles us. For this reason, it was believed that the artistic form of tiling was a product of faultless geometric planning.

Archaeologists insisted that a tile could not possibly be set crooked, that the culminating ornamental tile, or antefix, should be set vertically (otherwise it would be an imperfection), and finally that the palmettes or honeysuckle decorations must be absolutely symmetrical, as though they had been carved with the aid of a pair of compasses. But Romaios, who had observed that such "imperfections" actually existed, did not dismiss them as fortuitous but dared to believe that perhaps they were deliberate intentions of the architect and that there was some technical and aesthetic reasoning behind them. And in fact, after long and persistent research, he explained why these imperfections existed, what they served technically, and how they contributed aesthetically to the spiritual elevation of the work.[4] He discovered that, for initial technical reasons, the ridge tiles were slightly slanting to give better cover to the sleepers, and that this slanting was also followed by the palmleaf of the antefix. The slanting became a permanent feature because its aesthetic significance was finally recognized. Thus, Romaios observed that, when we stand in the middle of the long side of the temple, there is a visual axis from which all the antefixes on the right incline slightly to the right and all of those on the left incline to the left. Something similar occurs also with the lions' heads of the water spouts in the Parthenon, which turn slightly, half to the right and half to the left. In this visual axis the opposing movements of the ornamentation also meet, subject not only to the direction of the motif of the ornamentation but also to the alternation of the colors of the decorations in a certain defined rhythmic manner. Romaios, in fact, believed that this visual axis was adopted after the Corinthians made the great discovery of covering the temple with a pediment on both short sides, abandoning the protruding shelters originally used as roofing at the narrow rear side of the temple. Finally, he was convinced that the antefixes were never absolutely symmetrical, and therefore lacked the axis of symmetry at right angles to the coping, and that they possessed a certain curvature suggesting a three-dimensional effect.

Yet Romaios did not stop at this point. He had made similar observations about ancient statues. In an art that as a rule is regarded as having subjected the anatomy to rigid geometrical form, as being immobile and stiff, he had noticed the curvature of the *linea alba* of the *kouroi* and other deviations from the symmetry of the face, of the chest, legs, and generally the turns that precluded the famous principle of frontality of Lange. Were all of these imperfections and irregularities deliberate?

It would be easy for Romaios to answer in the affirmative, as most archaeologists did. And it would be even easier for him because, as he now admits, he formerly found no beauty in ancient art. Yet his scientific honesty combined with an artistic sensitivity moved him to look beyond the apparent phenomena to uncover the hidden reasons why harmony emanated from the works of art—to find ways of explaining these "imperfections," why they were deliberate, and how they contributed to the expression of life that emerges from worthy works of art. He thus formulated the theory of "latent movement," as he called it, which includes within its framework all similar deviations from the established canons of classical art, the imperfections making the expression of a perfect work of art more lively and more real than the lifeless and sterile intellectual perfection of the academic school. Within this theory fall the curvature of the Parthenon, the divergence of its columns, their entasis or bulging, all the deviations from the normal to be found in ancient sculpture, and all deviations present in ornamentation and pictorial representation that enhance their apparent visual verisimilitude, though this gives them the appearance of a faulty perspective.

It is certainly true that the age in which we now live, in which the artist has renounced the academic mentality and can easily avoid the conventional in art so as to approach primitivism, this age appears ripe for the refutation of older views, even those of the scientists. Our age has aroused the spirit to move toward the exploration of phenomena formerly unacceptable to art. But Romaios is not influenced unilaterally by the wind of change in his age. If he refutes something, he at the same time builds something else that is closer to the truth. He casts so much light on the older corroded views that the refuted ones collapse and disintegrate of their own accord. It is indeed very moving to see with what patience and persistence he has pursued his research over many years, observing attentively, examining the finest detail, checking and counter-checking until he is absolutely convinced of the new facts before attempting to convince others of his discoveries. Then when he decides to convince them, he has at hand the proof of his observations culled from facts and a theoretical weapon of his own thinking, the theory of latent movement. This is the subject of the second half of his study, "a contribution towards a more accurate interpretation of Greek art."

The entire work consequently is a fine example of what a really scientific project should be. I have been inspired by his ideas, and, though I have some reservations regarding his theory, this only indicates

how fruitful a study can be that has the power to generate further ideas related to the first principles of art.

Romaios characterizes every deviation from the norm contributing to the enhancement of the work (the constriction and bulging of columns, their pyramidal divergence, the curves of the base and the cornice, the slanting of the antefixes, the turning of the lions' heads, the asymmetry of the *kouroi,* the curve of the *linea alba,* and so on) as movements accounted for by one and the same source, which he illuminates through the theory of latent movement.

Movement means life; thus those scholars who noticed the curves of the Parthenon or other deviations from the normal interpreted them as aiming to give life to the works; but they did not proceed to elaborate why and how this was achieved. On the other hand, those who wished theoretically to justify the curves of the Parthenon were influenced by the theory of Vitruvius to the effect that the curves constituted a means of inverting the optical illusion which would have resulted had the lines been straight. In other words, if the stylobate and the architrave were geometrically straight lines, they would appear to sag in the middle, whereas now they appear to be straight.

The same purpose is served by the bulging or entasis of the column to avoid the optical contraction which, according to the ancient author, appears in the middle of the cylindrical column. The pyramidal convergence of the columns was meant to avoid their appearing like an open fan. In other words, these deviations were deliberate, petrified illusions, reversing other illusions that arise without our having any control over them. This was therefore a means of restoring geometrical rectilinearity. The ideal was a Parthenon with cylindrical columns having equal intercolumnar spacing, absolute verticality, and straight horizontal lines throughout. The fact that geometrical rectilinearity did not possess the advantage of moving the soul escaped the notice of most. Indeed, most scholars wanted to find a scientific basis in the writings of Vitruvius, some basing their interpretations on the physics of optical illusion, others on perspective. Those who explained the illusion as optical alone did not bother to say why illusions displease us. Those who accounted for the curvature as aiming to satisfy the spherical perspective of primitive man failed to explain why these curves are pleasing to us.

Once, when I dealt with the subject, I made the observation that if we were to accept optical illusions as due mainly to psychological factors, then the curves are not merely optical corrections but are at the

same time expressions of something. For this reason, when we discover curvature, we are charmed by it, and we want to see the lines as curves. And so this is a case not of restoring rectilinearity but of sutstituting for straight lines other and more expressive lines.[5] Romaios and I see eye to eye on this point. But our views diverge when it comes to explaining what curved lines express, how they affect us visually, and how they are justified aesthetically. Let us first see what Romaios maintains.

The theory of latent movement is based aesthetically on the concept of rhythm. Romaios maintains that when we observe a curved stylobate or base, we have the impression that it is linear. Thus, between the straight and the curved line there takes place a rhythmic alternation in our minds which results in the evaluation of the length of the stylobate (for if it were straight, our sight would run down the line more quickly) and its upward rise.[6]

Romaios correctly observes that the meaning of rhythm is not wholly integrated with the simple rhythmic arrangement in which the same element is repeated. Rhythm is something beyond this arrangement; it is a pulsating action, a flow of dynamism, wherein the movements of the work fluctuate, as, correspondingly, do the movements of the spectator's soul. But Romaios believes that movements in architecture are imposed upon the spectator through the movements of the eyes.[7] I need not point out that the movements of the eyes are not controlled by us, and that the muscular responses do not therefore convey to us information about phenomena. At all events, Romaios does not examine those movements which are visible, but only those which escape us—the latent movements—and he believes they are imposed upon the spectator by the deviations from the geometrically normal, for in this manner a continuous comparison of the deviations with their geometrical counterparts is created in the imagination of the spectator.[8]

The same principle applies to the tops of the antefixes, half of which lean to the right and half to the left along the length of the temple. They are aligned opposite each other in two series, though at first glance they appear to be arranged in vertical fashion and convey the feeling of movement because in our imagination the corresponding figures interchange places. According to Romaios, the spectator can rhythmically alternate various figures of one and the same kind because in our intellectual space the impenetrability of the natural world does not hold true; instead, the means of differentiated time movements and frequent image formations overcome this lack.[9]

About these theories I should like to say, first, that rhythmic pulsation is created within us also through the observation of the elements of a work identified with geometrical shapes, such as the flat area of the wall of an enclosure, the triangular shape of the pediment, and other elements where there are no opposite or contrasting figures; second, that we do not see the curves of the temple, or, when we do see them, we cease to see them as rectilinear and enjoy them because they are curves—we do not want them to be straight lines, since, as I have said, the curves are expressive; and third, if, despite this, we admit a comparison with the geometrical figures, the result is an intellectual action and not an aesthetic expression. In any case, in our intellectual space, although the impenetrability of the natural does not apply, we need arrangement and order. We arrange, classify, and organize our impression; otherwise confusion would result. For this reason, every rhythmic creation possesses primary and secondary elements, measures, and expressions, and periods which repeat themselves are equal to and balance themselves in a coordinated array within the whole of which they make up the rhythmic differentiation. Thus, an infinite alternation of curve and straight line in our imagination does not constitute rhythm and would not make it possible for us to choose one of the two lines in order to locate properly the section or part in the whole work. There is no doubt that every partial formation and every partial deviation must be judged by the arrangement of the whole, which will of course follow some kind of logic. Let us now examine the deviations and irregularities of the temple in this light.

If we are to explain the irregularities logically, we must first accept the premise that wherever there is a deviation from the proper arrangement of elements, there is an inconsequence or an *anacolouthon*. Art often uses the inconsequential or *anacolouthon,* for in this way it goes beyond the standard reasoning as it strives to express higher thoughts. Yet, lest there be an irreconcilable conflict through the use of the *anacolouthon* or the inconsequence of the part with respect to the whole, the consequence of a superior meaning or idea must dominate, and this, together with the *anacolouthon,* will be enhanced.

I quote an example from poetry, cited by Charles Lalo.[10] The verse of Alfred de Musset, "Poète prends ton luth et me donne un baiser," is an *anacolouthon*. It should have been written: "Poète prends ton luth et donne moi un baiser," but in this way the verse would become prosaic and the appeal for a kiss commonplace, whereas the *anacolouthon* is poetic because, with the change of the imperative to the present tense,

the invocation for the kiss, which is understood, takes place even before this has been revealed, almost like magic. Such *anacolouthons* exist in all poetry, even in Homer, but no one objects because they are aesthetically appealing.[11]

Quite similar is the case of the antefixes. Inclined to the right, or to the left, the antefix falls out of line, but without the series losing its order because both are subject to the immediate whole which contains them: the crown. But the crown of the antefix in the front constitutes a free termination which can, as a result, acquire movement. It is true that if the antefix inclines too far to the right, then the impression repels because the antefix refuses to be subordinate to its place, and a disharmony of the part and the whole results.

There is a limit beyond which these "movements" in architecture must not go so that they may each time fit in harmony with the overall direction. But Romaios does not indicate this limit, nor is it defined by the confrontation of the figure of the real image or the image of the theoretically normal shape because, as he maintains, they possess a "likeness despite the difference." Here indeed is the weakness of the theory of latent movement, for without a limit, every irregularity, every chance imperfection in construction, or artistic shortcoming, or exaggeration for the elevation of the "life" of the work would give rise to an alternation of contrary images and consequently would be the cause for aesthetic rejoicing. Confronted with such danger, it is understandable that the "academicians" who standardized the arrangement of rhythms on the basis of logic would resent a priori any discovery of irregularities in their works, and would consider the prohibition of geometricity, regularity, frontality, and precision, and, in a word, the sequence of formal logic in the arrangement as leading to the low evaluation of a great art.

From the preceding analysis of the antefix, one sees that in the imagination of the spectator there is not an interplay between the images of the vertical with the slanting tile but, rather, an accomodation of the tile in its organic position within the whole, as a crown of the temple with a free termination. To this is due not only the toleration of its deviation, but also the evaluation of its merit. In other words, we do not regard the members of the temple as inanimate shapes logically arranged but as organic creations acting in the composition of the entire body in the unique spirit of artistic freedom.

Thus, when we see the curve of the stylobate, we do not in our imagination alternate it rhythmically with the horizontal line for the

reason that, as Romaios believes, such would be the geometrically correct line of the stylobate. Furthermore, the geometrical straight line is nonexistent for the spectator. Only the geometrician would recognize it. And if the aesthetic spectator should think of it, then he is mistaken in his aesthetic interpretation of the work. He would also be mistaken in blending in the regular hexadron, which contrasts with the pyramidal form of the whole temple, or the cylindrical column in opposition to the thinner column. What takes place, however, is something quite different. For the aesthetic observer, the stylobate is a body which lies on the earth and rests. If he sees it curving upward, he feels this body as reacting against the curvature. If he sees it curving downward, he feels it sagging under weight, as though it were being buried in the earth. If he sees it remaining at rest on the horizontal, he feels it as inanimate and lifeless, and is indifferent to it. It is true that this body has lines along its edges. But the spectator does not see only lines without a body, because he otherwise would be seeing incorporeal geometrical shapes in his mind, and these can be known only by the mathematician. So the spectator rejoices to see the stylobate rising in the middle, not succumbing to the weight brought to bear on it by the columns, provided, of course, that all the members of the temple show the same disposition in overcoming the weight and in being liberated. In this higher meaning they find their common link.

Something similar occurs when the constricted column is observed. Its vertical posture conveys the meaning that this body rises upward, stands on its feet, and strives to act, and it does act very obviously with the thinning of the shaft, for the base is correspondingly broadened, the center of gravity drops lower to make it more stable, and its top is constricted to react better to the weight it receives through the echinus. Our bodies react in the same way when we wish to support something. If the body dies, then it collapses to the earth and lies there. Even inert materials collapse under the pull of the law of gravity, and they form a heap whose slant differs with each material. For this reason the tomb expresses the peace of the grave, and the pyramid of the Egyptians is nothing but a man-made tomb in the sea of desert.

Briefly, the vertical, the horizontal, and the pyramidal inclines of the sides have no geometrical significance in aesthetics but have a meaning interwoven with our innate knowledge and our experience of the importance of the vertical posture of the body, the horizontal posture, and the pyramidal broadening of the base. The body has the experience of gravity, of inertia, of the hardness of materials, and feels

the resistance to the forces which strive to act on and move it. Without the innate feeling of the tensions that act on the object, therefore, there is no worthwhile aesthetic experience of architectural and sculptural works for the spectator insofar as postures and movements are concerned, at least from the mechanical point of view. Without this "aesthetic mechanics," these works would have spoken a language completely unintelligible to us, and then we would not have been interested in curves, or constriction, or entasis. And when seeing optical illusions by chance, we would not have noticed them, nor could we have considered them illusions to be corrected.

Moreover, the theory of Romaios fails to explain why he believes that when the spectator looks upon a work, he correlates the curve with the straight line, the constricted column with the cylinder, or, in other words, the actual phenomenon with its corresponding geometrical part. The fact that he thinks of the stylobate as straight when he thinks of a stylobate does not, as we have seen, constitute an infallible argument for referring to the rectilinear line. Despite this, however, if we were to agree that the spectator makes some kind of correlation with geometry, then the question arises why, when he sees the curve of the stylobate, he refers it to the straight line and not to the arc, and why, when he sees the constricted column, he refers to the cylinder and not to the sharper cone, since the constricted column is nothing more than a truncated cone. Why, when he sees the sides of the temple converging upward, should he refer to the cube and not to the pyramid, since the body of the temple is nothing more than a truncated pyramid? If he wishes to understand that the column diminishes in an upward manner, he should refer to the cone and not to the cylinder, since the converging edges of the column are not unrelated lines but are the edges of a geometrical solid, that is, of a cone.

Romaios' statement that the protruding eaves of the cornice with its vertical metope suggest the cubic form for the temple is not very convincing.[12] I would say, rather, that the cornice with its protruding eaves and vertical metope emphasizes even more the inclination of the eaves. Moreover, as we have seen, the vertical is not to us a geometrically significant edge of a cube or cylinder but is a directing or guiding line, a guide to gravity against which we instinctively weigh each inclining edge of the building or the column, since our innate knowledge of the vertical is given us by the sensation of balance. But such measuring (which we accomplish by closing one eye, as when the builder checks his angles with the scale) does not oblige us to refer to the

cohesive support of a geometrical cube or a cylinder to bring about a comparison between them and the shapes of the temple. We forget these geometrical shapes (and as spectators we should forget them) in order to enjoy the temple constricted upward, as in the column, so that the whole can be enhanced. Thus a higher common tendency unites them all, an uplifting tendency with which the spectator is directly in harmony; and he judges how each part is coordinated with the whole, and, if there is agreement, he is happy. And for the agreement to take place, he must spurn the straight lines which he may have thought made up the outline of the shapes of the work. With the acquisition of this uplifting force, the temple overcomes gravity, and the material is spiritualized.

And so rhythm is based on the alternations of visible images observed by sight. It is true, however, that with the appearance of an artistic form the imagination begins to function. Yet, an aesthetically healthy imagination does not dream up geometrical shapes to correlate with the visible; it visualizes where the shapes lead to, beyond what the pedestrian spectator visualizes. Thus an alternation between the apparent real form and its projected ideal is created which is not merely geometrical but is an active, pulsating existence which perhaps no hand of any artist could ever bring about except through suggestion and the use of symbolism.

After all, it is the gift of art to our souls to liberate our imagination in all its forms. We see the form not merely as it actually is, but as it wishes to be, a rich tone of harmonious melody, a world within a world, a symbol of the ideal. This explains how those who have not discerned that the lines of the Parthenon are curved can still feel that they are unusually beautiful.

Romaios says, "In constriction two factors of the rhythm which are coexistent are only subjective and intelligible, the cylinder and the cone, and only the result of their coincidence is present."[13] I believe that the coinciding of the constricted column with that which does not exist (the cylinder) cannot possibly occur, and even if it does, it will not please because it is directed to the intellect. The impartial observer is unacquainted with geometry; nor is he interested in learning geometry; and he should not be so interested; if he is, he begins to think and not to feel. Thus, as long as he observes impartially, he feels the column is supporting something and in fact is directed somewhere, so that it acts as more than a mere support. It strives to function in such a way that the entire temple, and the column as well, becomes elevated. Both overcome

gravity and spiritualize the material. In this ideal situation, the shape of the column is a being possessing the beat of action, a rhythmic beat, and it is to the column and the column alone that the spectator is attuned and about which he judges whether he is in harmony with it or not. The column is thus in a state of "movement," and its real shape is the image of its momentary movement, but it is the most significant movement, that which guides the imagination where it should be guided. It is an image of the productive moment of the column, the moment which has gone beyond the enslaved work only as a support, and it acquires value in itself because it works in harmony freely to bring about elevation and style.

All worthwhile sculptures generate similar images. They embody postures suggesting movement. They therefore come to life. For this reason, their postures would be unnatural were we to judge them by strict canons of anatomy. But they succeed in convincing us that a *kouros* who stands on his two feet is ready to move on, that Rodin's *John the Baptist* is moving, that the *Victory* of Paeonius has just alighted and is still in flight. On the contrary, photographs, also of momentary posture, though not of artistically productive moments, reveal people as walking unnaturally, sometimes with one foot raised in the air or in other comical positions. The same applies to works of sculpture which ignore the productive moment and therefore appear nailed to their pedestals, unable to convey to us the feeling of life. It is true that if a natural being were to assume the posture of a productive moment, it would seem to us unnatural, and that is precisely why a bogus creation of art in an identical posture appears to be real. A complete action in time is compressed in space, which suggests in the imagination of the spectator the train of images that calls for the spurring of such action in life. Such moments are selected by the sculptor, the painter, the playwright, and the architect, a fact always known in aesthetics.

These, then, are the actual postures which Romaios, after noting their deviations from geometrical regularity, studied in the *kouroi*, the antefixes, and the temples; and he concluded that all of these forms had a common source, the need to express a latent movement. But movement whither, and how? These questions have remained unanswered, just as has the definition of limits within which any part incline away from the normal. For architecture especially, these two questions are of special significance. What would happen if the curve of the stylobate because of exaggerated "movement" should become an arc? The impression of columns set on a curved surface would be created. The

feeling of balance would be discordant, and the pyramidal slanting of the columns would appear ludicrous; for, whereas they tend to lower the center of gravity of the temple, the stylobate would appear to push them upward excessively and would convey the feeling that they are sliding down the stylobate. Here, too, the adherence of the part and the whole to a single higher principle remains the criterion of the limit allowed each movement. The movement of a secondary element must be subordinated in such a way that if for a moment it opposes this subordination, it will emphasize and elevate the primary element; for over and above both elements there is a superior pulsating force inspiring the work. Then the movements of the parts are harmonized, the contrasts are composed, and the poetic objective of the work is realized in the posture of the creative moment. In it is compressed the palpitating rhythm of the work, and in the imagination all the phases of its creation march past.

But how does the creative moment succeed in being present? In what image? Although Romaios does not speak about this, it is nevertheless obvious that he feels this when he says that in a work of art there simultaneously coexist successive movements in frontal and non-frontal postures, as in the lions' heads. I believe that the slanting of the lions' heads does not reflect the presence of two images, but is only an indication of life. And when it does not possess an excessive turn, it is not projected as a turn but suggests the possibility of the turning of the head. The spectator thus is inspired and re-creates in his mind a living being which can make an infinite number of movements. The Baptist steps with his two feet on the ground but seems to be moving, not because another raised foot is present but because his posture is such that movement is suggested. So the coexistence of posture and movement occurs in the mind of the spectator; or rather, the impression of eternal movement is created; and for this reason the Baptist is accepted, standing as he does in eternal motion without appearing to be lifeless.

Let us now see how the phases of life in the column are perceived. As we follow the form of the column from the bottom up, we first note that it is set on a base; then that it moves upward, and easily, since it is constricted; and, finally, that it carries weight. Looking downward, we see the weight as being carried to the base, which becomes broader and is firmly grounded. But to stand somewhere in eternal motion, it lifts its center of gravity by means of a swelling or entasis, and thus acquires the air of the creative moment.[14] The eyes, however, do not see the column alone; they also see the pedestal, the colonnade, the entablature, and,

finally, the entire temple. And if all parts agree with the individual elements, and each element with the whole, and above all if the spirit of victory over gravity emerges, the rhythmic pulsation of the work of art overwhelms us and leads not to geometrical associations but to visions of divine archetypes of which the perceptible symbol is the direct reflection of the temple itself. Each form is unique, and this explains why there are remarkable temples in which the columns do not possess the pyramidal slanting such as are found in the temple of Phigalia, a work of Ictinus (fifth century B.C.), though in this temple as a whole, because of its site, size, and the spirit pervading the whole work, such columns are the most appropriate.[15] Thus, each work of art is a special example of a harmony which selects its own special means of liberating the spirit from the weight of the material.

A representative image of the spiritual power which refinements convey to form in classical art is provided by a relief in the Olympia Museum on which Hercules is depicted as struggling to carry the weight of the canopy of heaven. Behind him stands Athena with the palm of her left hand extended to help him with his burden. What the goddess accomplishes with one hand no human strength could possibly accomplish. Hercules would have been crushed by the weight, as would the temple, if these slight refinements which lift the weight, as does the hand of the goddess, were lacking.

Along with the unfortunate interpretation of frontality as Conrad Lange understood it, Romaios is given the opportunity to deflate the mistaken notion of symmetry in sculpture. To the ancients, "symmetrical" was identified with "well-measured" or "well-proportioned." But the academicians interpreted this in a quite pedestrian way as involving a central axis of equal and similar forms on either side. This theory destroyed every free interpretation of classical art. In fact, ancient art with its stereometric rigidity was taken as an art which totally ignored the anatomy of the body and all departures from the canon of resemblance to the natural state. Yet Romaios shows that anatomy is everywhere alluded to: the youth is distinguished from the young man by different proportions of the torso; the forehead, the cheeks, and the ears are as a rule unsymmetrically formed, just as in the natural state. There also are slight deviations in posture, height, and frontality in a combination of two *kouroi,* which point out and emphasize the movement of each torso and of the whole in one unified composition. Thus, archaic sculpture comes to life and is linked with classical sculpture.[16]

Another great truth emerges from this observation: the idea of

progress is attacked, an idea which for centuries has tormented art, and particularly classical art, since it was deemed a final stage in the gradual development of archaic art, the latter consequently being inferior. One is really amazed at the fact that much effort was required to convince us that there is no such development or progress in art. The compositions of each age are or are not works of art. And if the composition is not a work of art, then the age itself is artless. But if it is a work of art, then it is unimportant whether its anatomy is deficient, whether its perspective is different, whether it tends toward a stereometric representation of the mass or is naturalistic. For a work of art, all of these factors are a means to an end, and not the end itself. The end is to move us aesthetically through the symbolization of an idea. The means used to bring this about are of only secondary interest. And so the proof that Romaios proposes—that is to say, that identical rules of art and the same disposition characterize Greek sculpture from the archaic period through the finest period of classical art—is of tremendous importance.

If we talk about the creation, the flourishing, and the decline of each period in which a certain style predominates, it is because the laws defining each period begin somewhere along the line to accumulate, then to crystallize, then to decline. But when we speak of laws declining, we mean they are beginning to alter. By gradual stages they take a new direction because both the ideal of the period and the symbols which it tries to express undergo change. Thus, in remote antiquity, the spiritual world which begins to assume priority in sculptural works turns away from the restrained dynamism of classical art. And finally, the Christian ideal will provide other means and symbols of expression, so that Christian art will replace pagan art. In other words, extroverted art will become introverted.

The theory of latent movement, therefore, is a pleonasm for classical art, as no art can conceivably be without movement. It may well be restrained in classical art and more pronounced in mediaeval art, and for this reason the former is usually described as static, the latter as dynamic. But latent movement exists in all arts. And I call it *latent* because the outer representation of a work of art—for example, the posture of the hands in a statue—conveys not this movement but the representation of an inner movement at the creative moment of its action. A statue depicting a certain action may be artistically motionless and lifeless as compared with a *kouros* whose hand is glued to his torso and who barely walks.

The contribution of Romaios lies first, in the proof, which he based

on his observations of the tiles of Calydon, that certain irregularities in archaic architecture which had been attributed initially to the technical tradition were also retained subsequently in the classical tradition for aesthetic reasons; second, in his disproval of Lange's theory of frontality in archaic statuary, which he calls utopian; and third, in the daring with which he noted that the lack of symmetry in archaic sculpture is of an identical nature with the deviations in classical architecture from the geometrical tradition.

III. the latent picturesque

In all fairness, one must say that relating archaic and classical architecture from the point of view of irregularities was first done by William Henry Goodyear,[17] who, examining the irregularities of the classical temple, began with the inequalities existing in the intercolumnary axes of the archaic temple, and maintained that the constriction of these axes in the classical temple was nothing more nor less than a systematized irregularity. This irregularity, he added, is not disturbing because we see the inequalities in the intercolumnar axes perspectively. But with the inequality of construction, the impression of this inequality becomes greater, and in the imagination there arises an aesthetically pleasing confusion. He adds also that a somewhat similar result is obtained when one looks at the curves and other irregularities of the temple. It is for such a reason that he considered them not as optical corrections but as refinements of form, a temperamental architecture, as he calls it. And to substantiate his argument that it was not corrections but characteristic and expressive lines which the Greeks finally evolved systematically on the basis of experience, he sought for and found curves, deviations, and refinements generally in Roman, Byzantine, and Gothic architecture. Thus the tradition continued, and, as has been proved, it survived briefly in the Renaissance period and then disappeared.

It is quite clear that Goodyear's aesthetic interpretation of the constriction of the intercolumnar axes is unfortunate, although it draws on the idea involving confusion as propounded by Ruskin, the bitter foe of any regular geometrical shape. Moreover, the correlation Goodyear made of the refinements in architecture of different periods was external, since he did not take into consideration differences in elevation. It is a well-known fact that the refinements in mediaeval art are not of the same kind as the refinements in classical art. As a rule, the former are

unsystematic and emerge freely in the course of construction, thanks to the artistic instinct of the builder, as long as he does not lose sight of measure. The refinements of classical art are as a rule pre-planned and allow no room for incidental or casual construction. This is because mediaeval art not only does not refuse to accept inaccuracy and lack of regularity in its forms but actually cultivates them, since on them it bases its grace and attraction. Classical art, on the other hand, depends upon precision and regularity. In short, mediaeval art is picturesque in style, whereas classical art is plastic or tectonic.[18]

These refinements, therefore, no matter how much they may be of the same genus, in accordance with the style of the order in which they are applied, change form—that is to say, they assume another direction and another significance. In classical art, the refinements enliven the form so that they lose their intellectual dryness of shape and approach the natural through their dynamism. In mediaeval art, on the contrary, they consolidated the free tracing out of the form with so many deviations that only its intellectual shape is seen. It is true that these deviations do not destroy the directions of the basic lines, or the general proportions, or the mass. They retain the proportions so that the unity of the part to the whole is not lost, and in this way also they approach the ideal shape. But whereas classical art had as its ideal the realization of the perfect imitation of its archetype, a definitive, exemplary form, mediaeval art had as its ideal only the suggestion of the ideal of perfection within a transient form. Mediaeval art, in other words, created its shapes as nature produces its creatures, by sacrificing the individual for the race. Consequently, proportions in mediaeval art lost their absolute meaning, and the effort towards exactitude slackened. For this reason, Plotinus (205? – 270 A.D.), the forerunner of the mediaeval period, had as a principle another ideal in art. Beauty, he said, does not depend on pleasing color and symmetry but on the expressions of an idea which the work reflects. This gives it unity.[19]

From the artistic point of view, therefore, both kinds of deviation are in fact refinements of the form approaching the ideal. But the classical deviations are positive and the mediaeval ones negative. The former as much as possible make perfect the realized form, while the latter suggest the perfect form by giving rein to the imagination to grasp the form, as does a painter's sketch containing many lines, from which one's imagination must select one and must then visualize the complete ideal shape. But since it is never possible to realize the ideal, and each work, even though classical, is but an approach to the ideal, it follows

that the distinctions between the positive and negative approaches to the ideal are only external ones. It is therefore quite obvious that what creates the picturesque or the plastic expression is the different ideal of perfection. And classical art strove for the ideal of abstract beauty in the archetypes of ideas, whereas mediaeval art strove for expression of the characteristic beauty in creations which had been enlightened by divine grace. This explains why in mediaeval art form recedes before content, and art, from being an outer matter, becomes an inner one.

Another result of the differential ideal is the pervading synthetic principle. In classical art it is democratic, while in mediaeval art it is monarchic. In the former, arrangement dominates, and the parts acquire a self-perfection and completion, whereas in the latter subordination is dominant and the parts lose their completeness and self-perfection. In classical art, the parts cooperate freely to make up a whole, but in mediaeval art they resemble derivatives of the whole. Moreover, the very structure contributes to such a resemblance. Classical architecture builds out of nothing except with regular stone and with the system of beam-on-columns in which the thrusts act vertically. Hence the triumph over gravity is based on elevation. On the contrary, the mediaevalist builds stones and bricks with a joining material, creating in this manner a kind of monolithic or massive structure in which the deviations occur within themselves. And lastly, the system of dome construction can also withstand lateral thrusts, and the entire mass, to overcome gravity, reverts to dematerialization, hence the abolishing of plastic advancement, the elevation of the surface, the plane reliefs of the ornamentation, and the freedom for completion with irregularities which invite the eye to escape, to roam over, and to conceive of the whole as a transient expression of the content. At the other extreme, classical art asks one to stop and enjoy its plastic creation and the proportions of the forms themselves.

It is true that mediaeval art is not lacking in plastic elements; hence the corresponding refinements it presents. Its columns possess an entasis. The center opening of the trefoil is narrower, or even wider, so that it can be seen, the arcs are raised on high to acquire elevation, and, if we are to believe Goodyear,[20] Byzantine churches enlarge the center aisle vertically, and the arch of the apse becomes almost butterfly-shaped so that the church can breathe.

The plastic arts also possess picturesque elements, irregularities, and inequalities in form which arose freely in the course of construction. Such elements are found especially in archaic architecture, but who

knows whether the inequalities in the abacuses on the sides of the Parthenon are a product of a similar freedom in construction? At all events, the picturesque refinements include the deliberately unequal axes of the intercolumnations, the slanting of the antefixes, the turn of the lions' heads, the slanting of the acroteria, and so on. Therefore, when we say that the refinements in archaic art survived in classical art in a systematized manner, we mean that a latent picturesqueness survived—latent because it was subjected to a new ideal in art which required exactitude and regularity of form to express the ideal of abstract beauty, hence, the tendency for curves to take on a regular geometrical shape, that is, the stylobate the part of an arc,[21] the echinus the part of a hyperbola. It is true that the term *picturesqueness* is generally not used for classical art, but it is the picturesqueness that controls the refinements, the irregularity, the ungeometrical form, the curves that approach its works in nature, since, as Aristotle says, "neither are perceptible lines, such lines as the geometer speaks of (for no perceptible thing is straight in the way in which he defines 'straight' and 'round')."[22]

From this analysis we see that every art contains within itself two clashing tendencies, the plastic and the picturesque; sometimes one dominates, sometimes another. But never does the one eliminate the other; for this reason, the ensuing slanting of the one emerges from the latent slanting of the other.

Picturesqueness formerly appeared in the abyss of the decline of art, when the ideal of Greek art was destroyed and Byzantine art haltingly emerged. Even today, therefore, many classical archaeologists are reluctant to accept Byzantine art as equal to classical art. Yet the refinements of form have shown the deeper relationship pervading both. The classical spirit was rich enough to contain within itself the latent slantings of subsequent art. Moreover, in the classical age itself there was the Ionic order, which is more picturesque than the Doric, and the classical style consists, in substance, of the union of both. A similar duality is continued in the Byzantine style, despite the dominance of the picturesque.[23]

We have now brought together plasticity with picturesqueness as two tendencies which co-exist in each art and in certain periods where the one or the other dominates. It now becomes obvious that the ideal form of a plastic work of art cannot lack picturesqueness or be intellectually dry, nor can the ideal form of the picturesque be crudely characteristic and devoid of plasticity. Hence, when the imagination refers to the archetype of the classical work of art, it does not refer to a single

geometrical form as opposed to its actual form, but to a perfect living form containing irregularities whose incomplete form is only the fulfillment of the work itself. This incompleteness of the material is perceptual, however, whereas its prototype is conceptual. But because the desire for fulfillment is the source of creativity, man is made glad as he looks upon its creation. And he rejoices even more when the work of art has the power to lead him to the conceptual form which is its prototype. Thus are generated the successive flight and return of the imagination from the imaginary to the real which nurtures aesthetic happiness. These are the deeper rhythmic pulsations of aesthetic interpretation.

If one considers that the inequality of the intercolumnar axes of archaic architecture was systematized in the classical, that the slanting of the antefixes and the turn of the lions' heads were also established as means of expression, and that the curves and the entasis, and perhaps other refinements, were derived from an unconscious tendency towards picturesqueness, one sees that the picturesque of classical art plays an active role both in the larger lines and in the details of its works. And in fact the picturesque appears unexpectedly and expressly in certain areas of classical art:

(1) In the decoration which imitates natural motifs.
(2) In the polychromy which through colors links the artificial composition with nature.
(3) In the building complexes, as in the Acropolis, which are "open" and not "closed" in arrangement.
(4) In civic architecture, which is closely related to contemporary popular architecture in Greece.

Romaios suggests that great freedom existed in the composition of decoration. Not only do the antefixes have slants and curvature, but their palm or honeysuckle design itself is not absolutely symmetrical. An unbelievable freedom dominates their outlines, which we believe to be symmetrical and regular. This freedom indicates that the forms were not carved out or cut using a pair of compasses. It follows, therefore, that the deviations from the normal appearing in certain elements are not always voluntary. They are unplanned; that is, they depend upon the inspiration of the artist who is making them. In any case, these irregularities are examples of a pronounced picturesque disposition, and it is interesting to see that they fit harmoniously with the restrained dynamism of the work characterizing the style of classical art.

Polychromy also is an example of picturesqueness, a link with nature. Color elevates each member within the unity of the whole. The

impression of the white marble is lost, and with it the domination of the line in architecture disappears. Classical architecture was not a combination of lines of a dead monochrome material but a structure of mass in a living material which had weight, elasticity, and continuity—that is, the qualities expressed in nature. It is certainly true that colors in classical art are unnatural, but on the whole they constitute a harmony which imbues the work with life without itself being an artless imitation of life. With color, the element of picturesqueness penetrates deeply into the plastic composition of this architecture; otherwise it would have remained a composition of dead mass. This lifeless mass would be readily supported by the academicians, and for this reason they fought against polychromy.

The theoreticians took the color of the decoration away from Greek architecture and delegated the decoration to geometry; thus, they made of color a lifeless element or simply an ornament affixed to the architectural body. They tried to explain the origin of motifs by referring to floral prototypes, or to patterns in weaving which were at one time used to decorate buildings. In other words, they made of color an element extraneous to the organic association of the members of the work. According to them, the decorative motifs were attached to the work just as May Day wreaths are suspended from our balconies today. Probably some motifs did originate from the custom of ornamentation or were taken from patterns of weaving. But the value of classical architecture lies in the fact that it organically absorbed these motifs—in other words, it made them part of the structure, elements basic to its expression: it gave to the motif a tectonic purpose. This truth was reinforced by the theory of exactitude, according to which the inverted Lesbian volute appears to overflow, or the echinus appears to exert its forces to support it. Going beyond the floral or other origins of the motifs, this theory showed the organic importance of the volutes in the association of parts and, indeed, in the expression of forces acting upon the parts. This interpretation, moreover, was inward. It is true that the theory referred to profile, but in decoration there is yet another facet, the pure imagery unfolding on the surface, to which matter we must now return.

Romaios correctly observes that decoration is directed toward emphasizing movement. It sometimes combines conflicting movements which stress the dominant one, and in this it is helped not only by the actual plan or outline but by the color, which varies from gray to the lighter shades. Romaios attaches great importance to the Corinthian invention of putting a roof over the temple with two pediments along the

narrow sides, and he assumes that this made a deep impression in ancient times because the roof created a vertical axis along the sides which permitted distinguishing not only the slanting antefixes and the lions' heads but also the direction of the decorative motifs. But the center axis is not discerned.[24] At all events, I believe that the greatest importance of this innovation lies elsewhere. The building ceased to be a building with a single facade containing an entrance. The building acquired two facades which, combined with the wing, became a single facade. The entrance diminished in importance, and the structure acquired a value within itself beyond its functional purpose.

The building complexes also testify to a freedom in arrangement which can only be described as picturesque. These complexes are not "closed," that is to say, they do not form a closed space with the buildings arranged around it in the manner of the continuous building system; they are "open." Spaces are left between the buildings, and the buildings project out towards the spectator, usually in a diagonal fashion. The buildings are adapted to the site so that the site is emphasized, and they follow the morphology of the ground, as is seen in the Erechtheum, which was asymmetrical and was built on different levels so as to be adapted to the ground itself. Even in the town-planning system of Hippodamus (fifth century B.C.), the space in most instances retained the picturesque irregular arrangement and the apparently fortuitous shape.

Finally, the purest form of picturesqueness in ancient Greek art is to be found in urban architecture. These houses, products of the folk architecture of the time, are freely arranged both in composition and in decoration, a plan which much later characterized the official religious architecture of Byzantium. One is tempted to say that Byzantine architecture is nothing more than the folk architecture of antiquity with the openings bridged by arches and the space sheltered beneath domes. The spirit of the arrangement remains identical, free from the austere rhythm of classical religious architecture—that is to say, it is strikingly picturesque.

In the archaic period we already encounter ground plans having movement and alternations of space characteristic of dynamism, both in the rectangular and in the curved structures. In the classical houses there are irregular ground plans, asymmetrical and not equiangular. The windows are arranged freely, the balustrades often recall Byzantine balconies, and all are related to the contemporary popular houses found in Greece today. These principles return in the houses at Mistra. The

Renaissance later took the austere rhythmic order of religious classical art and applied it to its secular buildings, at least to the palaces of the rulers. But even in the Renaissance, the slanting toward the picturesque in the urban buildings of the common people could not be totally abandoned. This was to be expected because in popular architecture the builders and the aesthetic principles of official classical art lost force. The mass was taken as a single dynamic material, the contrasts were intense, and the parts lost their independence, for even in construction they were not clearly distinguishable.

And now, after suggesting that there was latent picturesqueness in classical art, we can organically associate classical painting with classical architecture. In vases which are examples of the painting of the ancients, the representation of a single nude body will not disturb the perspective, but one cannot deny that the depiction of a chariot or of a lily on the same vase would jolt the senses because of the unorthodox perspectival combination. Archaeologists justify the ancients' lack of perspective as an effort toward gradual perfection, but I believe that it is rather a change in technique which corresponds to the change in sculpture and painting, moving away from the archaic style toward a more faithful depiction of the anatomy of the figures. These changes were not due to a progressive and gradual development but were the result of a change in concept. They were the result of the tendency toward more realistic depiction. This tendency inspired the artists not to progress but to present the subject in such a way as to approach the new ideal. Yet, again, their perspective was so imperfect as to allow considerable scope for an apology to the ancients on the part of those whose ideal still remains the scientific perspective of the Renaissance. For this reason, despite the somewhat more adept perspectival representations of the classical age, I believe that classical Greek art did not strive to seek the orthodox perspective followed by the Renaissance, as many maintain, because this presupposes a different mentality which would require approaches scientific and naturalistic, both of which are alien to the Greek mind.

In any case, the latent picturesqueness of Greek art leaves scope for free perspective, or, rather, it makes picturesqueness an artistic value. An eye that is picturesquely disposed has no need, in accordance with the prototype of the painters of the Renaissance, to concentrate on one point in order to notice that it aims at naturalistic imitation; and for this reason painters systematized their perspective. The eye can roam about and collect pictures from many points, composing from out of

these a single characteristic posture of the object which is more expres-
sive than is the strict posture of austere perspective the stiffness of which
could never have been the ideal toward which the Greek mentality
strove. Proof of this is the painting of a chariot cited by Romaios. A
chariot driven by Victory is depicted in a frieze on the vase in two scenes
in order, and at first glance they appear identical. But when we look
more closely, Romaios points out, we notice that one depiction is
slightly different from the other. Thus, one imperceptibly receives the
impression that two chariots are racing and does not have the impres-
sion that the same chariot is painted in cinematic sequence, which
would have been aesthetically unacceptable and would have been the
case if one picture had not differed, however slightly, from the other. But
what is more significant here, to my mind, is that all four of the legs of the
horses are spread out in an unnatural posture and yet suggest move-
ment. Somewhat similar are the postures of Théodore Géricault's horses
in his Epsom racing scenes, which Rodin so highly extolled.[25] It is, in
fact, a depiction of the creative moment of the running horse. Such a
moment, it now becomes obvious, had its place in Greek painting.

Such versatility of the eye is to be found also in pottery decoration
and in ancient vase painting in general. This kind of perspective is
closely related not only to the folk art which still survives in Greece; it
reflects the artistic eye of the Byzantines, who abandoned all attempts to
systematize perspective and entrusted the understanding of the pic-
turesque to divine vision.

It now becomes clear that classical architecture was primarily
sculptural and therefore pre-eminently plastic. Plasticity predominated,
but sculpture which created the works depended not only on the sense
of touch but also on the vision of the panoramic eye, which captures the
movement; and thus vision was the means by which this conception
was rendered. The vision of the ancients was to give fullness of move-
ment to works of art, to resemble Daedalian works—that is, creations
which need to be tied down so as not to take flight, as the ancients
themselves were wont to say of great archaic statues.

Thus movement was not latent in classical art, no matter how
restrained it may have been. What was latent was its picturesqueness,
latent because of the special manner in which the picturesque is re-
vealed in classical art, in accordance with its style, which had abstract
beauty as its ideal. The folds in the robe of a classical figure, despite its
obvious picturesque arrangement, are subject to the austere tectonic
articulation of the whole. The carvings or reliefs of the decorations,

despite their richness and variety, are also subject to the tectonic arrangement of the whole. And this accounts for the fact that rarely is there ornamentation of the architrave, or the triglyphs, of a temple which are deemed supporting members. This fact nevertheless did not hinder the classical spirit from developing, in contrast with the Doric order, a new Ionic order with a picturesque tendency. The delicacy of the Ionic order, the picturesqueness, and the more pronounced shadings of its plastic decorations are all products of the grace which pervades the work, and grace means beauty in movement. The Doric order, on the other hand, retains all its seriousness and the great and austere grandeur of beauty. Yet nothing hinders the two orders from standing side by side in lasting works, as they do in the Parthenon or the Propylaea. Thus, the classical spirit consists in substance of the coexistence of these two manners of expression, the Doric and the Ionic, the original plastic and the more picturesque.

I have elsewhere pointed out that in Greek art plasticity and picturesqueness coincide, or, more generally, that this division in the Greek spirit is the source of its creativity because it is the source of its dialectic. It is not only in classical works that we find a coinciding of the Doric and the Ionic orders; in Byzantine art too the classical spirit coincides with the Eastern, as it is called, but which in effect is the Ionic renewed by Eastern influences. This is a coinciding not of two alien influences, of Rome and the East, but of two self-generated contrasts of the Greek spirit itself.

If in classical art the restrained dynamism of the Doric spirit—that is, beauty and not the dynamism of the Ionic spirit and grace—generally prevailed, this does not alter our conclusions; on the contrary, it explains them. It explains how, through dialectical contrasts, a union is born with the dominant position as the basis. Under the influence of Christianity, the grace of the Ionians was later elevated to the grand heights of the divine grace of the Apocalypse and became the transcendental feeling of the sublime, which is the basic characteristic of the Byzantine style.[26]

2

art and technology

The problem of the relationship between art and technology is of primary interest today: first, because the forms of art as followed in the past have changed so radically as to be unrecognizable now and because there is the question of whether they in fact any longer continue to express the value of the beautiful or, instead, represent ugliness, irrationality, and the drama of the anguish of contemporary life; second, because the astounding development of technology threatens to destroy man who created it and subjects him to a technocracy which increasingly constricts the intellectual values of his centuries-old civilization.

For these reasons, we make a distinction between technological and intellectual civilization (that is, our culture,[1] a unique phenomenon in our history), and from this distinction we have yet to see any emergent unity so that goals and the ways to achieve them can again be put into a true hierarchical order of value. Here lies the crux of the problem: technology as a means to an end is in danger of becoming that end, and man is placing material accomplishments above the gifts of art and intellect.

Man is an artisan from birth, for he comes into a world of deprivation in which necessity is the pervading and driving force. He must

therefore invent ways to survive. To this end, he fashions tools to increase the power of his hands (and, in fact, his hand is the first tool he discovers), and with these tools he creates utilitarian utensils and weapons for hunting and for protecting himself from his enemies.

But even when man still lived primitively in caves, with unbelievable dexterity he drew pictures on walls of animals and of hunting scenes. He erected large stone columns as memorials and circular temples and graves for the perpetuation of the life of the dead. These works of prehistoric man are impressive because they required great skill, large numbers of disciplined workers, and great artistic talent. Thus, from the very beginning of his history man needed both practical and artistic expression. He built not only utilitarian objects for everyday use but also works symbolizing his ideas, works into which he later put more effort and artistic sense since he assuredly felt their greater significance and greater social necessity. Such works have the power of uniting men because they attract common admiration much as the magnet attracts iron. And when all is said and done, this admiration of the forms of the world is what, through a kind of magic and subjective attraction, drives man to imitation and to the production of beauty.

Such symbolic creations we now call works of art, though it is obvious that primitive man did not distinguish them from his utilitarian works. With artistic sense, primitive man decorated and created whatever he built. He did not distinguish the useful from the beautiful, nor art from technology. For him the natural and the metaphysical world were intermixed, and the perceptible was not distinguished from the aesthetic. Hence, at the beginning, art and technology are not distinguished from each other; they are innate, and in fact vary with the individual ability of anyone who practices any kind of art. And they are indistinguishable where art specifically is practiced with the hands, as in manual labor.

But when the mind intervened and man began to seek out ways for facilitating his manual labor and for releasing himself as much as possible from such labor, then technology developed and eventually became an objective method of production, a method independent of the individual who performed the work. To this end man began to produce, first, tools which extend his physical power, then, machines which convert one kind of power to another, and, finally, machines which act automatically and replace the hands of the artisan, who is now needed only to supervise and control them.

The only arts which could not be freed from manual labor and the

individual talent of the worker were the fine arts because in them the success of the work depends not only on the conception but also on the creative execution of material. The execution of the works depends exclusively on the artist himself, who must possess not only imagination but skill.

For this reason, because artists in ancient Greece were artisans and worked by hand, they were considered crude workers. In ancient Greece theory was considered the only noble profession. Even science did not accept or recognize experimentation. On the other hand, science assumed a practical turn in the Hellenistic world. Technology was developed; but the Middle Ages did not allow it to become independent of art. Even in the Renaissance artists were hired by noblemen as manual laborers. Only toward the end did artists like Leonardo da Vinci or Michelangelo earn respect and admiration as gifted men and assume a proper place on the social scale. Since great discoveries and inventions began and science became experimental, however, technology has become an applied science, and the fine arts have been distinguished from the crude arts and the artist from the craftsman.

This development in the direction of science resulted in the negation of art in other sectors of human activity. Military strategy, politics, and medicine were formerly known as arts because fundamentally each of these sciences, if it was to succeed, depended on the uncertain and unknown abilities and discretion of the general, the political leader, and the doctor—in a word, on his personality. Personality in each instance determined action, and logic alone did not bring about the decision.

But representing science as an impersonal and objective theory became so widespread that science threatened to dominate every human activity. Today, therefore, strategy, military politics, and medicine are called sciences despite the fact that every strategic maneuver, every political action, and every medical diagnosis remains intuitive, depending on the talent of a certain general, a certain politician, or a certain physician.

Science is a product of rationalism, of the realm of generalization and of abstraction, the area over which the law of causality reigns. Science advances and continually adds to its corpus of knowledge, but to advance it must rely upon suppositions conceived by talented scientists, concepts made intuitively, exactly as are those of the fine arts.

In similar fashion, technology also advances, continually adding to its store of knowledge through the application of scientific laws to matter; it is now completely liberated from the personal ability of the

skilled worker. The skilled worker has been replaced by the technician, who constantly discovers something new. Technological discoveries themselves are the creations of certain talented technicians, intuitive or accidental (if one assumes that the technician is in a position to evaluate the importance of coincidence and to exploit this fact, but here, again, intuition is needed).

Science and technology help one another in their progress, since many problems are posed by one for solution by the other; and they are thus driven into research. Furthermore, today technology too is a science, an applied science, whose purpose is to exploit the forces of nature and to produce material works. Art alone appears not to accept progress. It does not advance as does science, nor can it possibly do so, since its purpose is not to add to knowledge or to exploit it for practical purposes but to express ideas which are eternal. For this reason, furthermore, works of art of every period retain their value, whereas technical works lose their value as soon as the purpose for which they were intended can be served by something better. Likewise, scientific theories are rejected when new theories provide more satisfactory answers.

Art materializes ideas or at least expresses the deeper spiritual anguish of man and his highest ideals in eternal symbols—eternal because they are superhuman and for this reason identifiable, like, for instance, the symbol of Virgin and Child. The symbols of art are not conventional, known only to the instructed, as are algebraic symbols; they are images recognized by everyone because they are based on the imitation of the evident phenomena of the world and, perhaps, also on the recollection of their archetypes in terms of Platonic theory.

But even when art fails to imitate for the sake of the style, the harmony, and the measure introduced into its works, it succeeds in making a form having unity in variety, so as to make its parts members of an organic whole just as members of the human body are parts of a whole. Thus we cannot alter a single part of a work of art, for when a part is altered, the whole is destroyed. On the other hand, technological works are not concerned with form: they are constructions and not compositions. A machine has no organic members; it simply contains parts, and, because its form has no organic unity, we can replace a part without aesthetically destroying the whole.

Moreover, art creates works that cannot be duplicated. Original works carrying the seal of the artist who conceived and shaped them also differ from technical works, which, without special value or worth,

are mere products of an assemblyline. The aim of technical works is to be utilitarian, that of works of art to be beautiful. This does not mean that works of art have no useful purpose of their own; but in their value as works of art they go beyond the limits of the utilitarianism which created them and become ends in themselves.

For this reason, art fascinates man and releases him from immediate practical concerns, transports him into the peaceful environment of a transcendental vision, and fills his soul with joy. Art mirrors the eternity of the spirit.

If art does not progress as do science and technology, this does not mean that it remains indifferent to and uninfluenced by their progress. Art is an action, and to fulfill its concepts it needs technology. Every innovation which technological knowledge presents makes it possible for art to create compositions that would have been impossible in the past. This is quite evident in architecture, in which the presence of the arch or the dome, of metal or concrete structures, radically changed its form. In fact, architecture itself often forces technology to find new methods of construction to serve the newer needs of man and to use certain forms which could not be created with older methods.

Hence art does not progress aesthetically; it does change form, however, and assumes new shape in accordance with the development of technology, the progress of science, and the universal theory of the period whose spirit it expresses in its style. Naturalistic painters in the Renaissance discovered perspective in order to imitate natural phenomena faithfully and to render the third dimension of depth, because in the Renaissance the celestial metaphysical space of the Middle Ages became transformed into the earthly space of three dimensions. And its style conveyed the humanistic ideology of the time.

Whenever the style of technology changes because the spirit of the age changes, assumes other interests, or illumines the world from a different perspective, art also abandons certain techniques, just as painters today have abandoned perspective. This does not mean that the essence of art changes; its aesthetic autonomy is retained because the beauty of artistic works does not perish. In fact, the opposite occurs: in time, that beauty is more widely appreciated.

As civilization developed, as the fine arts were divorced from the crude arts, as technology became autonomous, it was quite natural that in the fine arts a division should occur between conception and execution, between creation and skill. It is true that the mature artist always tends to disengage himself from the actual execution of a work and

confines himself to its composition, so that he supervises the work and leaves the execution to his pupils. Even in the Middle Ages the guild master was concerned with the composition and supervision of his skilled workers. He was always the chief master, just as Molière and Shakespeare remained actors and Michelangelo went to the quarries personally to select the marble on which to sculpt his works.

But Leonardo da Vinci came to prefer painting because it demanded less physical effort than the other arts. Moreover, the training of artists gradually shifted from the studios to the academies of fine arts, in which students were educated for a number of years and did not begin their skills as young boys, as did workers in the handicrafts. After the mediaeval guilds were abolished, architecture was the first of the arts to become a science; G. B. da Vignola (1507–1573), it will be remembered, wrote the primer of the architectural orders. The architect ceased to be a master builder and became a draftsman who, in the conventional language of projective geometry, strives to convey to the contractor what is to be built.

Likewise, in the academies of art, painters and sculptors first learned to compose works. The sculptor made something out of clay, poured it into plaster, and then turned it over to the stonemason to be rendered in marble. The painter became a painter with an easel. He no longer scaled the scaffold and remained on his back for months on end painting the ceiling above, as Michelangelo did in the Sistine Chapel. And if he was to execute a fresco in a church, he would seek skilled painters to complete his plan, limiting himself to casting a final glance at the completed work. This was even more evident in music. The adroit performer, the virtuoso, and the maestro—each acquired an individual identity and came to be considered an "interpreter" or re-creator of a pre-existing work. Composition began to be understood as a purely intellectual activity, and execution as a technical one.

For this reason, not only were arduous techniques such as fresco almost abandoned, but something more significant in works of art began to emerge from the time of Frederigo Baroccio (1528–1612), that which Andrea del Verocchio (1435–1488) called the *non-finito;* that is to say, works of art which somehow eluded completion and resembled rough sketches composed without the exhausting final execution formerly required in a painting. Thus the painter turned inward and made an effort to draw from himself experiences which usually endure for a moment, sudden flashes of beauty which would perhaps be lost had the rendering been more painstaking, as happened when he attempted to

reproduce natural phenomena exactly.

Something of deeper significance must have occurred here. The artist began to appear to the idealists as a creator who, like a small god, shaped his work without soiling his hands in the material. An artistic creation was considered a product purely of the imagination, independent of the material and technique, and the work of art as an expression of absolute beauty, a direct, sensible action but without meaning and without aim. In fact, Benedetto Croce went so far as to maintain that a work of art is an intuition that has been expressed; that is to say, from the very moment that intuition comes into existence, it is identified with expression, though expression is influenced neither by the material nor by the techniques with which it will be completed.[2] "Art for art's sake" was the signal for the separation between art and technology, nature and life, and for the isolation of the artist from society and its ethical values.

As a result of this separation, art became dominated by form and unable to reshape itself or to adjust to technical progress; thus contemporary art inevitably rebelled against technical progress.

Creation in art, then, must be based on technique in order to be sound and healthy and must take into consideration the material with which the work is to be accomplished, since a work of art is a portrayal of ideas in material and not an imaginary and abstract representation. Indeed, it is very strange that so-called contemporary abstract art is based precisely upon this principle, that art is action and that its forms are not simple concepts of the imagination. In fact, action painting has carried this principle to the extreme and relies on coincidence, so that the concept of the work takes shape in the course of the execution. Such painting shuns ideas, themes, and imitation for fear that these will lead to shapes that are baseless or subject to form. I should say that for contemporary art the maxim of Faust holds true—in the beginning was the act; whereas in the art of the past the opposite held true—in the beginning was the Word.

For this reason, it has been justifiably maintained that modern culture is Faustian,[3] not only because contemporary science depends on experimentation and aims at action, thus making technology an applied science, but also because man is forever a slave to progress, anxious for constant discovery and for an explanation of the world, and prepared at every moment to demolish old idols and to set up new ones. His civilization is in a perpetual state of historical becoming in time, whereas Greek civilization, where it was believed that all events constantly recur in obedience to the laws of Being, was ahistorical. Both

49

concepts are rationalistic: whereas Greek civilization regarded the world from a distance as a work of art, the Faustian suffers and aims at action in the world. Whatever the Greeks examined was examined simply out of a drive or love for theory. But what more modern generations examine they examine out of a desire for application, thus promoting technology to the status of an autonomous science.

The new direction first began with Christianity, which gave a beginning and an end to time. For the Middle Ages, eternity was certainly in celestial space, but the Renaissance drew the infinity of the heavens down to earth, and treated natural space as three-dimensional, identical in origin, and similar in properties, whereas eternity was treated as measured time. All things became measurable quantities. Even in art, the ratio of the Golden Mean, which Luca Pacioli (1450?–?1520) described as the "divine analogy," could be measured. Thus the Renaissance systematized the quantitative relationship of distance and its perspective as a way of depicting objects in space. The entire naturalistic painting of Leonardo was, in the words of Alfred North Whitehead, also "an important element in the formation of our scientific mentality."[4] By this he meant that to explain the world, mentality no longer depends upon metaphysical dogma but on direct observation of events and on experimentation. The deductive method atrophied, and science henceforth drew its conclusions by way of the inductive method. Francis Bacon characteristically said that he knew something before he was able to accomplish it.

Man thus emerged from the mediaeval civilization in which, especially in the West, science had been replaced by magic and in which thought was pervaded by mystery and superstition. Henceforth, alchemy became chemistry, metaphysics became physics, discovery became a rediscovery of unknown continents, and technical contrivances became inventions. The world became smaller and internationalism was encouraged, especially after the invention of printing. Science and technology acquired systematic principles of knowledge and could be transferred from one country to another. The style of art also acquired international qualities; its language was that of Greek morphology and order; Greek mythology and symbols were combined with Christian dogma.

This tendency in the direction of rational development in science and technology, however, resulted in so immense a growth of knowledge that it is now impossible for the human mind to grasp it, especially since at the same time the philosophical training which formerly gave

man general enlightenment, or simply knowledge, was curtailed. The scientist gradually began to specialize and this specialization advanced so rapidly that the specialist, to the detriment of his specialty, lost an overall view. At the same time he began to lose confidence in his intellect and his intuition, and relied ever more on the measurements given him by instruments. Today we often rely upon the judgment of a "brain trust" and speak of the collective mind, which, if in fact it does exist, has the great disadvantage of not possessing an inspired individual gift or even an aptitude.

At all events, the specialization of scientific work also introduced into science a division of labor which was valid for the execution of technical projects, in factories, or in the army. The technician who undertook the execution of one part was unaware of the direction the whole work would take; the soldier who fulfilled a general's order that he make a certain move did so though he did not understand the purpose of the overall maneuver. Such is the tragic fate of the man who executes an order, a fate applying equally to art and to the skilled practitioner, who often, instead of interpreting, *mis*interprets the work of the creator.

The masses that are needed to execute the idea of one person constitute the first phase of the mechanization of man, and for this reason Lewis Mumford rightly maintains that before man invented the machine, he had already been mechanized precisely because he lacked the machine.[5] In this instance man became an automaton, an impersonal unit—in other words, a slave, and hence the word for work in Greek (*douleiá*) is the same as the word for slavery.

At all events, the revolution of the machine began when man invented machines suitable for automatic production, moving under their own power and capable of performing manual labor. Then the dream of Aristotle became a reality: once the shuttle began to work under its own steam, slavery would be abandoned.[6] These machines brought about the growth of industry but at the same time created vast economic, social, and aesthetic problems, and one can rightly argue that when the machine appeared, there also appeared a monster!

The growth of industry brought death to the handicrafts because mass production destroyed the artisan class. Industry now produced cheaper products in greater quantities and was therefore able to compete with the handicrafts. It is true that from the point of view of form these products were standardized, and none possessed the uniqueness of the products of handicraft workers—in fact, in the beginning, in an

idle effort to re-adapt to the new conditions of production, they imitated the forms of the artisans' products. There were steam engines with Ionic and Doric columns, and sewing machines with decorative Baroque attachments. The first automobiles resembled horseless buggies and had not yet found their aerodynamic form. Generally, the products of the machine, instead of being functionally formed, as they subsequently became, were ornamented in an artificial and inorganic fashion.

When the absurdity of this form was realized, the reaction was a movement in favor of reviving handicrafts and returning to the motifs of folklore. But this notion, proclaimed by John Ruskin and William Morris, was uneconomical and aesthetically impossible. The only healthy reaction would be the creation of an industrial aesthetic capable of exploiting the properties of the machine and of giving industrial products a form analogous to their new material and the new conditions of production.[7] Industrial design now requires special training, and the industrial planner has become the brain of industry, a fact which has not been realized in Greece as yet.

Business companies outside Greece, however, have realized that it is to their interest to have a staff of designers directing production aesthetically so as to suit the tastes of the international market, toward which, after all, mass production requires every industry to look. Naturally enough, industrial aesthetics, because it attempts to attract the international market, has some striking qualities in its form. At all events, modern industry, in order to eliminate intolerable monotony and similiarity, tends to produce a variety of models at the same time.

Mass industrial production also requires a new kind of economy, like that which has developed primarily in the United States of America: if industry is to produce and sell continually, there must be a large market and a high standard of living. Therefore, industries must pay their workers well; workers can then buy, and they buy so that they can be paid. Hence, workers are always replacing their furniture, utensils, clothes, automobiles, and refrigerators, with the result a useless waste of raw materials and of labor potential. Industries, on the other hand, every year persuade customers to buy new models of their products, often by promising useless innovations. In this way, man's needs constantly multiply. After he acquires a phonograph, he wants a radio, and then a television set, because, as we know, there is no end to these needs. But the worst feature is that man alienates himself from these products, he ceases to maintain them, and he wastes the materials out of which they are made. He has forgotten how to make anything by hand: even his

food is available in cans. Music is canned; he takes his transistor on excursions, and, instead of singing himself, he lets the machine sing for him. Thus a great void is created in his soul. It has been very aptly said that the machine has dehumanized the world.

It is certainly true that the aim of the machine is to release man from the slavery of labor and to give him free time to occupy himself with intellectual pursuits. But ever since man set his mechanized culture in motion, these automata of work—the machines, the factories, the IBM computers—all these robots have slipped out of his control and, like the apprentice magician of Goethe, now threaten to destroy him. For this reason, every morning when we awaken to learn that a rocket has been launched to the moon or to Venus, we are not certain whether the achievement will benefit mankind or create some disaster. Mechanical contrivances are two-faced, and the ethical level of man will determine their direction. It is precisely this quandary which creates our anxiety. Will man be able to remain in control, or will some more powerful fate make decisions for him?

At all events, according to Mumford, the machine is parasitic as far as man is concerned, and must become symbiotic.[8] The phase of neo-technology, however, into which we are now moving as we abandon the barbaric old technology, is influenced by the advances made in biology and psychology. It discards uncontrollable mechanistic concepts and strives to adjust the machine to man's scale so that it can become his assistant and not his exploiter.

A natural consequence of this development was that the fine arts were influenced by machines, some directly, others indirectly.[9] In architecture technology provided manufactured building materials which, thanks to easy transportation, circulated on an international scale. It also made possible the prefabrication of building elements, so that they could be assembled with great speed at the site. Moreover, the machine became part of the building—providing heat, air-conditioning, elevators—so that the building itself became a machine. By extending the mechanization of the construction even into the building layout of the project, Le Corbusier characteristically said that the dwelling also has become a "machine for living."

Examples of beauty in architecture were provided by the products of machines and shipyards, such as bridges, ocean liners, and factories, where everything is functional. Hence, the motto of contemporary architecture is that form follows function.

Architects have ceased to consider their work as the creation of

monuments for the perpetuation of symbolical ideas: they look upon their buildings as useful structures which, once they have depreciated economically, must make way for more modern ones. Utility has supplanted beauty, modern technics have replaced the notion of the eternal youth of Beauty, and inspiration has given way to inventiveness.

The emergence of photography made the imitation of natural phenomena almost superfluous for painting and sculpture. Moreover, the speed of pictures in motion when one is traveling by train or by plane forced the Futurists to seek a way to give the impression of movement. The microscope, the telescope, and the X-ray disclosed worlds unknown to the naked eye; they attracted the artistic imagination, as did the analysis of light through crystal prisms. Moreover, the scientific examination of colors and the coordinated contrasts of Marie Eugène Chevreul (1786–1889) inspired artists to experiment. Thus, all of these factors led eventually to Impressionism and Cubism. Primarily, however, the automation of the machine and the spell which it exercised led sculptors to construct moving sculptures, such as the famous "mobiles" of Alexander Calder, and painters, especially those working in the cinema, to construct machines projecting colors and shapes in action or creating "cine-painting." Even music tends to be electronic.

But it would be fruitless to believe that the external influence of the machine was sufficient to effect this change in the arts, and that the results were simply detrimental. On the contrary, I believe that modern art constitutes an attempt to purify and rejuvenate, an endeavor which strives to return to primary principles.

It is undoubtedly true that modern art first rejected imitation, subject matter, form, and symbols, but it is also a fact that forms had degenerated, subject matter was devoid of any real significance, and symbols had become lifeless. No other solution remained than the rejection of all such forms and a return to the original sources. To support this contention, we need only cite the example of architecture, which, static since the Middle Ages, only now turned to the foundation of a new and original building system. The Renaissance had no such system: it repeated the morphology of Greco-Roman architecture, adapting it primarily as a decorative garb because it had no organic relation to the structure of the works. Neither the Reformation nor the Counter-Reformation succeeded in introducing anything new; eclectic architecture finally burst upon the scene in the nineteenth century, when every old style reappeared on the scene as a dead language. Hence the revolution in architecture was not only unavoidable but also

necessary; it had to address the new problems of sheltering the masses and also of surviving as an art.

Again, if art and sculpture rejected imitation, the reason was not only that photography adopted it but also that the Renaissance had transported celestial space to earth and that the saints and angels it portrayed, though depicted as walking on clouds, could not shed their material weight. Its naturalism was more successful with worldly subjects, and because of this, two avenues of escape remained after the Renaissance, the psychology of the individual or a study of landscape, glorified by Rembrandt and Constable, respectively. But all other historical and mythological subjects had become devoid of any artistic content. For this reason, contemporary artists abandoned imitation, subject matter, and symbols and sought to produce an absolutely "pure art" whose attraction would depend not on the subject and the sequences that aesthetically mislead the spectator but on rhythm, harmony, and the structure of the work. Thus, its objective ceased to be the external phenomenon, and became the work itself.

Finally, painting and sculpture moved closely to music, an art which was always abstract and never possessed subject matter or imitated anything, and these arts also became a music of colors and abstract shapes. This is why they were called abstract, though the terminology is not really adequate. At any rate, in the seventeenth century mathematics flowered, thanks to such philosophers as Descartes, Newton, and Leibniz. Henceforth, abstraction assumed such significance in science that today we understand the perceptible only through the abstract syllogisms of mathematicians. Not only the music of a Bach or a Mozart but the fine arts too are seen in terms of this abstraction.

If, on the other hand, modern art brought the illogical element to the forefront, its nature was not contradicted because art was always a product of poetical enthusiasm and not of logic. Only science depends upon logic, although for its advancement it needs hypotheses which are in fact a product of perception. It is true that art also is not devoid of logic, but it does not develop syllogisms. Art communicates directly through images even when it is imageless, or represents the formless. After all, nothing in nature is formless. We describe a piece of stone as shapeless when we approach it closely and lose sight of its general form, but the piece of rock has a structure, and its appearance is not lacking in beauty. Everything shapeless possesses structure. But we are accustomed to say that only what has form in an organic whole has structure,

like animals or plants, and that in inorganic nature only that has form which has a clear shape—a beginning, a middle, and an end.

In any event, the quantum theory, the theory of relativity, and other concepts of modern science have discarded the determinism of the nineteenth century and have accepted the fact that, in the order of natural phenomena, probabilities also intervene, that material is energy, and that space and time are not independent, absolute units but a combination of one with the other. It is no surprise, then, that Impressionism dissolved the limits of form and that Cubism, first referring phenomena to their basic geometrical shapes, later broke those shapes down into various planes of mnemonic perspective and then regrouped them into a space-time order. In a special study,[10] I showed that art always composed its work in a space-time arrangement and that this is nothing new. Comparison is important if one is to show that art does not emerge from external influences but, on the contrary, anticipates everything done by science, which moves logically and which can be comprehended only today. Nor is it strange that the recent art of Tachisme entrusts its work to coincidence or, rather, to the reactions that the artist will have on his journey into the unknown, for he then denies the subject and the foresight. Conception occurs during the execution, so long as the execution is not mechanical but is motivated by creative passion. This is why, as I have said, contemporary art can cry out, as did Faust, "In the beginning was the act."

It is certain that if Plato, Pythagoras, or Ictinus were to return to earth today, each would be surprised at the turn of events in the world, although they themselves had set down the bases of science, philosophy, and art from which Western culture developed. But whatever they studied out of love of theory has now become an object of research, aimed at practical applications. Thus technology developed as an applied science. Whereas they considered the individual to be a personality, a small reflection of the city, the individual of today has become a faceless unit. The crowd has replaced the individual; quantity has replaced quality. And whereas they believed that art reflects universal harmony because it can reveal the god who hides in a rock and can bring him to light, contemporary art obscures the gods in shapeless forms.[11] Contemporary art has become dehumanized to such an extent that it is in danger of abandoning its social purpose. And if the goal of our technological development is to enslave nature on man's behalf, the ancients would have considered this aim arrogant because man would then have surpassed the limits which the gods set for him.

But these same wise men could discern that out of the depths of the dark horizon of contemporary life a new dawn is breaking. The fact that man has become conscious of the decline which has occurred and is already struggling to make a recovery is a guarantee that he will find the solution with which to establish technology as an instrument of noble purpose and art as an expression of lofty ideals. Technology unites people when a bridge joins the two banks of a river, but it also disunites them when a bomb destroys the bridge. Only art unites without separating. Modern art has reached the lowest point of the poverty of form of which it had to be purged, and from out of the depths it draws the first principles of a true rebirth and an international style. Today more than ever internationalism in art and science is a reality, not only potentially but in fact.

But the primary instrument of communication for mankind is language, since it expresses thought more directly than other means. Language is the first instrument man discovered, and the most important. Once the mind draws upon the first principle, the Word, man's thoughts are advanced by language, and his power develops not only materially but also intellectually, to achieve a metaphysical level. Thus, the Word is synonymous with the mind. For this reason, the Prometheus of Aeschylus says to mankind:

> whereas at first
> they were like children, and I gave them a mind and
> heart.
>
> .
>
> . . .At first they saw, but did not see
> They heard and did not hear . . .
>
> .
>
> And I gave them number, the greatest wisdom of all,
> And letters I found for them,
> Of memory, the mother of the Muses. . . .[12]

But if the mind is to realize its thought and ideals, it is compelled to use stratagems to overcome the resistance of material, to give it form and expression. With stratagems, the wheel overcomes friction and a military maneuver overcomes the resistance of the enemy; with imitative stratagems, painting represents phenomena and sculpture creates statues. With cunning, Prometheus stole fire from the gods to succor mankind.

And so the art of man, no matter how much it aims at the absolute, develops within the confines of the possible. This is why works of art are products not only of the imagination but also of technical experience. The Parthenon was built as a temple to the goddess, but if it was to be built and gravity overcome, static and optical artifice was required. And since it succeeded in its aims, it expresses values and attracts mankind. It is the same with poetry, which, to express the ineffable, needs strategems, myths, images, tropes, meter, and rhythm which will shake off obscurity and the perceptive rigidity of words, making them dancing, living, symbolic voices. The artist cannot do anything more than this because he is not the creator of the world. He is the creator of "worlds within a world," and his is a great and admirable gift.

3

art and the machine

I. society and the machine

In the last century technical progress produced a monster on earth: the machine. It was certainly nothing new; the machine had existed ever since man discovered the wheel. But in the nineteenth century, mechanical development took place so rapidly that it was imagined as something quite new. Up to that time the machine had simply been a vehicle aiding man; it broadened man's power to some extent and increased it only to a limited degree. But the development of steam engines, turbines, internal combustion machines, electric generators, and other power-converters resulted in the creation of railways, steamships, airplanes, electric plants, and telegraph and telephone networks which encompassed the earth, reduced distances, linked continents, and increased man's power and field of action to a degree well beyond human measure. Man began to feel like superman, and his technical conquests rose as a hubris before nature and the gods, especially after the splitting of the atom, when he turned to interplanetary spheres with the intention of conquering the stars. But technical conquest also contributed greatly to man's self-destruction: two world

wars took place, and a third one, which could be so inhuman and totally destructive as to stagger the mind, still threatens. We have arrived at a point where the machine appears to have escaped from man's control, and, like the automaton of Goethe's apprentice magician, seems to be creating unfathomable dangers for its own creator, unless man can succeed in morally rising to his circumstances.

The nineteenth century also saw the development of machines other than power-creators, fully capable of making almost everything the human hand can make: yarns; fabrics; household utensils; glass, metal, or plastic receptacles; refrigerators; radios; motorcars; and numerous other things. Factories began to flood the market with industrial products because they were mass-produced. Thus, industry almost killed handicrafts. Industrial products certainly helped to raise the general standard of living by providing the people with material goods, but simultaneously they caused man to underestimate the value of intellectual goods. Furthermore, industry gave rise to urbanization, to various labor and class conflicts, and finally to the need for a change in the entire economic structure so that workmen could purchase goods and thus enable factories to continue their abundant production. Man thus has become economically servile to industrial production. He continually struggles to maintain his purchasing power in order to support industry. The machine has become his parasite: it feeds on him and drains him, while it should be his slave, if what Aristotle envisaged is to take place—when looms begin to work of their own accord, then slaves will cease to exist.[1] Therefore, some means of coexistence between man and machine must be found. All the efforts of the civilized world are now bent upon attaining this coexistence.

Man is assisted in this task by the latest developments in the machine itself, developments which took an unexpected turn in the twentieth century. With an incredible leap forward, technology produced informational devises which can perform the work of the human mind—I mean the electric brains, computers, and similar machines capable of transmitting signals and information, and hence able to control and to guide other machines. In the past man alone supervised machines, but now he can control them by means of other machines functioning not only as slaves but also as intelligent creatures.

This leap forward has to some extent relieved man of the worst effect of machines: the mechanization of himself. A cruel example of this mechanization is the conveyor belt, which forces the workman to repeat the same movement at regular intervals for hours on end. We

remember Charlie Chaplin's movie *Modern Times* and the reaction of the workman who must perform the same operation over and over again, something which can lead to insanity. Today, many of these movements can be carried out by other machines, which, with the aid of man, can control machines of production.

In any event, the new machines for conveying information are bringing about a great, though as yet obscure, revolution in man's culture, only some external results of which are now visible to us, like, for instance, space travel from earth to moon, or the issuance of computer scores for the admission of students to universities. But if we want to see the deeper, internal results of the general impact of machines on man, we must examine a field of activity which is particularly sensitive to and expressive of man's spiritual and intellectual life: art. In other words, we must turn our attention to the influence of the machine on art.

II. the seventh art and the dissemination of art

I may begin by saying that the machine has created an entirely new art form, known as the seventh art: the cinema. This art of moving shadows, whether colored or not, stereoscopic but also tediously realistic, has certainly not supplanted the theater, and perhaps its practitioners have realized finally that it is more powerful when it does not attempt to imitate the theater, because a play is based on the word, whereas a film is based on the image. The theater attempts to broaden the distance between play and viewer, whereas the cinema attempts to narrow it. Yet the cinema has succeeded in becoming the primary art of spectacle, the great storyteller of the twentieth century; it has succeeded in creating contemporary myths and even mythical characters, even if most of its myths and characters are ephemeral and unpoetic. Here again I need only refer to Charlie Chaplin or to Greta Garbo. Even though the myth-making ability of the cinema is not inconsiderable, it still proves how essential myth is even to the spirit of twentieth-century man.

I should like to mention another basic phenomenon of modern life: the astonishing dissemination of art among people. Thanks to the progress of printing, photography, and offset reproduction even of colored images, the works of painters, sculptors, and architects circulate by the thousands, reach the remotest corners of the earth, and acquaint us with works of art we otherwise would never see, not even as mere pictures. Without these reproductions. Malraux's *musée imaginaire,* in

which all works of art parade before our eyes in various combinations, irrespective of style or period, so that for the first time in history man has a total, all-encompassing view of art, would be impossible. Justifiably, then, the civilization of the twentieth century has been called the civilization of the image. And because the image is a substitute for the work of art, we can even call it the ersatz civilization.

Aside from the dissemination of the fine arts, we have that of music, thanks to the phonograph, the radio, records, and broadcasts of musical events. In recent years, the advent of television has brought before us concerts, operas, and so on as they occur in London or New York, as though our eye had extended its vision to those points.

But we must keep in mind that the dissemination of art through these mechanical means is merely a dissemination in breadth, not in depth. It is nourishment supplied abundantly and consumed rapidly by a civilization which justifiably has been called a consumer civilization. But this is the civilization we live in, and it is well for us to be fully aware of the fact. We must get to know its particular features, its methods, its goals, its weaknesses, and its advantages, if any; and if we can see no advantages, then we must see how we can bring to it whatever we can from the older tradition of the high meaning of art.

III. industry and art

One of the first consequences of the advent of the machine was the decline of handicrafts, as noted earlier, because industry assumed the task of producing mechanically all things formerly made by hand. The difference between industrial products and handicrafts is that the former are mass-produced by mechanical means cheaply, while the latter are scarcer, more expensive, and less uniform. It is the slight differences among them which lend artistic charm to such products. The machine's uniformity and precise repetitive action means that industrial products cannot compete artistically with handicrafts on such a basis.

Industry, however, did not at first see the problem in quite this way. It attempted to embellish its products with ornaments in a variety of styles. When it became clear that this process was not artistically effective, and that it also added to the cost of production, a radical change came about: forms were stripped bare and extreme geometrical design prevailed. This was followed by the principle that form follows function, a phrase also applied to modern architecture.

To be sure that its vast output was consumed, industry was quick

to see the need for teams of specialized designers to take advantage of the machine's capacities and ensure its success in the marketplace. This led to the creation of industrial designers and to a new aesthetics called industrial aesthetics.

The industrial designer, contrary to what many people believe, is not simply an artist who is employed to improve the appearance of an industrial product; he is a person who has received specialized training and education, basically architectural—fairly elementary training, of course—and who can design an object, a receptacle, on the basis of the requirements and potentialities of the machine alone, without consideration of the abilities of the human hand. This kind of aesthetics is usually rather sensational and depends on publicity, since it is commercial and directed toward the tastes of the average man all over the world. Industrial aesthetics is not related to folklore, nor is it purely national; it is colorless, international, and impersonal. Basically it is simply another aesthetics of abstraction, the creation of standard types which are generally acceptable.

Furthermore, industry is not concerned with creating a lasting work; on the contrary, it seeks continuous innovation, and therefore constantly changes models, as in the case of automobiles, in order to attract new consumers. This is the aesthetics of the consumer culture, whose products cannot endure aesthetically. Their whole attraction is based on novelty and newness, and for this reason any damage, any flaw, renders them aesthetically unacceptable, not simply impaired, whereas a work of art can withstand the ravages of time.

Efforts have recently been made to create works of art—that is to say, non-functional works—by strictly industrial means. Such programmed art, however, excludes any personal touch in the execution. It has been adopted by the Récherches Visuelles group in Paris, by a group in Padua, and by various other groups. In the Art Nouveau movement there was also an attempt to make works of art with the machine; its products are now being revived and duly appreciated, but soon after its first appearance, it was stifled by the Bauhaus and Piet Mondrian's Neo-Plasticism, which were totally dominated by the principle of functionalism.

In America, the term "styling" is often used in relation to industrial products. This is a pejorative term as far as art is concerned because it denotes something which will appeal to the masses (a kind of popular art). Styling, like fashion, is a manifestation of the entire style of a period, and in a way reflects it.

The symbolism of the industrial product is informational; its aim is to impress and to make its functionalism recognizable, as an automobile projects its aerodynamic aspect. The industrial product can therefore be judged according to the aesthetics of information precisely because of the novel aspect of its form, which attracts the viewer and informs him of its symbolism. This is all very well provided that we do not confuse the informational factor with the aesthetic one; what is made to be rapidly consumed does not necessarily have permanent value, as does a real work of art.

But let us now put aside the minor industrial arts and look at the influence of the machine on the fine arts, and primarily on architecture.

IV. the machine and architecture

We first find the influence of the machine on architecture in the course of the development of the building industry, when building materials became standardized and entered the international market. Thus, in Athens we use Swiss elevators, St. Gobain windowpanes, and American air conditioners.

The second instance of this influence is prefabrication. In 1851, at the International Exhibition in London, the Crystal Palace reached the workshop already prefabricated of metal pieces which were put together on the spot. When the exhibition was over, the Crystal Palace was dismantled and moved elsewhere. A construction of this kind was totally unprecedented for those days, and one can say that it still has not actually been surpassed as a technical achievement. There is a lot of talk nowadays about prefabrication in architecture, but we have not achieved much in that direction. We prefabricate basic elements, whether metal or wood—columns, beams, trusses, slabs, and even entire sides of a building or of small houses—but if we want mass construction, we get better results by organizing the work scientifically. In the case of large buildings, we are content with on-site construction of metal skeletons. It has been said that if an automobile were produced the way a building is constructed, its cost would rise by 50 percent. This shows how backward we still are!

Another way in which the machine makes its influence felt is through its invasion of the building in the form of elevators, heating devices, ventilation machines, plumbing, and electrical installations. To realize the importance of the elevator, it will suffice to say that New York

skyscrapers would have been impossible without the invention of the Otis safety elevator. What is more, elevators influence the shape of the skyscraper because the more floors are added to the building, the more elevators are needed and the more space they will occupy. There comes a time when the space required for the elevators is so disproportionate that the building cannot go any higher. A good example of this is Rockefeller Center. So great was the influence of the machine, however, that Le Corbusier ultimately used the word in his definition of a house: une machine à habiter, a machine for living. This is the extreme of mechanocracy; the machine becomes the symbol of the work of architecture, the mother of the arts; it becomes the highest aim of functionalism. I shall not attempt to refute Le Corbusier's definition because it is obviously exaggerated, if not totally erroneous. It reflects the total mechanization of the world, of the individual, which is a notion that was always deep in Le Corbusier's mind. For this reason, he was attacked repeatedly for his apartment building in Marseilles, which was intended as an exemplary solution to the problem of mass housing, yet Le Corbusier never actually sought to satisfy people's needs, but instead forced them to live and coexist according to his own collectivistic models. This attitude also resulted in his carrying too far his faith in the principle of form following function, a principle which is really one-sided because form never follows function entirely: function also follows form, since without form there is no function, and vice versa. Form is also a by-product of man's way of thinking; for instance, the shape of a chair depends on the way I want to sit, and not only on the function of sitting.

But it is only natural that such misunderstandings should occur in architecture: since the advent of the machine, the architect himself has ceased to be a master builder, as were all the great architects of the Middle Ages and the Renaissance, and has become a scientist confined to an office. There he sits, using a geometrical language as he puts down his ideas, which are then translated by the contractor, depending on how well he understands them and how good his workers are; as a rule, the drawing board is responsible for the geometrical coldness and bareness of facades and walls and for the use of straight lines in the designing of architectural parts. One cannot possibly expect the drawing board to capture the entasis of the classical column, the subtle curves of the Parthenon, and many other exquisite forms in architecture of all centuries except ours, which expresses only those forms visibly essential, as does, for instance, the upward slant of a concrete canopy. Such architec-

tural subtleties demand a closer relationship between the architect and the molding process, and especially a close supervision as the architectural forms emerge. This kind of architecture presupposes less prefabrication than is allowed by such modern features as curtain walls, or the glass walls of the Lever House.

The style of contemporay architecture has become "mechanical," rather like the style of industrial products (Fig. 1). It is an international style, but one which cannot endure aesthetically. The moment a modern building begins to age, it becomes ugly; it is sustained by its novelty alone.

This should not surprise us. Architectural products, particularly in America, are usually the work of a team of architects, not of a single person. I respect teamwork, but I believe that genius and artistic talent can be found in the individual alone. Furthermore, in the climate of the new economy prevailing chiefly in America, an architectural work has ceased to be viewed as a permanent structure. It is considered a useful but temporary work, destined to be replaced by a more updated one as soon as it becomes expendable. Here again we see the mentality of industrial aesthetics: constant change and production of works without aesthetic permanence. Indeed, in the beginning novelty simply exhibited only technical effectiveness; technique thereby became an end in itself. This is technocracy.

Despite these weaknesses of modern architecture under the inevitable influence of the machine and technocracy, style has not become completely sterile. On the contrary, a number of new principles have emerged which, without being more analytical, I shall simply mention: (a) lightness of construction through the use of shell structures, a tendency toward geometrical design, a lack of plasticity, and the negation of the effects of gravity; (b) equivalence of space and mass, obvious in construction on stake, as in Henry Moore's sculpture; (c) continuity of space, and its apparent extension into infinity (as in the work of Mies van der Rohe); (d) dynamism of construction, as in Frank Lloyd Wright's "Falling Water" (the suspension of shell structures); and (e) diffusion of light during both day and night (large openings, artificial lighting). It seems as though modern architecture has become aware of the aridity, gracelessness, and geometricity of functionalism and is already turning toward more plasticity.

I should like to emphasize two more points: first, modern housing architecture, especially in America, is an architecture which presupposes a home without a domestic staff. Only the machine aids the

housewife. Hence the abolition of isolated rooms, hence the large living room, hence the kitchen converted into dining room. A new society calls for a new architecture. Second, the electronic brain also comes to the architect's aid. Machines that can draw can instantaneously convert whatever the architect designs on paper into highly precise geometrical shapes. Other machines take over the task of drawing up complex statistical tables on town planning and carry out difficult calculations which would take much time and hard work for a civil engineer to do (structural engineering systems, the Solver-STRESS program). All we can do is hope that such a machine never falls into the hands of an uninspired and ignorant architect. Be that as it may, such is the turn of events, and we had better know it. An American professor of architecture, M. Glickman, once wrote to me that he had "participated as an observer in the 8th Congress of the International Union of Architects in Paris, from July 5-9. The subject was architectural training. I was greatly impressed by the fact that out of 30 nations represented at the Congress, the Institute of American Architects was the only one that avoided using the words 'beautiful' and 'aesthetics' in its introductory report. I believe they are being led toward a future that will be dominated by the digital computer." A depressing fact, but true.

V. the machine and the fine arts

Let us now see how the machine has influenced the fine arts, especially painting and sculpture. Technical progress has shown us landscapes and forms of nature heretofore inaccessible, either through the microscope and the telescope or the camera, the cinema, and the stroboscope, which registers the motion of a body in its successive stages. We know that the French Orphic painter Robert Delaunay (1885–1941) was influenced by the phenomenon of the shattering of the light spectrum through a lens. The pictures of the stroboscope recall the successive postures utilized by the Italian Futurists to express motion, as we see them in Giacomo Balla's *Dog on Leash* of 1913. In other words, strange though it may seem, painting abandons the artifices of "the fertile moment" with which it represented motion far better—as, for instance, in the unnatural opening of the horse's legs in Henri Rousseau's *Bellena*—and by means of a series of successive images resorts to a realistic analysis of motion which is hardly convincing. This is the result of a more fundamental change in modern art, however, a rejection of the imitation of natural phenomena in favor of the reorganization of

67

their structure at various mnemonic levels, as first practiced by the Cubist movement. It is also the result of another shift in direction, eventually leading to the highest form of abstraction. Abstraction had already begun with Henri Toulouse-Lautrec's attempt to create poster paintings which caught the eye from a distance by their bright colors and simple, characteristic forms (as in *Cassandre*) and which ultimately ended in pure abstractionism (as in the work of Piet Mondrian), where the picture itself became the object of painting. Thus we see that the relationship between certain forms of abstract painting and the publicity orientation of industrial aesthetics is external, no doubt, but nevertheless quite marked.

The machine, however, proved to have a powerful and immediate attraction for most painters, something especially apparent in Fernand Léger, in whose paintings we see human bodies with metal, tube-shaped limbs and ovoid, impersonal faces (Fig. 2). He is one of the few artists who managed to harmonize with the mechanical and technological environment of his age, as did Giorgio de Chirico in *Hector and Andromache,* where he presents the two bodies as robots mechanically submitting to fate. Francis Picabia, in *Love Parade,* presents a piston-activated machine ridiculing his subject but in a deeply tragic sense (Fig. 3).

Finally, I should add that the impact of the machine on modern painting was so forceful that its dynamism went beyond the static vehicle of two-dimensional expression and sought to conquer movement through *cine-peinture,* that is, through an art of metamorphoses, highly interesting, but ephemeral.

The dynamism of the machine found a more suitable vehicle of expression in the new sculpture (as in the works of Antoine Pevsner and his brother Naum Gabo), and culminated in the mobile works of Alexander Calder, whose sculptures are better known simply as mobiles, an unrivaled example of this kind of art. Ever since Daedalus first separated the arms and legs of statues from the trunk, sculptors have always been fascinated with motion. Daedalus, in fact, dared to fashion wings for himself and his son Icarus, who met a tragic death in his great fall from the heavens. Such is the attraction of the machine which becomes reality. And it is not Daedalus alone who succumbed to its spell. Archytas, the Pythagorean philosopher and friend of Plato, is credited with having invented a flying dove. In the palace of the Byzantine emperors was a throne supported by lions which emitted loud roars, to the great terror of those present, and artificial trees on which mechan-

ical birds chirped. In modern times, E.T.A. Hoffman's dolls continued to fulfill man's ingrained desire to imitate living creatures by means of moving figures. Furthermore, the machine itself imitates the movements of the human body, especially those of the hand and mouth, in order to serve the individual, as Leonardo shows in one of his drawings.

We should not consider it strange, therefore, that modern sculpture inclines towards mobile sculptures and machines, to which, in fact, voices are sometimes added. Jean Tinguely's works are a case in point. At times they illustrate the brutality of the machine stripped of its very entrails, unmasked, and without its usual shapely covering, as in the case of an automobile (Fig. 4); at other times, they enact the tragic aspect of the syncopation of automatic mechanical movement, as though presenting the miracle of perpetual motion (Fig. 4). The artist's work may simply express the miracle of a flower's growth, moving though rooted in the earth, or of a forest—on the scale of a hedgehog's back—touched by light (Fig. 5). Other artists, like the Greek sculptor Takis, illustrate the power of the magnet which causes weights to oscillate in the void. Needless to say, sculpture of this kind is always fashioned in metal. The texture of metal obviously holds a certain fascination, as seen in the works of César, who compresses broken-down automobiles into sculptures.

Pop art ("popular art") is a strange combination of painting and sculpture. Pictorial two-dimensional representation is frequently extended by the addition of real, three-dimensional objects. A tube with a shower nozzle at the end of it, for instance, often extends the picture into space on the wall, or the entire work may be composed of a giant tube of toothpaste (which is unnatural) or an immense lock. Nonetheless, Robert Rauschenberg, the main exponent of Pop art, is a gifted artist who juxtaposes various images from advertising posters or industrial products without sacrificing symbols, as he does with the moonrocket, the face of John F. Kennedy, and the American eagle (Fig. 6).

Another interesting tendency in contemporary art is the use of purely optical phenomena, such as lines which are curved as a rule, or black and white dots in attractive combinations, and optical illusions indicating that the visual act, not the object, is what is important in the painting. I am referring, of course, to Op art, whose main exponent is Victor Vasarely. Op art, more than the art of any other school of painting, provides the best opportunity for the use of the computer because the computer can better arrange an infinite number of combinations simply by juxtaposing these lines. We come next to permuta-

tional art, as Abraham A. Moles, a theoretician of information aesthetics, calls it, which allows innumerable variations on a single motif, so that a cheap tablecloth, for instance, becomes a unique version of the product for each buyer. And so the Prisunic's department store culture,[2] as it is known in Greece, or the consumer culture, grown tiresome as a result of the uniformity of industrial production, at last can offer the individual a bit of personal pleasure.

VI. the machine and music

Of all the arts, music has perhaps been most affected by the machine, whose first incursion into the field took place when certain mechanical instruments were developed for recording and transmitting it, like the innocent barrel organ, which still attracts smiling crowds with its clumsy syncopations. In the old days, mechanical pianos tinkled away mournfully on their own after being fed metal cylinders on which music had been recorded. Then came the phonograph, which also used cylinders, and later records; finally, there was the tape recorder. The ability to record music or speech is extremely important because it means that whatever takes place in time can now be transferred into space and can enjoy all the properties of space. The musical work thus can be reversed—whereas time is irreversible—and many people do find pleasure in listening to musical works in reverse. The experience is an entirely new one.

Finally, the radio conquered everything by broadcasting throughout the world concerts being performed, let us say, in Athens, London, or Milan, at the very moment of the actual performances. Perfected by stereophonic devices, the strains of an entire orchestra can be heard in our living room. There is also television, which adds pictures to the sounds transmitted to us. Thus, there is truth in the saying that the distinctive feature of the twentieth century is that man now possesses artificial channels of communication.

Indeed, all of these devices enable people to communicate through music, speech, and pictures; they have become giant sources of information for the public when their programs are composed skillfully enough to appeal to the taste of the average man and thus to influence him. For this reason, just as a special aesthetics was created for industry, so a special aesthetics was created for mass communication: the aesthetics of information.

Information, as such, is the exact opposite of entropy; in other words, it is a function which cannot be expressed in a work. Information presupposes organization, whereas entropy is synonymous with disorder. Entropy inclines toward the most probable situations, whereas information is anti-probable, anti-chance, because it must impress with its originality and remain distant from the conventional and accidental. There are, of course, two kinds of information: the semantic and the aesthetic. The first is rational and translatable, whereas the second is untranslatable and a creator of situations. Nevertheless, aesthetic information, no matter how impressive, cannot acquire any value so long as it lacks aesthetic endurance; it simply retains its commercial character and thus is linked to industrial aesthetics, since both are inevitably directed to the tastes of the common man and to communication through the mass media.

I should add that the communication of art is not sufficient to produce an artistic experience. What we need is communion with art, in the same sense of the word as Holy Communion in church.

As for music, I should say further that the machine has offered music new auditory and audio-technical possibilities which have found their expression in electronic music.

In addition, the electronic brain was ready to offer its services even to the composer, by facilitating the solution of various problems he encounters in the combination of sounds. The Greek composer Yannis Xenakis, who lives in Paris, uses an IBM 704 computer to achieve combinations of sounds according to predetermined rules, an impossible task for one man or even for a team of men. As A.A. Moles says, "Man is too weak to carry out the ideas which his imagination conceives."

We may not enjoy Xenakis' music, but we have no right to reject it a priori because it utilizes the electronic brain. We would be equally unjustified in rejecting a modern piece of architecture because the static calculations needed for its construction were made by a civil engineer instead of an architect, who would have done so in former times when the science of statics did not exist and when he had to make his own calculations in a purely empirical manner. One might contend that the use of an electronic brain in music is unattractive because it interferes with the art of composition and is not concerned, as is architecture, with the endurance of matter.

Any intervention or response from the machine, however, undoubtedly depends on the artist's judgment, and it is he alone who as-

sumes the responsibility for its proving fruitful or not. One might pose another question, that of the utilization of a machine. In the science of statics, the utilization of the machine is almost imperative to facilitate calculations and to insure the solidity of a construction, but how useful is it in music, where masterpieces have been created over the centuries without the intervention of mechanical calculations, and where, without such calculations, even the solidity of musical works is not endangered? The answer is that man cannot deprive himself of the use of any new means of creation, perhaps because this particular means seems to open new perspectives and new possibilities and simultaneously to arouse in him a desire to test these new perspectives. It is time, therefore, to clear up the question of the relationship between the human mind and the mechanical brain, to see how mechanical information came into being and what its foreseeable benefits to the civilization of man are.

VII. the brain and the machine

Information machines are the offspring of a new science called cybernetics, which is also a product of the twentieth century. A group of scientists and physiologists headed by Norbert Weiner laid the foundations of cybernetics in America; its aim was the study of both organic and artificial information machines. All the other power converters man has invented are comparable to organisms lacking brains which can replace only manual workmen; but once they are equipped with information mechanisms, they acquire a brain and can replace intelligent workmen, of whom attention and initiative are required. According to the scientists of cybernetics, the sensory nerve organs in living organisms are in principle information machines, and they also control machines when they are fed information. As early as 1872, Samuel Butler wrote: "Until now, a railway engine emitting a cry to demand right of way from a railway engine coming from the opposite direction and finding a response to this cry, is simply communicating with the other engine through the engine-driver's ear, because machines are deaf. There was a time when this communication between machines by the intermediary of man was considered impossible. Can we not then admit that there will come a time when machines will no longer need the mediation of man's ear and will be able to communicate by means of the sensitivity of their own organisms?" This day has finally arrived, says

Raymond Ruyer. Machines now understand each other and communicate on their own.

I could refer to a much more ancient text and, consequently, a much more prophetic one, in which Aristotle says: "if every instrument [like the shuttle or the plectrum] could accomplish its own work, obeying or anticipating the will of others . . . chief workmen would not want servants, nor masters slaves."[3] In this passage Aristotle points out a probability which he envisaged: one day, he says, perhaps each organ (instrument) will function in accordance with orders given to it, or will sense that it must so function. The word "anticipating" in this context is astonishing. In other words, Aristotle could foresee that it was within the realm of possibility that the machine could one day anticipate that it must carry out a certain task, be informed about it, without, or prior to, receiving orders from man. When that happens, architects will no longer require servants, nor despots slaves. This day has come: machines not only obey orders but sense them before they are formulated; they are in a position to inform themselves unassisted.

Here is an example taken from architecture: we all know that the thermostat regulates the heating machine in a building; as soon as the temperature falls below 18° C, for instance, the thermostat tells the heating machine to start working again. In the near future, we foresee that the thermostat itself will be regulated by the surface of the building, which will be equipped with the essential photoelectric cells and will regulate the temperature of the building according to season and weather. In a civilization dominated by applied cybernetics, says Ruyer, lights will go on of their own accord, doors will open the moment we break an electronic circuit (as is already the case in a number of American and European railway stations, hospitals, and elevators), and many more similar things will occur, all thanks to information machines.

The potential of these machines is enormous, at least quantitatively. A memory machine can supply all the memory required for a large library, since this machine is in a position to give thousands of items of information from cards. Apart from memory machines, there already exist translating machines, thought machines, and machines to make you think, otherwise known as *philosophical machines*. Finally, it is predicted that we shall soon have creating machines.

At this point I should like to draw again upon the thoughts of Moles, who believes that a work of art is more appropriate than a scientific work for cybernetic analysis because the criteria of its validity

are less precise and coherent than those of a scientific work. This is especially true of the criteria for non-figurative, or abstract, painting. Indeed, he believes that it will be the aesthetician who will program the machines entrusted with the simulation of artistic creation, just as linguists and grammarians program translating machines. In this way the aesthetician as theoretical philosopher of the beautiful will become a practitioner of sensations.

Moles outlines five potential uses of this machine:

(1) It can function as an artificial viewer or listener which can analyze the architecture of a work, from the informative point of view, by means of a filter program. It thus will aid the aesthetician to become an engineer-critic of the work.

(2) It can aid the artist, like the composer Xenakis, to perfect an idea he has conceived because neither individual nor collective work can achieve this, the task being beyond human capabilities. Man, he says, is too weak to express the ideas his imagination conceives. In painting, a slight transposition or extension of parallel lines from a distance produces a new image, an impression of a new kind of structure, rather like moire—that is, of undulating silk.

(3) It can exploit a whole range of possibilities following the determination of a combinational algorithm. Only a machine can execute a multitude of combinations leading to an art of transposition such as we have described above.

(4) It can control the processes of artistic creation, the trials and errors of the composer, and even more, the manner in which a composer surpasses the mechanical work. In this way, we are able to judge whether Brahms, for instance, did in fact compose the music he was capable of composing, which, Moles remarks, is an interesting philosophical problem. If the mechanical composition produces only a pale imitation of a Brahms concerto, there are secrets of composition which defy analysis. But if the machine produces something good, or something better than a Brahms concerto, then it is clear that Brahms did not choose the best possible course open to him for the composition of this concerto, and that a better way existed. Moles says we cannot afford to leave such a valuable source of information as the machine unexplored.

(5) Moles considers it possible to make a creation machine based on the idea of integration on successive levels. If, he says, a viewer is shown a series of paintings in quick succession, he will have no time to capture the waves of impressions received and will simply abandon the

attempt. A seeing machine, on the contrary, can convert the visual optical figures into cards and analyze the unbelievably numerous relationships between them. Here is precisely the function of the stroboscope and of the accelerated movie projector, which are able to compose extraordinary figures, retain them, and replay them as sources of inspiration.

The invasion of man's mind by mechanical processes is a revolution, says Moles, not unlike the revolution brought about by the introduction of the notion of chance into scientific thought. The artist is not replaced, however, he is simply displaced. He is turned into a programmer, and as such, he can be as enthusiastic and as passionately involved as were Paul Valéry and Ludwig von Beethoven.

I have presented Moles's thoughts in order to stress a simple fact which of course nobody questions: that man is not simply mind, but also awareness. I hasten to add that no matter how perfect information machines become, they will never acquire consciousness, which will remain the prerogative of man, in particular, the prerogative of the creator. The creation of a work of art is not a mechanical consequence, nor is it a result of coincidence and chance, as some people believe. A psychiatrist once asked me if there is any reason why a monkey toying with a typewriter could not, perhaps, produce a sonnet. I replied that this possibility cannot be excluded. But who is to judge whether this fortuitous sonnet is an important work of art? Certainly not the monkey! So it is with information machines. Despite their amazing potentialities, they are outside the world of values, whereas man moves inside both a natural world and a world of values. There is in man something which is beyond man, something transcendental. But it is impossible to conceive of a machine which can become informed without assistance and then regulate itself on the basis of value judgments. For this reason information machines have been called imbecile geniuses. How are we to explain this contradiction? They are imbeciles because they have no consciousness, and they are geniuses because they are unsurpassable in their mechanical potentialities. As memory machines, they surpass human potentialities by far. Physiology and psychology, says Ruyer, learn much from the behavior of automata, just as we have learned much about vision from photographic machines, though this does not mean that the human eye can be replaced by the photographic lens. The advance of the human mind over the mechanical brain is related to order and not to performance.

Thus, man will always have the final word; but since he now holds

in his hands these mechanical means, he will exploit them, or at least play with them. It is to this tendency toward play that I wish to ascribe the attempts of various artists to utilize the mechanical brain for creativity. The tendency to play, as we know, is important in the whole process of artistic creation, so much so that Schiller, in attempting to explain the creation of art, built a whole aesthetic theory around it. But we should not forget that it is dangerous for man to play with machines.

VIII. man and the machine

Playing with machines, especially in art, is dangerous because the artist risks losing the spontaneity of his imagination and the immediacy of his creative inspiration. A creative machine programmer risks benumbing his taste and contenting himself with the interweaving combinations and transpositions which feed the culture of "kitsch," the German word for cheap, tasteless products, which has become an international term for describing our dawning mass culture. In my opinion, however, mass culture, basically soulless and mechanical, cannot possibly prove profitable to the masses. It simply drains the spiritual and artistic potential of the common man and leads to the death of folk art, in which for centuries the poetry in the folk spirit found release. Folk art is anonymous, as is industrial art, but unlike industrial art, it is not anti-poetic or devoid of national roots.

Some people believe that the genuine artist will be liberated through the machine and that there will remain an elite which continues to enjoy original art, even though the artists are assisted by machines. Yet it is impossible that the machine should leave no imprint on this kind of art. It is highly doubtful that these small elitist islands can survive in the ocean of kitsch culture surrounding them, a culture in which the masses will have become *kitschenmenschen* and lonely crowds.

I regret drawing such an ugly picture of the future, and I earnestly hope that it will remain only a picture, a bad dream. But on a trip I made to the United States some years ago I was offered a taste of just such a future. Everything was done with the masses in mind; true, the standard of living for the masses has gone up, but then the masses have become industry's major consumer. The new economy which has prevailed demands that man work in order to purchase and, in fact, that he not only support anything, but continue to buy the latest model of car, refrigerator, radio, and all the other kitsch products, so that industry may

continue to produce. A vicious circle has deprived the average man of his creativity because he no longer makes anything himself; even the housewife no longer mends her stockings because new ones are cheap. This situation has reached such an acute stage that mental disease has spread to an alarming degree in the United States. As an antidote, people are urged to acquire a hobby, so that they can learn to make something, to create, and to love what they make. But it is impossible for man to stop technical progress, which is his own creation. He is compelled to accept the present and assimilate it. The sooner he does this, the better, because technical progress is proceeding at a rapid pace.

In all fairness, we must admit that along with its evils this progress has brought art some benefits. Here are the evils:

It has abolished imitation and introduced the non-figurativeness of abstractionism.

It has shown contempt for the need of eternity in works of art and put the ephemeral in its place.

It has to a large extent elevated technique from being a means to being an end.

It has become the devotee of novelty for its own sake.

It has killed age-old symbols.

It has brought about the death of the poetic metaphor.

It has withdrawn from nature and the natural forms of living creatures; and lastly,

It has put everything into motion with a kind of insane energy. And these are the benefits:

It has rid our spiritual being of dead, rotten, or superficial matter.

It has propelled us towards an international style, not to say a transcendental one.

It has given us a sense of continuous creation, a sense of plunging into depth.

It has allowed us to exchange messages and images from a distance.

It has given us the feeling of release from gravity.

Finally, it has opened up a new perspective of the world.

Naturally, these conquests put man to the test, a social, moral, spiritual, and artistic test. Yet fundamentally man is infinite. He has all the essential prerequisites to survive the ordeal. As long as he exists, man will remain the victor. But if he is to maintain his humanity, there is only one way to remain in contact with the values of the humanistic spirit: that is through classical culture.

Regarding art in particular, I should like to say that it is in no danger either of disappearing or of turning counterfeit. Man's deeper need for spiritual experience will remain spontaneous. Good is inherent in man. Therefore there will always be men who will bring art to light. Even in countries deprived of freedom and condemned to spiritual silence, there have always been Pasternaks. How much more so is this true of countries where freedom still prevails.

4

abstractionism in contemporary art

Contemporary art is a revolutionary art; therefore, as in every revolution, there is first of all a denial of the established principles and forms of the past, since only in such denial can the revolution be relieved of the existing forms and conventions and move freely to its new positive contributions. If we are to analyze contemporary art aesthetically, it would be useful to examine its negative aspects to see which forms it destroyed and which forms it established. In other words, we should examine first the destructive aspects of the movement of contemporary art to understand more fully its constructive aspect.

I. destructive aspects

Painting and sculpture, of all the fine arts, were the first to deny the principle of the imitation of the apparent objects of the external world, and thus from being descriptive they finally became non-descriptive. This is in fact their new characteristic feature—that they are non-descriptive, or non-figurative—and we erroneously interpret them as abstract.

At all events, the negation of imitation did not come suddenly. It arrived by degrees, but when it became aware of itself, it was so radical that it almost changed the meaning and the purpose of these arts, and it was doubted whether contemporary works, since they no longer represented anything specific, were in fact paintings and sculptures.

The abandonment of imitation went hand in hand with a progressive elevation of the principle of abstraction in art. Ever since Impressionism, which sought to convey vision with fleeting glances, imitation diminished in use and abstraction grew. This occurred even to a greater degree with Cubism because it refers the apparent forms to their basic geometrical shapes, analyzes them, and recomposes them. Expressionism distorted objects and disregarded their similarities when it expressed inner experiences. Surrealism cast out reality entirely and turned to the metamorphoses of the dream world, from which it imitated the inconceivable. And finally, with Neo-Plasticism, we are carried into the world of the formless to reach the "world without objects" of Kasimir Malevitch, and then to Suprematism, where abstraction is converted into abstractionism, and imitation ceases to have meaning because objects no longer exist.

What is the difference between abstraction and abstractionism? It is a fact that art without abstraction is impossible. Even when art imitates phenomena of the world, it does not copy mechanically: it imitates the substance and abstracts the superfluous. Yet no matter how far abstraction proceeds to shape the object by retaining only its general characteristics, it can never attain abstractionism—that is to say, it can never reach something non-specific and become anti-representational unless it makes a radical shift in its conception and agrees either that "a world without objects" does exist, as in the case of Malevitch, or that the representation of the formless is the aim of art. Certain critics are therefore wrong in maintaining that contemporary art is merely the application of the eternal principle of abstraction. Abstractionism is a new principle which begins from another base: that art has nothing to imitate because its object is no longer external phenomena but the actual work of art itself.

From the moment that art recognizes this principle, it turns within itself and aims to create—to compose, in other words—works which express its creative action, its poetic action, free from the visions of forms familiar in the external world; that is to say, it aims at expressing creativity itself.

The rejection of imitation is accompanied by the negation of

perspective. Classical perspective is a method of representing forms of the external world in accordance with the mechanism of sight. To bring this about, it is based on certain fundamental conventions. It agrees that the line of vision is single and stable and that the optical lines are intercepted by a plane, perpendicular to the axis of sight, upon which are sketched the forms seen with lines directed toward one or two points of departure. Consequently, whatever is near appears larger and whatever is distant appears smaller, in accordance with the distance. In this manner, perspective manages on a canvas of two dimensions to convey the impression of the third dimension, that of depth.

This method, which is believed to have been discovered during the Renaissance and then formulated scientifically, was even then not entirely new in the history of art. The Greeks were cognizant of the matter to a considerable degree and applied it, however imperfectly. Moreover, as a system, it itself is imperfect because its principles do not bear examination: in ordinary sight the point of vision is never one and permanent because our eyes are constantly moving and our sight is bifocal; also, the field of vision of our lines of sight is not a plane but a sphere, as is borne out by the distortions of images on the edges of a photographic plate. Finally, we see not a single image but many images which are retained by the memory and from which with the mind we critically derive one.

Thus, we see that the perspective of sight is not mechanical, and we see why the artists of the Renaissance themselves violated the principles of perspective when they wished to obtain convincing results. And this is why in other ages of art, such as in the Byzantine period, anti-classical principles of perspective quite contrary to this idea were followed, so much so that Byzantinologists believed that a system of inverse perspective was involved in which the points of departure appear in front of the image in such a way that the figure which is further away is painted larger and was hieratically higher.

In any case, the Cubists, having studied the perspective of the Egyptians, the Byzantines, the primitives, and people of other periods, reached the conclusion that they also could use not one but several points of vision—consequently, more points of departure in the same canvas—to mix systems regularly or inversely, to depict in larger size that which to them was of greater importance, and, finally, to draw from memory, as children do, what they recognized, rather than what they saw. They thus reached the moving point of vision in the perspective of Paul Cézanne, the multiple perspective planes of Pablo Picasso

(polyperspectives), the remarkable perspective of the dimensions of Paul Klee, and the many-dimensional memorial perspectives of the Surrealists: that is to say, they arrived at the pure subjective evaluation of perspective, its every objective system being abandoned. Finally, they abandoned perspective completely because with the rejection of the subject, no perspective has grounds for existence, and art becomes perspectiveless.

With the jolting of classical perspective, the upsetting of the views of space for which it was intended naturally followed. Actually, this perspective involved a space of three dimensions in which the third dimension, that of depth, was conveyed on canvas by a system of two dimensions, the stable point of vision being the basis. But from the moment at which this point ceased being a single one and became many points, and also began to move and assemble various cinematographic views of the object, which only the mind had the power to hold, the space in which the object was contained changed meaning and became dependent upon time. With Cubism the concept of art very obviously began to include a space-time concept; that is to say, space began to acquire not three but four dimensions.

I say space-time very obviously because artistic theory always was essentially about space-time,[1] even if the point of vision was accepted as permanent or the geometrical interpretation of space was not suspect. But now the static visual phenomenon surrendered its place to the mental combining of its many views, which permitted as much as Cubism demanded, that is to say, the analysis of the object on different planes, the transparency of the planes so that one aspect could be discerned within another which covered it, and, lastly, the hermetic recomposition of the whole into an artistic unity, as in the works of Picasso.

One could say that in Cubism external space became a many-dimensional internal space, sight became mind, and simplicity of representation became a multiplicity of image. In Surrealism, space became the dream space of "metaphysical" painting, as it was called by Giorgio de Chirico, or the space of dream anxiety for the visionary Salvador Dali. And finally, in abstract art, space became a plane of the forces of a world without objects—that is to say, the space of forms in chaos in their conception.

But if art was to reject imitation, perspective, and the space of Euclidean geometry and to turn to abstractionism, in which it creates an object without objects, it had to believe in some deeper negation, and

this was the negation of the subject. In fact, artists began to feel an abhorrence for the representation of objects, of experiences, and of actions of mythical or historical content. Only in such denial could they avoid the "empty words," the representations devoid of meaning, or rather, full of meaning but devoid of artistic content, and free themselves from the vicious circle which had been created between the conventional writing about subjects and the established form which hindered the renovation of the forms of art. Piet Mondrian appeared on the scene, abolished the arrogant and arbitrary domination of the subject, and attained a pure plastic art and a stable reality.

Returning one evening to his residence, Wassily Kandinsky was finally convinced of the necessity of the abandonment of the theme when he was surprised by the beauty of a work that was hanging upside down. He then understood that shocks of colored spots are enough to make a work artistically interesting because they free us from the sequence or established chain of impressions. At all events, with the progressive abstraction and the superimposition of forms in Cubism, this freedom occurred even where the subjects were retained, whether they ceased to be clearly discerned and hermetically sealed or whether they ceased to be representational symbols. And lastly, with abstractionism, representations completely disappeared, and the works became abstract points, non-figurative symbols.

The abandonment of the subject did not come abruptly, but was gradually imposed by the progressive destruction of form. Impressionism, with its regard for fleeting impressions, had already dissolved the limits of form. Pointillism dissolved colors and placed them on canvas to permit the eye, and not the paintbrush, to recompose them visually. Robert Delaunay later proceeded with the analysis of the color spectrum. Expressionism, with its passion for expression, attained distortion, a corruption of the conventional proportions of form. Cubism analyzed form to recompose it with the mind and thus to dissolve its unity, causing in the spectator a confusion about its wholeness, since one form often becomes intertwined with others. Aimed at expressing movement, Futurism arranged its successive poses cinematographically, thus destroying the unity in the foundation of form. Surrealism projected the most extraordinary transformations and correlations of improbable forms, and thus made poetic transference apocryphal. Advertising art—that is to say, posters—had from the time of Henri Toulouse-Lautrec reached a shorthand kind of distortion and a surprising representation of form. Mondrian, and especially Kandinsky, led art

83

to the complete rejection of form: for the spectator the form becomes formless and undefined. But, as Picasso remarked, "It is one thing to see, and another to paint."

Finally, contemporary artists and sculptors rejected the natural tendency to be static arts of space in favor of becoming dynamic arts of time. It was not enough that Futurism conveyed only impressions of speed on the two-dimensional canvas, or motionless sculpture in space: under the influence of the attraction of the machine[2] and the possibilities of the conversion of energy, painting was led to cine-painting and sculpture to the mobile sculptures of Naum Gabo or to the famous "mobiles" of Alexander Calder. Indeed, the pupils of the Bauhaus, with Laszlo Moholy-Nagy in the lead, created machines to project successive chromatic impressions in space, or combinations of sound and color (the optophone, the clavilux, and so on). Thus, that movement and motion which the static arts initially sought to impose through artifice and machination they wanted now to impose upon their works through material means, they themselves becoming arts, like music, of time.

It is true that music was always not only a dynamic art of time but also an abstract art rejecting the imitation of the sound phenomena of nature. And, therefore, the art of abstractionism naturally looked to music as its model, or at least tried, through the forms of colors and plastic materials, to express the transformation of the structure of material, or the spiritual function of creative poetic action itself. According to these aims its works would have become a frozen music, as Schelling said of architecture, unless it could succeed in becoming, as in musical works, a moving architecture. Thus, painting, starting from imitation, leapt into the music of colors of Pierre Soulages, to the psychic recordings of Hans Hartung, and finally to the painting-outcries of Pointillism, forming the material in the space of the chaos of creation.

The acme of this poetic activity is action painting, which was especially attractive in the United States. Starting off with certain initial spots and exploiting successive coincidences, it completes an unexpected structure on the canvas. Jackson Pollock goes to the point of laying his canvas on the floor, walking around it, and slapping colors on it, thereby exploiting the technique of dripping. In this way his painting is identified with his physical action.

II. reasons for destruction

Before proceeding with the constructive aspects of contemporary

art, however, we must consider the troubling question of why all this change took place. In other ages, the styles of art also underwent change as theories became radically different, as, for example, when the Greco-Roman world gave way to the Christian era, and yet basic negations and a complete destruction of symbols and forms did not follow. The conventional and established principles of art survived, and no matter how much the symbols changed meaning (like, for example, the figure of Orpheus, who came to represent Christ), they remained the same externally. The theory of the universe, it is true, ceased being anthropocentric and became theocentric. But the God of the Christians, no matter how much he was the ever-present, nevertheless remained a person. On the other hand, man has disappeared from art today, and his place has been taken by abstract intellectual shapes and by the formless world of matter.

Nevertheless, the wave of non-figurativeness overwhelming us today is not completely new. It appeared at many points in the history of art, and indeed in Byzantium itself, where it shook the very foundations of the empire. The non-figurative in art was aimed superficially at the abolishing of the worship of representations depicting holy men, but fundamentally it was a new direction taken towards the transcendental sphere of intellectual abstraction, where the spirit influenced by the Judaic mentality sought to become monastic and secluded, the forms of its creations being denied. The non-figurative, because it exists within the soul of man when the anthropocentric theory of the Greek spirit and the love for form is not deeply rooted in us, exists in the art of the Vikings; it survived in Islamic art; and it was revived in the Protestant church. From this point of view, therefore, contemporary abstractionism, no matter how much it may be a movement of purification, is also an example of the decline and rejection of the Greek anthropocentric theory which had been revived during the Italian Renaissance in the form of humanism.

At all events, it is abundantly clear that in the nineteenth century the symbols and forms of the anthropocentric theory had already atrophied and lost their meaning. No one any longer noticed whether a bench had leonine legs, and if anyone did, he did not feel that it was an artistic symbol of strong support, that it achieved an appropriate poetic transferral. And the technician who carved it no longer knew why he was shaping the legs in such a manner. Through their continuous use, symbols had become useless and degenerate. At the same time, poetic transference as an artistic principle had fallen into disuse.

By constant use, even the letters of the alphabet degenerated from being symbols of images, which they were initially, into being phonetic points. The same kind of change holds true of language. Who today remembers that many words, such as whisper, buzz, murmur, or splash, originated from the imitation of external phenomena? The spoken symbol has finally become an abstract meaning, an intellectual sign whose meaning must be known to understand it. Artistically this means the destruction of the spoken form of language, the corruption of its symbols, and lastly, a state of conventionality in which the feeling for language in men does not renovate or rejuvenate it.

Corruption has also struck at the symbols of architecture: who now feels the poetic transference which formed the echinus of the Doric capital, the acanthus of the Corinthian, or the volutes of the Ionic column? All the forms the eclectics of the nineteenth century accumulated for finding a solution and a point of departure for a new style had in reality no connection with expression. Also expressionless were all the mythical, heroic, or imaginary artistic themes whose ideology belonged to the past. Even interest in portraiture had diminished, not only because the newly discovered photograph took its place, but because the human personality ceased being the center of interest of the human soul. The individual's place was occupied by the crowd—that is, by the mass and its material concerns, or, generally, by materialism.

These changes are more pronounced in architecture, which is an art attending to the needs of man. Actually, the architect of the twentieth century is no longer called upon to construct monuments, eternal symbols of the ideas of man, but to provide shelter for the masses in ephemeral buildings, in workers' communities, in complexes of offices, hospitals, or schools—that is to say, in buildings having practical purposes. Architecture in the twentieth century is utilitarian. Its works are no longer monuments, or aristocratic mansions, but shelters which, once they have depreciated in value, can be torn down to be replaced by others. The form of these works is therefore determined first by their usefulness of purpose (and it must be functional) in conformity with the principle that form follows function.

Aesthetically, the forms of contemporary architecture also, although rather slowly, followed the currents appearing in the other arts, as is always the case, because architecture by nature is more conservative than the other arts.

Architecture first renounced all forms of the past and removed all remnants of eclecticism from its works. Initially adhering to a certain

artless geometricity, buildings were denuded and assumed cubistic shapes known as "boxes." But when they wished to express its new plastic possibilities, architects began to separate the carrying frame or skeleton and to break up the mass, replacing it with light, non-supporting exterior walls surrounding the building like a stretched skin, to raise the body of the structure in the air on piles, to make the walls transparent by means of glass and thus to expose the outside to view, to cover over those walls visually, as in cubistic painting, and to unite the external and the inner space. It thus created striking space-time impressions, left the material naked to speak through its texture, as happens in sculpture and in collage painting, and, finally, combined the solid with the empty in a free rhythm having cuts and unexpected intrusions, as in jazz music. Examples are the buildings of Le Corbusier at Chandigarh in the Punjab.

All of these new features to be brought about in architecture, however, also presuppose new technical possibilities, new materials, and new methods of construction. Technical progress did in fact provide these conditions. By the nineteenth century, iron structures had already become fashionable, and reinforced concrete had been discovered, but the maximum architectural exploitation of these factors began in the twentieth century, and especially after World War I. Then the revolution of contemporary art mushroomed. If, up to that time, architects were slow in getting started, this was due on the one hand to their wallowing in the dominant form of eclecticism rather than embracing the new techniques outright, and, on the other hand, to the problems of the masses, economic, social, human, which only became apparent and pressing in the shambles left by the war.

After all, technical progress had provided newer means for destruction. At all events, the rapid development of the machine had resulted in the move to cities, and with the development of industry had created vast housing problems in the large cities, an ailing capitalist system, and a wave of materialism, to such a point that dialectical materialism found fertile ground for its theory of the class struggle.

And yet the sufferings of man cannot be laid at the door of technical progress. Man is responsible for his own fate because he did not use technical knowledge wisely. And, in fact, man began to submit to the power of the machine, which got out of his control, mechanized man himself, and finally dehumanized him. Therefore, it is to be expected that art too would be mechanized and would dehumanize its forms, as we see it did in the works of De Chirico, Léger, Moore, and

others. The *Guernica* of Picasso expresses all the heart-breaking anguish of the tragic Spanish civil war.

During World War I the Dada movement in Switzerland looked upon logic as responsible for the war's destruction, and proclaimed that from then on art should be based on the irrational element. One may well ask why the art of the twentieth century did not again humanize man by putting logic on a sounder foundation, rather than destroying the meaning of beauty, adopting a kind of madness, and pressing de-humanization and mechanization to their limits. Yet art does not return to the past, first, because it does not preoccupy itself with morals but seeks to express the present, the spiritual condition of contemporary man, his ideals, his desires, and experiences; second, because art is not subject to logic or reason but is the product of creative enthusiasm in which the irrational element rules; last, because even had it wanted to, art could not itself have changed the course of events ever since science, and even philosophy, as a reaction against the positivism and deter-minism of the nineteenth century, began to exalt the irrational.

The psychology of Freud had already disturbed the stagnant wa-ters of the subconscious, which to him was the motivating force of every action of man, and particularly of creativeness. Surrealism rightly demanded that the artist turn to spontaneous drawing for sincere expression.

Applied science itself had destroyed the traditional classical views of three-dimensional space and absolute time, and ended with four-dimensional space-time. Material became a form of energy in which even light acquired mass. According to the quantum theory, natural phenomena were controlled by the laws of probability. Generally, the picture of reality was given by abstract mathematics, and not by in-terpretations of the perceptible world. It is not surprising, then, that Cubism dissolved classical perspective, that the abstractionism of Mondrian was related to some Pythagorean type of mystical proportions and numbers, and that Pointillism entrusted the structure of its com-position to coincidence.

It is not strange that in this chaotic space of the new cosmology, which shook the accepted principles of psychology and science, the values represented by positivistic philosophy and set up by Nietzsche's philosophy of the *Übermensch* should have remained unaffected. The new philosophy rejected an intellectual interpretation of the world. The anguish of existence became the center of its thought, and it proclaimed that there was an existence anterior to the substance itself. Art helps man

to feel his existence because, thanks to its creative activity, it confirms its freedom. This is why it today tends to become the substitute for religion, a redeeming factor, whereas before it had always been religion's agent. How can this be?

III. constructive aspects

To understand the constructive aspect of contemporary art, we must examine not only what has been altered, but also what has remained—that is to say, we must see whatever is permanent in every manifestation of art. And in fact, no matter how much art may change in style and form, it still adheres to certain aesthetic principles which are beyond history and applicable to its every expression: the principles of style, of harmony, of measure. Even when its works at first sight appear to be incomprehensible to us, to be without measure and harmony, the fact that they move us aesthetically means that they do possess some style, some latent harmony, and some measure. These principles had been relaxed in descriptive works and those drawn according to theme, and for this reason Henri Matisse stated that he was no longer interested in the expression of experience, but in the relationship between solid and empty space and in the proportions of his work. He thus prepared the ground for Mondrian, who based the value of his abstract shapes on these qualities. This is why Georges Seurat, Le Corbusier, and the younger artists and architects gave such importance to harmonious engravings.

Following a period of extreme abstraction, therefore, those basic laws of art which had been in danger of being lost in nonsensical ideological themes and symbolism were revived. In fact, artists believed that the laws of style, harmony, and measure would themselves be sufficient to attract and charm, once art had been freed from imitation and once the spectator had been freed from the superfluous sequences of thought created by representations. Thus, the form would become absolute and pure; and art more chaste, more internal and esoteric. Rightly, therefore, Mies van der Rohe, the architect of pure form, took as his motto, "less is more."

Actually, no matter how strange it may seem, every abstraction is at the same time an addition. Once we revert, by abstraction, to the more general forms, we see the view more completely, just as when we observe things from a distance. It is true that we lose sight of the details,

but we gain the substance. One would under the circumstances believe that through extreme abstraction, a person would be led to the ideas of things. But abstractionism denies ideas, and especially Platonic ideas. As Naum Gabo remarked: "For us the only reality is not the ideas of Plato but our structures." And this is because the ideas of Plato went beyond sight, beyond the outward form, whereas a non-representational or non-figurative art can possess only meanings, or, rather, signs or marks of its non-figurative action.

Plato condemned painters because they deceive us doubly by imitating with both artifices and deceptive phenomena, and he praised architects who built because they thus partook of science. But for Plato, even structures were elevated to ideas as long as the idea of the table or that of the temple exists. But the structures of Gabo are not raised to the level of ideas; their mobile forms are the result of creative constructional action, and his architectural works are the result of function, forms that serve us and invite one to move, or rather, to act, within them, rather than to view. Thus the static meaning of form was replaced by the dynamic meaning of continuous transformation, and viewing was replaced by acting.

The gradual abolition of imitation in art therefore was aimed at liberating art from external phenomena and leading it to construction, freeing it from the sequence of thoughts, and establishing it as a pure artistic content of action, true creativity, poetry. At the same time, the abandonment of perspective was to liberate art from the optical artifices with which it once deceived the spectator: to convince art that whatever is organic and consistent in the service of an aim, consistent with its structure itself, is beautiful. In this way, the idea of organic form was revived, primarily in architecture. But that art was to become non-perspectival did not, however, mean that perspective was completely wanting. In place of the perspectival mechanism, there was optical or visual order, that order which evaluates phenomena hierarchically, and recognizes and emphasizes their importance. And finally, it freed art from the demands of perspective and enabled painting to rid itself of the tyranny of the model to become an art of the studio and of the imagination.

It is true that, in studying the first stage of the gradual destruction of form, we ascertained that contemporary art in the end reached the formless state. But there is no formless state in nature. And whatever we call formless, in contradiction to specific form (like, for example, clouds) also has form, a form which we cannot define geometrically or grasp in

its organic content because its end, its aim, eludes us. It, in effect, has no beginning, no middle, and no end, and if it possessed limits, it would not have an end; but we do discern in it some structure of the material which sets it in our consciousness as a form that is "becoming." It does not yet possess the concrete entity of a species. We cannot say that it is this and not that; but it does contain within itself an infinite number of possibilities, equally as much as does a piece of marble awaiting its sculptor to mold it and give it form. The material is found precisely at this extreme limit of formlessness, but it therefore has a certain fascination, as does the spot, the *macchia,* which Leonardo observed on the plaster of the wall and which so intrigued him.

And so, starting from the beauty of being, we now come to the beauty of non-being, the material—or rather of the unshaped and the primeval, not to say the ugly—of beauty which also possesses its own charm because with the repulsion it causes, it purifies or cleanses our being.

Thus, the cleansing of art from the established form in substance brought about the destruction of form, and there was a return to the raw material which the creator, unfettered by phenomena and symbols, is called upon to take in hand and mold.

What, however, when he has no theme, when he has no representation, can the artist create without symbols? His imagination faces a *tabula rasa,* and he is compelled to return to the spontaneous or automatic drawing of the experiences of the subconscious, as in Surrealism, or to entrust his work to coincidence, as in action painting or in Pointillism.

In such works the action precedes the thought. The conception of the work takes place during the execution; it is a selection, from among the many and endless paths that open before it, of the one which seems more suitable and seems faithful precisely to the state of the first moments. One could almost say that, following its own peculiar pace and style, which does not adhere to that of the creator of the work, the work is created by itself. The creator, not knowing where the work will end, simply helps it take shape. It is the case of a journey into the unknown.

Such a work, even if it is finally finished, is pregnant with many possibilities. It does not contain within itself the seed of a specific form, a being which aims toward an end and is organized accordingly. Its organic feature is an embryonic, Protean, always changing form, a field of energy stretching out before us and pulsating with mysterious life, as in the works of Mark Tobey. This is why, when it is finished, it remains an enigma, and the spectator is called upon to guess what it symbolizes, as

in surrealistic works, where the viewer is to be a dream interpreter and translator of the symbolism. On the other hand, older art with its symbols provided its own answers and interpreted its own divinations.

It is true that the oracles of art were never clear-cut; they were ambiguous. But we know that they involved some specific idea that art was encompassed in the material. The symbols of art were also of great importance in depth, but by drawing recognizable forms artists gave us the means of understanding the poetic transference which had taken place. Today, however, when we have no symbols but only points, only traces of the path to the unknown, our art has become Pythian and its paintings canvases of clamor, Pythian utterances of the consciousness of the artist who is striving to interpret the world. It is no longer an embodiment of ideas.

There is no doubt that these Pythian utterances, emerging from the very depths of the artist who is struggling to express himself, can, when they end in dream symbols, as in Surrealism, be prophetic, as is the work of Dali, who prophesied the destruction of World War II. At other times, they depict the archetypes of the Protean form of our souls, if one accepts the Jungian theory, or terminate in apocryphal hieroglyphic tangles, as in the works of Joan Miró, or recall, as do the statuettes of the Cyclades, symbols of a still irrational worship of the divine.

The Pythian bent in art coincides also with the high estimation of its irrational element, sometimes in the pre-rational form, as in the works of the primitives (Henri Rousseau and others), other times in the post-rational form of a Mondrian or a Ben Nicholson. Contemporary man is presented in this way as a civilized primitive, a person who, despite the blessings of technical progress, has allowed his humanism, his first principles, to slip through his fingers.

Despite the dominance of the irrational element, there is no doubt that imminent in contemporary art is a large supply of deep-rooted mental thought (cerebralism) whose representative, I believe, is Mondrian, in contrast with Kandinsky, who is more of a sentimentalist.

Abstraction is an intellectual act, and abstractionism is even more intellectual. This holds true for the analysis and recomposition of the Cubists. And finally, the use of abstract points, even though coincidental, means a withdrawal of man within himself and a carrying on of a dialogue with non-being rather than with being, exactly as mathematics explains the world today. One may well ask whether, since mathematics explains the world, mathematics alone is valid. Perhaps. Everything is number, as Pythagoras would say, but art with only numbers is

impossible and cannot communicate with man. At all events, art also uses mathematics in an irrational manner. This is why, deep down, the opposite poles, Mondrian and Kandinsky, coincide. In their art, the dominance of the irrational element is clearly evident, in that the ambiguous is presented as the expressive attraction, together with faulty composition, ellipticality, extraction, and the unfinished.

These properties are not new in art. Every work of art contains them because rational clarity, syntactical exactitude, and the completion of the finished element alone do not make art. I shall cite but one example, the Parthenon. The axis of the corner triglyph does not coincide with the axis of the column. This constitutes faulty composition because the frieze ends in a triglyph instead of terminating in the middle of the metope; but in this way the frieze is projected. Moreover, the end columns are closer together, with the result that the colonnade is reinforced, the parts respond to the whole arrangement, and the temple reacts against the weight of the material. With respect to geometrical regularity, an anacolouthon results in the curves. Homer also used anacolouthons, and all of poetry is full of them because they are expressive.

Ellipsis or ellipticality is present in all works of poetry, for poetry does not relate events but condenses them and expresses their substance. This is why Aristotle maintained that poetry is more philosophical than history. With ellipsis, poetry in fact becomes more suggestive. Sometimes, it is true, it becomes obscure, as does that modern poetry which avoids description entirely and fails to communicate its meanings clearly. But, as T. S. Eliot said, to enjoy a poem one must study it as though one were examining a lawyer's brief. After all, what is ellipsis but an abstraction, a leap, a gap in the sequence of meanings which gives flight to the imagination?

Extraction and the unfinished are also in substance a part of abstraction, but with the difference that the extract presupposes a whole which has pre-existed and a part of which is presented, like a torso of a limbless sculpture. Yet the torso has value in itself since it suggests the completed form of the whole. This accounts for the fact that the torso has become an independent theme. Each motif in a musical work is an extract from the whole, and in fact a substantial part of it, which appears and returns again to remind the hearer of something, as are the various planes carrying an extracted view of a cubistic painting, as in the works of Juan Gris.

On the other hand, the unfinished, or the *non-finito*, suggests to

93

the artist the possibility of his leaving the form incomplete, as did Michelangelo with the sculptures at the tomb of Giuliano de' Medici. The work then appears like an incomplete sketch made at first hand; but the imagination can complete it in its own way. This does not mean, however, that the sketch lacks completeness, as one can see in the "unfinished" sculptures of Michelangelo. Completeness, or the finite, is relative in terms of the style of an art. It is therefore in comtemporary art, where action precedes thought, where conception occurs at the same time as execution, that the work should maintain all of the characteristics of the unfinished.

And in fact abstractionism, in moving from one negation to another to give us a clean and pure art, an art of purification during the creative act, raised the means of art to an end and entrusted the work itself to the material and to coincidence.

But the material is drawn from deprivation, poverty, and imperfection, and coincidence from the irrational and the fortuitous. Thus, it is fated that contemporary art possess the style of deprivation and of a thirst for form, where only syncopated rhythms, discordant harmonies, and measureless measure are celebrated.

The lack of form makes difficult the communication of the artist with his fellowmen. His dialogue has become a catalytic and at the same time an irrational monologue.[3] This is why, as Picasso pointed out, there are no schools of art today, but only artists. He thus expressed the fact that contemporary art is very deeply subjective; and therein precisely lies its hope, that it will draw inspiration from the depths. At all events, an escape from this anguish is action, the molding of material, without end and without beginning—that is to say, without purpose and without ideas. It is an endless and interminable pathway into the plain of the deprivation of the material, into the plain of want which awaits the seed of the spirit giving birth to new forms. Its only joy lies in the fact that it is now fluctuating in the world of the infinite, a world without end, a world of the unfinished, and that it is activated by the love of creation for the sake of creation.

This seed will some day take root because Eros, the daemon who pervades the world and spreads our wings towards the Beautiful, is the offspring of Porus, the god who contrives, and of Poverty, the mortal who lacks material means. Abstractionism which appears to move from the Anti-Eros will thus grace us with a new form of beauty.

5

the beholder and the work of art

When we urbanites find ourselves in the countryside, we are delighted with the enchanting spectacle of fields of flowers and of mountains with forests and streams, and many times we ask ourselves how it is that people of the countryside who enjoy this beauty daily can leave it to come to work in the cities. This problem has many facets, the social and economic, as well as the aesthetic; it is to the last of these to which I should like to confine myself.

People of the countryside do look on the countryside not aesthetically, but in terms of fields to be cultivated or of forests as sources of timber, and so forth. That is to say, they see the earth from the point of view of its utility and the amount of labor required to make it economically profitable; they conclude that doing less work in the city, they can earn more, and thus they leave the country. The economist or the engineer who exploits the watersheds also regards the countryside in somewhat the same manner. Analogously, a fabric merchant considers cloth from the point of view of weight, quality, and profit, and only the woman who buys it to clothe herself judges it in terms of beauty.

These observations do not mean that the people of the countryside, the engineers, the merchants, and the economists are insensitive

to beauty, but that instead, they think of insuring their livelihood in practical terms—in other words, in terms of utility—so that for them aesthetic considerations are secondary or disappear altogether.

Urbanites, however, who, being free from practical concerns and lacking a utilitarian point of view, every so often go into the country to relax and look at the uncultivated fields are in a position to enjoy the beauty of nature because they are simply spectators who can delight in the spectacle itself. They can look at nature with "disinterested interest," and this attitude generates aesthetic observation.

When Pythagoras was once asked what kind of people philosophers were, he replied that life is like a festival to which some go for commercial purposes, some seeking a profit, some to gain victory in the games, and some simply as spectators; the philosopher represents the last group. In other words, the philosopher is a spectator because he is interested in the spectacle without, however, having practical or personal interests in it. Pindar was such a spectator when he eulogized the victors of the games in his odes, the difference being that he judged the spectacle of life not, as did the philosophers, through abstract intellectualizing, but through hymns of the poetic imagination.

To be an observer, and especially to be a disinterested one, one must maintain an external distance from the events and the movement of life and an internal distance from subjective and practical interests. This distance we easily achieve when we go on a trip, when we find ourselves in the country, as I have noted, or in a foreign city. Then, nothing, neither practical concerns nor utilitarian ties, unites us with faces or things that we see. Everything is foreign to us and seems to be observed for the first time, as if it were an artificial or a simple phenomenon. Everything, as though isolated, is near and yet far from us. We have the impression that we are watching a theatrical production. The buildings of the city become the stage set on which people move as actors. We follow their actions, their misfortunes, and their attitudes as if they were dolls in a puppet show. From this distance from reality, we find it easier to observe something that until now one had never noticed before, such as, for example, that gypsies have a beautiful stride, that architecture is an important art, and so forth. Such observations come about because, in the city where one lives, one's habit of seeing the same things daily has made one less aware, and aware only of those things of a practical interest. One is careful as he walks not to stumble and to greet anyone he knows, but he never stops to loiter, to become a simple spectator. It is because of this that an Athenian often knows the

beauties of Kalmata better than the Kalamatan, and the Kalamatan has often climbed the Acropolis, which many Athenians have not climbed and by the beauty of which they have never been delighted.

We assume the spectator's position of disinterested interest before a work of art. Consider, for example, the theater. A dramatic performance on the stage we regard as a spectacle, as a simple phenomenon, without, however, losing our sense of reality. But this reality is at a distance from us; it is on the stage and thus isolated; it does not affect us directly, nor does it involve us actively. It is because of this that we endure murder on the stage without protesting, tears of the actors without weeping, and so forth. The author, moreover, has been careful to lead us into the essence of the play's actions without any superfluity and in so doing he has thrown the ideas of the work into relief, thus exciting our enthusiasm. The truth of what I have said about aesthetic theory, that it demands that we keep a distance from events and maintain a disinterested posture, is illustrated by the example of a fireman who, while watching a play, considered it his duty to warn the leading lady of what was in store for her by shouting to her from where he sat. The audience, of course, burst into laughter. Obviously, the position of the fireman with regard to the play was not an aesthetic one. He had lost aesthetic perspective.

The basic stance which an onlooker must take to appreciate a work of art aesthetically having been clarified, it remains for us to see how through its creations art succeeds in putting us into this position. We will see the deeper meaning which makes us perceive the world that art imitates. To do this, I shall examine the three principal characteristics of a work of art to which I alluded above: (a) its image-like character; (b) its isolated character; and (c) its symbolic character.

In remarking that a work of art has the character of an image, I mean that it appears as an image of reality, whereas in fact it is not. It is like a mirror-image of ourselves. Children as well as animals when they first see themselves in a mirror are taken aback; they assume that they see another person; before long they understand that the image is a counterfeit, however, and cease to be disturbed and affected.

We follow the theater in much the same way. We watch as if we were seeing dolls, even though we know that we are viewing living people. Moreover, we know that they are play-acting, that they are deceiving us; and yet we enjoy being deceived. Why is this? Because it is possible for us without emotional involvement, without passion and fear, to follow and yet to comprehend the meaning of life. If the actors

did not have this phenomenal character, if they were not images, invulnerable shadows that die without dying, that kill without killing, the spectacle would be unbearable.

To create images, art imitates, and in so doing deceives us with phenomena resembling reality. This deception was insupportable to Plato, who for this reason said that only architecture is an enlightening art for society because it does not create images, it does not imitate, but, instead, it constructs realities: imitation in art is an evil.

Art does not simply imitate exterior phenomena, however. Painting is not photography, reflecting images as if they were in a mirror. Imitative painting attempts to interpret realities, and in so doing it forces us to experience their deeper significance. The painter Max Liebermann remarked to a client, who was complaining that his portrait did not resemble him, "It more closely resembles you than you do yourself." In other words, the painter brought into prominence the hidden self which was obscured by ephemeral and transient appearances. Therefore, the actors in classical Greek theater wore masks, since the changing features of Oedipus or Clytemnestra were of no interest; what was of interest was their external characteristics, the types of creatures they were.

When sculpting the statues of the Medici Chapel in Florence, Michelangelo represented Lorenzo without a beard although he had one, and he justified himself by asking who after a thousand years would be concerned with whether Lorenzo had a beard or not. What concerned Michelangelo was the idea of ruling power, and the statue was the image of this idea. Only thus can we explain those arts that imitate nothing concrete, like architecture and music—which imitate the rhythm and structure of the world. The myth of Amphion declares that as he played the lyre the stones of themselves rose and constructed the walls of Thebes. The works of music and architecture are also images of the ideas of the world.

Only images, the phenomena of art, can be vivid enough to express ideas and thus allow us to experience them without the distractions of ephemeral concerns. For this reason, we say that when objects of nature appear highly expressive, they appear artificial, and when a work of art is so expressive, we say that it is life-like. This use of "like," "as," and "if" indicates that we view things as phenomena, that they are representations of ideas, of a type of reality.

The second characteristic of art is its isolation. It appears to us as an isolated world at a distance from us. Its isolation does not depend

only on its phenomenal character—in other words, on our awareness that it is something artificial; since we know it, like the image in the mirror, to be artificial, we are not struck by the fact that it is an isolated and self-sufficient world. To isolate his work, to separate it from the rest of the world, the painter places a frame around it, the sculptor places his statue on a pedestal, and the architect places his church on a substructure. All of these means are external. What are the internal ones?

A work of art has unity within itself, and, what is more, it has unity in variety. In other words, it is like an organic world put together in such a way that no one can change it. When we exchange one part of a machine for another, the machine may not change but may continue to function, whereas as soon as a part of the Parthenon is changed, the whole beauty of the temple is destroyed. Everything is in place, and only that which is in its proper place is connected with something else. The Parthenon thus does not consist of parts, or of sections; it contains members, as does the human body, for which no other hand, foot, or head can be substituted. It permits neither deletion nor addition. According to the variety of its component parts, it has total unity, rhythmic movement, and a harmony of parts.

For this reason, when we find ourselves before a work of art, we marvel at its perfection. A dramatic event in our lives unfolds out of a thousand superfluous and meaningless details, chronological interruptions, and actions that hinder us from grasping its significance with clarity. In a play, on the contrary, the drama unfolds rapidly, without pauses and superfluities, for the playwright has abstracted the superfluous and highlighted the essential. Cohesion, continuity, and meaning characterize its action. As Aristotle says with reference to tragedy, it is the imitation of an action that is complete and has a beginning, a middle, and an end, and can be easily remembered (*Poetics* 1450b).

We stand with admiration before such a work and are struck with wonder at the harmony, rhythm, and unity with which the life we hitherto took for granted is represented. In such a way does the work isolate itself from us as a new world, as a "world of the world," as if it were a world that had fallen from heaven—divinely sent, as the ancients said of the wooden images of their gods.

Thus, we say that art takes us out of time and reality and puts us into an ideal place and time where the images of ideas move by themselves. According to the distance which art forces us to take as regards life, place, and time, it translates us into a world of ideas where everything, lacking the pressure of necessity, lives and moves freely. Art

99

is therefore the bridge to the freedom of the spirit.

The third and last characteristic of art is its symbolism. In our lives there are many symbols: the blue-and-white flag is a symbol of the Greek nation, an algebraic formula is a symbol of a mathematical syllogism, and so forth. In order to understand these symbols, however, we must know what they are. The French flag must first be explained to us before we can recognize it. This does not occur with the symbols of art, however, which are immediately recognizable by everyone. When Homer tells us that Zeus moved his eyebrows and Mt. Olympus trembled, we immediately understand what he wants to say: he indicates the power of the Father of the Gods. When the sculptor places a lion on a memorial to heroes, we immediately recognize that it symbolizes their courage, and when an architect constructs an arch in order to allow the passage of a king, we at once understand that his triumph is symbolized.

The symbols of art do not constitute a mystical language. On the contrary, art is a universal language which moves everyone because it suggests meaning through intelligible forms. The language of symbolism has its roots in poetic metaphor. Because we liken ageing to the setting sun, for example, we say that a man is in the twilight of his life. In this way the image is magnified and becomes more significant; the subject is related to a great natural phenomenon; it takes on a deeper significance as it indicates that everything sets and rises. Similarly, the architect in applying an acanthus to a capital indicates the elasticity of the support.

All of our demotic poetry is full of symbols that owe their origin to poetic metaphor:

> Scarlet lips I kissed and painted my own,
> And on my kerchief I wiped them, and painted the kerchief;
> In the river I washed it and painted the river,
> And it painted the shore and the heart of the gulf.
> The eagle while drinking then painted his wings,
> And half the sun did he paint and all of the moon.

Here the red color, the symbol of erotic passion in man, is transferred from element to element and eventually conquers the world. One could say that the entire poem becomes the symbol of the love that moves and causes the world to continue.

What happens, however, when art imitates natural creations? How does it succeed in creating symbols? We have seen that art does not imitate in the same manner as a photographer's lens. Art interprets

phenomena and creates images—in other words, symbols of their ideas—which express their forms. This is why Lieberman said to his client that the painting looked more like himself than he did. He meant that his portrait had become a symbol of the client's personality. Here of course is no poetic metaphor: there is a transference of idea into matter, however, and this essentially is the achievement of art.

Certainly to symbolize ideas in art and to convey metaphors poetically is not an easy matter. It is also dangerous because with a few false comparisons or allegories artists often think that they have created symbols. For example, Vitruvius says that the Kores of the Erectheum represent slaves. But this does not influence us. The Kores are an allegory. What affects us is their stature. How often do we see a flashy symbolic title on a poem but are disappointed as soon as we begin reading it?

This indicates that true art does not depend on external devices but on deeper meanings, and that it is a creative effort exciting the imagination. But bad and unreal works of art do not excite the imagination; on the contrary, they crush it. A bad statue, for example, gives us neither the man nor his significance because it simply symbolizes him externally and not internally.

The form art gives to ideas is not an external covering, an additional ornament, but a deeper expression of their essence. Only thus is the true end of art attained. The true fulfillment of art is great. It does not deceive in order to deceive us. It deceives us in order to enlighten us, to reveal the world of ideas and their meaning, to interpret the world around us, the world of which we are not aware because we do not know how to think of it. The artist is the person who knows how to see, who knows how to read the book of the world and of life in a manner that is different from that of the scientist.

Science teaches us how the world is, how matter is composed, how the stars move, what the law of gravity is. Philosophy teaches us why the world is, how much we know, and how much we do not know. It instructs us in knowledge and ethics. Art teaches us what the world is, what life is, and what the forms of ideas are. This is the meaning of Schopenhauer's remark that philosophy is to art what wine is to grapes. Philosophy with effort extracts a meaning, but art simply points and says, "This is what you wanted to say!"

Finally, I should make one observation. At the beginning I stressed how necessary it is that, in order to understand art, we create a distance between the elements and ourselves. We must remove ourselves to a

theoretical distance and become onlookers of the world. Only then can we observe it aesthetically.

I have attempted to show that art drives us into this disinterested position because in its creations it reveals the character of phenomena, the character of isolation, and finally the character of the symbol. A work of art is a symbol of ideas.

But let us for a moment examine the word *symbol*. A symbol is that toward which everything contributes, toward which everything tends to move. We onlookers of a work of art hasten as we read to find the symbols of art in the ideas symbolized. Thus, while we assume a distance from the elements and separate ourselves from them, we return to unite ourselves with them, because, charmed by beauty, we look at the world with different eyes; we regard the world as a representation of ideas. It is as if we were leaving on a journey and when we turn to look back, we, thanks to the distance, better appreciate the value of things we left behind us. We are entranced by contemplating their true significance and the ideas they represent.

A work of art is not pleasing because it flatters feelings or instincts. The Venus de Milo does not please us because we see her aesthetically as a beautiful woman, nor do we like the Parthenon because it has straight lines or, rather, curves that are pleasing to the eye. A work of art is not created by the eyes or the ears. Homer and Milton were blind when they described beautiful images, and Beethoven was deaf when he wrote the Ninth Symphony. The images the eyes see and the chords the ears hear are used by the artist to invest nature with spirit and to reveal a harmony discovered behind phenomena. As Heraclitus says: "The harmony that is hidden is better than that which is obvious."

A work of art does not please us because it evokes emotional responses. When a painter paints a beggar, we would not say that he made a work of art to provoke feelings of pity. For such an end a painting would be superfluous, since the reality is more effective. Tragedy does not want us simply to feel sorry that Oedipus puts out his eyes when he learns that he has married his mother; it wants to create a "catharsis" in our soul; to bring this about, it harmonizes the opposing emotions, and thus gives meaning to the final action of the tragedy. This is why tragedy is "the imitation of a significant and perfect action . . . by means of pity and fear terminating in the catharsis of these feelings" (*Poetics* 1449b).

Art thus frees us from our personal feelings and lifts us onto a spiritual plane where we have a perspective on the action of life and on ourselves. What, however, is this perspective?

A work of art does not please us because it satisfies our sense of logic. A work of art is not a scientific treatise of the abstract intellect, but a work of the poetic imagination. As soon as we see or hear it, we recognize whether it is beautiful or not, without having to exhaust ourselves with the syllogisms of logic. This is not to say that the work has no interior logic, that it is not composed intelligently by the mind. Rather, the work of art speaks to us directly, it suggests its idea, it symbolizes it and excites our imagination, which, thus freed, visualizes what the work of art wishes to say.

These are reasons why our position with reference to a work of art, if it is to be aesthetic, presupposes our assuming a distance which enables us to be ourselves free from our petty and everyday feelings and to elevate ourselves to the plane of the spirit, where the view of the world is changed. This is why art is valuable—valuable especially for the education of the young, whose spirit is ennobled so that their own instincts, passions, and limited cogitations are forgotten.

6

art and time

Art stops time. Whatever it represents is imaginary, and for this reason it goes beyond time and becomes a moment of eternity.

Art also overcomes the corruption of time. No matter to what degree time has impaired a work materially, it has, oddly enough, increased its value instead of decreasing it. In fact, a certain charm emanates from the ravages which time has left on a work of art. Stranger yet, the charm sometimes increases when the work has suffered major alterations from the elements or from man. New paintings sometimes cover old ones, and architectural structures are repaired or almost completely demolished. Nonetheless, their beauty continues to emerge out of the ruins like a fragrance. Statues lose their arms or legs, yet the beauty of the whole speaks out of a torso, while, simultaneously, the torso acquires a certain self-sufficiency and another kind of fascination.

To what does a work of art owe its victory over the ravages of time? Whence does its new fascination come? First, it comes from the ability of the imagination to conceive the total work from a part of it. Imagination, in fact, appears to delight in this activity almost as a reaction against decay and as a struggle for survival. Moreover, part of the work of art is equal to the whole from the point of view of perfection, technique, and

style. In other words, it is like a part of the unity of the whole; and for this reason, the part is intellectually continuous with the whole and expresses the style and value of the whole. Second, the passage of time removes the luster of a new creation, the freshness of a recently completed work, thus making it more mature, more inscrutable, while simultaneously inviting the imagination to act more conspicuously to display the novelty. And it succeeds in doing so because the broader lines guiding it safely to the end are always evident in a work of art. There remains only the arrangement of the whole composition. This arrangement in fact acquires a new force when it is concentrated on one portion of the work, as, for instance, on a torso, and we view the torso at times as a source of the entire work, and at other times as though it in itself constitutes the entire work toward which the composition had aimed. The body of a statue which is now headless or limbless suddenly is transformed into a new composition and is the source of a body which breathes, even though it is mutilated. A temple also continues to breathe from within its ruins. Finally, we rejoice at comprehending that a work of art, despite its appeal to the senses, in order to present its essence does not base its value only on what is apparent, on colors, shapes, and volumes, but also on the intellectual excellence that structures and composes it through the exploitation of colors, shapes, and volumes to express something more significant. This conversion from the apparent to the substance constitutes a joyous discovery also in art.

The interventions by contemporary man on works of art often act to exhibit their value in much the way as do the ravages of time. Goethe rejoiced in reading *Faust* in French translation because great poetry, even if it loses something, also gains something in translation: if "Translations are traitors," the statement can be both negative and positive. The translator also reveals the value of the work. He clearly shows that the greatness of poetry depends not only on the external attractions of the particular language in which it was composed, but also on the profundity of the ideas and the arrangement of the composition as a whole. On this account Sophocles, Shakespeare, and Cavafy survive no matter how poorly their works are translated. This also is a victory of art over its material means of expression, which pleases the reader when he discovers it. In the final analysis, every study of a work of art from one point of view also constitutes a translation, which to a greater or lesser extent "betrays" the work in its two aspects, and perhaps even from a third: when the work is inferior, the translation discloses this fact.

Finally, the passage of time increases the merit of art by placing

the work at an aesthetic distance. Though it removes the work beyond the wheel of time, the passage of time comes to remove it once again from the contemporary scene and places it at a distance from the spectator. The spectator, uninfluenced by the emotions of his time, thus judges it more objectively, more productively, and more loftily. The subject, the content, the form and spirit of the work acquire an objectivity they never possessed in its own time. Hence a work judged as a great innovation or as in advance of its own time is later considered to be a genuine expression of that period. Time is the greatest judge of values because with increasing distance judgment becomes clearer, the spectator penetrates the essence of the work more easily, and he also, removing himself from time, confronts this essence candidly and sincerely.

At the same time, however, art touches its own times, and should in fact tread firmly to express those times, so long as it knows how to place the ideas of art beyond time itself. Contemporary art has attempted to make this leap beyond time by way of abstraction. Painters said, "Were I to eliminate the subject matter and take away the basic forms which constitute them, I should find myself in the essence of the world and should express this essence, as do music and architecture, without imitating anything specific. I shall not need the passage of time to remove me from contemporary times. And I should be indifferent to the ravages of time, since both the part and the whole of each of my compositions shall be an assemblage of abstract forms which will lose nothing if they are unable to recall some known natural forms." But abstract art neglected one thing; it did not allow for the passage and corruption of time to subtract anything, nor did it allow the spectator to remove anything so that his imagination could function. Thus, from both points of view—that of time and that of the spectator—nothing can be added to the work. Architecture and music never fell into such error.

These thoughts frequently occurred to me once in the Simon R. Guggenheim museum in New York, when I noted how few works aesthetically overcame the passage and the destructive effect of time. I had the same experience when I stood before the famous abstract architectural works of our time, which disillusioned me. These works, with their geometrical shapes and modeled forms devoid of any plasticity, with their impressive contrasting fissures and solid forms, quickly lose their freshness; and once they lose that, rather than being inscrutable, they are suddenly revealed in their nakedness. As soon as they are slightly worn or weathered, they lose their attractiveness, something that

never occurs with handicrafts. So it appears that the style of industrial aesthetics has to a great extent influenced the art of our times. A lifeless intellectual style replaced the spiritual, and the emotional, the distinctive, replaced the aesthetic—the inventiveness of the mind supplanted the revelation of imagination. For this reason, it is correct to speak of the dehumanization which the production of the machine has brought to the relationships of modern man and his world. But who is responsible for the aesthetics of modern art? Léger even paints man as a product of the machine, his limbs looking like pipes and his head like a sphere. Man has become a robot; all that remains is for the robot to become man again. But I believe that to become aware of this fact and to react accordingly, it does not suffice for man to read the symbols of the art of our times. The distance of time is once again essential. Man will one day see himself and become terrified. Thus time, which we call a ravager and an all-destroyer, will have offered man the potentiality of a new triumph: that of being reborn.

7

the artistic principle of *non-finito*

One of the basic pursuits of art is the achievement of perfection. This presupposes that the work of art must be completed—in other words, it must reach its end, it must be made whole.

But this completion or fulfillment is not always possible, for either external or internal reasons. For economic reasons, nearly all the cathedrals of the West had to remain incomplete: either one belfry was finished while the other remained unfinished, or both remained unfinished, as is the case of Notre-Dame de Paris. Various circumstances often compelled artists, like Schubert with his Unfinished Symphony, to interrupt their work and leave it incomplete. Then there were also various calamities which came after the completion of a work of art and reduced buildings to ruins and statues to mutilated stumps, which reached posterity in the form of torsos, limbless bodies, incomplete fragments of a whole.

The strange fact, however, is that in defiance of adverse circumstances, calamities, and wear and tear in general, these works of art have not lost their artistic significance. Indeed, they have acquired an additional attraction because they urge our imagination to complete them and allow us to visualize infinite extensions which a finished work

would preclude. What is more, although these works are fragmentary, they retain the style of the whole; in this they manifest an aesthetic endurance against time which allows them to proclaim their eternal youth, their incorruptible spiritual presence.[1] We cannot, therefore, equate perfection—to which art aspires—with the completion of the work of art. The unfinished work of art has its own particular attraction. This explains why art, in answer to some inner urge, often seems to seek the form of the unfinished.

Even classical art, which nearly always equated perfection with completion, (following the Aristotelian rule that a work of art must have a beginning, a middle, and an end, and must also be succinct and well-rounded), even classical art allows some parts of the work to remain incomplete or undefined in order to enhance the main points and allow imagination a free rein. For instance, at the corners of the Parthenon pediments, the heads of the horses of the Sun and Moon protrude in the absence of bodies; the spectator's imagination is asked to visualize what is missing. In this way, the whole scene depicted on the pediment becomes extended, in our imagination, into infinite space. The same process of extension occurs in the case of the incomplete body of Christ the King in the domes of Byzantine churches. Symbolized by the semi-spherical dome, it becomes a spiritual presence in the infinite space of the heavens. Tragedy itself allows certain points of a play to remain shadowy, almost incomplete, by means of elliptical speech, dense and infinite in depth, all prosaic, rational reflections being removed so as to let the poetic imagination rove freely.

In both classical and Byzantine art, however, the artistic principle of the unfinished remains in a state of latency. It begins to become apparent near the end of the Renaissance, as if perfection had finally appeared impossible and the unfinished work were the only adequate means of suggesting perfection. It is well known that for many years Leonardo could not bring himself to finish the Gioconda. Michelangelo left the face of Day unfinished on the tomb of the Medici in Florence. The bodies of the slaves which he intended to use for the monument to Pope Julius II can only just be singled out from the unprocessed material surrounding them. Certain art historians, like Vasari, believed that this was because his hands could no longer keep up with the proliferation of his visions, so that he often began to fashion figures, only to abandon them. Others, like Henry Thode, support the view that such works were merely points of transition towards perfection, sketches, *abbozzi,* which discouraged the artist, as if to show him that he was not able to give

shape to his vision.[2] But it is possible that they encouraged him too because they began to persuade him that the *abbozzo* as a means of expression was of some value in itself and that it was perhaps the only adequate means of expressing the sudden conception, the mysterious depth, from which all things rise and to which they return again.

Indeed, at the end of the Renaissance, a period in which the artistic ideal was perfection, completion, fulfillment, and clarity, the *abbozzo,* as opposed to the finished work, began to be appreciated. This was because the sketch, in spite of its imperfections, or perhaps because of them, retains all the freshness of the initial inspiration, the mania of art, the *furore,* as Vasari used to call it, which is in danger of getting lost in the harassing process of finishing and which often, instead of making it perfect, robs the work of art of its inner life.

Here is what Vasari says in a passage from the life of Luca della Robbia: "it often happens that sketches, suddenly brought forth by the mania (*furore*) of art, succeed in expressing the initial conception in a few strokes (*colpi*); conversely, fatigue and too much elaboration sometimes sap strength and wisdom in these artists who have not learned to keep their hands off the work under progress at the right moment."

The dynamic quality of the sketch can be traced through the entire Baroque style which followed the Renaissance. As Heinrich Wölfflin remarked, the limits of form begin to grow unclear, imprecise, in Baroque painting. The poetry of undetermined depth encompassing the figures in a painting, so that they seem to be immersed in infinite space, is to be found in its most glorious form in the works of Rembrandt, as if to justify Spinoza's claim that "any definition is perforce a negation" (*omnis determinatio est negatio*), as Joseph Gantner[3] remarked.

In the Renaissance is also noticed a new fondness for the fragmentary in art: first, in the guise of hybrid or monstrous forms, as in the famous *grotteschi* sketches, in which imaginary animals and plants, animate and inanimate elements, men and beasts, as André Chastel says, mingle in a quasi-surrealistic fashion.[4] Chastel considers that the figures of the architectural idiom known as *rustica* are also hybrid and monstrous forms, for there is an alternation of hewn and unhewn surfaces in the length of a wall, of hewn and unhewn sections in a pillar, so constricting the drum as to hinder its full growth. The term "fragmentary" might also be applied to pilasters which suddenly break off in order to continue in the form of mutilated telamons. Mutilated caryatids even appear on the facade of the Palais du Louvre. In other instances we find unhewn alternating with hewn vaultstones.

But the most tragic form in which the fragmentary appears in art is the torso, in the sense that it is a product of the destructiveness of time—as in the symbolic painting by Perrin, in which Chronos (Time) seems to be devouring the torso of Belvedere. Time not only destroys but also accumulates ruins, so that it can even be said to create a landscape of ruins. Leonardo himself was haunted by the theme of the destruction of the world by some future cataclysm. He described the successive stages of this cataclysm in a series of extraordinary sketches, which he even used in the backgrounds of some of his paintings. I might say that almost all the backgrounds of his pictures, especially that of the Madonna of the Rocks, reflect this mysterious, cataclysmic landscape.

This fondness for ruins seems to grow after the Renaissance, for it becomes part of the spirit of Romanticism. I have no intention, of course, of dealing with the artificial ruins which in the eighteenth century were considered an indispensable complement to the art of gardening, which could neither represent the natural aspect of real ruins nor endure artistically, because they were simply affected and mannered imitations, let us say, of an unaffected calamity. Consequently, they are devoid of charm, though they are an interesting sign of the times. What is interesting is that the love of ruins grew into a mania which survives to this day and indeed influenced great artists like Auguste Rodin—to such a degree that it may even be considered an artistic perversion. Rodin was spared this perversion only because of his genius. But this is the only possible way to explain how he dared state that "more beautiful than any beautiful thing is the ruin of a beautiful thing."[5] He was not content to plunge his figures in clouds of unprocessed marble or even to fashion a profusion of mutilated bodies. He chose to represent his "walking man" as a headless body. He remarked to Ambroise Vollard: "People ask me why he is headless. But does one need a head in order to walk?"[6] This tragic piece of sophistry cannot convince us on a rational level, but it does provide an artistic explanation for the creation of this work because—as Aristotle says—in art it is better to show things that appear probable, even though they are not possible, than to show things which are possible, but appear improbable.[7] There is no doubt, however, that this work is a tragic cry, a cry which tells us that man is dead as far as art is concerned. Look at Henry Moore's warrior in action—he is mutilated too. From this point forward, sculpture can only offer us abstract figures. Beings have been replaced by inanimate shapes and inorganic structures.

The strange thing in all this is that the eclipse of the human

element in art has been brought about precisely by an inordinate subjectivism—in other words, by man himself—ever since man began projecting his personal psychological drama, as against objective, supra-personal ideals and, more specifically, ever since he ceased to be concerned with a naturalistic rendering of phenomena and chose instead to express personal experiences and ideas. At this point there occurred a disjunction between mimesis and expression, and the objective criteria applying to form began to disappear. J. W. Turner proclaimed that he liked unfinished works. And thus from Impressionism, which dissolved formal limits, there came Analytical Cubism, which analyzed the representation of form into mnemonic levels, and finally abstract painting, which is the ultimate flight from form into formlessness. Jung once said about Picasso that his work is a "perpetual Necyia," "an eternal journey towards the realm of the dead, the realm of the Mothers."[8] Having definitely abandoned mimesis, art finally had recourse to Tachisme and activism, to a world without form. Nothing is formless in nature, however. We can use the term formless only comparatively: in relation to the world of being, that which lacks the autonomous form and consistent structure of being is formless. But even as regards Tachisme, we must go back to Leonardo; the *macchie,* he said, have peculiar properties capable of directing the spirit (*lo'ngogno*) towards various inventions (*invenzioni*).

But even though abstract art is an escape from form and mimesis, it is at the same time an escape from subjectivism towards an objective goal which is not to be found in outside phenomena, but within the work itself, which art has turned into its own subject. The artist's concern begins to turn away from representation and to center on structure, the structure of form in the process of becoming.

We may now pose the question of whether this principle is new or has always been valid in art.

The principle of *non-finito* is indeed by no means new; it is eternal and ever-present in art at all times. We already implied as much when we said that even in classical art this principle appears in latent form because every composition, while pursuing perfection, is forced to leave secondary elements relatively imprecise and incomplete so as to bring out the main elements. But what happens when the principle of *non-finito* is actually exteriorized in the composition—when the incomplete sketch replaces the perfected work, when the fragmentary replaces the finished whole?

This distinction between the sketch as something incomplete and

the finished work as something complete, perfect, refers primarily to the duration of the work's elaboration, the brevity of its execution; the distinction thus becomes a matter of works rapidly executed, on the one hand, and works slowly elaborated, on the other—works which are stopped short after the first quick drawing and works which are carried on to the stage of careful execution, plenty of time being allowed for the revision of the initial sketch; in short, works which are only begun and works which have been finished. I believe this is what tempted Gantner to formulate the theory that works illustrating the principle of *non-finito* stop at the stage of prefiguration, whereas those illustrating the *finito* principle go on to reach figuration, which can, however, coincide with prefiguration, as in the works of Raphael. The separation between the two begins with Leonardo, proceeds further with Michelangelo, and becomes complete in modern art. It is only in Romanesque and Byzantine art that there can be no question of prefiguration, because, Gantner says, the artist's subject does not interfere at any point, since he is dealing with transcendant, supra-personal themes. In contemporary art, Gantner concludes, figuration is totally abolished by abstraction, and thus the circle is complete; the dialectical relationship between figuration and prefiguration, begun in the fourteenth century with the awakening of the artist's personality, or, as Henri Focillon[9] would have it, first appearing in the figures on Gothic tombs, comes to an end.

The characteristic point about prefiguration is that it is dynamic, however, whereas figuration is static. I doubt that a work of art, even if it is only a sketch, can stop at the stage of prefiguration. Every work of art, provided it has serious claims to being a work of art, is the representation of a prefiguration, even if it remains at the stage of a sketch. The sketch can be considered as mere prefiguration only if it were not a work of art; but the moment it becomes one, it is also figuration, and we have no way of knowing what inner process allowed the artist in one leap to reach this expression of maturity—in other words, to put across a message which might have been lost forever if he had delayed its formulation in his first sketch. This is why we so often see an artist ceasing to work on a painting as if his answering some inner urge assuring him to proceed toward completion would mean spoiling it. An artist perhaps finds it far more difficult to know when to stop the process of completion than to insist on achieving a finished work.[10] The completion of a work of art should not rob it of the breath of perfection, that great gift of art which endows lifeless images with a life of their own, but, on the contrary, it should become the means of capturing this vital breath. This does not

depend on outer elements, however, as, for instance, on whether the work of art will stop as a sketch or will proceed to the finished stage. It is rather a matter of style and the ideas which inspire it. These ideals also define the artist's personality—whether he will choose to turn inward, toward himself, or toward objective goals. This is why dynamism is not always inherent in the sketch, just as the static quality is not always inherent in the finished work. Early Renaissance sketches are fashioned in a static manner, and it is only in the Baroque age that they begin to acquire a dynamic fluidity in the shaping of figures. We may say, then, that both static and dynamic qualities are inherent in style. We are thus led to the conclusion that the completion, the perfection, of a work of art is a relative, not an absolute, notion, and that it is closely relevant to the style of the work of art in question.

It is a fact, however, that we may distinguish two tendencies in an artistic style: one inclines towards the finished, static form, and the other toward the unfinished, dynamic form; or, if one prefers, one tendency takes advantage of the virtues of the finished form while the other takes advantage of the virtues of the unfinished form. Classicism is a good example of a style aiming at the finished, whereas any anti-classical art style, Byzantine art in particular, exemplifies the style which aims at the unfinished. As far as classical art is concerned, its propensity toward the finished form is quite obvious: the work as a whole, in spite of its relative autonomy, is complete, and each component part contributes toward the creation of a consummated unity. A wall of the classical era is composed of marble slabs so perfectly adapted to each other that the joints separating them are invisible. Every single ripple is worked out in detail and finished to perfection. Conversely, the wall of a Byzantine church has irregular joints of varying thickness showing a fine disregard for straight lines, and various ceramic motifs placed across its surface in an asymmetrical fashion. The total impression is, of course, pleasing, even enchanting, but the elaboration of the component parts betrays an amazing indifference to regularity and precision. The success of such a work depends wholly on the craftsman's skill; if he does not achieve the desired effect from the first, he, just like the painter who bungles a sketch, will have to start all over again. Here too, as in a sketch, the ideal line is to be found somewhere in the midst of many others, which are merely approximations of it, and it is up to the spectator's imagination to capture it. This is why, during my studies on the aesthetics of Byzantine art, I singled out its peculiarly graphic character, as opposed to the plastic austerity, the linear precision and regularity of classicism.[11]

These differences in style are naturally due to differences in the conception of form and in the relationship between the ideal and the real. In classical art, the achieved form must be no less than the representation of the perfect itself, the ideal representation of an ideal archetype. In Byzantine art, however, the achieved form is no more than a characteristic expression of a beauty that is transcendental, and therefore is a transient form leading the spectator to the ideal which lies beyond life. Classical art, as Friedrich von Schelling says, encloses the infinite with the finite, whereas Christian art uses the finite as an allegory of the infinite. And to recall Plotinus, whereas the aesthetics of classicism demands pleasing coloring and a symmetry of the component parts in relation to each other and to the whole, in order that the form may be qualified as beautiful, Plotinus insisted that the beauty of the form depends on the idea inherent in the work; it is this idea which holds the component parts together as a whole. Hence the importance of form in classical art and the importance of content in Byzantine art—hence the static quality of classical art and the dynamism of mediaeval art. In other words, the object of form in classical art is to express the immovable Being of ideas, whereas that of form in Christian art is to express the eternal Becoming of the infinite spirit. And this is why the perfection and beauty of classical form, though ideal, are to be found here, in the world, whereas in Byzantine art they lie beyond, are transcendental. Thus a diffuse imperfection seems to reign over the works of Byzantine art, as regards precision, regularity, and lucidity; nevertheless, as works of art, they too have reached perfection—the perfection of their particular style.

The word "end," indeed, has two meanings: termination and aim. For a work of art, the termination, or ending, is its material realization, the final presentation of its form; but its aim is the inner purpose toward which it strives. A work of art reaches its ending when it is finished, when it has taken shape; it reaches its aim when it succeeds in expressing itself. Because the form of a work of art is beautiful, it should be an "aim in itself" and should appeal to us not so much for its practical usefulness or its technical soundness as for its artistic presence alone. That is why in popular parlance a musical melody is called *scopos* ("tune"), meaning aim, "end," in the deepest sense of the word, and that is why the word *telos* ("end") finally took on these two meanings: termination and aim.

Termination and aim do not always coincide, however. We have already seen that there do exist unfinished, incomplete works of art

which have achieved their aim, which are beautiful. And there exist works of art which are finished, but which have deviated from their aim, and have thus been unable to capture beauty. There also exist works of art aimed at unending forms, indicating that they can never be finished, that they have no end. Lacking an apparent beginning or end, they meander. Oriental arabesques are heightened examples of such forms. Besides, we have noted that even classical works which set out to have a beginning, a middle, and an end finally leave a kind of resonance an extension towards the infinite, which in essence makes them unending. In this sense, then, every work of art is unfinished: it is form suggesting the infinite which lies enclosed in its essence, in the same way that Plato's dialogues either refuse to supply the ultimate answer to a subject or choose to supply it in the form of a myth. Every work of art is therefore both complete and incomplete, a mixture of the finite and the infinite but, in spite of all this, gives the impression of perfection.

I use the phrase "impression of perfection" because, given human imperfection and the technical inability to realize conceptual perfection through matter, perfection is theoretically impossible. This is why art has recourse to artifice in order to make a work of art look as though it were perfect, as though it had reached perfection—artifice in the disposition of both content and form, artifice of expression, of poetic metaphor, of consonance, of optical correction, and so forth. The way to perfection consists of a succession of approximations, of an alternating advance and retreat, which eventually succeeds, all at once, in giving one the impression that the end has been reached. This is why Plotinus said that art cannot possibly render ideal perfection and that, as a natural consequence, it seeks beauty not in formal symmetry but in the idea of the content. This was not enough, however, to convince Friedrich Gerke that Byzantine art turns this inability into a virtue, exploiting it in order to overcome the phenomenon of imperfection and to reach the transcendental. Byzantine art, Gerke says, is incompatible with the unfinished for reasons related to theological doctrine; he believes that what Plotinus says on the matter has no dramatic consequences for the art of his age and for subsequent Christian art, both of which aimed at transcendental ideals. Gerke says that the drama of art begins in the mediaeval West and continues in modern times, with the emergence of the artist's personality and his effort to express his inner passions. In my paper for the Byzantine congress of Ochris,[12] I attempted to show that Byzantine art too was aware that it could not master the perfect, and that this was why its aim was to express characteristic concrete beauty, as

opposed to classical art, which aimed at abstract beauty and finished form. Byzantine works of art are an imperfect, transient form, implying that perfection, completion, are to be found beyond, in an infinite, transcendental world. Besides, if there ever was a time in which the human spirit began to experience a dramatic upheaval, it was surely the early Christian era. Even though the art of this period did not express personal passions, the artist participated personally in the drama of trying to express the transcendental. Thus were created the original formal types which were consecrated in later centuries as indestructible symbols of a highly dramatic art.

But as has already been remarked, in spite of differences in style among works of art, each form type is both finished and unfinished. This explains why, when analyzing the picturesque in Byzantine art, I indicated that it is not entirely deprived of a latent plasticity, mainly apparent in the curves of buildings, in the profusion of color, and in all those other elements which attempt to bring the work of art closer to nature—as opposed to abstract beauty, which draws it away from nature. And since I am discussing the picturesque in art, I should like to mention the words of Eugène Delacroix on what he called *license pittoresque*—artistic license: "it is to this *license pittoresque*," he says, "that every great artist owes his most splendid effects; the unfinished in Rembrandt, the *outré* in Rubens. Only the mediocre artist will not dare to attempt such things; for he never goes beyond himself."

A question of course arises: a work of art is a mixture of the finite and the infinite, of the finished and the unfinished, though it gives the impression of perfection; then up to what point can a work of art remain unfinished, and, again, at what point must it be finished in order to appear complete, perfect?

We have seen that a work of art is perfected by means of successive approximations, but there is a moment beyond which, instead of being perfected, it begins to lose the breath of life. In this case, instead of emerging from the artist's hands as a living thing, it ends up as something dead, which is what it really is: a piece of inert matter. Just as with natural creatures, there is a span of time between the conception and the birth of a work of art, and the nobler the species, the longer the time span required. But whereas in nature the new-born creature within a predetermined period of time is separated from its mother according to the laws of the species, in art it is up to the artist to decide when his work has reached completion. This is far from easy to do because the artist often confuses technical with expressive perfection and forgets that the birth

of a work of art is also in a way predetermined by its very nature; all the work requires of the artist is his help to make it come into being, whereas the artist believes that the existence of the work of art depends solely on him. The artist is often unaware that the work of art has its own existence (hypostasis) which goes beyond his artistic abilities; that is why he finds it hard to recognize his work once he has finished with it, and cannot quite understand how it can possibly be the product of his own hands. He does not realize that he is a medium, a means of expression serving a purpose which is beyond him, and that the work of art is suddenly born, like the revelation of a conception for which he is hardly responsible, even though he is the womb which conceived it and gave it life. On the contrary, the artist is often dogged by formalistic ideas and old-fashioned habits, by the inability to recognize the particularity of his own work, and to admit that it is a mixture of the finished and the unfinished, of the finite and the infinite. He also lacks the courage to admit that the less he says the more he will signify. If this is so, how can he possibly dare to attempt the *licenses pittoresque* which Delacroix seeks?

Since the conception of a work of art is secret, the sketch in which it first takes shape is to be seen as a birth—a birth which may turn out to be a final representation of the work. It is true that we come across this strange phenomenon: an artist's starting point may well be the moment of execution; in other words, he conceives the idea while making the sketch; conception coincides with execution; there is no preconceived idea. But if the artist is able to realize that an idea is contained in this sudden material revelation, it means that for some time past he had been searching for this very idea, which he now recognizes in the sketch; if this were not so, he would not have discovered the idea. Thus using Tachisme and activism, contemporary art appears to start at the end—that is, at the stage of execution—without any preconceived ideas, and seems to be conceived during the very act of execution, in the belief that it is only giving birth to works that express various repressed experiences, intentions, and ideas.

Finally, the perfection, the completion, of a work of art depends very much on which stage of development the style of the period it represents happens to have achieved. Each style matures as its rules are applied to a profusion of works of art succeeding one another. In other words, style is perfected through repetition. A work of art is unrepeatable, however; it is a kind of irregularity in the flow of style, an exception within the canon, yet impossible without the existence of that particular

style. But when the style of a period matures and its canon becomes concrete, then formalism, beginning to prevail, hinders artistic originality. Consequently, we find that artists living in such periods suddenly react to formalism and attempt to break its fetters; then works of art are deliberately imperfect, incomplete like the slaves of Michelangelo, fragmentary like Rodin's mutilated trunks, shapeless shapes like the structures of contemporary art, which reject imitation and turn the work itself into the object of art—in brief, forms striving towards the discovery of a new style. When this happens, the latent principle of *non-finito* in art reveals itself and indicates that the unfinished form is pregnant with multiple possibilities.

It is a fact that by abandoning imitation contemporary art has introduced us to a world of new forms which do not aim at reproducing an existing being, but which treat the work of art itself as object; they are the structural forms of a world in the process of becoming. We therefore see that the works of contemporary art too are pregnant with numerous possibilities; they set the imagination free, for the end is unknown and the final aim unclear. These works are the trail marking an adventurous course, and the spectator is asked to guess where this trail may lead. Consequently, such works come under the aesthetics of beginning, the aesthetics of birth, of becoming. Conversely, classical works come under the aesthetics of the end, the aesthetics of death—death being the point at which they attain the perfection of an ideal reality. The moment they reach this point, however, they acquire a new spiritual life—the very life they were in danger of losing when the ideas inspiring them descended into matter. This is why all works of art present a strange combination of life and death. They are like the warriors of a classical frieze who retain the smile of life though they are smitten by the deadly arrow of the enemy.

The manifestations of this tragic contradiction in art are diverse, but the contradiction is always present, and it gives the work a figurative life and makes beauty attractive. The contradiction also explains why classical art, for all its abstract beauty, retains realistic signs of life, like, for instance, the glass balls in the eye sockets of statues. The immaterial, unearthly figures of Byzantine art assume characteristic resemblances, while contemporary abstract compositions unfold all the textural wealth of matter. In brief, the unfinished element of living reality is always married to the finished element of idealized reality.

But if this contradictory combination is to be achieved in art and if it is to be appreciated aesthetically, the artist must be aware that the

work of art is something more than, and beyond, the elements which compose it. Only then will it be possible for some of its parts to remain unfinished, imprecise, while others are finished and precise, for all these parts together, both finished and unfinished, help to reveal that which moves them to merge together into a unique and unrepeatable unity. And that unity is nothing less than the living breath, the idea of the work, as we would have put it in former times, or its aesthetic value, as we would say today. The idea, if it needs to be expressed, will always find a way to overcome the imperfections which cannot be mastered, which cannot render the perfection of the idea, without the artifices of art. As Paul Valéry said: "Art teaches us what is possible within the order of the impossible."

For this reason, we come across elements which were considered imperfections in a certain style (for instance, certain stones in the Propylaea which were left uncut) but which later became a predominant motif in Hellenistic and Roman architecture. We now come across ways of rendering perspective which in Renaissance art would have been considered in error, yet they have become the beginning of a new expression in modern art.

In this connection Plato's myth is brought to mind, according to which Eros, who causes our spirit to seek beauty, is the son of Poros (resources) and Penia (poverty). In other words, he is the son of a god who devises and discovers resources through the spirit, though he has a mortal mother who suffers from material deprivation. Indeed, a work of art has to contend with all the imperfections and weaknesses of matter in order to reach perfection, and this is achieved only because of the various resources and devices of art which enable it to overcome imperfection and reach visible perfection. It strives and strains, but finally, by some miracle, it emerges victorious; it is imbued with figurative life and becomes immortal.

II

the aesthetics of
Byzantine art

8

reflections on Byzantine art

At its conference in Athens, May 1966, the European Foundation of Culture selected for its topic "The Living Tradition of Greek Antiquity," with special reference to the influence of the values of antiquity on contemporary life. It may perhaps have been by chance that the foundation included a lecture on Byzantine art; but in all likelihood it did so because the International Exhibition of Byzantine Art, organized by the Council of Europe, was taking place at the same time in the same city. This exhibition bore the title "Byzantine Art, a European Art"; its intent was to emphasize the European origins of an art generally treated as of Eastern origin—that is, as something alien to what we call European civilization. But if we consider that European civilization is nothing more or less than an amalgam of Greek education, Roman law, and Christian religion, then Byzantium was the first form of civilization Europe assumed, and Byzantine art can rightly be called European. It thus follows that Byzantine art is the heir of certain values of antiquity which through the Middle Ages were transmitted to our own times because in one area, that of the Eastern Orthodox Church, especially in Greece, Byzantium continues to be a living tradition.

It is generally assumed that Byzantium ceased to exist after the

downfall of Constantinople in 1453, but in actual fact it did not perish then. Proof of this is provided by the existence of post-Byzantine art works, which are found in profusion in Greece and especially at its great center, Mount Athos. Therefore, Byzantine art should indeed have had a place at the Athens conference even if the international exhibition had not been taking place at the same time.

Moreover, the study of Byzantine art is essential for the following reasons: first, if we understand it, we can better understand classical art: formerly it was erroneously thought to have aimed at geometrical regularity, as having been devoid of any feeling of space and dynamism; second, if we were to proceed directly from antiquity to western mediaeval art and ignore Byzantium, we would have cut the thread of European history, which we wish to preserve; and, last, Byzantine art throws light on contemporary art. The clash of two worlds, the pagan and the Christian, brought with it basic changes. Then, as at the present time, space, material, and light acquired an unexpected dynamism. Illogical elements began to take hold, and the artist became an iconoclast, without of course expressing the abstract. There were no similar tendencies in European art except in the Byzantine age. Moreover, Byzantium itself over its ten centuries shielded the emerging Western civilization from the invasions of the barbarians.

At all events, simple though it may seem today to accept the European origins of Byzantine art, this claim was formerly much doubted. From the time the values of mediaeval art, which the Renaissance condemned as "barbaric," began to take hold, Byzantine art was treated as an art of Roman decadence, a popular art, crude, and devoid of beauty. Then archaeologists and art historians were divided into two camps as they sought to interpret the peculiarities of Byzantine art through the influences it had received from Rome or from the Orient; thus originated the famous problem described by Joseph Strzygowski as "Rome or the Orient." One faction (Franz Wickhoff, Francis X. Kraus, Alois Riegl) maintained that Byzantine art originated in the Roman catacombs, the other that its beginnings were to be found in the East. Strygowski pointed to highly imaginary sources from which Byzantium ostensibly received the influences of abstract art. More wisely, D. V. Ainalov pointed out the importance of the Hellenistic centres of Alexandria and Antioch, and of Syria and Palestine.

Today these extreme views have certainly been much modified, and most scholars realize that no matter how much Rome may have offered, the principles of the new (Christian) religion came from the East,

as did its art. From thence came new techniques and artistic elements, such as dome construction, the principle of frontality, the dematerialization of form, and other tendencies common to Byzantine art. The Eastern element shaped the Hellenistic forms which adopted anti-classical forms, that is to say, new forms within which the new religious ideals could be expressed.

Of even greater import is the fact that today the basic and primary role played by Constantinople in the development of Byzantine art is at long last being recognized. Constantinople was the creative center, the crucible in which all the influences were absorbed and in which new and original forms were created. Byzantium was molded in Constantinople. In the absence of this center and in the absence of the new spirit, the Byzantine, various foreign influences could not have been absorbed and resolved into new forms. This is a fact forgotten or ignored by all the scholars who looked abroad for those influences. It is a mistake to assume that civilizations are passively influenced by others and that it is possible for a civilization to be influenced without its seeking out a similarly or equally dynamic influence from within. Each civilization selects the influences it is destined to accept—that is to say, it receives or rejects in accordance with its own spirit. It energetically reacts against certain influences and adopts only those which in its own particular fashion it deems beneficial and useful. Otherwise, the same amalgam of foreign influences could bring about an altogether different result.

Byzantium reacted against Rome because "Rome does not sing" (Roma non cantat), as the Byzantines noted. Its works were heavy and materialized, whereas the works of Byzantine art are light and airy, poetic and full of religious lyricism. The technique of the Roman buildings was appropriate for use by the masses of non-specialized laborers lacking initiative, whereas, as F. A. Choisy aptly observes, the technique of Byzantine art presupposes specialized technicians with the initiative and daring which only the Greek East could offer, who could build light domes without shells in the void.

Byzantium also energetically reacted against the Eastern spirit, although it received its religion of the one and only God from the East, because its tendency was anti-symbolic, and because it followed the principle of an unbounded continuity of decoration, it blunted Judaic dogmatism. It also reacted against Greek rationalism and pagan religion, although it had taken from antiquity the philosophy essential for making Christian dogma viable, and had converted the anti-classical elements of the East and its own rejection of figurative representation

into expressions of the transcendental. There were two basic intellectual influences which Byzantium absorbed from the East, the theocentric ideas of the Orient and the anthropomorphic ideas of Greece; the result is the splendid amalgamation of religion and Byzantine art.

This was made possible because, after Athens, Antioch, and Alexandria had fallen silent, Constantinople became the pre-eminent center in which the Greek tradition of education and wisdom was continued. A university was established in Constantinople. There, in the new Rome, the triumph of the Greek spirit over the old Rome took flesh. In the sixth century, in the age of Justinian, the laws were already translated into Greek, and eventually Greek became the official language of the empire. And when Byzantium neared the end of its long road, its inhabitants, even though they themselves were Christians and Roman citizens, considered themselves Greeks, heirs of the Greek race and of the ancient civilization whose letters and values had never ceased being cultivated. Humanism had already taken root in Constantinople in the tenth century; and when the city fell in 1453, Greek intellectuals fled to the West to teach Greek to Italy, where the flowering of the Renaissance and Western humanism began.

And thus Byzantine art, no matter how much it may appear anti-classical in form, in its own mold continued the classical Greek tradition by means of which it also penetrated western Europe. Through this influence of Hellenism Wilhelm Worringer wished to account for the classicizing form of certain sculptures of the Gothic cathedrals of the West, much in the way we trace the Attic spirit in the classicizing forms of the mosaics of Daphne. In any event, to cite only one illustration of how much of a living force the ancient Greek tradition was in a more modern Greece, I mention a sixteenth-century church at Yanina in which one can discern, among saints pictured, Plato, Aristotle, and other wise men of antiquity.

How can one support the contention that the anti-classical forms of Byzantine art retained the classical tradition?

Judging the forms of Byzantine art from the outside, one immediately sees that it takes motifs from classical art and converts them into Christian symbols. The Orpheus in the Byzantine Museum of Athens is an eloquent example which in substance represents Christ, who with the music of his Word gathers round him all manner of creatures. Numerous similar symbols of antiquity, sometimes put into Christian garb, can be seen in the miniatures of Byzantine manuscripts (for example, the Vienna Genesis) of the Old Testament, the Gospels, or

worldly themes. In architecture as well, the column follows the classical models with its division into base, shaft, and crown. The basket of the capital continues to be decorated with acanthus leaves, irrespective of whether the acanthus is pointed or soft or whether it is worked with the drill. Ionian spirals also survive, albeit in quite an imperfect state; and in several small churches the very classical columns themselves are used as they were found at the sites, since it was customary to build churches at the sites of previously existing pagan sanctuaries. Attica is full of such examples, like the Caesariani monastery. The indication would be that classical form is reconciled with the Byzantine order; in other words, there are some relationships which are external.

But the similarity of symbols and forms is not external only, or they would never be reconciled. There is also an internal kinship. Byzantine art retains certain values of the classical tradition, such as representation, moderation (that is to say, nothing is in excess), simplicity of expression, and subdued dynamism. Procopius (fl. A.D. 527) rightly says that despite its mass, St. Sophia retains a harmony of dimensions; it is neither too broad nor too long, nor is it too high, like Gothic cathedrals, which with their frenzied verticality tend to reach for the sky. By contrast St. Sophia imitates the heavens with its dome; within its space man feels small, though he is not crushed, as he is in the Gothic church. His soul is lifted up high to the concentrated light which illuminates the dome and transports him in ecstasy. And something further: thanks to the Greek synthetic spirit, the Byzantine church combined the thrusts and counter-thrusts of the arches in such a way that the buttresses were inserted in the partitions of the church—hence were not visible to the naked eye, as they are in the Gothic church which shows its flying buttresses. In F. A. Choisy's words, this visibility of buttresses would have been deemed barbaric by the Greeks, who hid the skeleton of the structure just as the human body covers its skeleton inside flesh and skin. But then the Gothic spirit is analytic.

Again, if we observe the iconography of the church, we note that the arrangement of the scenes from the Passion of Christ is made symbolically, on the basis of dogmatic ideas, as though outside time. No chronological order is followed because the Byzantines, who were steeped in Greek philosophy, had followed a contemplative mysticism and not a practical mysticism like that of the Western church. For this reason Otto Demus says that the Byzantines were not interested in the crusades to the Holy Land, as were westerners.

And, finally, the most significant example of intrinsic kinship with

the ancient tradition was humanism, of which not the Italian Renaissance but Byzantium was the forerunner. This humanism was due to the Word (the Logos) of Greek philosophy, which the Byzantines carried on no matter how mystical they became with the advent of Christianity or how much they believed in the Dogma. The last and most outstanding representative of Greek humanism was the great philosopher George Gemistos Plethon (1355? – 1450?), who in the later years of the Byzantine Empire appears on the scene as a rationalist and almost as a polytheist. But when Constantinople fell, Greek humanism found no open space for development except in Italy.

In Byzantium, the dialogue between the theocentric spirit of Christianity and the rationalistic anthropocentric spirit of Greek philosophy never ceased, though the former spirit dominated. Thanks to this dialogue, the Christian dogma became a religion based solidly on philosophical foundations, and philosophy in turn was enriched with a metaphysical inner world and an enlightened mysticism. Unfortunately, Byzantine philosophers are still unknown to most people. Greeks would study the philosophy of Plotinus (A.D. 205?–270) or even that of St. Augustine (354–430). The historians of philosophy often omit the Greek Fathers and preoccupy themselves with the scholasticism of the West, which derived much from the Byzantines.

Also, there was a continuous dialogue in Byzantium between the monarchic spirit and the democratic individualistic one which was part of the Greek tradition. Although the monarchic spirit prevailed, and the emperor was considered an equal of the apostles and a representative of God on earth, the people never lost certain rights, as becomes evident in the successive riots and mutinies through which they expressed their views, and, moreover, in the demand that anyone from the ranks of the people could rise to the highest offices, such as that of patriarch, even to the extent of establishing ruling dynasties. In other words, the people of the empire were never a faceless mass of humanity but remained a race of individuals, even though among them were monks who conscientiously sank into the sea of anonymity. Anonymity was one of the great virtues of the artists of the Middle Ages because they believed they were performing a sacred work, and they therefore never deliberately asserted themselves, as did Renaissance artists.

Continuous also was the dialogue between the courtly and the monastic mentality and art. The palace tended always to the austere, learned tradition, while the monks supported laic realism and mysticism, hence the phenomenon of the coexistence of a learned language

worthy of the ancients and a developing popular tongue which still survives in Greece today. It is customarily maintained that the monks represented Eastern influences in their monastic productions, whereas the court represented the Greek tradition. Yet the palace for a certain period represented the anti-image spirit of the East, which led to the iconoclastic struggle during which the monks remained fanatical icon worshippers—that is, representatives of the Greek pictorial spirit. Thus, the matter is not so simple and schematic. After all, the iconoclasts prohibited only the pictorial representation of holy figures, but their art remained pictorial nevertheless. For this reason, I maintain that the Byzantine spirit itself was divisive and allowed for a dialogue of contrasts and clashes which resulted in an enrichment of this spirit.

The classical spirit too possessed this duality or division, an illogical mysticism carrying on a continuous dialogue with rationalism. Its art was an amalgamation of the Doric and Ionic spirits, of grandeur and grace, of plasticity and picturesqueness. Therefore in Byzantine art the two currents of classicism and anti-classicism are in continuous dialogue, and Byzantine art cannot be explained solely as the result of various foreign influences, Greek and Eastern.

In Byzantine art there was also a continuous dialogue between form and content, in the sense that form tended to adhere to the classical tradition while content, because it was new and derived its ideas from dogma, sought to break this hold. And, understandably, content acquired priority. This fact had already been made known by Plotinus when he stated that the beauty of a work of art does not depend upon "pleasing color" and "right proportions"—that is on harmony of color and the proportions of the form—but on the unifying idea embodied in each work. This new aesthetic principle was also a rejection of the cosmocentric character of Greek art, in which number and the proportions of form objectively determine the beauty of the work. Henceforth a new factor, both metaphysical and anthropocentric, entered art. According to Plotinus, beauty unites us in mystical ecstasy with the divine. And thus we discern a new feeling for beauty emerging from Plotinus, a feeling for the sublime which, though latent in the art of this period, was not long in coming to dominate Byzantine art.

The sense of the beautiful in Byzantine art is in constant dialogue with the feeling of the sublime—that is to say, the sense of awe and veneration and ecstasy conveyed by massive works, or works which are intellectually incomprehensible or transcendental. Quite naturally, the sublime became the dominant theme in Byzantium, since the ideas its

compositions were intended to convey were transcendental. Again, for the expression of these ideas, forms, symbols, and principles of the classical mentality were sometimes used, and reference to beauty at some moments was unavoidable. Yet the beauty of a Byzantine Madonna or angel was not the abstract beauty of a Venus or a Hermes or the naturalistic beauty of a Raphael Madonna but a transcendental beauty, an expression of real sublimity.

Generally, all these dialogues of the new spirit with the remnants and the memories of the ancient world could not possibly have revived or stimulated Byzantium and its art if the dialogues had not had a groundwork in Greek philosophy itself, and if the innermost sense had not sought the dialogue from within.

In fact, the Christian religion did not appear suddenly, alien and unexpected. Despite the great surprise it caused when it asked that man revise or reconsider certain basic life principles and become a mystic rather than a rationalist, man was not unprepared. The Eastern religions had made great inroads into the ancient world, especially in Rome, the slaves were seeking their freedom, and Greek philosophy itself began to shake the foundations of existing polytheisms. Aeschylus foretold the fall of Zeus, Plato spoke of the raising of the soul, and Socrates spoke of one god. And when Saint Paul visited Athens to speak to the Athenians, he informed them that in walking about their city, he encountered an altar dedicated to the unknown god. "This God," he said, "whom you do not know, is found within yourselves, and I have come to speak about him. He is in every one of us, and thanks to him we live and move and are, as some of your own poets have said. For him to be revealed, all you need is to believe in him."

Thus, knowledge was supplanted by the discovery of a divine grace which descends upon everyone, whether rich or poor, cultured or unlearned. For the miracle to take place, it was enough if one had faith, love, and hope. Henceforth man turned inward, toward his soul, which predominated over body and mind. The ancient ideal of a sound mind in a sound body was replaced by a new ideal, the ascetic ideal, according to which the body must suffer to elevate the soul. The ascetic, whose ideal was sanctity, supplanted the athlete. Thereafter arose the anchorites, the monks, the saints, and the martyrs of the church. The gods of Olympus died out slowly. The god of the Christians descended to earth, was incarnated, and suffered martyrdom for mankind; he was resurrected and summoned the faithful to prepare for His second coming. Thus, time acquired a beginning and an end, a fact which radically

changed the ancients' understanding of time and had a tremendous influence on art. From a cyclic year, time changed to a linear one—and became historical. In other words, art no longer aimed at the beautiful and the perfect in the existing world but at another, a transcendental world. It could no longer be cosmocentric, but theocentric, an approach which, as we have seen, coincides also with the beliefs of Plotinus about the beautiful and the divine as the first principle which is found in the Beyond.

Certainly Plotinus does not speak of the sublime in art, yet he speaks of an intelligible beauty which brings us into a state of ecstasy and unites us with the divine. His philosophy becomes metaphysical because, to him, everything flows from the One into the world of reality and tends to return to the One. Consequently, the passage of man on earth is transitional. His theory coincides with the Christian dogma which also speaks of the fall of man and his tendency to return to God. Yet the One of Plotinus is impersonal; it does not possess the consciousness of the creator, but creates life just as the sun creates heat by radiation. In a contrary fashion, the God of the Christians, the one and everywhere present divine spirit, is personal, has the consciousness of the creator, and forms his infinite love for man, who is his crowning creation. For this reason, Plotinus is not the first of the Christian philosophers, but the last of the Greeks. His philosophy is not enough to explain Christian dogma or the technique of Byzantine art, for his metaphysics runs the danger of becoming physics. Nevertheless, the metaphysics of Plotinus becomes the agent through which the Greek Fathers, and Origen (A.D. 185?–?254) especially, shaped the theory of orthodoxy and its religious symbols. Suffice it to say that in accordance with the theory of the icon defined by the ecumenical councils, the icon is considered to be a reflection, so that when one worships it, he is venerating not the icon itself but the saint which it represents. Otherwise one would be idolatrous. The picture, it was said, is identified with the painted saint "in essence," whereas it differs from him "in substance."

If, however, Plotinus does not speak about the sublime, his contemporary Longinus (third century A.D.) in On the Sublime describes it as "an echo of high-mindedness that leads to ecstasy." He finds it in several ancient verses and in phrases in the scriptures, like the following: "And the Lord said, 'Let there be light,' and there was light." It is curious that the same example is cited by Hegel many centuries later when he speaks of the sublime and observes that Jewish poetry in the Bible and, by extension, Christian art belong to the aesthetic category

of the sublime. But whereas Hegel recognizes the sublime in Gothic art, he deprecates Byzantine art by saying that it is an example of Roman decadence.

In trying to explain the symbols in the works of Byzantine art, many scholars turned to theology, but they forgot that the religious significance of symbols is not sufficient to justify a work of art. The fish, the cross, the icon, no matter what religious meanings they may have for the believer, do not suffice to convey aesthetic emotion if they do not also, by their beauty, become artistic symbols sufficient to charm both the faithful and the nonbelievers. And thus one always returns to seek out the basic aesthetic feeling of that art which enables the symbol to express itself artistically. This feeling should be the same today as yesterday. If we find works artistically worthy, the feeling in the artistic soul should be an eternal one. This is a feeling of the sublime, the only feeling corresponding to the transcendental ideal of theocentric Christian art. It did and still does continue to be generated in the soul of the spectator when he looks upon the works of Byzantine art, a feeling which always exists strongly in the soul of man, just as do the feelings for grace, the beautiful, the tragic, the comic, and the ugly. The feeling of sublimity is foremost in the works of Byzantine art, although other coexisting and intertwining feelings are not excluded by it. The supreme grandeur of the figure of the Christ the Pantocrator Almighty at Daphne (Fig. 7), or the limitless space of the church of St. Sophia (Fig. 8), at Istanbul do not exclude the heavenly grace of the angels at Daphne (Fig. 9) and the small Byzantine church in Athens (Fig. 10). But the moment that we adopt the sublime as a basis when we approach the aesthetics of Byzantine art, everything changes, everything comes to light.[1] The morphological descriptions acquire a unity and our emotional condition acquires a reason.

Let us now proceed with the architecture and the painting of Byzantium to discover the principles followed in their expression of the sublime. The turning inward which occurred in man with the establishment of the Christian religion also occurred in the physical space of the Christian church. In contrast with the pagan temple, which stands like a statue in the area of the sacred grove (that is, facing outward), the church turned inward. To bring this inwardness about, the practical-minded would be satisfied with a spacious church within which the faithful could be accommodated, for the liturgy now took place within it, whereas pagans performed their blood sacrifices outside the temple while they gazed upon the statue of the god through the main eastern

entrance. Thus the interior space of the church, in the words of Strzygowski, became a "carrier of an idea." The church is the terrestrial sky wherein the ever-present spirit, "God in heaven, lives and walks." The space therefore tends to appear to be aesthetically infinite despite its boundaries; and the need to eliminate its confines accordingly arises. This is brought about by the longitudinal axis in the basilica, by the apse of the sanctuary greeting us, and by the heightening of the middle aisle, where the illumination is concentrated on high to exalt our souls. This impression is brought about even more effectively in the domed church in which the cupola becomes the symbol of heaven.

In St. Sophia, that unsurpassable marvel of Christian architecture, the cupola dominates the entire space seen by the spectator (Fig. 11). Supported in a crown of forty windows, it appears, in the words of Procopius, to be suspended from the heavens by a golden chain. The shell enclosing the space, thanks to the principle of the perforations which pierce the large apses with smaller ones and the smaller ones with colonnades, allows the spectator's eye to gaze upon the interior and return repeatedly to the space, which appears to grow until it reaches infinity. The eye moves over the curves of the arches, the domes, the pendentives, and the circular crown of the cupola; and the "eternally turning" sphere, as Procopius says, returns to itself and rejoices in the musical dynamism of the forms. It has already been pointed out that, despite the vastness of the church, no dimension is exaggerated. Length, width, and height are harmoniously proportioned and retain the classical measures of the Greeks.

The principle of piercing is also applicable to the sculptural decoration of the capitals, which have been worked with the drill and give the impression of being covered by web-like lacework. A kind of miniature scale is created which, in combination with the mosaic, conveys the impression of vast size. The visible shell of the church becomes lighter and more distant. At the same time the third dimension of the piers is hidden. We see only contours outlining the arches, and the domes are intercepted by incorporeal edges. The shapes are thus dematerialized and breathe freely.

The fact that the supported parts appear heavier aesthetically than the carrying parts does not distress us. On the contrary, this gives an altogether new air to the interior. First, the columns, which, because of the impost, retain their elegance and do not swell out, acquire an additional grace because they appear to convey a sense of the victory of the spirit over matter. As a consequence, the church appears to begin

from above as though the very firmament of heaven were covering us. This aesthetic inversion, which has a special charm, was misinterpreted by Otto Demus, who maintained that Byzantine architecture is a "hanging architecture" and consequently is inorganic, in comparison with Gothic, which is organic and gets thinner and lighter towards the top, or with classical Greek, in which the carried parts and the supporting parts are balanced.

Furthermore, the light concentrated in the cupola carries us up into its height. And the entire church is flooded with light, even though that light is diminished by half with the closing of the large side windows in the drums and the small windows in the large apses. And Procopius is right in saying that the church looks as though it generated its own light from within.

All of these factors contribute to making the church a temple and symbol of the wisdom of God and not a temple and symbol of some female saint with the name of "Wisdom."[2] The daring of erecting a temple to the wisdom of God suffices to reveal the transcendental ideals the Byzantines strove to incorporate and to show that the study of their forms of art could not fail to generate awe and the ecstasy of the sublime.

From this large church I now turn to a small one, the Capnikarea of Athens (Fig. 12), to illustrate yet another principle of Byzantine architecture, which I call the picturesque; it is based on the freedom with which the forms are combined, no attempt having been made to realize geometrical regularity and exact shapes. The joints are of unequal thickness, the bricks are not laid out exactly in straight lines, the tiled combinations change from place to place, the inclinations of the roof-coverings also change, and the overall picture almost resembles a tree which grows freely, rather than a plastic mass which adheres to a tectonic plan. The success of the structure is due to the dexterity and the originality of the technician, and cannot be repeated. The significance of this principle in Byzantine art is clear, since in restorations or in modern copies regular geometrical shapes were used, and the character of Byzantine architecture was thus altered. Today we better understand the significance of the curves in the Parthenon, that is to say, the deliberately arranged irregularities of classical architecture and sculpting which I describe as "latent picturesqueness,"[3] whose intent is to give a natural freedom to the structure. Here is yet another kinship with the Byzantine style.

I now cite the small cathedral of Athens (Fig. 10) as an example, first, of how harmoniously the sculptures of classical art combine with

the Paleo-Christian pieces in the Byzantine church, and second, of the degree to which simplicity, freedom, and grace are to be found in this small church, which I would, if I may, call the Erechtheum of Byzantine art. But here the grace is heavenly, and not the natural grace inherent in the buildings of the Acropolis.

Before moving on to painting, I should like to say a few words about sculpture, in particular citing the example of the Orpheus in the Byzantine Museum of Athens (Fig. 13), which I have described elsewhere as a Christian symbol. To become such a symbol, the expression of the face had to be changed. And in fact, at the very first glance, it is obvious that this modeled form cannot possibly belong to the classical school. Even though it could not possibly have been created without a pre-existing classical tradition, the mien is anti-classical. One has only to look at the expression of the face of Orpheus to understand that the turn inward, toward the internal world, has occurred, just as it occurred in the faithful themselves. There is a certain self-centeredness, a mystical exaltation, and a certain sublime ecstasy in the expression which springs forth from the high forehead, the eyes, and the mouth. Furthermore, the body has almost lost its three-dimensionality. It is not a plastic mass, but a two-dimensional torso in perspective which, not being tangible, is visual. For this reason the stance of Orpheus is not natural, but is so attractive as to draw our attention to the face and, through the face, to its soul. And the long, thin fingers, like the fingers of an El Greco figure, touch the strings of the lyre, and a music is heard that attracts the beings and creatures around him.

There is also a bas-relief in the small cathedral which archaeologists would say was influenced by the weaving patterns and the motifs of the East. It is impressive, though two-dimensional, in flat relief—that is to say, it is a painting rather than a three-dimensional piece of sculpture.

At all events, sculpture began to fall into disfavor in Byzantium and was eventually almost totally abandoned. Painting and mosaics became the primary media, not because there was any law prohibiting statuary which smacked of the pagan past, but because, as I believe, the ascetic body and the transcendental ideal could not be as fully expressed in sculpture as in painting. Representations in painting are by nature incorporeal and immaterial, even when they are naturalistic, and so much more so when they are designed to be dematerialized, two-dimensional, expressive spiritual beings who are not of this world but who look forward to life in heaven.

Many scholars have described the depictions of Byzantine mosaics as distorted, stiff, and ugly; many still feel that way, though they do not openly say so. The influence of a long tradition of education in the aesthetics of the Renaissance and of classical art still holds us back when we are confronted by this art. We find it difficult to be unprejudiced and not to seek in these figures and representations the anatomies and the postures of the bodies of a Venus, a Hermes, or a Zeus. Furthermore, the beauty that tantalizes the feelings is much nearer to man as a whole. But in the Byzantine figures we generally see only the head. Even in secular figures, such as those of Justinian and Theodora, the body is covered by a long robe, luxurious certainly, but one which makes the whole figure two-dimensional. And to many persons the lack of this third dimension plus the richness of the glittering colors and the gold background convey the impression that Byzantine art is decorative. Again, they are repelled when they see John the Baptist with his ascetic, distorted body, and one must have the strength to understand that this repulsion leads to a feeling for a different kind of beauty, a morally high exaltation which idealizes ugliness and which overflows unrestrainedly within us.

Let us look at St. Demetrius of Thessalonika (Fig. 14). Extremely tall, his hand raised to us palm outward, he keeps us at a distance. His body is lost to us, covered by vestments; it is immaterial, and he seems to be hovering above, rather than treading on earth. All action is centered in the face, in the expression of the large eyes and the penetrating gaze. "The eye is the lamp of the body," and before this gaze we retreat, somewhat shuddering in awe, and then we are transported to spiritual heights.

Yet why should the distortion and the ascetic figure upset us so, if it portrays the truth? The Byzantine martyrs and saints were not imaginary personages, beyond time, like the gods of the ancient Greeks, who never lived on earth, but persons who actually existed—historical persons. Their figures are not symbols of the goddess of beauty, like Venus, or the god of war, like Mars; all they needed for depiction was appropriate features, properly idealized. The saints, on the other hand, were people who actually lived on earth and were sanctified. Therefore the Byzantine artist was obliged to portray the characteristic beauty or ugliness of each person. This is why a Byzantine painting, though it was a work of the studio and portrayed stylized types for each person, nevertheless copied the features of its model more faithfully than did the ancient Greeks, who beautified their symbols.[4]

There was no need to borrow frontality from the East. It was necessary in every portrait intended to meet the spectator's eye; the spectator was to look upon the features of the saints, and to a much less degree upon the movement of the torso and its anatomy, hence the stiffness of the depictions. At all events, this is not to say that movement and rhythm are lacking in Byzantine art. Movement is there, hieratic and majestic, as seen in the religious procession of the saints in the Ravenna mosaic. Yet it should be understood that the key to these representations lay not in the posture of the body, as in the ancient statues that were supported on one foot while the other moved freely, but in their spiritual stance. For this reason their posture seems to us quite pedestrian, as in the case of the Four Moors of St. Mark, who alight on the earth with two feet (Fig. 15), or unsteady, as in the apostles in the dome of St. Sophia of Thessalonika, which, however, is nevertheless expressive and most impressive.

The postures and the movements of Byzantine representations are related to the gold backgrounds, which for many scholars represents an empty space. This is why, in observing that the figures are never shown in full but in three-quarter profile, Otto Demus concludes that they seem to be moving into the natural space of the church in which they circulate. In other words, according to his interpretation, the space in the panel is not behind the picture but in front of it.[5]

Yet it is impossible to conceive of the gold background as a void. It represents the depth of a heavenly, or ideal space. The gold mosaic cubes are not placed flat on the surface, but are here and there inclined to reflect the light, conveying in this fashion the vision of depth. The figures within that space appear to be moving, and thus the third dimension is created. I need not add that for non-plastic scenes such as those of Byzantine art, the monochromatic background is the most suitable. Being two-dimensional, they adapt very beautifully to the curved surfaces of the domes.

In Byzantine art the lighting is of the studio. It does not originate from a single source, as in naturalistic painting, but from many sources in accordance with the wishes of the artist as he aims to convey a transcendental vision. For this reason, the shadows often become whites, as in photographic negatives—and not, as Demus believes, only in places where there is insufficient light in the church, but wherever the design calls for it in the interior.

Some scholars have also maintained that since at certain points the perspective appears to be "reversed," Byzantine art generally uses

reversed perspective—that is to say, the vanishing points are found in front of the painting and not behind it. But, first of all, the perspective of the Byzantines is not reversed everywhere. They did not apply one system only. Some scenes have vanishing points both in front and behind the image (at the Chora monastery) to show these from afar as well as from below. Hence, there are many vanishing points in the same painting because to them most important in the perspective arrangement was the visual arrangement, the knowledge of which the artist possesses and according to which he brings his inspired views to bear. And when the reversed perspective appears to be total, as in the Last Supper at Kaisareniani (sixteenth century) or in the ivory of Dijon representing Christ and his apostles, the intention is obvious: not to make Christ, who is in the depths, appear smaller but, on the contrary, to emphasize him as he should be, since he is supreme in the hierarchy. In other words, it is a negation of the negation that is imposed by the perspective in the hierarchical order of sizes terminating in the correct position. To avoid diminishing the size of his Christ, Leonardo in *The Last Supper* depicts all the apostles as ranged along one side of the table, and to give a feeling of repose and amity to the scene, he emphasizes the horizon. On the other hand, Tintoretto (Fig. 16) reduces the size of Christ, subduing him to the perspective system, and, to make him more distinct, encircles him with a halo—but to no effect. How much more impressive is the Byzantine work!

The Pantocrator in the church of St. Luke of Stiris (Fig. 17), although situated at the highest point of the dome, is much larger than all other figures; thus the hierarchical order is maintained. He is the grand figure; from him flows all, and from his gaze the entire world is suspended. The height of his position is further accentuated by great size. This, as F. A. Choisy has pointed out, is in the Greek tradition. For this reason the Zeus of Phidias was so disproportionately large in the space of the Olympia temple that, in the words of Proclus, if the god tried to stand up from his throne, he would have carried the roof with him. The Greeks have been accused of having no feeling for space. But, plainly enough, the Greeks also felt the need to impress upon the spectator the superiority of the father of the gods through his size.

It is certainly true that in the long thousand-year history of Byzantium, the style of its art underwent changes. The monumental, majestic, and high tone of the works of the first period, such as the St. Sophia of Justinian, or the mosaics of St. George of Thessalonika, are still found in smaller works, such as the mausoleum of Galla Placidia, or the vision

of Ezekiel in the Holy David of Thessalonika. It was a period of expansion in style.

The second period was the period of intensity. The style, practiced in the age of the Comnenians and the Macedonian dynasty, in about the eleventh century, presents an art more vigorous and dynamic. In fact, at Daphne there are Atticizing mosaics (Fig. 9), whereas at the church of St. Luke there is an Eastern influence or a more popular art (Fig. 7). At all events, the size diminishes.

In the third period, during the reign of the Paleologues, in the thirteenth and fourteenth centuries, emphasis was on the characteristic. The Holy Apostles, or St. Catherine of Thessalonika, and the churches of Mistra are distinguished by decorativeness and plasticity. Human passion enters into the paintings—and exaggerated movement, and a certain naturalism. Here is the Byzantine Baroque.

There was an extension of Byzantine art on Mount Athos in the form of post-Byzantine art. Monks and ascetics gathered on the holy mountain or clambered up the steps of Meteora over rugged rocks and strove, in splendid isolation from the earthly world, to get nearer to God. They were the disciples of the Hesychasts of Gregory Palamas (1296–1359), who envisaged the mystical divine light of God. Besides the remarkable monastic architecture, this period boasts of great painters unknown in the West. The works of Theophanes (ca. 1370–ca. 1405) at the Laura monastery (sixteenth century) and of Manuel Panselenus in the Protaton (sixteenth century) would be the envy of any great artist, but the painters of these great works have been ignored by the West. Even histories of art continue to ignore them, though they should be placed on the same pedestals as the artists of the Renaissance and the Baroque, whose works are in no way superior. Painters such as Michel Damascenus (1535?–ca. 1591) of the Cretan school, some of whose works are found at the Campo dei Greci in Venice and at Euphrosynus on Mount Athos, are worthy of more recognition than they have received in the West. It is the school from which El Greco (1540–1614) sprang.

Byzantine art was born and matured at a time when two worlds were fighting a life-and-death struggle; one world, the pagan, was dying, and the other, the Christian, was emerging. The Christian world brought with it new demands and new values, new forms and new symbols. But the pagan world did not die out completely, for many of its values and its symbols passed into the new world, often changed and modified, but never dead. This fact makes it possible for us to turn our eyes to the past without being startled by it. It is enough that we should

know how to look at it, discarding what we should not remember and recalling things we should. For the memory of man goes much deeper than he believes.

9

the grace of the Byzantine column

The aesthetics of the Byzantine column is of particular interest, for in Byzantine architecture there appears the singular phenomenon of supported elements seemingly outweighing the carrying parts.

When the spectator's eyes wander around the interior of a domed Byzantine church, where the cupola, resting upon arches and pendentives and countersupported by apses, semi-vaults and cross-vaults, rises as the symbol of heaven, he has the impression that a hand-made universe has alighted upon delicate columns; the cupola so dominates its supporting members as to make the church look as if it were flowing from above. This phenomenon led Otto Demus, in carrying the impression to the extreme, to propound the view that Byzantine architecture was a "hanging architecture" and, consequently, that the columns of the church resemble descending tentacles or "hanging roots."[1] He furthermore adds that in contrast with Western and primarily Gothic architecture, which is "organic" because it follows the "principle of organic development," the Byzantine is "inorganic" because it adheres to the "hieratic manner of thought," enlarging or emphasizing that which is religiously more sublime, as occurs in the hagiography of the church, with Christ the King, or Pantocrator. Only in Greek architecture, he adds, is there an idea of the perfect balance of forces.

I felt compelled some years ago in another study[2] to challenge this view of Demus, since if it were to be accepted, it would in essence mean the denial of the tectonic foundation of Byzantine architectural works. The church would be a kind of stalactite cave without structure.

There is no denying that the Byzantine style presents a reversal of the relationship, not met with in the classical orders, between supported and carrying members; that is to say, the supported members appear to be much heavier and more massive than the supporting ones. Yet this relationship is only apparent; otherwise the supporting parts would surely have collapsed under the greater weight. But Demus' definition of the principle of Gothic architecture, the carried members of which seem considerably lighter than the supporting parts, as alone "organic" does not hold water; examples in nature itself display the opposite principle. In many plants, for instance, the supported parts appear to be heavier than the carrying stems. This also occurs in Chinese architecture, where heavy, curved roofs are supported by lighter and widely spaced wooden supports. Hence the precise principle which is condemned as "inorganic" in Byzantine architecture constitutes that basis for a new rhythmical and morphological expression, the source of a new style. And thus we must begin with this principle if we are to grasp the aesthetic peculiarity of the Byzantine column.

If I repeatedly refer to the subject of "hanging architecture," I do so not to reiterate my criticism of this idea, but to focus my observations on the column and to investigate its particular aesthetic. In other words, I regard as of great significance the notion that the grace of the Byzantine column emerges precisely from this daring attempt, which, at least to the naked eye, appears to be a phenomenon: a heavy load being held up by a slender support and being so held with remarkable ease.

After its restoration, the new columns in the Church of St. Demetrius of Thessalonika were interspersed with the old along the central aisle. But the new columns seem heavy and inelegant as compared to the older ones. I investigated this impression further, and discovered that the late Aristotle Zachos had in fact enlarged the diameter of the columns and had prepared massive capitals for emplacement on the shafts. Following his death, the restoration committee headed by George Soteriou fortunately intervened, all those columns that had not been destroyed by the 1917 fire were left *in situ,* and efforts were made to adjust the diameters of the new shafts to fit those of the original columns. But it seems that this rectification was not an easy operation, to say nothing about the exact copying of the original column, for why do the

new columns still appear less elegant and heavier than the old? I therefore reverted to certain measurements which showed that, first, the older shafts do not all possess the same diameter; they "play," as we would say, for the sake of the picturesqueness which is so much a part of Byzantine art and which even goes so far as to allow a different capital for each column. Second, the older columns have a certain stress or "tension," if I may call it so, which gives them a grace the new pillars cannot imitate successfully.

The following table shows the precise measurements of the columns, as they were made by my colleague N. Moutsopoulos in January, 1964. I had asked him to take these measurements to convince myself too by the actual figures that my impressions were justified, as in fact they were. The table gives the circumference of each shaft above the base (Point A) and the circumference at a height of 1.85 meters from the floor where the "tension" appears (Point B). One will note that in the older columns the slenderest has a circumference of 1.67 meters at Point A and 1.66 meters at Point B, whereas in the new shafts the slenderest measures 1.81 meters at Point A and 1.75 meters at Point B; and the thickest measures 1.86 and 1.82 meters at A and B, respectively.

Thus the widest is equal in width to the slenderest one (1.81 meters). And yet the difference between the lower circumference (A) and the circumference of the point of tension (B) varies as much as 1 to 7 centimeters in the older and more slender columns, whereas in the newer columns, which are thicker, the variation is as little as from 4 to 6 centimeters.

Hence, the newer columns are somewhat larger in diameter than the older and appear to be heavy and inelegant next to the older. The colonnade thus becomes a lesson in rhythmical arrangement: it shows clearly that the newer columns, seemingly heavier, are aesthetically weaker. On the other hand, the older, more slender shafts appear stronger and retain the spirit of great art. The support by these older columns seems daring and venturesome: they manage to support the apparently heavier arches and also to express a victory of spirit over matter; consequently, the overall structure assumes a character of festive lightness and grace.

In classical architecture the basic structural element is the post and beam. The column and architrave are of the same material, marble, and this accounts for the uniformity in construction. The same material undergoes compression and flexion, and the column and the entablature are also of marble. Burden and support are evenly balanced in

Measurements of the Columns of the Central Aisle, Church of St. Demetrius of Thessalonika

COLUMN NO.*	CIRCUMFERENCE† POINT A	POINT B	DIFFERENCE‡	OLD OR NEW	COLOR§
1	1.75	1.69	6	O	W
2	1.83	1.80	3	N	W
3	1.74	1.67	7	O	W
4	1.72	1.65	7	O	G
5	1.86	1.82	4	N	G
6	1.83	1.79	4	N	G
7	1.68	1.63	5	O	G
8	1.81	1.74	7	O	W
9	1.85	1.77	8	N	W
10	1.85	1.79	6	N	W
11	1.82	1.75	7	N	W
12	1.84	1.79	5	N	W
13	1.67	1.66	1	O	G
14	1.84	1.80	4	N	G
15	1.86	1.82	4	N	G
16	1.73	1.70	3	O	G
17	1.82	1.76	6	N	W
18	1.81	1.75	6	N	W
19	1.82	1.74	8	N	W

*The numbering of the columns was made on both sides of the colonnades from the narthex towards the sanctuary, so that the colonnade to the *right* of the person entering includes columns 1 to 10, and the colonnade to the *left* of the person entering includes columns 11 to 19.

†The circumference (2 r) of the columns is given in meters. Measurements were made at Point A, that is, above the sima of the base of the column, and at Point B, at a height of 1.85 meters from the floor, where the greatest entasis or "tension" is observed.

‡The difference is given in centimeters.

§Green marble is marked G, half-white, W. Green columns are the four middle columns in each colonnade.

conformity with the principles of classical art—that is, that one element does not outweigh the other. This does not mean that there is no intense clash between column and architrave, a clash which may well be one of the reasons for the eventual development of its form and the division of classical architecture into three orders, the Doric, the Ionic, and the Corinthian. The clash arises when the columns tend to soar freely as though unencumbered by any weight, whereas the architrave and the other elements carry the burden which is transferred to them.

If for a moment we were to examine the Egyptian pillar, with its bell-shaped capital, we would notice that the abacus does not cover the entire surface of the capital so as to take the weight of the beams more easily; it provides a larger area for support. For fear that the fine lips of the bell be broken, the abacus is confined to a small cube placed midway between the capital and the beam in such a way as to make the capital appear freely terminated. In other words, the column does not appear to be supporting the beam. An obvious floral composition in imitation of the papyrus plant, the Egyptian bell-shaped pillar resembles a growing flower beneath the beam, and the roof seems suspended above the huge columns like the sky, the paneling painted in blue and decorated with stars and flying vultures. Naturally, such a solution is technically feasible because of the mass of the pillars and the close arrangement of the colonnades.

But to return to the classical column: in comparison with the Egyptian, which is phytomorphic or floral, the Greek, and especially the Doric, is a "tectonic" column. It is obviously designed to act as a support. The echinus is nothing more than a geometrically worked element so constructed as to make easier the transition from the round shaft to the square abacus. The abacus covers almost the entire surface area of the echinus, so that the support for the beam is complete. The impression of a free termination, very slight in the archaic Doric column, where the echinus is large and ineffective, disappears in the classical column because the echinus has been limited in size but is at the same time more heavily emphasized. This is especially noticeable in the Hellenistic column.

Yet something further is to be observed in these three stages of development of the Doric column: the shaft becomes more delicate, the column more elegant, and the architrave lighter, and one has the impression that the burden is gradually lightened since the free flowering of the column is precluded. I need not dwell upon the fact that the victory over the pressing weight of the material and the spirituality of the work are the results, first, of the morphology of the columns and the architrave, and, second, of the pyramidal inclination of the columns and the fine curves of the stylobate and the architrave, about whose aesthetic significance I have written elsewhere.[3]

The aesthetic disposition for freeing the column from the yoke of the beam remains undiminished, and this is quite possibly a further cause for the quest for orders and forms other than the Doric. In classical architecture there are two other orders, the Ionic and the Corinthian. I

shall not dwell on these, however, since the delicacy of these columns and their more spacious alignment are obvious. The emphasis given to the Corinthian capital, which conveys the freedom to the column, is also obvious, although in reality this occurs also under the yoke of the architrave. But it is perhaps the only classical column which, if it is deprived of the architrave, stands alone as a pillar with floral decoration, such as we see in the columns of the temple of the Olympian Zeus in Athens. This signifies that the capital of the Corinthian column is the vital element in the entire composition, as though the purpose of the column were to support the flowering marble acanthus at the top. Indeed, for an austere tectonic morphology, what an unexpected spectacle one encounters in classical architecture, and what wealth! Surely that is why the Romans selected the Corinthian column as their favorite.

I referred to Egyptian and classical architecture to point out that even in the so-called austere and balanced architecture of the Greeks, there existed aesthetic tendencies which freed the column from its tectonic structure. Moreover, the harmony of forces at play was not brought about in one manner only. In classical architecture there exist at least three so-called orders, and in each the basic elements of the parts change character, shape, and organic arrangement.

In Byzantine architecture, on the other hand, the beam of the architrave is replaced by arches. The arch is as a rule constructed from brick. The result is a heterogeneous or dissimilar material between the arch and the columns, which are usually of monolithic marble—that is, built of material of greater strength. The brickwork of the arches works with a thrust like that of the marble of the columns, but the different degree of resistance of the brick material makes necessary the erection of arches considerably larger than the abacus of the marble column. The diameter of the column would need to be greater to accommodate the load or would have to be replaced by brickwork abutments. But such a solution, though cheaper, was deemed technically too timid and aesthetically inelegant. Preferred was the positioning of a middle element, the impost block, between the abacus and the crown of the arch, which acts like a pier receiving the wide arch and carrying its thrusts to the column. So much for the construction.[4]

Morphologically, the result is that the capital of the Byzantine column becomes two-storied and is generally disproportionately large in comparison to the shaft of the column, which remains slender. Aesthetically, therefore, the relationship between the support and the load becomes dangerous because the supported parts appear to be

greater than the supporting ones, and the arches, especially, look as though they are being carried by piers. Attention is focused on the two-storied capital, which is projected as a point of meeting of two clashing forces and is drawn to the contrasts, for although both of the soffits of the arches work in compression, they carry thrusts which clash with the counterthrusts of the adjacent arches just at the impost of the capital.

The question may well be asked how, in fact, the balance of the work and the contrast between supporting and supported elements is aesthetically preserved. The fact that this problem was also faced conscientiously by Byzantine architects is seen in the happy solution they achieved when they decided to keep the marble columns thin and not build them in the fashion of brickwork arches, lest they become too massive or bulky, as we often see them in Romanian churches. They preferred, in other words, to distinguish the materials in column and vault so that, aesthetically, the supported clearly dominates the supporting element. This principle is reflected in domed churches primarily, where the cupola and the vaults with the columns form a kind of ciborium. So viewed, with some stretch of one's imagination, they give the impression of a "hanging architecture."

It is certainly true that through classical architecture we have become accustomed to expect a lightening of the load as we look upward, where the vertical lines seem to converge and thus make the burden less heavy. But in Byzantine architecture this pyramid effect appears to be inverted. In reality, the frontal vertical lines of the arches project beyond the abacus of the capital through the impost, which makes a kind of pier. This contraction of the inner space of the church as it rises (no matter how slight it is) is counteracted visually by what William Henry Goodyear describes as a divergence from the vertical in the sides of the central aisle and the apse of the sanctuary in certain Byzantine churches, thus widening the space upward. This is certainly the case in S. Giorgio Maggiore of Andrea Palladio in Venice, which, according to Goodyear, carries on the mediaeval tradition.[5]

To dispel the impression of the weight of the vaults and domes, the Byzantines abandoned the aesthetic principle of the articulation of volume and cultivated the aesthetic of surface. In fact, their vaults and arches possess no plastic ribs. Incorporeal lines frame the surfaces wherever they intersect or wherever their curves interpenetrate, so that the whole resembles an unfolded surface which is curved and remains undistorted, thanks to a certain continuity and flow accompanying the

147

rigidity. This is brought about technically by the somewhat monolithic composition of the brickwork through the use of brick powder mortar and by the fine domes, which are light and airy and cohesive, almost like self-supported shells, not like the massive domes of Roman architecture. The cornices are chamfered; the frieze, the bands, the borders of marble paneling, the decorative work, all are in flat relief so that the aesthetic expression of surface can be fostered, and, in conjunction with the phantasmagoric illusions of color and the pierced technique, the impression of dematerialization can be conveyed.

I do not propose to deal further with the analysis of dematerialization, of the piercing technique (or, I should say, the passion) possessed by Byzantine architecture, or of the plastic principle of drill-carving, in which the capitals are covered by a kind of lacework so that they lose their mass in the light and dark patterning. I shall cite a single tectonic example from St. Sophia, however: consider the north and south pilasters would project quite a few centimeters beyond the pier. They do not, two of the large arches supporting the dome. Accustomed as we are to Roman or Renaissance architecture, we would expect that these pilasters would project quite a few centimeters beyond the pier. They do not in fact, do so at all. They are drawn out on the vertical marbling and merge into a junction of variegated marble. Thus, their mass is completely effaced, and there remains an almost imperceptible linear representation which also adds to the dematerialization process of the mass. These pilasters represent yet another innovation: the negation of the principle of the differentiation of architectural members, a principle which applies to classical architecture, where the differentiation is perceptible. But in Byzantine architecture the members tend to blend into one mass; they are subdued by the whole. And this effect has been perfected technically only now, in contemporary monolithic structures in concrete with their continual flow of material. In Byzantine architecture, however, this continuity of material is not fully realized. Here there are architectural members, and each member has various elements. Yet that austere stereometric articulation of the classical architectural form and its separation into base, shaft, and crown is weakened. The tectonic transferral, through intermediary differentiated moldings, from the supporting to the supported element is also weakened. The perceptible lightening of the shape as it rises is reversed, and the "democratic" arrangement or cooperation of parts synthetically makes way for a "monarchic" tendency in which subordination, not free arrangement, is the rule. The result is that the carrying members are subordinate to the supported parts.

In principle, this change is evident in the Byzantine column which, as I have pointed out elsewhere, with the impost, resembles a two-storied structure. It is obviously true that of the two stories the first—that is, the actual capital itself—dominates because of its size and its decorative motif. On the other hand, the impost is smaller and usually simply decorated, sometimes with only a cross or a monogram on the face. This is so because it acts only as a mediator or as an intermediary element between the capital and the arch. It is a new abacus, or rather a projection shaped appropriately to take the arches, for the square abacus of the capital does not suffice for this purpose. Moreover, morphologically speaking, since the column terminates with the richly decorated capital, the impost seems out of place, and we tend to look upon it as a part of the arch, whereas in fact it belongs to neither the arch nor the capital because it is an intermediary element. Such hesitancy or doubt is not encountered in classical architecture, not only because there is no impost between capital and lintel—unless we look upon the abacus as an impost—but because the principle of the differentiation of members is evident and complete.

The intermediary element, or impost, as I have pointed out, helps make the Byzantine column two-storied. In other words, it takes on height because it sometimes appears to belong to the capital and at other times to the arch. Yet because it at the same time changes the form of the area of the base of the abacus, and from a square becomes rather rectangular in shape as a result of its intersection, it creates a perceptible turn in the column. It is as though it had been changed into an elongated pier, with the large axis set transversely to the axis of the middle aisle. Whereas the column is round and the axes of the square abacus are equal and intersect at the center, the elongated impost allows its lengthwise axis, set crosswise to the longitudinal axis of the central aisle, to dominate. This gives the impression that the crown of the capital is alienated from the impost. The column acquires an almost free termination, whereas the impost appears to be turning toward the crown of the capital to support the arches, the frontal area of which projects beyond the area of the capital. Here in the Byzantine order we see repeated what occurs in the Egyptian order—that is, the column tends to reject its static destiny and strives to flower freely.

The arches spring from the imposts with their curved lines and invite the beholder to follow them. The curves emerge to meet with those of the neighboring arches and to rest on the imposts. Thus a dynamic arched architecture is created whose supporting points are also transition points, like temporary stopover points, from one arch to

the other. And there the thrusts with the counterthrusts are obliterated and give the whole a balance and harmony despite its dynamism. The arches take shape freely, and Byzantine architecture strives to raise them even higher so that they become lighter.

Wherever and whenever the feeling of the tectonic factor was atrophied, Byzantine architecture gave an exaggerated elevation not only to its arches but also to the drums of the domes and to the entire building, and at times it gave a spiral decorative turn to the drums. It provided a verticality recalling the Gothic style. But as a result Byzantine architecture lost its divine charm. Its supports remained slender and delicate, but lacking in elegance. Its static balance became more precarious, and safeguarding it became a matter of acrobatic dexterity. Its grace was affected and unnatural.

The dynamism which is especially strong at the points of support of the arches—that is, at the imposts and capitals—enabled Byzantine architecture also to embody "wind-blown" leaves—in other words, capitals which, if not spinning boldly, seem to allow their marble leaves to be moved or swayed by some metaphysical wind. Thus the capital appears to repeat, if not to go beyond, the turning motion of the impost.

And, finally, the dominance of the supported over the carrying parts gave scope to Byzantine church architects, especially of the provincial school, for placing beneath the arches and the domes the various columns of classical orders as they were often found at the sites of earlier pagan temples. The domed part of the church rises in dominating fashion and comes to rest upon a few subordinate supports. The same principle made possible the use of a variety of capitals in the basilica of St. Demetrius, something which could not possibly be acceptable in a classical colonnade. These capitals with their appearance of having a free termination provide the pleasant sensation of looking at rare flowers. The spectator who follows the rhythmical steps of the colonnade sees a different capital with rich and unexpected plastic decoration on each column, he observes that grace is nothing alien to the Christian art of Byzantium, and that in fact a mystical note is conveyed.

Grace coexists with that expression of the sublime which dominates all of Byzantine art, not only because the aesthetic categories coexist and are interdependent, as I have pointed out at length elsewhere,[6] but also because in every composition, despite the dominance of one characteristic, as in a tragedy, art aspires to various kinds of intellectual emotion. And because Byzantine architects chose the column for displaying their skill in creating a rather precarious structure,

the ease with which they brought this about fills the soul of the spectator with relief and charm. The entire firmament of the man-made heaven supported by the Byzantine columns gives the impression that this creation could be balanced on a fingertip, so light does it appear. To create such an impression was the ultimate aim.

10

Neo-Platonic philosophy and Byzantine art

I. the aesthetic approach to Byzantine art

Various recent works on early Christian and Byzantine art have approached it through Neo-Platonic philosophy. The influence of Neo-Platonism in the shaping of Christian philosophy is indisputable; so too, consequently, is the influence of Neo-Platonic aesthetics—particularly of Plotinian aesthetics—in the shaping of early Christian and Byzantine art. But in order to understand why the factor of Neo-Platonic philosophy is now brought into play in connection with Byzantine art and to determine what part it should play in the aesthetics of Byzantine art, a historical survey of the latter from the moment it began to be explored is necessary.

There is virtually no systematic aesthetics of the Byzantine period; all we have are observations of Byzantine art—observations,moreover, which from the point of view of aesthetics are not moreover, which from the point of view of aesthetics are not systematized, since the scholars laid stress either on archaeology or on history without examining deeply the main aesthetic problems. Furthermore, the aesthetic approach to Byzantine art has always been indirect, as has been its recognition as a

full-fledged art. Now, Western mediaeval art was approached directly and it was, in consequence, this offshoot of Christian art (particularly the Gothic) which was taken as a model in the aesthetics of the Christian art period. Conversely, mediaeval Eastern art was long considered as a by-product of Rome's decline, an art bereft of spirituality, ossified and uncouth. The aesthetics of Byzantine art was, therefore, also tardy in acquiring status, and followed all the phases which the recognition of Eastern art underwent.

The small attention paid to the mediaeval art as a whole is due to the Italian Renaissance, which, as a result of its complete absorption in antique beauty, condemned mediaeval art as barbaric. Inevitably, our entire aesthetic education has since then rested on classical ideals, and, in fact, on the Renaissance conception of them, which often misinterpreted the ancient spirit. Since then, a narrow humanistic education with a one-sided aesthetics has crippled our aesthetic judgment, and to this day prevents it from being objective. The only justification for this insistence on the classical ideal is that it presupposes a more accessible—an anthropocentric—philosophy, and a corresponding aesthetics. This is in contrast to mediaeval art, which reflects a more abstruse theocentric philosophy and aesthetics. Despite man's inherent propensity to both, the former, more directly than the latter, lends itself to the understanding.

In any case, the appreciation of mediaeval art could not begin before man's philosophical and aesthetic outlook accorded with the spirit of this art—namely, until the anthropocentric had turned to a theocentric approach. This turn occurred in the Romantic age. Then, in contrast to the neoclassicists' standards of antique beauty (chiefly represented by Winckelmann, with considerable positivism) an aesthetics emerged which regarded beauty as the "reflection of the divine," as the human illustration of God's perfection,[1] according to Schelling. The infinite depths of the soul, the sublimation of love, a certain renunciation of the flesh, and the turn to nature which Rousseau had heralded led Romantics to a new aesthetic perception. The aesthetics of pictorial beauty, as Ruskin finally formulated it, in strictly denying geometrical patterns and even in referring to moral values, paved the way to appreciation not only of mediaeval but of every anti-classical art also.

Goethe showed this tendency as early as 1772, in his study of German architecture (meaning the Gothic); and in 1830 Victor Hugo showed it again in Notre Dame, not to mention others who followed. With the reaction of the academicians to Romanticism came the Neo-

Renaissance and finally eclecticism. In any case, the movement for the revival of mediaeval styles, like the Neo-Romantic, the Neo-Gothic, the Neo-Byzantine, and even the Neo-Arabic (as itself being anti-classical), was actually set afoot then. Yet no aesthetics of the Byzantine period even then found shape. The Neo-Byzantine forms created at the time were, in essence, Neo-Romantic—for they were still treated in the light of Western mediaeval art. Appreciation of Byzantine art was prompted chiefly by archaeological research, but could not be either complete or accurate, for it followed these methods of aesthetic approach:

(a) It rested on classical standards, and so sought ancient beauty in Byzantine art, which, as it fell short of it, was underestimated. In this sense, the method may be called negative.

(b) It judged by morphological criteria and, ignoring the essence of Byzantine art, examined its external peculiarities, such as the low-relief work in sculptural decoration, the monochrome background of painting, and so forth. Naturally, all these external traits remained aesthetically unrelated and, in fact, often clashed with one another, so long as the one deeper binding link remained undiscovered. In this sense the method was external.

(c) It relied on historical-genetic affinity. It sought, that is to say, to explain Byzantine art by the influence it had received from the Roman or Oriental tradition and civilization. Hence, the famous problem posed by Joseph Strzygowski, "Rome or the Orient?"—a question which only an archaeologist's mentality could apply to the appreciation of the art of a period.

Archaeology in those days, with its mainly historical interests, assumed that Byzantine art might very well be the product of certain arts historically preceding it, and that these could therefore be taken as the only guides to its appreciation. Thus, it overlooked the special character of this art, which sprang, not from the merging of two previous ones, but from an original inspiration in composition that was able to assimilate influences and traditions. This method, therefore, overlooked the subject it proposed to study. In this sense it may be called annihilating.

This reliance of archaeology on historical sources was due to the general turn to history which marked the age. But history for a long time underestimated Byzantine civilization and was thus responsible for the indirect and misguided attention paid to the art of the Eastern Church, which it sought to minimize by characterizing it as a by-product of the Roman decline, or, at best, a compound of foreign influences. Thus, the main factor of Byzantine art—its Greek spirit—was ignored.

Hence my contention that no proper aesthetics of Byzantine art had come into being, and that what appreciation Byzantine art had gained up to that time had been only indirect. Of course the Greek element in it was recognized (indeed, prematurely so by some archaeologists such as Millet); but since this inheritance was sought in the letter and not in the spirit, its detection, far from shedding light on the art under study, rather tended to obscure it. So it is that Morey, one of the later art historians, transposed Strzygowski's question from "Rome or the Orient?" to "Atticism or Alexandrianism?" as Otto Demus aptly remarks.[2]

It is evident then that what we need in the case of Byzantine art is an aesthetics uninfluenced by historical prejudices, and the raw material of which, so to speak, shall be the Byzantine works themselves, an aesthetics that shall judge those works directly, by aesthetic criteria. It will be well to ask at this stage whether Western mediaeval art, if thus approached, might not through the aesthetics it provided act as a guide to an appreciation of its Eastern counterpart—might not be treated as a starting point for a comparative aesthetics. To associate the two arts is justifiable enough, since—despite the fact that one sprang up in the East and the other in the West—both are expressions of the same ideal—the Christian religion. Christianity changed man's aesthetic outlook, irrespective of race or country. Let us then see first what were the aesthetic demands of Christianity, and then how the Greek, the Roman, or the Frenchman conceived and expressed them.

It was chiefly the German philosophers of idealism who formulated the primary aims of Christian aesthetics. Schelling has said characteristically that if classical art aimed at the inclusion of the infinite in the finite, Christian art sought to achieve the reverse; that is, "to make the finite an allegory of the infinite."[3]

But these philosophers too, and the Romantics generally, owe their attitude to Kant, according to whom the core of all philosophical and aesthetic outlook is subjective. It was this Copernican revolution in philosophy which impelled the Romantics later to place ineffable, transcendental experiences in the infinite depths of the soul, and which caused them to seek in art the reflection of divine perfection. But Kant is also a pioneer in the field of aesthetics; for here, influenced by the Englishman Burke,[4] he places beside the beautiful another value—that of the sublime—which alone can explain the profound aesthetic emotion aroused by the sense of the infinite, the immeasurable, the transcendental; for, according to Kant, the sublime does not exist in nature.

Hegel was thus able to establish later that Christian art comes under the aesthetic category of the sublime,[5] through which, chiefly if not exclusively, is expressed the infinite in which is immanent the omnipresent God, the One and Only God, Who said, " 'Let there be light,' and there was light." Unfortunately, Hegel misinterpreted Byzantine art—partly perhaps because he had no direct knowledge of it; chiefly, however, because to his German mind the idea of the sublime (as he found it expressed in the Gothic cathedral) did not even enter into Byzantine art, which he regarded as merely a declining one. In any case, these were the lines which the art historians and critics automatically followed in their aesthetics of Western Christian art. On the basis that the depths of the human soul were infinite, and in the conviction that art was capable of expressing the divine, art critics like Worringer, Dehio, and Schmarsow were profoundly impressed by the steep heights of Gothic architecture; they justified its tendency to suggest infinity in the disposition of its spaces, its verticality without measure, and the expressionism of its painting and sculpture which sought to reproduce the transcendental experience. Simultaneously, others (like E. E. Viollet-le-Duc) studied the system of proportions of the Gothic cathedral, the principles and techniques employed in it, the methods of working the material, and its other technical and artistic features. They thus succeeded in gaining from direct study and experience an inner appreciation of Western mediaeval art. But the findings of this study could not be applied to Byzantine art without strain, for although both arts arouse in the spectator a sense of the sublime, they yet stand apart in their conception of sublimity, and therefore in the means they employ to express it. Expressionism, the suggestion of infinite space, upward flights, and other features of Gothic art do not play the same role in the Byzantine, or appear there in another form and in other combinations, for the simple reason that the Greek spirit differs from the Northern, and Greek art is always distinguished by measure, harmonious calm, and spirituality.

An inner appreciation of Byzantine art therefore spells, as does a similar appreciation of Western art, an aesthetics of the sublime, since both refer to the Christian ideal; but in the case of Byzantine art, it is the sublime as Greek sensibility grasped and expressed it. And the Greek spirit has certain inherent and traditional tendencies which appear as permanent principles in every one of its manifestations.

The reason why the aesthetics of mediaeval Western art only subconsciously followed the lines laid down by Hegel and was not formed into an aesthetics of the sublime was that only art historians then

dealt with this art period. On the one hand, they produced an applied aesthetics that paid little heed to philosophical justification. On the other, they were interested in the phenomenon of the mutations of art in time, were anxious to bring this evolution under laws and principles. They therefore elaborated a philosophy of art history which sought the basic concepts underlying the latter. In this search, they formulated theories of which the starting point was now the form (as in the case of Wölfflin), now the content (as in the case of Schmarsow), now the race (as in the case of Worringer).[6]

Philosophers proper were usually indifferent to the incidental manifestations of the arts and the mutations of artistic expression in historical periods unless, like Hegel, they saw in history the teleological evolution of the spirit. If they specialized in aesthetics, they were interested in little more than the sort of normative aesthetics which fairly covers every manifestation of art irrespective of time and place. They would indeed have found it difficult to accept either an anthropocentric or a theocentric aesthetics; instead they elaborated an aesthetics now of form, now of content. Broadly speaking, they split into two schools— that of realistic, objective, and that of idealistic, subjective aesthetics. Ultimately, there appeared adherents of critical philosophy who wished to merge both schools.

There is no doubt that, as Theodor Lipps maintains, aesthetic principles have no history; but there is as little doubt that every great art period shows a certain characteristic style, inspired by the peculiar trends of the age, which alone can explain the structure of its art. If, then, normative aesthetics is to retain its stability and at the same time its link with the philosophy of art history, we must, I suggest, in a survey of the history of art, reduce basic concepts to aesthetic categories and view each great art period as the expression of one of these. I would suggest that in a philosophy of art history, we raise aesthetic categories from concepts of species, which they are in normative aesthetics, to concepts of genera. Thus the category of the beautiful engenders all classical art; the category of the sublime all Christian art. The categories of the beautiful and of the sublime are found to be recurring alternately throughout the history of European art, because man possesses an innate sense of beauty and sublimity, ever in opposition to each other. Not unnaturally in an anthropocentric attitude toward life, it is the category of the beautiful which prevails, whereas a theocentric view of life brings the category of the sublime into its own. The third category—that of the graceful, which partakes of both—is often to be found mediating be-

tween them, and dominates art periods like the Rococo. The tragic, the comic, and the ugly are secondary categories deriving their primary elements from the two fundamental categories of the beautiful and the sublime. Karl Groos,[7] in asserting the beautiful itself to be but one of other equivalent categories, has made such classification possible.

The alternate recurrence of the aesthetic categories well explains why an art era will generally feel a greater affinity to one which is two removes from it than to the one immediately preceeding it. We therefore find the Romantics reviving mediaeval Christian art, which the Renaissance had condemned.

This view of aesthetic categories as genera does not necessarily exclude their interpenetration in any art period, for however much one or the other of them may predominate periodically, they are in fact all related to one another, since all have a common spring in aesthetic joy. In studying the predominant aesthetic category in an art period, we should examine it also in the light of the inherent tendencies and traditions of the people which constitute the main factor, the nucleus of this art period. As the Christian dogma was filtered through Greek philosophy, so the idea of the sublime was filtered through Greek sensitiveness when it marked Byzantine art—an art of which Greeks were the main creators. Through an aesthetic approach to the philosophy of art history, I have elsewhere attempted to analyze Byzantine art.[8]

If further proof were needed of the purely sublime inspiration of early Christian and Byzantine art, we have it in the turn, already evident in the latest period of antiquity, from the philosophy of the beautiful to that of the sublime. Of course, aesthetics did not at that age constitute a separate and specialized science. But we find as early as Plato's day a nascent consciousness of the soul's upward striving. Love is the demon moving the soul to reach out for the divine, and in the *Phaedrus* Plato describes the soul's divine ascent as a direct illustration of the ineffable and the transcendental.

The Neo-Platonists later speak clearly of the soul's fall from, and return to, the One. "Our country whence we came and whither the father resides,"[9] says Plotinus, in the manner of an apostle of Christ. In his tractates on the beautiful and intelligible beauty, he speaks of the good as lying in "the beyond," and as being "the source and the origin of the Beautiful";[10] of the soul's intuition as "preceding seeking and reasoning";[11] of vision as inner, mystic, "inwardgazing";[12] and he affirms that "never would the eye behold the sun if it did not become

sun-like, nor would the soul behold beauty, if it did not become beauti-
ful. Let everyone who would behold God and Beauty first become
God-like and beautiful.''[13] Rightly, then, Robert Zimmermann charac-
terizes him as an "ancient romantic" who sought beauty in the divine
and the transcendental, of which worldly beauty is but a reflection.

The idea of the sublime is more clearly discernible in Poseidonius
and Philo the Alexandrian.[14] Longinus, probably at about the same time
as Plotinus, writing "On the Sublime," defines it as "an echo of the lofty
mind." As an example of the sublime style, he quotes the words of
Genesis, as Hegel did much later: "And God said, 'let there be light' and
there was light."

The influence of Neo-Platonism on Christian philosophy, which
need not here be stressed, and the transcendental Christian dogma
could have inspired no other aesthetic category than the sublime in the
religious-minded early Christian age and the age of Byzantium. That the
manifestations of this aesthetic category underwent mutations, went
through phases of grandeur and decline, is only natural. It is not to be
wondered at, then, that the later students of Byzantine art, who realized
the need of examining it "from within," should have had recourse to the
Neo-Platonic precepts and their application in Byzantine philosophy
and religion on which to build their aesthetics of Byzantine art.

The conversion of philosophical and theological teachings, or of
religious creeds, into aesthetic principles is no easy task, however. Two
studies on Byzantine art and aesthetics, which rely for their conclusions
on the Neo-Platonic factor, afford us an opportunity to examine how this
factor could best be used to obtain a deep insight into Byzantine
aesthetics. In the order of their publication, they are André Grabar's
Plotin et les origines de l'esthétique médiévale and Otto Demus'
Byzantine Mosaic Decoration.[15]

II. the philosophy of Plotinus and mediaeval art

(1) Plotinus, says Grabar, heralds the spectator of the Middle
Ages and his philosophy finds expression in mediaeval art.[16] This sen-
tence seems to me incomplete without this supplement: he was also the
last of the Greeks. That, in fact, is why his philosophy finds expression
chiefly in the art of the transitional period of latest antiquity, preceding
the early Christian.

Let me try to prove my statement theoretically first. Plotinus lived

in the third century A.D. He came to Rome from Egypt and taught a philosophy which lent support to those mystic-probing tendencies instilled into the declining Roman state through the Eastern religions. But in his mystic quest, he addressed the pagan world with philosophical, not dogmatic or religious, arguments; indeed, he was himself a pagan, although aware of the existence of Christ. That Christian theology later exploited his philosophy is immaterial to our present purpose.

The philosophy of Plotinus, in any case, brought a radical turn to Greek thought. Metaphysics took the place of dialectics.[17] In Plato dialectic is confined with certain clearly defined bounds, and when these must be expanded to express the super-rational, illustrative myths are introduced for elucidation. The philosophy of Plotinus, on the contrary, deals with all aesthetic and mythological problems in relation to a metaphysical source of Being—the One.

In Plato we have a certain dualism: on the one hand, the Ideas—eternal and immutable—and, on the other, the sensible world which is a representation of the ideal. The two worlds are of course related, with the second subordinate to the first, but how the one issued from the other—the image from the archetype—remains in Plato a secondary consideration.[18]

In Plotinus, however, the source is the One; beyond all predication, amorphous, unconfined, It does not think, does not will, does not act, has no consciousness, nor can we imagine It. But in Its immanence, It engenders its many derivatives by illumination, as warmth emanates from the sun, leaving it unchanged. That is the theory of emanation.

The One first engenders *Nous,* which has duality as being both intelligence and the intelligible; afterward it engenders the Ideas which are both archetypes and forces; then Nature; and, finally, Matter, where there is division and plurality. All is linked by harmony and sympathy. We have, then, clearly outlined a descent from the spiritual to the material, yet along with it a continuous tendency of the material to return to the spiritual. Matter indeed becomes the vessel of this return, for no spirit is wholly immaterial, just as from matter some vestige of spiritual perfection is never absent. Spirit and matter permeate each other. Thus Plato's dualism is bridged, and the Platonic world of Ideas begins to flow. The Idea in its descent begins to participate in multiplicity; that is why in Nature perceptible beauty is an exception. Art, however, purifies the Idea, of which the perfection lies in completeness and in unity. The appearance of the Idea in Matter constitutes the beauty of the work of art—a concept which reminds one of Hegel. The down-

ward flow of the Idea is then checked on its appearance in perceptible beauty; and art, in so far as it achieves this, rescues man from the fall and becomes a religion in that it alone can render the spiritual visible to man's bodily eyes. Man, however, has also inner vision which can reveal to him the spirit in a perfection no longer visible, but in which his intellect may apprehend clarity, goodness, truth, and beauty. If, then, perception is the lowest rung in the ladder of gnosis, with intellectual activity above it, and apperception above that again, we have in ecstasy the topmost rung—for ecstasy comes of intoxicating participation in the One.

Plotinus has therefore rightly been called an ancient romantic. He too, like the later romantics, considered beauty to be an image of the divine, since he affirms that it springs from the higher source—the One. The soul of the seer is lured by the beauty of the object of vision, because the soul unknowingly sees itself in it, as the child is fascinated by its own reflection, which it does not recognize, in the mirror. But, as Theodoracopoulos rightly observes,[19] Plotinus, in contrast to the Romantics of the West, considers that the infinite, too, should be accepted as a form, even though without relation to the finite. He maintains that the soul cannot grasp the idea of formlessness and is "possessed by form from beginning to end." Theodoracopoulos thus recalls Philebus, who affirmed that the Universe is constituted by forms, and he adds: "The reasonable nature and the beauty of the world is not a projection of subjective cognition, in the sense of subjective idealism, but an a priori structure of the universe, prior to all seeking and all reasoning."[20] He continues: "Where beginning and end call for one another, there we have the whole simultaneously presented; this, in fact, is not the principle of mystic search but the law of Greek art."[21]

If Plotinus, then, is the herald of the Middle Ages, he is also the last of the Greeks. This strange admixture in him of mystical search and of a dominating sense of beauty gives us the peculiarly Plotinean aesthetics. Of course, his is an aesthetics founded on the mystic elevation of the soul, but on confronting the spiritual it is beauty which charms him; and it is through beauty that he attains the spiritual realm. He pursues mystical ends by intellectual means; and because he is led there mainly by his aesthetic faculties, the artistic element in him can hardly be separated from the mystical.

No philosophy has given such prominence to the aesthetic factor as has that of Plotinus. And however much his aesthetics may unconsciously aspire to the sublime, it is still impregnated with the sense of

beauty. The art he seeks yearns for the sublime, but is not yet sublime. And a romantic art, like that of the age of Plotinus, could not be so (unlike early Christian, and particularly Byzantine art, which has a transcendental character). Before art could turn to the sublime completely, it had to adopt another attitude—indifference to, if not renunciation of, beauty—an attitude which Christianity, influenced by Eastern models, brought to art and which it introduced also in its philosophy from the moment it ceased to hide under the pagan garb.

Of course, the philosophy of Plotinus was later used as a pedestal for the Christian dogma. But there are fundamental differences between them, of which the main ones are:

(a) Plotinus' One is impersonal; the Christian's God is a Person.

(b) The One generates by illumination; God creates because He wills it and out of infinite love for his creatures. Nature to the Christians is irrational.

(c) The highest rung of cognition, to Plotinus, is ecstasy. The experience, however, is a personal conquest and must again and again be renewed in order to participate in the One. For the Christian there is revelation, which, if by a divine act of grace it be vouchsafed to him once, is enough for his permanent enlightenment as long as he himself also endeavors.

(d) In Plotinus, art, which makes the Idea perceptible, is a means of preventing man's fall. Conversely, in Christianity, art is not a means of salvation, although it helps man to elevate himself by representing symbolically the Passion and the Saints, who intercede on our behalf when we worship them in their icons.

(e) The idol of the pagan has value in itself; the icon of the Christian has not, except through the spectator. In Christian art, the active participation of the individual in the aesthetic act is attained, as was sought by Plotinus. But the artistic act is not sufficient in itself.

(f) In Plotinus every manifestation of the spiritual in art is redolent of beauty. In Christian art, however, the need of presenting transcendental symbols and beatific conditions makes it sublime and intensely expressivistic, to the point of being indifferent to beauty (although in Byzantine art, even in its extremest manifestations, the Greeks preserved the element of beauty). But let us now come to examples.

(2) The mediaeval anti-classical forms, more than any others (says Grabar), correspond to the theory of Plotinus.[22] His ideas exercised no influence on his immediate environment, but found response in the early Christian age.[23] Grabar brings forward as evidence the classicist

revival led by the Neo-Platonists, an artificial imitation of the past which prevailed in Rome of the fourth century, as the low-relief diptych of the *Symmachs and Nicomachs* shows.

Surely, however, this turn to the past is no proof that Plotinus' views were ignored by his age; but, on the contrary, the natural outcome of his views—the outcome of a mystical quest which, dominated by the idea of the beauty of form, strives between two irreconcilable trends. I think with G. Rodenwaldt[24] that the art forms of his own age are those most in keeping with Plotinus' ideas because in them we find a strange combination of mysticism and Greek morphology—an art romantic in spirit, but eloquent of beauty in form, as in the diptych above mentioned. It is as characteristic of Neo-Platonism to be mystic-searching yet pagan in its faith as it is of its art to be romantic in spirit but classicist in form. That is precisely why it did not exclude a return to form-dominated classicism, as it did not exclude the turn of Christian art toward the transcendental when its inward-dwelling tendency gained supremacy.

This turn inward is foreshadowed in examples of Christian art in which the spiritual expression is undoubtedly intense, but in which—while the external symbol is still pagan (as, for instance, in the Orpheus in the Byzantine Museum at Athens—the expression is necessarily subordinated to beauty of form. However, any work in which the influence of the East is immediately obvious, and in which the symbols are purely Christian (as in the well-known sarcophagus of Ravenna with the Magi), at once comes near expressivism of the kind we find later in Byzantine art. The movements become intense, the bodies almost levitate, the background is anti-naturalistic and infinite in its monotony, while the whole takes on a transcendental character.

I would say the same of the Tetrarchs or Four Moors of St. Mark, in which Grabar sees archaism and a retreat from the concept of space, perhaps because he brings to the work a naturalistic conception of the attitude of the bodies and the presentation of space. In the sculpture of classical art, of course, the attitude of the statues indicates bodies which are in harmony with the mind. In the Tetrarchs, however, merely the "fertile" moment that refers to a spiritual condition, which the bodies by their unnatural position help to express, is presented. (Let us observe, incidentally, that these bodies show movement and that movement in itself indirectly suggests space.) Finally, Grabar's observation on the sarcophagus of the philosopher (probably Plotinus) in the Lateran Museum, that the philosopher's feet are presented in perspective be-

cause the low relief unfolds along what is almost a single plane, proves nothing so well as the important fact that sculpture is beginning to give way to painting, which, with its two-dimensional surfaces, is by its nature the more suitable medium for expressing spiritual conditions and transcendental visions and for depicting dematerialized bodies. Grabar's efforts to derive from Plotinus the inception of a new perspective suitable to express the transcendental and to explain through this the composition of early Christian paintings are exceedingly farfetched, for in Plotinus there is no inkling of any such idea.

(3) It is not Plotinus' attitude toward the art of his age which concerns us, says Grabar, but his manner of looking at a work of art and the philosophical and religious value he attributes to vision.[25] To Plotinus, the work of art (Grabar says) is not only the mirror which reflects the original as an image, but also a work which receives the influence of the universal soul. It partakes of it, namely, according to the law of universal sympathy.[26] Consequently, Grabar concludes, naturalistic imitation is, according to Plotinus, artistically inferior; and before the artist can learn how to treat representations of another kind, he must learn about the nature of vision.[27]

In a tractate of the Second Ennead entitled "How Remote Objects Appear Small," Plotinus asks why faraway objects dwindle and those near appear in their true size. And he explains that this happens because size dwindles to the degree to which colors fade. Then, no longer able to distinguish their parts, we can no longer estimate the size of the whole by comparison with them; so too, with a hill looked at from a distance. From this Grabar concludes that Plotinus, in seeking to discover the true size of things, wants them on the first plane, on a single plane, and consequently debars geometrical perspective and aerial perspective, and puts in the place of the tints of distant objects local colors.[28] Plotinus, however, mentions neither perspective, nor single plane, nor space, nor local colors. Grabar's conclusions reflect only his own determination to explain a posteriori through Plotinus an art with whose technique he is himself familiar. But we could by this same method explain through Plotinus other arts too, with similar anti-naturalistic techniques— explain perhaps even contemporary art, which discards perspective, several planes, and chiaroscuro, and yet is not Neo-Platonic. Moreover, assuming we can thus explain mediaeval painting, how are we on the same principles—without space, given one plane and the help of local colors only—to explain mediaeval architecture?

Grabar supports his argument on the grounds that Plotinus, in all

he says about vision, seeks the true size of objects. But Plotinus does not make their size depend only on distance. This is evident from his assertion that, even when an object is near, a fugitive glance which does not catch the details will not allow us to assess the total by the parts. Plotinus thus wants us to guard against the deceptive impressions of sight, in a philosophy which lays much store upon subjective elevation, and is bent, in consequence, on protecting the mind from illusions of sight and from superficial impressions of participation in the object.

Not only in the case of architecture but also in that of painting, the single-plane principle is utopian, as is the refutation of space and mass. No matter whether a painting's representations are two-dimensional; no matter the degree to which in anti-naturalistic painting the accentuation of depth with perspective devices is avoided: space is always indirectly suggested by the gestures of the figures and the difference in colors and in scale, which has the effect of making some of the figures appear nearer and some more remote. The impression is created of several planes and of life in the picture. The depth here, if it is not presented as natural, is suggested as ideal.

The difference in the size of the figures in a composition of early Christian art is not due to a sense of perspective, but rather to a sense of proportion which impels the painter to make the more important figures larger. He does not look outwardly, but uses his inward vision. He appraises and ranks. So it is that on the pedestal of the obelisk of Theodosius, [29] the emperor and his courtiers are on a larger scale than that of the populace below. Furthermore, by superposition an illusion of depth is created. One gets the impression, in fact, that the spectators at the Hippodrome are drawing near one because the superposition is accompanied by more prominent sculpting, the higher the heads—or in reality, the further back they are. They thus seem to be leaning forward. This device of magnifying the remoter objects is assumed by Grabar to be a reversed perspective—as though, that is to say, the spectator is intended to look at the work from the emperor's gallery. [30] And he thinks that space and the mass and weight of the objects are ignored.

But let us see where Grabar derives the theory of reversed perspective.

(4) Plotinus (he says) denies that the impression of vision is created in the soul and stamped there, and maintains that it is created where the object of vision stands; the soul, therefore, sees without being impressed by the object of vision like the wax by the seal. [31] From this Grabar concludes that the artist, necessarily heeding the precepts of

philosophy, inevitably produced a reversed and ray-like perspective, since he saw the picture as though from the point at which its reproduced object stood, and not from his own point of vision.[32]

Reversed perspective, I venture to suggest, is a figment of the art critics' imagination. From the time the Renaissance worked out a system of perspective which, because it obeyed scientific laws, won general currency, art critics have considered it an obligation to provide the anti-classical arts with its counterpart—a reversed perspective. Their assumption is illogical because: (a) the fact that Renaissance painting employs perspective (whose correctness, incidentally, is questioned today[33]) does not necessarily entail a reversed perspective for the earlier Christian art; (b) perspective as a system is not an end but a means in art, to be employed or not at will, since art can exist without it; (c) the paintings of the Middle Ages testify to the fact that they at no time follow a definite system of perspective, whether orthodox or reversed. Grabar indeed admits as much, but considers it an undecided attitude.

Are there, one wonders, paintings with a decidedly reversed perspective? Grabar mentions one that might at least seem so, and we would do well to examine it because it might easily mislead us. It is a fifth-century ivory relief, showing Christ with his disciples seated around a table.[34] On the face of it, the composition might suggest reversed perspective because Christ, who is in the background, is larger than the disciples, who dwindle in size as they near the foreground. In fact, however, the four apostles in the foreground are all on one plane, as the feet of their seats testify. The table is also on this same plane. The rest of the disciples are drawn about a semi-circular bow, perpendicular to the line of the floor; there is, consequently, no perspective system here. Grabar notes these imperfections,[35] but imputes them to the copyist's lack of skill, his inability to show space and perspective flight. "The whole composition," he says, "has been projected on a single plane, as the curtain which falls behind the head of the Apostle proves."

To my mind, the impression derived is not of one, but of numerous planes—at least one for each pair of apostles opposite one another. And in art, it is the impression that counts and not the scientific accuracy of the composition. In this work, for instance, the four apostles in the first row do not seem to the spectator to be on the same plane because they are caught up in the whole composition, which suggests a circle to our imagination. If, however, Christ, who is in the background, had been drawn smaller than all the disciples, according to orthodox perspective, he would not have been the most prominent figure in the composition.

He has been made larger in proportion to his eminence and all the rest are therefore subordinated to his person. The natural sizes of the back- and foreground figures cease to seem reversed and appear true to the artistic imagination; and, as in logic two negatives make an affirmative, to deny here the reduction of Christ's proportions is to postulate his eminence. On the same principle, the Almighty in the Byzantine churches is larger than any of the other icons, although he is placed higher. Conversely, Leonardo in *The Last Supper,* in order not to lessen the eminence of Christ in perspective, made the length of the table face the spectator and was thus forced to present all the apostles on one side of it. Other artists who painted the Last Supper with perspective accuracy in placing Christ, the most eminent figure, in the background, where he appears the smallest of all, have often been forced, in order to enhance it, to exceed his scale or to place over his head clouds and angels and employ other—often ridiculous—devices.

Reversed perspective can not well be explained as due to the fact that the painter transfers himself to the object he draws, acting on Plotinus' principle that he should participate in it. Were he to do so, his bodily eyes would see nothing; as for what he would see with his inner eye, that is not to be reproduced by reversed perspective alone. Moreover, Plotinus tells us that before we can become conscious of the ideal intellectual vision, which at the moment of impact practically deprives us of our faculty of seeing, we must successively detach ourselves from the object of vision, and again submerge ourselves in it. Besides, Plotinus himself insists in his tractate on vision that two things should be distinguished—the seer and the seen.

As an example of ray-like perspective, Grabar brings forward a miniature in which the choirs are drawn ray-wise, although incidentally; the composition also shows examples of other conflicting kinds of perspective.[36]

I consider that the so-called ray-like perspective is no perspective. In the first place, man never sees all around, as though pivoting on a center. But even assuming the artist to give us a bird's-eye view of persons sitting in a circle, there will still be in the picture an upper and a lower part; and this is not the case in the work under discussion. If, finally, we concede that the point of vision coincides perpendicularly with the center of the circle, then we would have an almost geometrical projection of the bodies. Their heads would appear to rest directly on their shoulders, they would be practically trunkless, and only their feet would emerge, unless they were lying flat in a circle. And, indeed, here

the seated figures frontally presented are lying supine in a circle forming a rosette. There is therefore no question of perspective here, but of an ingenious, persuasive composition which, being schematic, has a decorative character. Before we enjoy the picture and its content, its geometrical pattern impresses us.

Visual order in mediaeval art, then, depends on a gradation of values which is not concerned with the perspectival arrangement of objects in outer space but with interpreting them to the inner understanding. It is content with a plausible presentation, as long as it conveys its vision to the imagination. That is why the painter does not record what he observes standing immobile, from one point of vision, but as though he had been moving about observing from several angles. He grasps a scene, then looks around, then up, then down, and so he interprets rather than records. (Contemporary painting again has spurned academic perspective because the attitude of art toward the physical world has changed. It is no longer interested in the naturalistic imitation of the phenomenon, but in displaying its inner significance and potentialities.)

(5) The illumined eye, according to Plotinus, glancing at the outer light and the colors, which are themselves modes of light, distinguishes the existence of the dark and material depth hidden below the colored surface. From this Grabar concludes that the picture aspiring to the presentation of the *Nous* must abolish depth and shadows and confine itself to chromatic surface only.[37]

But even could this be accomplished, how would it ensure the representation of the *Nous,* the Reason which Plotinus seeks? "And the depth of everything is matter, which is, consequently, all darkness. In that light is Reason and the Mind sees Reason."[38] But how is light to be presented? The fire to Plotinus is beautiful because it belongs to the "order of Kind,"[39] being a very fine matter. But is a red color alone enough to convince us that it is a fire? And again, did we grant that in mediaeval painting we are confined only to a chromatic surface with local color effects, the variety of colors alone with their different degrees of intensity would in themselves suggest plastic depth. Nor can masses be dematerialized by the mere subtraction of matter and abolition of shadow. A spiritual quality must also be brought into play. Mediaeval painting did not do away with shadows, but it did not render them naturalistically and as coming from a single source of light. Thus it led our vision from external appearance to inner import.

(6) The physics of Plotinus, as Bréhier has rightly characterized it,

is spiritual and not mechanical. In his physics, then, the parts are not the elements of the whole, but its products. Therefore the idea of the whole is more real than the idea of its parts.[40] Hence Plotinus affirms that the world becomes lucid to the spirit. The eye, flashing its inner light, meets the outer; the one becomes transparent to, and interpenetrates with, the other. That is why Grabar, commenting on the Doura fresco,[41] finds that faces and objects in it merge into one another, and that the objects touching the ground without standing on it lose their weight and mass, so that an insubstantial, transparent world is thus created.[42]

The merging of bodies into one another implies disintegration of form; but Plotinus categorically asserts form throughout. Besides, however much the bodies may be dematerialized, they live in space and have plastic depth—both impressions suggested indirectly by the difference in tones and scale and the movement of the forms. The spirituality of the world here presented, then, is achieved by such spiritual means as expression and symbolism, and not by the subtraction of matter. As Plotinus himself says in his tractate on intellectual beauty, "All is transparent, nothing dark. Every being is clear to, and within, every other; for light comes to light and, there, the sun is both all stars and each star; and each and all the stars are the sun. There too, each ever comes of all, and is at the same time each and all." Such sublime concepts, however, are not to be brought down to the sphere of the material, nor is the view warranted that they can be reproduced with the aid of external means only.

As Plotinus put the whole above the particular, so in anti-classical art the parts lost the self-sufficiency and completeness they had enjoyed in classical art, in which each part separately represents the whole. In the former art, the composition follows the monarchical law of submission instead of the democratic marshaling of parts to be observed in classical art. The parts are subordinated to the whole, often represented by a dominant element, instead of being, as in classical art, coordinated with one another. The law of unity in variety is preserved in both cases, but classical abstract beauty gives way to characteristic beauty in anti-classical art.

(7) Finally, to Plotinus, total knowledge of a subject does not proceed from a succession of propositions about it. Knowledge must possess the whole subject and be identical with it. Art is an instance of this, since its knowledge includes the very prototype it imitates. The wisdom of the gods is not propounded in propositions but exposed in beautiful images. It is expressed integrally, as, in the Egyptian script, a

single symbol expresses a whole idea, in contrast to the Greek or Latin, which puts several letters together to compose a word.

Art provides with its pictures direct consummate knowledge, thanks to the intellectual vision. This kind of knowledge is not reasoning, but a sort of contact, or ineffable intellectual touch—an action antecedent to the birth of reasoning. Grabar concludes that, as a result of this theory, art rejected imitation, which stressed the appearance of things or their proportions. Plotinus seeks, Grabar reminds us,[43] not imitation of, but participation in the object of vision and, through it, in the One.

Yet art of the age of Plotinus and Christian art later did not reject imitation. In fact, in a sense it became more realistic than its predecessor had been, since both sculpture and painting—particularly the latter—now focused their attention on portraiture.Christian art of course combated its realism with expressivism and reproduced its subjects' characteristic beauty, just as classical art had opposed idealism to realism, and rendered abstract beauty. In any case, art showed a tendency to turn inward. Beyond pleasing color and good proportions Plotinus sought in composition the unity of the idea.[44] But in order to make the beauty of the Idea evident, Plotinus demands of the spectator unity of consciousness, so that all the faculties of the soul take part in his judgment; in aesthetic judgment, the contemplation of the Good and the True comes into play. In this he differs from Plato. Kant, however, is very much of the same opinion.[45]

Now, according to Grabar, the frontal attitude in art was a result of Plotinus' demand that the spectator should stand before the statue of God, face to face, eye to eye, in order to realize participation. But Grabar, finding no precedent for the frontal attitude in Eastern art (other than in the Doura representations), is puzzled. In my opinion, its absence from the earlier and appearance in the later art merely proves (a) that art each time creates for itself the forms it needs, without always drawing on antecedents; and (b) that the frontal representation was most likely created by the artist without reference to the letter of philosophy, and certainly without any intention on his part of applying its precepts prosaically in his work.

In interpreting Plotinus, we should guard against converting his metaphysics into physics, but treat it as such; we ought, above all, to keep in sight the sublime feeling running through his aesthetics. (And this must surely have been the spirit in which artists approached him in his day.) Otherwise, we are in danger of ascribing to Plotinus intentions

and suggestions concerning technique of which he himself must have been utterly unaware. The aim of an aesthetic philosophy can never be to offer suggestions in technique, particularly in the case of the ancient philosophers, who did not condescend to deal in such matters. Therefore, despite the importance which Plotinus attributes to beauty, indeed precisely because of it, we should not view his aesthetics as the science it is today—a science treating of art in the main. Plotinus was interested in beauty chiefly as a vehicle to the spiritual domain.

Of course a change in the artistic technique of an age is invariably the result of a shifting in the view of the scheme of things, the unconscious adaptation of art to the prevailing world theory. And in our own age, it is our world theory to which we should look for the explanation of our art, which, in abandoning perspective, in disclosing many angles of vision, and in employing local color effects, has surpassed impressionism and now, seeking the structure of the world's patterns, attempts to analyze their essence.

III. theory of magical realism in Byzantine art

If Grabar has put a materialistic construction on Plotinus' metaphysics, Demus has done the same for the theological tenets derived from it. The result is that he too has misunderstood Byzantine aesthetics. Let us examine some of his theories in this connection.

To begin with, Demus explains how, during the iconomachy, Theodore of Studium and John of Damascus founded the theory of the icon in relation to Christian dogma. The image, according to the Neo-Platonic theory of emanation, is a product of illumination; the icon, therefore, partakes of the sanctity of its prototype. If it differs from it according to its essence, it is identical with it according to its meaning. The relation between the prototype and its image is analogous to that between God the Father and Christ His Son. The icon is as authentic in its representation of the Divine as is the reproduction of the Passion during sacred liturgy.

(1) From the above Demus concludes that the painter "exercises a function similar to that of the priest."[46] But, in asserting this, Demus misleadingly overshadows the painter's purely artistic ends by the religious character of his work. In painting his sacred subject, the painter is as far from "exercising the functions of a priest" as is the priest from exercising those of an actor in officiating. Of course, the painter approaches his sacred subject with faith and reverence: he fasts and prays

before devoting himself to its representation, then sinks into the obscurity of the anonymous artist. But though he feels his mission to be sacred, his ends and means are primarily artistic. If he fails as an artist, he has failed as a symbolist too. His symbols must have artistic merit, and are intended to appeal, not only to the devout Christian, but also to the profane and the non-believer. The priest's symbols, on the other hand, without intrinsic artistic value, are meaningless to any but the believer to whom the priest exclusively addresses himself.

(2) Demus then goes on to say that the icon partakes of its prototype's sanctity; and veneration is due to it only because, through it, this worship passes on to the prototype.[47] But were the icon a purely priestly symbol, without art to propel imagination to a spiritual sphere, pious worship might have sunk to abject idolatry. The icon, in other words, helps to uplift the mind of the worshipper only so long as it remains primarily an artistic medium. And that is what Byzantine art achieved. (Of course, had the icon been beautiful, there would have been the danger of the spectator's falling in love with an idol; Byzantine art, however, was not concerned with reproducing physical beauty, but with conveying the sublime experience.)

(3) Now Demus suddenly introduces an anti-religious and foreign element, which he calls "Oriental"[48]—namely, the element of magic. Now, by magic we understand those arts which pretend to minister to man by the assistance of spirits and forces of nature. Magic is undoubtedly associated with Neo-Platonism and the East. It may even be said to have played a part in the lowest scale of the religious beliefs of the faithful, but what part it played was unofficial, and certainly not sanctioned by the Church; for the results would be catastrophic to religion, as they would be to art too if art did not take precedence over magic.

When Demus, then, describes the relation of the worshipper to the icon as a magic relation, we may not unjustifiably infer the implication that the icon becomes to the worshipper a vehicle for attaining base ends by the propitiation of such demons or other supernatural powers. When, furthermore, he characterizes the icon's identity with its prototype according to its meaning as a "magical identity"[49] (although he stresses that—in contrast to the idol, which has value in itself—this identity "exists only for and through the beholder") he little realizes that that way lies pure iconolatry. Finally, he speaks of "magical realism"[50] in Byzantine painting, achieved by the communion of spectator and icon, in the real space of the church. And he takes this as the guiding principle

in both the composition and disposition of the icons.

The pursuit of so materialistic an end, however, would certainly have spelt inartistic results; and this is far from being the case in the Byzantine church. Let us, then, analyze the inferences Demus draws from his premise and see whether it is not in fact untenable.

(4) "The image," he writes, "must possess 'similarity' with its prototype";[51] a frontal attitude is therefore needed to make this similarity visible and comprehensible and to establish the relation with the beholder. The profile view is reserved only for "figures which represent evil forces . . . like Judas." But because in large compositions, where the figures must converse with one another, this device would be awkward, the Byzantine artist resorts to the three-quarter profile. The representations thus become unnatural and rigid, and in order to avert the impression that the gestures meet at a point outside the picture plane, the ingenious solution is discovered of placing them in niches on curved surfaces and in domes, so that they face one another as they communicate through the physical space where their movements meet.

There is no depth behind the picture plane. Fictitious space[52] was superfluous in the Byzantine painting since it "enclosed the real space" in front of it, where the spectator stood, "not so much a beholder as a participant."[53] To Demus, the gold background does not stand for infinite depth, but "is left empty."[54]

Now, surely, if the spectator's impression is that the figures move only in the real space in front of the icon, this would have the effect of making the church seem like a cage in which the figures are imprisoned. In point of fact, neither Byzantine painting nor mosaic (with its monochrome background utterly bereft of a landscape) is devoid of fictitious space. Both must inevitably place their representations somewhere in space, and if they do not reproduce this space naturalistically (i.e., directly), they suggest it indirectly. In Byzantine painting and mosaic, the figures themselves do so through their gestures, their difference in scale, their gradation of tones, and variety of colors. Even their monochrome gold background with its scintillation gives the impression of ethereal, celestial space and diffused light, in which heavenly beings hover. And in thus transporting the imagination, Byzantine mosaics and painting, far from encaging the figures in the church, seem in fact to push back its very walls in an ideal plane.

Again Demus, in letting the Byzantine picture partake of the space in which the spectator moves,[55] does away with the aesthetic distance which even sculpture—placing its statues in physical space as it must

do—creates between spectator and statue; so that in imagination the spectator is transferred to that ideal space in which alone this ideal form could live. Painting, if anything, makes this distance more pronounced, since of course it achieves it more easily, thanks to its two-dimensional surface, which makes of the representations almost unsubstantial wraiths, immaterial reflections of reality. If the aesthetic distance does not exclude the impression that the figures move in front of the picture plane, this still does not make them move in the real space, but in a space again ideal, which is the illusion of a heightened imagination—not the result of the figures' placement in a niche. An instance in point is a mosaic of the Annunciation in Daphne, in which the "movement not only links the figures into a unit, but also creates space in the picture. The concave surface of the squinch itself contributes to this effect, since it apparently diminishes the distance between the two figures, allowing us for a moment to imagine that the Angel is actually flying through the niche's space."[56] Art, in other words—as, bringing the divine down to earth, it elevates man to the divine—creates an ideal sphere in which the two make contact, helped by imagination.

(5) Pilgrimages to the Holy Land and crusades, Demus maintains, found little response in Byzantium because the devout had, in the iconographic scheme of his church, the three zones representing (a) Heaven; (b) the life of Christ (and so "the magical counterpart of the Holy Land"); and (c) the earth with the Choir of Saints.[57]

The Byzantine worshipper had, therefore, according to Demus, little need of pilgrimages and was content with contemplating the icons because, on the one hand, these were not regarded as "pictures" but as "magic realities"[58] and because, on the other—and in contrast to the West—time is not construed historically but symbolically from the Byzantine iconographic disposition in the church.

Such a symbolic view of time in Byzantine iconography would of course entail a similar view of space; and this would seem to contradict Demus' earlier statement that the icons move in the real space of the church. If the worshipper's imagination surpasses the boundaries of time in his church, it must in the same way surpass those of space. However this may be, the above is a one-sided view in Demus, who is inclined to overlook the fact that the icon, a purely religious work though it is, is at least as much a work of art as it is a religious symbol. And the difference between a purely religious symbol and a purely religious work of art need scarcely be emphasized.

The reason for the lack of response to crusades in Byzantium and

the passion for crusades in the West is to be sought, I suggest, in their different conception of religion. The passion for crusades in the West was also partly political. Byzantium, according to Greek tradition, strove for the Christian creed as an idea remote from practical considerations. It analyzed theological problems and with its objective outlook risked destruction in raising the icon controversy, whereas the West, following the Roman tradition, was concerned with religion chiefly in so far as it affected the individual and his life.[59] Bréhier[60] writes that the West put the emphasis on subjectivism, on man's individual relations with God, and on the importance of practical acts, and that we find this point of view marking the movement which sprang from Augustine to this day.

In this mentality lies the explanation not only of the crusades but also of the Western preference for sculpture to painting, as also of the didactic and tortured scenes, the monsters of the *speculum universale,* and the chronological sequence in narrative in the mediaeval Western cathedral.

(6) Demus explains that the West, because of its historical taste for narrative, preferred the basilica, where there is a beginning and an end, "with its definite direction parallel with the unrolling of a story." Byzantium preferred the building centralized around a dome, "which has no strongly emphasized direction," and where the glance therefore wanders round and round and the icons can be disposed in hierarchical order from above downward, in three zones—Heaven, the Holy Land, the Earth.[61] So the church becomes a symbol of the world, "an ideal iconostasion."[62]

Byzantine architecture is essentially a "hanging architecture,"[63] Demus further asserts, and is "in complete accord with the Byzantine hierarchical way of thought." Its columns appear like "hanging roots." Conversely, Western architecture proclaims the principle of organic growth, and the Greek temple the idea of perfect equilibrium of forces.

Now, the columns of Byzantine architecture, although lacking ribs and entasis, do not seem to me to resemble hanging roots. What in fact happens is (as I have elsewhere stressed[64]) that in Byzantine architecture carried members are aesthetically superior to supporting ones; yet we are spared any sense of discomfort in witnessing this because the supports carry only arches and groin vaults, which by their curves lure the eye ever onward and thus make of the columns not, as it were, permanent pedestals for burdens, but only momentary resting places, whence they are shifted elsewhere. In other words, we lose the

impression of burden and support, as well as of pressure and bending, as we become aware mainly of cohesion and rigidity in mass. Moreover, in an architecture by nature monolithic, we tolerate thrusts and pierced surfaces. Finally, projections and plastic decoration have been abolished to let plain surfaces and lines of edges that demarcate their limits dominate, so that the masses seem to have shed their weight and to be dematerialized.

Nor is Gothic, in contrast to Byzantine, architecture organic in the sense Demus attributes to this word, thereby suggesting that Byzantine architecture is unorganic. The high supports of Gothic cathedrals rise abruptly, branching out into piers, which seem almost to carry the clouds. That is to say, here, in contrast to the Byzantine church, the burdens are aesthetically inferior to the supports, whose balance is aesthetically justified only by the ribbed formation of the carrying skeleton and is technically possible only because of its exterior buttresses.

Here again, the difference is not to be sought in "hanging" or "organic" architecture so much as in an unworldly and a materialistic spirit, respectively, which pervaded each architecture—in two varying conceptions of religion which, in the Byzantine church, found shape in restrained loftiness and harmonious proportions, in the Gothic, in an unrestrained fervor that displayed technical and material achievement. With the light flooding its dome, a symbol of the sky, the Byzantine church draws the spectator's thoughts upward to God. It achieves greater spirituality than the Gothic, in that, far from annihilating the spectator with its bulk, it helps him to elevate his mind. The Gothic church with its exaggerated height is in its very proportions expressivistic and overwhelms the spectator. Placing its representations in a succession of ascending strips, it little heeds whether the eye can see them at that exaggerated height. In the Byzantine church, on the contrary, the higher its pictures are placed, the bigger they are painted.

The Byzantine artist, in placing his more prominent figures higher and therefore proportionately enlarging them, reverses the scale of optical diminution and surpasses it, in order to preserve the essential scale of values appropriate to his figures. Thus, the Almighty is drawn on the scale of God. This indeed is in keeping with the Greek tradition, which placed in the ancient temple an oversize statue of the god.

Of course, this optical reversal in Byzantine iconography presupposes the etherealizing tendency of Byzantine painting, for were the Almighty, drawn as He is on a vast scale, naturalistically presented in the concave dome, the picture would have been as intolerable as are the

Baroque forms of the divinity and of angels. But here, two-dimensional as the figure is, the concavity of the dome helps it lose its bulk and so become an ectoplasmic body, precisely as the church, with its de-materialized mass, becomes a spiritual edifice, "not made by human hands." By this reversal, then, of the scale of optical diminution in Byzantine iconography, the realm beyond the sky is brought near the spectator, and the Almighty rules over church and spectator without annihilating them. To all this the concentration of light in the dome also contributes.

(7) The arrangement of the icons hierarchically from above downward, according to prominence both of size of icon and sanctity of figure, and their emplacement in curved surfaces brought with it, ac-cording to Demus, an "anti-perspective optic"—"optical principles aiming at eliminating the diminution and deformation of perspective."[65] He therefore considers that the disproportionate enlargements of iconography are optical corrections for the benefit of the spectator standing below, precisely as in the case of ancient statues. It is the tradition of statue-making being handed down in a "negative" perspec-tive.

Yet Byzantine presentations, even seen from below, still show distorted proportions and unnatural attitudes and gestures; their charac-ter is still expressivistic. An art as developed as the Byzantine was certainly well aware of the fact that height and curved surfaces distort the representation, and it naturally employed what devices it thought necessary to overcome these difficulties each time. But it was never the object of such devices to present naturally proportioned bodies. Moreover, such could not have been the aim of Byzantine art, for then its presentations would have depended on a single given angle of vision. In Renaissance and Baroque art, where the perspective did depend on a single angle of vision and which achieved realism, the representations seem distorted and unnatural as soon as the spectator moves from the set single point, usually marked on the floor of the central nave.[66] In the Byzantine church the pictures appear unnatural from everywhere be-cause they do not aim to appear natural from anywhere.[67]

Being a Greek art, Byzantine painting shows its wisdom in avoid-ing mechanical systems which, useful as they may be to science, are of little benefit to art. And if the system of perspective did in fact prove useful, it did so only to the art of the Renaissance, which was naturalistic and whose criteria we may not apply in judging an art so wholly different from it as the Byzantine.

(8) Demus affirms that the Byzantine painter never "depicted light as coming from a distinct source, but used real light in the icons."[68] It would have been more to the point to have said that an anti-naturalistic art has little need to confine itself to a single source of light in the picture, and therefore uses several (as does, in fact, art in our own day). This, however, does not mean that it uses the real light outside the picture. Demus seeks the cooperation of real light in the Byzantine picture as he seeks that of real space.

Demus goes on to say that sometimes, when there was not enough natural light, "a special kind of modelling was executed which recalls the inverted tonality of photographic negatives." The method gained currency in Paleologian painting, he tells us.[69] Surely, then, the very fact that Paleologian painting adopted the method wholesale, irrespective of the adequacy of lighting, vitiates the theory that it was employed only where real light was wanting. It would seem to prove rather that the method of inverted tonality was from the first a pictorial device and not a way of combining artificial with real light. But in St. Sophia, too, which Demus mentions as providing an especially interesting example of his theory, works with negative shadows appear not only in isolated points where light is poor but also in several groups of pictures placed at points where there is ample light. There is little need to attempt to justify inverted tonality by an alleged inadequacy of natural light; the introduction of this artifice is merely a note of impressionistic illusionism in an art which, contrary to the general belief, was full of ingenuity and had an aversion to uniformity and to system.

Moreover, we have seen in the example earlier quoted of so-called reversed perspective that such inversions in art often establish a thesis, as in logic the negation of a negation. In refusing to imitate the physical, the painter may be said to reject that which denies the spiritual; and a transcendental art is justified in thus refusing imitation if it is capable of creating another world in place of the physical—a self-sufficient, consistent, and harmonious world which fills all the aesthetic demands of the spectator.

(9) In modeling the Byzantine mosaic, two techniques are simultaneously employed, the technique of grading and that of sharp contrast.[70] Some have attributed these different techniques in the same work to an earlier and a later period, some to different influences on the contemporary artist. Demus cuts the Gordian knot by attributing it to technical reasons. The size of the mosaic, he maintains, determines whether or not gradation of colors is permissible, for if the artist adopts

the technique of gradations, he must bear in mind the limited range of shades of each color, and remember that he cannot afford to exhaust prematurely the whole range of shades at his disposal along the outlines of the forms.

Technical reasons certainly to a large extent decided the choice of technique, but I feel that the final decision rested with the artist; his initiative was not so much conditioned by, as given free play in, various factors—the height at which he should place his work, the light which would fall on it, the material he was using, the figures he had to paint, and chiefly the style he intended to give his work. Byzantine art provided a wide field of activity for individual conceptions—hence its mutations and infinite variety even in one and the same work.

(10) Paleologian art, Demus asserts, in the absence of niches in which to place its icons, painted them in the picture; in order to suggest the real space contained in such niches, it introduced architectonic features and curved thrones. It also "suggested space in front of and below the picture plane," a technique strongly reminiscent of the monumental paintings of the classical Byzantine era, when the beholder communicated with the icon through physical space. In describing the Paleologian painting as reminiscent of that relation between picture and beholder, Demus implies that the relation has now weakened; and he goes on to say that the "process" (of suggesting space in front of the picture) "goes so far that hands, feet and garments actually overlap the bottom of the frame"; figures seem to be "precipitated out of the picture into bottomless depth."[71]

In the first place, in classical Byzantine architecture, it was not the niche only, but the whole church which enclosed space. Second, in view of the fact that most of the icons were placed outside the niches, and that the niche was in any case peculiar only to the octagonal type of church, its absence from Paleologian architecture could not have been so much felt that it had to be imitated in painting. Admitting the niche, like the curved throne, in the picture to be the most characteristic architectonic form of a cavity enclosing space, I would then reverse Demus' sentence and say, not that Paleologian painting missed the niches of the church, but that it borrowed them to enhance its own fictitious depth.

The overlapping of the frame is to be seen also in classical relief work. It is an impressive way of eliminating the frame's limits and of stressing the continuity of space in front of the picture with the fictitious space behind. But here again, the space in front of the picture is

suggested as ideal, owing to the aesthetic distance art creates between the work and the spectator. Once that distance is lost, the work ceases to be a work of art; incapable of transporting our imaginations, it appears to us as an absurd and inadequate imitation of reality.

In the Byzantine paintings in question, there is no suggestion, as I see it, of figures being precipitated beyond the frame into bottomless space, but a suggestion of expanding fictitious space, which unfolds both in front of and behind the picture; so that the figure, in moving towards the spectator, increases the depth behind it. The device was useful to a technique lacking perspective.

The scrolls, the thrones, the landscapes, and the dramatic gestures of Paleologian painting are, obviously, expressions of a Baroque-like turn in Byzantine art toward its decline, a phase which succeeds the acme of every great art. In that phase, balance is abolished; passionate expression predominates, forms become curved, gestures become dramatic, celestial beings seem to be straining after the earth, and the picture space seems to deepen in front of and behind the figures. Hence the touch of illusionistic naturalism in Paleologian art.

Briefly, had the Byzantine artist confused the artistic and religious attitude of man (even when appealing exclusively to the pious spectator), we would not today have perceived any artistic value in his works. As for the magic element, it never inspired and never could inspire the lofty and hieratically-minded art of Byzantium, as I hope I have proved by this criticism of the implications of Demus' theory.

IV. conclusions

(1) Plotinian philosophy is inevitably misinterpreted when applied to early Christian art instead of the art of its own age, as would have been more natural. Christian art, no matter the degree to which it may have derived from Neo-Platonic aesthetics, is inspired, not by the Neo-Platonists' pagan mysticism which springs from the impersonal One, but by the divine revelation of the One and Only God. It is an art of the sublime and not of the beautiful.

(2) Aesthetic values are inevitably misunderstood when theological tenets are used to explain artistic questions. The historical and religious analysis of an art's symbols (unless these are artistically self-sufficient) does not attribute artistic value to them. Christian art has not provided purely religious symbols, intelligible only to the initiate, but

forms capable of moving any spectator, not by the degree of sanctity accorded to them but by their purely aesthetic appeal. Such forms can be best judged, then, in the sphere of aesthetics.

(3) The aesthetic category of the sublime corresponds to the spirit of Christian art. The way in which the Greeks perceived and expressed it characterizes the art of Byzantium.

The Romantics, who revealed anew the feeling of the sublime, were able to appreciate and revive mediaeval Christian art, whereas the Renaissance, whose ideal was the beautiful, condemned it.

the aesthetics of
architecture

11

the revival of architecture in the twentieth century

I. introduction

What we call contemporary architecture first dominated the international scene after World War I. But its first conscious indications had begun to appear even at the turn of the twentieth century, and then the problem of this new form of art became the topic for theoretical investigation. Consequently, contemporary architecture is only an expression of the spirit of the twentieth century. At the same time, it constitutes the first expression of a new great phase in the history of architecture in European civilization, for following classical architecture and mediaeval architecture, it is the third in a series of styles based upon original technical systems.

Classical architecture is based on the system of the beam on columns, mediaeval architecture on dome construction, and modern architecture on the steel frame and massive reinforced concrete, and therefore all three developed new forms. In the absence of a technical system, new forms are impossible, and the imagination cannot conceive of astonishing visions, no matter how much artistic taste may be developed. This explains why the Renaissance, which did not develop any

new technical system in depth, limited itself to combining Greco-Roman forms, harmonious forms of course, but lacking in profound originality. Thereafter, because of a lack of a new technical system, revivals of the classical and mediaeval orders appeared in succession. Beginning with the Baroque, which is nothing more than an expression of the Gothic spirit in classical garb,[1] there were the Neo-Classical, the Neo-Romantic, and the Neo-Renaissance styles, until at the end of the nineteenth century eclecticism provoked a revival of all the historical styles. Neo-Baroque, Neo-Byzantine, Neo-Arabesque, and Neo-Egyptian buildings appeared, with styles mixed in accordance with the taste of the architect and the eccentricity of the client commissioning the structure in question.

There is no need, I believe, to explain why the eclectic mentality could produce not works of art, but only artificial forms. Architecture had become purely decorative, and embellishment forced upon the building plan a perversion of the function it was intended to serve. The plan of a hospital had for practical reasons become a complicated problem, but hospitals, banks, and schools all took on the artificial style of monumental buildings of some past era, all with a similar plan; and thus behind the false columns, the heavy cornices, the small windows, and the closed courts, life became an agony. Society had assumed a new form, and new conditions of living, working, and moving about probably had created problems on a vast scale crying out for solutions, problems incompatible with the existing town plans and the building structures of the past, which deprived their inhabitants of even the basic requirements—zones of greenery, fresh air, and sun. And thus a different arrangement of buildings was required: large windows, open courtyards, simple decoration, and the comforts offered by technical advancement. Moreover, the new techniques with the means at hand could now bridge the great gaps, abolish the massive pillars, make the walls thin, make complicated arrangements in the plans, and remove the heavy cornices; but these innovations were to be hidden behind pompous facades. Steel frames or reinforced concrete structures appeared in disguise, just as the first steam locomotives and the first automobiles, although self-propelled, imitated horse-drawn buggies. Such architectural examples abound in Athens today.

The new architecture rebelled against these conditions. It abandoned all association with the styles of the past, and was forced to devise new forms in keeping with the practical function of the structures and the techniques used, just as these were slowly developed in the ship-

ping, the automobile, and the aviation industries, once they had abandoned the imitation of forms that had no relationship to the purpose and the conditions of their manufacturer. Inevitably, this new architecture bewildered those who had remained committed to the conventional forms of the past. They could not understand why the buildings, the so-called architectural structures of the end of the nineteenth century with their artificially ornamental style, had become so ugly, and why there was no hope for an artistic purification.

Even today, however, the new architecture often bewilders because, like every new movement which focuses on a display of its technical possibilities, it strays aesthetically.[2] Nevertheless, the new architecture has come to stay, if for no other reason than that it serves the needs of life today and builds accordingly. After all, the new architecture not only rejected the past, but also drew on it, sought out the eternally basic principles dominating every great age of architecture, and demanded that architecture serve mankind with works corresponding with man's aims and combining technical durability and beauty. These principles were, in fact, applied to contemporary problems by the new architecture, and in an entirely new spirit. With time, assuredly, its style will be integrated and will take on expression.

Architecture of the twentieth century can therefore be described as a rejuvenated architecture. Its forms will emerge from the manner in which in a new spirit it applies the eternal principles of art to the conditions of place and time.

What are the conditions to be met in the twentieth century? What are its demands? What is its spirit? Better to understand the replies to these questions, we must look back at the nineteenth century, since the great shift toward the new era began in the middle of that century, which followed the age of iron, or the age of coal, as it was called. There, in fact, we find the first germination of modern architecture, perhaps still latent, but nevertheless ignored by its contemporaries because artificial and pompous appearance in architecture reigned supreme over the needs of life and ignored truth. As we shall see, not only was art separated from technology, but the intellect was also separated from reality.

II. the first roots

From the middle of the nineteenth century onward, metaphysics surrendered its dominant position in thought to physics.[3] One invention

followed another. Trains cut across the countryside and steamships traversed the seas. The telegraph transmitted news almost instantaneously and people communicated quickly and freely. Industries were developed in which not water but coal was used as a motive power. And wherever coal deposits were available, industrial cities were springing daily. The machine became the demon of a new industrial age, and its products were shipped everywhere. They were ugly, but cheap. International fairs were held in the large capital cities to promote sales. Material goods made life cheaper, and therefore materialism and indifference began to reign. Individualism too still reigned supreme, but at the same time the masses, the working classes who produced the goods, were themselves deprived of them; they suffered and began to protest. Karl Marx appeared on the scene and, setting the economic factor at the core of social life, created a dialectical materialism to replace a dialectical intellectualism.

Thus, on the one hand there was a crushing of the individual and on the other an elevation of individualism, on the one hand the pessimistic philosophy of Schopenhauer, on the other the *Übermensch* of Nietzsche. Aesthetics, at the same time, abandoned the ideological systems of Kant and Hegel with their a priori deductions, and, influenced by Herbert Spencer and others, turned to empiricism, and, as a reaction against the aesthetics "from above," with Fechner established an aesthetics "from below." At the same time, art turned to realism.

The literature of Zola, Ibsen, and Tolstoy strove to break the shackles of social convention. Through the influence of Gustave Courbet, painting again sought nature, and through the influence of Jean Millet and Claude Monet, it became impressionistic. Architecture alone—as always happens—was backward, because its problems were not only aesthetic, but also social and technical; and if architecture was to proceed with new and radical solutions to its problems, social reform was needed along with significant technical advances.

After all, in reality, neither the realism of literature nor the Impressionism of painting could respond to the new social demands. They were only the first expressions of an aesthetic which, despite its experiences, was nevertheless dependent upon a subjective criterion. The realism of literature was described in the novel as life seen through the eyes of the author, and the Impressionism of painting relied upon the rapidly moving eye of the technician without demanding of reality an objective relation to the new values.

Despite this, Impressionism did contribute something new: it

analyzed light, and proceeded to rediscover local color, which was restored by Paul Cézanne. Reacting against Impressionism, Cézanne then turned toward Cubism: that is, he analyzed the object's basic geometrical forms and, in so doing, abolished the orthodox perspective of the Renaissance.

Architectural eclecticism placed its faith in the subjective preference of the architect for the admixture of various styles, in the hope that his genius would from this blend create a new and original style.[4] But the result, of course, was negative, and only negative, because there was no particular requirement for an objective examination of the morphological problem in conjunction with building layout and technique. The most positive result of this attempt was the Pre-Raphaelite movement in England, which, through the work of William Morris, as we shall see below, rediscovered the beauty of simple material and the value of the simple form which flows freely out of the utility of function. Solid results were also obtained in the first industrial structures of England and in the new iron structures with glass partitions which covered vast expanses of space in exhibition halls or railway stations. Flooded with light, these shelters almost abolished the distinction between inner and outer space, and therefore some people believed that in them was reflected the Impressionism of painting.[5] I believe that the comparison is rather frivolous, however. The fact is that the iron latticework, while initially imitating bridges (that is, a stone structure with arches), gradually revealed a new structural dynamism, for this material could support not only the pressure and the bending of forces, as marble did, but also tension and torsion. And thus it could strike a new chord in our feeling of stasis and create a new feeling of space.

But these first positive acquisitions of the new era in architecture, the only advances comparable to those of Impressionism, were overlooked and ignored by contemporaries of the architects. Embracing the new technical systems, they either erected temporary works or hid the permanent new structures behind conventional facades. It is not strange that these new phenomena gave rise to similar structures in all countries in the new and the old worlds which had become industrialized, but it is strange that everywhere a pompous style was deemed necessary for structures representing state power, such as the well-known monumental works of London, Washington, and Paris, cities which wanted to emphasize or to acquire the glitter of world empire. The Roman tradition survived and continued to survive. Just as Rome had borrowed noble Greek forms, barbarized them, and used them as a stage on which it

could reflect its own splendor, the newer nations did so too. The coarsest expressions of this mentality are present in the architecture of Hitler and Mussolini.

Let us now examine the historical development of the new architecture in more detail, beginning with England, which was the home of the Industrial Revolution.

III. historical development

In the nineteenth century Great Britain had turned radically from an agrarian to an industrial economy. The aristocratic class was over-shadowed by the middle class of merchants and industrialists, for these had become the possessors of wealth, and in substance made up the bulk of the ruling classes. Factories mushroomed in cities where working hands were available, and farmers flocked to the cities to become factory hands. Factories and dwellings were built in a hodge-podge fashion, no foresight being taken for health and sanitation. Workers were crowded into dwellings put up hastily by landowners who, indifferent to health conditions and feelings for fellow human beings, exploited both their properties and the laborers. Thus were created the famous slums in which entire families lived and died in single rooms without water or toilet facilities, light, air, or sun. The slums became pockets of contamination for both body and soul, not only for the working class, but for entire communities.

In general, the attraction of workers to the cities created the megalopolis—that is, an organism of people unprepared to receive others and to provide them means of transportation or dwellings offering comfortable or at least tolerable habitation. The increase in vehicular traffic and in the number of tenement buildings which vomited forth waves of inhabitants at certain hours of the day made the streets seem even narrower and more congested than they were. The squares became confluences of transportation, the courtyards of buildings, originally breathing areas, became wells of putrid smells and darkness, and green zones were erased from the cities. It became quite obvious that a solution to these problems could no longer be entrusted to the uncontrolled whims of private initiative, and that the problem of the human dwelling, if it were to be solved decently, had to become part of a town planning project. But town planning on its part had to reflect the new composition of society if it were to bring the matter to conclusion in a proper fashion; otherwise it would fail.

Yet town planners in those days saw the matter only from a morphological point of view. For this reason, the first worker communities created in England, with small, identical houses lined up one against the other to avoid the creation of slums, were both out of date and inhuman,[6] so that the mere sight of the area gave rise to affliction and despair (Fig. 18). Even the openings which Baron Haussmann insisted upon for the famous avenues in Paris, which were to prevent traffic congestion in the large city and to facilitate military maneuvers and celebrations, resemble medical operations which cut open an abscess without curing the cause but creating another abscess elsewhere. Off these avenues the building chaos remained, the vehicular traffic grew, and thus the town planning of Paris is still out of date. Man is deprived of the basic joys of life which the green of nature provides, and of light, sun, and air, and he does not live healthily, at peace with himself, or comfortably. But a radical reorganization of the town planning structure of life could not be realized in a society in which private enterprise was king. Today at least there are suggestions and proposals for a solution to the problem, and there is a greater understanding of the subordination of the individual's interest to those of the whole of society. And for understanding (that is, for meeting a problem of such great magnitude) great sums of money are needed.

The development of industry also meant the death of handicrafts, which were replaced by the ready-made products of the machine. Individual work was replaced by mass production. The pleasure of creation was lost in professional life, and the laborer was demoted to the status of operator of the machine, still another reason why he should be dissatisfied as a human being. Naturally enough, the mechanical product could not have the fine form given by the hand of the artisan, nor could the decoration have the spontaneous artistic finish of the work of its designer, who had been forced to sacrifice all ornamentation and limit himself to forms like instruments or wares for everyday use which were strictly utilitarian; nor could he achieve a decoration that arose organically from the new mechanical refinements. Instead, the eclecticism of the age preferred that he apply to the products of the machine false embellishments borrowed from the decorative arts of the past.

More specifically, the building industry in its progress gave to architecture new materials such as iron, steel, glass, and cement, which provided great technical possibilities, such as iron latticework, steel frames, and reinforced concrete skeletons. Moreover, it provided possibilities for new methods of construction: that is to say, the metal

framework could be prepared at the factory so that it could later be immediately set up at the work site. Only the foundations needed a wet structure, but even for them, building machines provided new tools for excavation, for weight-lifting, and for transportation, so that projects on a large scale could be completed rapidly and accurately.

And, in fact, such projects did begin to be undertaken, not only bridges of iron and shelters of a purely technical nature, but structures posing architectural problems. The Crystal Palace at the Great Exhibition of 1851 was the first architectural project of iron and glass (Fig. 19). It was assembled on site from standardized prefabricated pieces. This is why it could be disassembled after the exhibition and transported to Hyde Park, where it was reassembled. The rapidity with which this was done was a great victory for technical and industrial organization. But the architects of the time had no inkling of what this work foretold for the development of architecture. They continued to think of the project as a purely technical and utilitarian work, just like bridges, railway stations, or shopping arcades.

H.-P.-F. Labrouste was the first to try to exploit the possibilities of iron construction in France in permanent monumental buildings, such as the Bibliothèque Sainte Geneviève (1843–50) and the reading room of the Bibliothèque Nationale (1862–68) (Fig. 20). To light the reading room he erected spherical domes containing glass openings. He supported the domes on fine iron supports and hence was able to add a new architectural dimension to the structure. But this great accomplishment inside the building was hidden behind a conventional external facade. Technique and architecture had been separated.

Yet it was then that cooperation on a new basis began. Engineer and architect collaborated to create the famous hall of machines (Fig. 21) and the Bon Marché and Printemps department stores in Paris, which combined the new technique of iron construction with the new science of building. This new science began in a more practical spirit to study the structures aimed at serving numerous customers. Complicated organisms were the result. To decrease the number of supports, to facilitate the circulation of customers, and to provide large windows for the display of merchandise, forms were allowed to flow basically from their function, although these forms were still loaded with embellishments.

The principle was first proclaimed by Labrouste himself. In a letter, he records that he required "his students [to] understand that in architecture the form must be suitable to the function for which it is

intended."[7] This principle was already in part being applied, but it could not be practiced fully. When they did not have the memorial forms of the past, the works in the new technique were considered downright barbaric, like the Eiffel Tower, which, although called a vulgar work in 1889, today is nevertheless the symbol of Paris. The revolutionary proclamation that form follows function was daringly uttered in America by the great Louis Sullivan. Centered in Chicago, there arose an architectural vanguard later known as the "Chicago School," a vanguard, but one ignored by the forces of eclecticism. There, also, the use of metal framework for buildings began, the first plan for which, drawn up by James Bogardus, already existed in 1848, before it was applied in Europe. With the leading pioneers, H. H. Richardson, the first innovator, and William le Baron Jenney, Louis Sullivan, and others following, buildings made of metallic frames with large windows within the framework were created to house many-storied shops. Thanks to their special simplicity and the austerity of their form, they are still considered the classical prototypes of the modern skyscraper. For in the land of progress, in the country which one would believe had cut off all ties with the past, even the skyscraper, a new type of building, until recently was dressed in pseudo-Gothic garb. Strangely enough, the Gothic verticality of the cathedrals of Europe, a product of faith and spiritual elevation, was associated with the vertical addition of floors to the skyscraper; in fact, it was a product of the exploitation of a plot of land to the maximum. It had been forgotten that the church was based on a system of dome and buttress, whereas the skyscraper was based on the metal frame, and that the latter would have been impossible before the invention of the elevator. But all of this was overshadowed by the romantic escape from reality into dead ideologies, by remnants of the worship of the individual genius as established in the Renaissance, which had misinterpreted the Greek democratic ideal and the limitations upon the intellect imposed by logic.

As early as 1813 the first industrial edifices in England contained large windows between supports and embodied simplicity of form. In 1824–28, the London docks were built in an impressively progressive form. In 1830 the German architect Karl Friedrich Schinkel, visiting the industrial city of Manchester, seeing similar buildings, and understanding that in them was expressed something more in agreement with the new reality, wrote that "all the great ages have left some stamp of their times in the style of their buildings. Why should we not find a style for our own?"[8] Influenced by such thoughts, he planned a commercial

department store, something like contemporary shops, with large display windows and windows between piers. But he himself continued to build official edifices in the neoclassical style as though technical rationalism was incompatible with official architecture. In Germany the Wertheim department store, buildings corresponding to the Bon Marché (1876), by L. C. Boileau and Gustave Eiffel, and the Printemps (1881–89), by Paul Sédille, were being constructed in Berlin as late as 1896–99. And in France the official memorial architecture continued, for with the construction of the walls of the École des Beaux-Arts, the further progress of contemporary architecture was hampered until the early years of the twentieth century. And its progress was also hampered in all countries culturally and artistically influenced by France. In fact, even today, in England and in America, there still exists a memorial style of undefined form for official buildings.

In the meantime, in addition to the iron structures, a new technique was being evolved, reinforced concrete. In the Paris Exhibition of 1867, a French gardener named Joseph Monnier presented flower pots and pipes of concrete reinforced by metal meshing or rods—in other words, a new building material—which he had developed in 1849. This material was poured into molds and became a monolith after solidification. It withstood as much pressure as stone but as much stress and tension as iron, thanks to its iron reinforcement. The concrete presented vast possibilities, and ever since its invention, construction engineers have aimed at learning where and how much iron is needed for reinforcement in accordance with the forces that come into play in construction. By 1892, François Hennebique had prepared a complete system for the manufacture of reinforced concrete. But, up to 1900, even this new material did not appear except in subordinate structures or in buildings systematically hidden behind a borrowed morphological decor, since as material it was considered to be of a lower grade. Thus, the architecture of reinforced concrete remained a work for the twentieth century.

The feeling for material had been lost also in the nineteenth century. Official architecture recognized only valuable constructional materials, such as marble, granite, sandstone, and the like. It failed to appreciate that every material, even though cheap, has the grace of its texture, and that the harmony of shapes has no special preference for the more costly materials, for even in the most expensive material, ugly forms can result. By contrast, Byzantine architecture performed miracles with a very cheap material, the tile.

Fortunately, the Pre-Raphaelite movement in England reacted against the recognition of expensive material only. In fact, with this movement the theoretical quest for a new architecture began.

IV. theoretical movements

In the absence of theory, art would have found it impossible to emerge from the chaos reached in the nineteenth century. But around the middle of that century in England there emerged a tendency towards "primitiveness" (as it was understood at the time, of course), a movement influenced by Gothic and Japanese art and led by John Ruskin. It reached its prime with the Pre-Raphaelites and William Morris, who became the apostle of pure and unadulterated material, of useful form and planar ornamentation. Under his tutelage there developed a domestic architecture propounded by men like A. W. N. Pugin, Sir Aston Webb, and others.

These pioneers, reacting against the coldness and insensibility of the official styles and the difficulty of adapting them to the practical arrangement of the town plan, dared to compose dwellings, mostly country houses, with cheap materials, in simple forms, and in a picturesquely free arrangement (Fig. 22). Thus they freed architecture from false memorial or monumental symmetry, liberated the plan, rediscovered the beauty of the material, and adopted the principle of simplicity. These principles all pervade present-day architecture, except that they appear in conjunction with new technical systems.

The movement had repercussions all over Europe, especially in Germany, where Hermann Muthesius in 1904 made the English house known through his books. The results of this influence were surprising, for in Germany the historical materialism of the architect Gottfried Semper had preceded this movement. Semper had examined the origins of the forms of architecture, whether as to aim, material, or technique, and had proclaimed that "architecture is the meeting of aim and material."[9] Before him came Konrad Fiedler, who maintained that the artisan speaks with stone, with color, or with words, and the aesthetician Ernst Grosse, who examined art on the basis of its generative development and brought to the forefront the art of primitive peoples and of children, that is, of people who do not separate the imaginative from the realistic.

At all events, the first movement in continental Europe to apply new forms began in Belgium at the end of the nineteenth century,

because Belgium was the first country to be industrialized, to flourish, and to become an intellectual center. It had Van Gogh, Cézanne, Seurat, and the architect Van de Velde, who in 1880 revived the question of the relationship for a successful architecture between form and function. What we know as the New Art, or Art Nouveau, was born there. But this art did not at bottom possess any style. It was a naturalistic kind of ornamentation of the iron structures through spiral metal sheets, and of stone structures through floral reliefs from the world of nature, freely carved and often ugly. The innovation, however, was that the stylized floral decoration of the classical form was no longer imitated.

According to certain theorists, the influence came from the Pre-Raphaelites, according to others, from the theory of Darwin concerning the organic origin of life; but in my view, it came from a determination to break the chains of the past. For this reason, we find that, besides the embellishments, the plans acquired a certain flexibility of space and an independence in the arrangement of the plan of superimposed stories, which are forerunners of modern conceptions, as evidenced in a dwelling by Viktor Horta (Fig. 23). The New Art had a brief success in the Paris Exhibition of 1900, received a minor imitation in Germany under the name of *Jugendstil,* and found a striking representative in Spain, the architect Antoni Gaudí.

And now the center of the new movement shifted to Germany, and its first manifestation came in 1900 with the recall of the architect Van de Velde to Weimar to assume the directorship of the Bauhaus, which later, in 1919, with Gropius, grew into an important theoretical center. Moreover, in 1907, the Deutscher Werkbund in Germany was formed, the first aim of which was to use the artist for the aesthetic planning of industrial products on the basis of their mechanical production. Peter Behrens was hired not only as an architect by the electricity company called A.E.G., but also as a draftsman for its products.

But somewhat earlier, in Holland (perhaps because it was associated more closely with England and Belgium), Hendrik Petrus Berlage dominated the scene. He sought to simplify forms and reveal the texture of the materials, and in 1898–1903 he built the pioneer Stock Exchange of Amsterdam. In Amsterdam, too, somewhat later, a group was formed consisting of the artist Piet Mondrian, the architect J.J.P. Oud, and others who had cultivated the principles of Cubism promoted by Cézanne in his struggle against Impressionism. The principles of Cubism thus entered architecture somewhat later through Holland and influenced Le Corbusier primarily.

For the historical record, I should mention a movement which, though artistically insignificant, at the time created quite a sensation and which, because of its political nature, saved architecture from rejection by Italian fascism. This was the futuristic manifesto of Emilio Marinetti, who propagandized "the new beauty of speed," the beauty that is conceived while one speeds along in an automobile or airplane. In other words, it involved an impressionism mechanically generated, since the fleeting eye of the technician was now subject to a movement from the outside. This explains why Futurism did not strike a deeper chord in art, though it did possess its facile theoreticians. At all events, a young architect of that period, Antonio Sant'Elia, left a plan for a new city—a *citta nuova*—in which, wishing to express the intoxication of speed, he draws, beneath the skyscrapers and above the ground, criss-crossing roadways at many levels in space, including subways, highways, avenues, and so forth. Something similar has occurred today in New York, which has its arteries of communication crossing in space and its famous parkways in combination with the vertical arteries of the skyscrapers.

And thus the opening years of the twentieth century saw two discernible, great currents, the French constructivism of J.L.C. Garnier and Auguste Perret, and the German expressionism of Peter Behrens and Hans Poelzig, who were the pioneers. But these currents continued in force even after the First World War, and this is why I shall examine them in more detail after I have described the principles which contemporary architecture enunciated when, after the First World War, it had the chance to establish itself finally and decisively. For after the war, the problems of reconstruction were enormous and of vast importance: workers' quarters, new industries, and technical works had to be built from their very foundations, and quickly. New economic and social conditions had to be considered, new materials and new methods of construction were to be used, and, above all, a fresh breath of air was sweeping through the world.

V. the new principles

Architects had ascertained that:
First, the new economy had molded a new society not at ease in the existing forms of building and town planning.
Second, architects had rationally to solve problems of great magnitude and scale, and to these they had to subordinate the various parts.

Third, they had to make use of new materials and methods of construction.

The new architecture decreed the following principles in order to succeed in all of these respects:

1. Empiricism had to be abandoned for rationalism. City planning first had to become a science; it had to study the statistics of growth, movement, and density of population, of traffic, commerce, industry, the ground, the subsoil, the winds, and the waters; and it had to organize living so that health, happiness, and future development were assured. Perret first suggested skyscrapers placed far apart in the center of the megalopolis. Le Corbusier recommended similar buildings for the heart of the city and lower edifices for the edge of the urban center, and these on piles to ease the circulation of traffic. And everywhere there had to be green zones, of course. A new spirit on a new scale was to pervade the city.

Similarly, construction itself was to become a science studying the minimum of space required for the various functions of man in the individual dwelling, and adjusting the organization of a building according to its aim, whether that of school, hospital, or theater.

2. The construction had to adhere to technical rationalism, so that, thanks to the advance of statics, it could obtain maximum results with the least waste of material. Iron, steel, glass, reinforced concrete, plywood, aluminum, and plastics were to be used. Architects were to study heat conductivity, hydraulics, and other qualities of these materials, to standardize and pattern the parts of the construction and prefabricate them, so that they could be assembled quickly and with exactness.

3. Form had to follow the function. For this reason the facade follows the plan, whose function is expressed by the arrangement, which in fact is now developed freely without symmetries and stylized limitations. Moreover, from the static function emerges the form, like the projections, the balconies, the shell, or the elongated slab. Thus a new feeling of stasis is to be developed.

4. The form was to be plain, without additional embellishments except those coming from the machine or the construction, and was to display the beauty of the material.

5. Architecture was to become international, since, because of the ease of transportation, the materials were everywhere the same, and the needs of men, because they could communicate amongst themselves easily enough, at bottom were the same. After all, technology can

be indifferent even to existing climatic conditions since it can create an artificial climate within buildings.

It is true that in their early stages these tendencies were somewhat partial and revolutionary. Extremes were not late in coming, however, and aesthetic inconsequence still persisted, because it is not enough to study city planning scientifically if one is to see into the future correctly: a psychology of a society and its ideology also are required. Nor can building science, no matter how many comforts it may give him, offer man only the necessary minimum space for living happily. What we endure in a ship's cabin for one or two nights we would never accept in a dwelling meant for a lifetime. Thus the communities and the living quarters made on these bases resulted in class distinctions which, not being eliminated, were aggravated and emphasized.

Technical rationalism, on the other hand, does not have the capacity to define the use of the materials and the methods of their use. A constructional perspectivity is also required. This is why most of the new architectural works have proved to be bad as structures and appeared wretched in comparison with today's simple forms. Unfortunately, the architect has been isolated by fate from the execution of the work. He drafts the plans in his office, and the factory executes them.

Moreover, simplicity should not be identified with simplification. No matter to what degree form follows function, an aesthetic character is required if form is to be pleasing. In the composition, optical and psychological factors play a primary role.

And, finally, internationalism cannot eliminate local tradition. A house in the north of Greece to which a veranda is added will still not take on the character of a house in the east. And, in the last analysis, whatever emerges from a local character and its values is respected, and respected on such an international level and scale that every human being, no matter where his place of origin, will be moved by it. And one of these values is beauty.

Yet beauty has never been sought through technology, and especially not through mechanics. Whatever in the nineteenth century was looked upon dogmatically as barbarous and ugly has now become an aesthetic model. Ships, turbines, cranes, and silos have become examples of beauty. Thus the ideological romanticism of the nineteenth century became a technical romanticism in the twentieth century. A flight from reality became an admiration for and a worship of reality as it was blindly manufactured by the machine. The intellect turned towards material, and, to survive, sometimes towards rationalism,

and at other times towards the reckless dynamism of feeling.[10]

VI. later currents

After the discovery of reinforced concrete and the mastery of its stasis, iron structures were limited mainly to the metal framework of multi-storied buildings, especially, in fact, in countries where steel was cheap and abundant and real estate very costly, as in the United States. This is why skyscrapers were developed there. On the other hand, the use of reinforced concrete spread very quickly everywhere, and in the early years of the twentieth century it already dared to make its appearance in architecture.

Once solidified, this new material, as has been said, becomes monolithic and compact, and, properly reinforced, can withstand pressure, bending, and tension equally as well as iron; and the innovation of its use as a framework of a structure was revolutionary. Whereas formerly beams would be fixed on huge walls which used up a large part of the plot of land, the walls now became supporting members. To meet the requirements of any plan, they could therefore be light, fine, and arranged differently on each floor. The entire building could be raised above the ground level on piles so that people could walk underneath it; and the thin walls made for a tremendous economy of space. Furthermore, the supporting piles of the frame could be moved towards the back, away from the facade, and thus the windows were allowed to run around unbrokenly like a glass wall along the entire length and the height of the facade. With the discovery in 1908 separately by the Swiss Robert Maillard and the American Turner of flat slabs, beams were abolished from the floors.

But the possibilities did not stop here. In 1916 Eugène Freyssinet built the airship hangars of Orly in the form of parabolic arches having wave-shaped sections. Then followed the discovery of the shell structure—fineshelled curved surfaces (about 5 cm. thickness) which covered vast areas. And, finally, pre-stressed concrete was discovered which made possible the manufacture of prefabricated pieces small in diameter, and hence lighter, to bridge large gaps and openings, immediately emplaced, as with the iron constructions. Impressive discoveries were made also for the construction of bridges, silos, and other technical projects which too make architectural demands.

At all events, the actual architecture of ferro-concrete or reinforced concrete was developed in France initially, and perhaps there

found its most perfect expression and provided the opportunity for the existing innate French constructivism to reveal itself in new forms. Anatole de Baudot in 1894 in Montmartre first built a church of ferro-concrete, which, despite its still Gothic overtones of form in its cross-domes, was a lighter structure and breathed a new atmosphere. Then Tony Garnier (in 1901–1904) planned an entire industrial town in ferro-concrete. He boldly simplified the forms, but retained a certain classical style of motifs which are found in the Lyons stadium.

But the man who first was bold enough to reveal the framework in the facade and to characterize forms in accordance with their static peculiarities was Auguste Perret. In the house in Rue Franklin (1903) he suspended on cantilevers two covered balconies extending along the entire height. In the garage of Rue Ponthieu (1905) and the shelters of Casablanca (1916), he was also original, and finally in the church of Raincy (1922) he used concrete without mortar and succeeded in providing a structure that was so consistent with its function that it recalls the beauty of Gothic architecture, but of course in new form. The analytical Gothic mind is at the basis of the church architecture of Perret, despite the classical style he developed earlier in the theater of the Champs-Elysées and in other subsequent buildings.

French constructivism bears no relationship whatsoever to abstract mystical constructivism as understood by the purists of the North and the mysticism of the Russians, such as Kandinsky, Mondrian, and others, who wished to make painting into architecture, and architecture into geometry.

Previously in Germany painting reacted against French Impressionism, an impressionism traditional in that country and transposed to architecture as well. It first became obvious in the works of Peter Behrens and Hans Poelzig before 1918. But it reached a climax in the post-war era under the motto of "dynamism" in the works of Erich Mendelsohn. More specially, in the Einstein Observatory (Fig. 24), Mendelsohn, in contrast with the French constructivists, exposes not the skeleton of reinforced concrete, but the plasticity of the material itself, since by its nature it is cast in molds and can become one solid monolith. In this work the forms lose their touch with Euclidian geometry and acquire a tension and a whirling effect that converts space into a throbbing vibration. Although technical rationalism is not ignored here, it is dominated by the irrational dynamism of the feeling for plasticity.

But in Germany too the rationalism of technology assumed a romantic style, and a romanticism of rationalism was created with

Walter Gropius as its foremost representative. In 1919, Gropius was appointed director of the Bauhaus in Weimar, and in 1925 he transferred it to Dessau in buildings he himself had planned. In these he strove to resolve the plan rationally, to arrange the masses freely, so as to free the facades of columns, cornices, and embellishments, and thus gain in simplicity; and finally he created entire facades in glass. All these were correctly conceived and executed, but the soundness of calculation as a means practically became an end, and technical possibility was elevated to poetical expression.

At all events, under his inspiration, great theoretical endeavors were made at the Bauhaus to relink morphology with handicrafts and industrial production. But these progressive tendencies were alien to the Hitlerian state and to the pseudoclassicism employed to present buildings as a reflection of Hitlerian grandeur. In 1933 the Bauhaus was closed. Still, from 1925 to 1933 it was a center for admirable objectives for Germany. Following the model of apartment houses in Vienna, similar buildings were put up in Frankfurt, Berlin, and elsewhere. The works in Vienna reflected a new school founded at the same time as the Bauhaus and started by the pioneers Josef Hoffman, Otto Wagner, Adolf Loos, and others.

The romantic rationalism of Gropius was succeeded by the abstract mysticism of the Swiss Le Corbusier. His sources of inspiration were two, the Cubism of Cézanne, transferred to architecture by J. J. P. Oud via Holland, and the rationalism of the machine. A painter of depth, Le Corbusier constructed as he planned, and worked in quest of the basic shapes, the cone, the sphere, and the cube. He dissolved the mass, and walls became very fine, almost paper-thin, and, separated generally by color, moved into space in curvilinear fashion, as though they were immaterial. He as a rule built above ground on piles or slender posts—this in contrast with the picturesqueness of nature. He announced the theory of functionality of the plan, but was inspired by the function of the machine, and so fanatically put his faith in the mechanical equippage of the residence as to maintain that the dwelling was only a machine for habitation. This is why he usually imprisoned man in a residence, like the apartments of Marseilles, which as a machine could function perfectly, but often inhumanly. He thus demoted the individual to the condition of an impersonal unit and expressed his new theory in terms of mechanical conveniences and technical possibilities. For this reason, he was known as a utopian. At all events, in his fanaticism, he produced constructive results and works of great value. He also did

much to promote the new architecture through his literary productions in which, quite understandably, there was nothing new for the specialist, though he presented his ideas in the self-important, assertive fashion of a missionary.[11] We are surprised by his insistence that harmonious incisions and patterns be made on facades; thus he revived a certain scholasticism innate to his abstract mysticism.

The German Mies van der Rohe has a puristic disposition; he is the romantic of absolute form, a builder of pure scholasticism, a poet of material possessing a very highly developed feeling for space. He was the European par excellence who propounded the possibility of a continuous flow of space through the abolishing of the completely partitioned walls of the room. Room-boxes were abandoned, and the separations became transparent or were suggested only. Space broadened out, and wound about freely without divisions. Moreover, the difference between inner and outer space was practically eliminated.

But the principle of continuity of space and of the free plan was the work of the American Frank Lloyd Wright (1869–1959), the great innovator and genius nurtured in the "Chicago School." He was the first to abolish room partitions by making them transparent or barely discernible; he eliminated the separation of inner and outer space, and employed verandahs and shelters. He simplified the facade without, however, abandoning the embellishments, which he renovated by drawing upon the inspiration given him by the structure itself and by indigenous American motifs. He emphasized the beauty of both the natural and artificial material, and did not hesitate to introduce air conditioning and metal furniture for the first time. He became absolutely one with the development of structures, and out of these possibilities created a poem each time, like the mushroom-shaped slabs which decorate the S. C. Johnson building (Fig. 25). In similiar instances the dry rationalism of the European architect produced nothing more than a technical structure.

Where Wright would create works springing out of the earth like symbols of nature, as in the house "Falling Water" (Fig. 26), the Europeans created non-natural mechanical works. This is why even Europeans who learned about his work did not realize that within it were hidden all the new principles which they had been seeking: clearly enough, Wright had expressed these ideas through art, while the Europeans themselves were formulating them through technology. Today his influence is great, although for a long time he was ignored in his own country.

Many of the finest European architects came to America either as refugees from European dictatorships, or on their own, as did Walter Gropius, Richard Neutra, Mies van der Rohe, Alvar Aalto, and Eliel Saarinen. Thanks also to the contribution of native architects like Albert Kahn, Wurster, Wallace K. Harrison, and Wood, there grew up an architecture exemplified in many memorable works, like the Rockefeller Center of New York, which from the standpoint of city planning and architecture is still one of the most modern of skyscrapers. In California, especially, an architecture of local character was emerging.

In South America also, particularly in Brazil with Oscar Niemeyer and others, an amazing building movement took place. Large pioneering structures were erected, in the facades of which the curtain motif provided decorative solutions, and the local Spanish Baroque style frequently left its traces in rounded models.

Important works were completed also in Scandinavia, in Switzerland, England, and Italy. On the other hand, wherever dictatorships existed, every progressive movement was extinguished, and a return to the past followed.

The new architecture imposed itself on Greece as well. It is true that the country is not industrially developed, and its building industry in particular does not possess the qualifications necessary to the allowing of full exploitation of the new materials and the new methods of architectural construction. In addition to cement, all other contemporary materials and machines are imported. Nevertheless, the new spirit first revealed itself in the building arrangement of structures, in the technical molding of the reinforced concrete, and finally in simplicity of form. But this spirit of simplicity is not alien to Greek traditions, as is indicated by the works of folk architecture, especially that of Santorini, which is by nature monolithic, like reinforced concrete.

It is certainly true that from the city planning and architectural points of view, much bad work, together with other aesthetic aberrations, is being done today [1962], especially in Athens. But there are encouraging signs. And let us not forget that good architecture is rarely encountered anywhere in the world. Perhaps in Greece it is more rare because Greek society does not yet respect the role of the architect. The civil engineer and the architects responsible for architectural structures are hardly distinguished as professional men, whereas the two professions should work in cooperation even in purely technical projects, such as bridge-building. For if the civil engineers of Greece have zealously promoted statics, architects have introduced the new architecture

and are fighting for its principles. By ignoring the latter, a society lowers the degree of its culture. At all events, Greece, a poor unindustrialized country, in nurturing the new architecture proves that the principles of architecture are a matter not of technical progress alone, but also of the deeper intellectual needs of our century.

It is true that the new art is still going through a "geometric" period. It rejected the past, fell back upon primitiveness, and to overcome this, occasionally turned to rationalism and at other times to the automation of the subconscious. But it is equally true that it will not be long in coming into a balance with reason and bringing its style to a final maturity, provided of course that it transforms its utilitarian spirit into a humanistic one.

VII. aesthetic reflections

The unavoidable shift of contemporary architecture towards science, and the feeling that modern art is only at the beginning of a great stage in the history of art has convinced some theoreticians that art develops in a fashion parallel with the progress of science, or at least, expresses its great conceptions in each period. Classical Greek art, they go on to maintain, possesses a certain staticity because the mathematics of the time were static, and, on the other hand, Baroque and Rococo art, and particularly architecture, after the differential and integral calculus had been discovered, acquired dynamism and, in contrast with Renaissance art, strove to express the infinity of space. Today art reflects the discovery of space-time. The cubistic painters, Braque, Picasso, and others, abolished perspective, adopted many points of vision, and coordinated into one view many views of the one and single form. Architects abolished the distinction between outer and inner space by means of transparent walls and, like Le Corbusier, aimed at the marriage of contours.

In another study,[12] I analyzed this theory and maintained that art always instinctively combines space with time and that, even if scientific theories gave rise to the creation of the new spirit, the basic reactions of man do not change. What changes is the aesthetic attitude of man, because the direction of his interest is changed. And it is a fact that contemporary architecture shifted its interest from form to space. At the turn of the twentieth century, August Schmarsow already expressed the view that architecture is primarily the art of creating space, and that form is but a technically feasible representation of the idea of space.

On the other hand, Alberti, the theoretician of the Renaissance, emphasized form. He believed that every building consists of lines and structure. Thanks to the lines, architecture in its works achieves harmony, which is defined as well-structured or harmonious. The Renaissance, which never preoccupied itself with technology, would naturally enough have ignored the principle followed by present-day architecture that form follows function.

Architecture has always followed this principle, but not with so great a utilitarian emphasis as today. The realist Vitruvius defined the purpose of architecture when he stated that the form should arise from the aim of the structure and should be technically resistant and beautiful. Whereas the beauty of classical art is plastic, that of anti-classical works is graphic, so that the former emphasizes form primarily, but the latter, space. The former is extroverted, the latter introverted. For this reason, if we are to judge by what Procopius says, Byzantine art also gave great emphasis to space and light, for the dome of the church was a symbol of the celestial heavens, within the space of which dwelt the infinite spirit of the Almighty God. Gothic verticality also strove for the infinite.

Plasticity emerges from sculpture, and, actually, classical architecture is an architecture of structural sinews, as some were wont to say, because it expresses the action of the forces in its parts, and, indeed, does so anthropomorphologically. On the contrary, the picturesque stems from painting: this is why Byzantine architecture is an architecture primarily of space, in which is displayed the aesthetics of the immaterialized surface. And the framework of the Gothic with its webs does not cease, with its immaterializing tendency, to be picturesque in nature.

Modern architecture also rejects plasticity. It possesses the picturesque, such as large plane surfaces, flat and smooth surfaces, and often curved ones. But these surfaces are without load, are non-bearing. Thus a new aesthetic of non-bearing surfaces has been created. Moreover, its framework and mass, when they are solid and compact, are by nature monolithic; hence the cantilevers, the frames, and the shells which summon man to dwell within structures that can withstand not only pressure and bending forces, not only thrusts, but also tension and torsion. A flowing plastic material unwinds in space, and space tends to appear continuous and indivisible. It is true that the importance of carrying and carried parts is diminished, whereas other properties of the material, such as cohesiveness, inflexibility, and coalescence, are

emphasized. The construction is as light as the air it breathes. And in this air of freedom the body moves freely; because the new building science expertly and thoroughly studies function, it does not feel it is being confined or impeded.

But all these effects are usually emphasized more easily as technical accomplishments, as is the continuity of inner and outer space through the transparency of the partition. The great difficulty arises in any attempt to suggest to us this feeling of rejoicing in harmonious proportions and of sensing lightness in our spirit. A building is erected easily enough above the ground on piles, but it is difficult to convince ourselves that it stands up there with grace, without any apparent effort, or, rather, with as much effort as to make us feel that the gravity and weight of the material takes wing in airy lightness and elevates the spirit. This feeling is yet to be engendered by contemporary architecture.

That this feeling cannot be brought about by any additional embellishment or ornamentation, is, in the light of what has been said, pretty obvious. Only in an eclectic age did the theory of Wilhelm Wundt—the theory that architecture begins when the form of aim and purpose is determined by ornamentation[13]—have an audience. Ever since, as a reaction against artificial embellishment, everything has been entrusted to technology, and the structure has been denuded. But beauty emerges when art and technology become identical and synonymous, as occurred in ancient times among the Greeks.

12

aesthetic reflections on contemporary architecture

"in this city . . . among the buildings
that fill it, some are dumb, others speak,
and yet others, the fewest, sing."
Paul Valéry, *Eupalinus, or the Architect*

To define the beauty which contemporary architecture still seeks
and will find when its expressions are perfectly in accordance with the
new technical possibilities, we must first determine how the beautiful is
expressed in architecture as a whole, for the beautiful has its own special
manner of expression in each art. And actually, whereas the other arts
imitate known forms from the external world, only music and architec-
ture reject imitation and create original and imaginatively pure forms, as
they are known in aesthetics. And if we examine how and why the
material is molded as it is, we can grasp the characteristic sign of
architectural beauty without having to seek out the definition of the
beautiful itself.

Divorced from imitation of any and all outward elements, music
restricts its morphology not to create vaguenesses, but rather to express
what no other art has been able to express so strikingly: that is, move-

ment. Dancing and poetry also express movement, but with known images which first recall outward experiences, and then create individual feelings and thoughts before clarifying the limitless and boundless vibrations of the poetic pulse. In music this poetic vibration becomes an immaterial world of sound, is shaped and reshaped, is pure, and moves one directly, and not, as in other arts, indirectly. With movement, therefore, music leads one from the parts to the whole, and expresses the very "becoming" of the mind.

On the other hand, architecture expresses staticity. In other words, it presents motionlessness at a given instant, and what in music is analyzed successively in time, here in the light of day is presented completely in space.

The observer of the architectural structure makes a "movement" unlike that of the listener to music. He begins with the impression of the whole and then moves to the various parts, again in his mind to re-create the whole. Thus with body and mind he gives movement to the static and immobile creation of architecture. Painting and sculpture, works appearing all at once in their entirety, also express staticity. But the forms of architecture clearly define how the material is erected and how it overcomes its weight and stands outside purpose, one would think, since like musical forms it rejects any imitation. The observer expressing his admiration for a work of architecture does so not because he is amazed that the work remains standing but because he admires the power of its architectural beauty to hold his attention. And this standing and admiring is the result of the balance of the spectator's spiritual and intellectual worlds, of which the outer reflection is the structure itself. Thus, architecture expresses the "being" of the spirit itself, the established balance of the universe which is also established in ourselves. It constructs its project according to the laws which make up the universe, and, like music, it *presents* the work, but in stone.

But to express the rich and varied forces that are harmoniously balanced in the work, architecture is first articulated into the elements which carry and those which are carried, those which support and those which are supported. Here begins the rational construction of the work, as the Greeks showed with daring and with truth. The Egyptians had recourse to the imitation of external forms, as their column exemplifies, whereas the Greeks showed how each element so acts as to resist without any strain, but also without flaccidity. One need not emphasize that the material must be so placed as to "work" in accordance with its natural properties; that is to say, the question is how the marble, or the

wood, should be placed when it is subject to pressure and flexion. The architect, on the other hand, knows and should properly show the webs and ribs of the material so as to expose its natural charms with engravings and incisions and at the same time reveal its vitality.

But this is not enough. The artist composing a work of art does not only make a construction of materials; he organizes the materials as if they were living elements. For this reason, the theory of Schopenhauer about support and load threatens to demolish architecture because it requires of it only a rational system of carry and support. In his terms, every technical work would have to become a work of art. But if feeling is to emerge from an architectural structure, two factors are important.

First, we must be conscious of all the richness of the flow of forces within the form so that the system which joins them comes to life. In other words, we must make contact with the pure forms of architecture when we have mentally reconstructed the work as a whole. Second, this balance of forces must be so perfect that the architecture carries us beyond the system of construction in such an unobtrusive manner that we gaze upon it as if it were a wonderful game of forms. The harmony will become so great that we will no longer be conscious only of its transcendental perfection, but will become ecstatic, as we are when we see the celestial dome. Some other grandeur opens up within us, and we suddenly grasp its plastic revelation—architecture as a "world within a world."

The architect will conscientiously satisfy the first requirement, that of giving life to form—that is, if he can mold the work in such a way that the spectator will rediscover in each form the effort he himself would have exerted in undertaking it: he will then feel himself stretch out like the foundation, lie heavily like the beam, open up like the capital, and finally find an equilibrium as it exists in the whole work. Only in this manner does the inanimate and immobile architectural edifice come to life. In other words, it is reassembled within ourselves.

The second requirement, that of transcendental perfection, of a harmony that surprises us when we look upon it ecstatically, will be fulfilled by the architect whose work (an original temple or theater) also reveals an idea—when the forms, in other words, are functioning, not only for a re-erecting of the material, but also for something more than this; and it is precisely this something more which transports us in amazement.

But if the work is an idea, it also possesses a body perceptible in space and time. The passage from the perceptible into what is outside

space and time, into the imaginative, will be accomplished by way of the grace of the proportions and the rhythmical movements. Only thus will the architect succeed in transporting us, mechanically, I should say, from the whole to the parts and vice versa, so that we can conceive unity in variety vigorously and simply, so that we can recover the idea. Then the deeper unity of the natural and the supernatural worlds becomes a reality.

With such movement fossilized music comes to life. The static becomes a dynamic vibration, and whereas architecture formerly was at the opposite end of the pole from music, it now mingles with it in depth and appears to deny its own characteristic—that is, staticity. Or perhaps architecture overwhelms its own work, and out of a lifeless and immobile creation it reveals movement and life in space.

Assuredly this is what happens. Yet it does not suffice for one to ascertain the musicality of architecture through logic. Architecture must make this vibration objectively perceptible as it works to produce movement. Nor is it enough that the spectator is moved, that he approaches and retreats, to awaken the static revelation. Does, perhaps, the perspectival escape of lines suffice to bring this about?

Even when he is stationary, the spectator moves his eyes continually. Basing his theory on this fact, Milontine Borissavliévitch observed that section CB of a straight line AB appears to be larger than section AC,

$$A \text{———————} C \text{-++++++-} B$$

whereas in fact they are geometrically equal. According to him, this happens because the eye, being encumbered by the subdivisions, requires more time to move along CB than along AC. Thus the apparent distances are proportional to the time—that is, AC is to CB as t_1 is to t_2; and since architecture, to make an impression aesthetically, is based on perspective and on optical illusion, and not on geometrical proportions, Borissavliévitch argued that architecture is an art of time.[1]

It is sufficient to note that these time spans are so minute that there is no perceptible difference in time between them. CB appears longer than AC because it consists of many small parts, and in taking the greater number as the larger, the spectator is deceived. Because the eye is not the judge, it is the spectator himself who estimates and who sees the whole among the parts, and at the same time the whole in an instant. Each glance is a contribution to memory, which continuously recomposes unities on a comparative basis. The eye is therefore not deceived by the time which is increased by the impediments in line CB, but

judgment deceives the eye because it compares, since judgment recognizes innately that wherever there is a quantity, there is an increase, and wherever quality exists, there is tension. For this reason, even if it sees *CB* as longer, it will always prefer the straight line *AC*. For this reason, also, the same area seems to enlarge when it is enriched by a point, and the greater the number of points or lines inserted, the more the figure increases visually.

I cannot go into greater detail about these interesting observations. Let us not forget that the eye after all is an organ; therefore in art it will also be a means and not an end; art and architecture are indeed not merely stage productions.

Moreover, the ordinary mind protests, and justly so, at the requirement that architecture be an art of time, since architecture owes its grace to staticity and rejects any movement because with even the slightest movement the structure collapses. Its ideal equilibrium, that perfect musical vibration, would have been inconceivable, certainly, if the aesthetic observer did not prefer his own spiritual vibration and his own judgment as he photographs and reconstructs the whole from the individual parts and, inversely, in an instantaneous moment, does so in his memory and within time. With this "becoming" emerges the "being" which exists actively.

Yet, if the observer is to bring this about, the harmony of the forms and the visual escape of the lines of the work do not suffice. There exist beautifully lined and well harmonized buildings which do not possess movement. Their forms are dead, as though they failed to exist in space and time: they are not plastically so articulated as to express the inner vibration of the life of the work. Architecture will have movement when it reveals its internal "vibration" (because it is immobile) through an external agent which moves, resolves, and recomposes in seven colors, and this agency is light.

And in fact, if one carefully studies architectural creations, he will understand that to be seen they must be exposed to light; accordingly, they invite one to light them artistically. What is a rhythmical stoa or arcade but a repetitive contrast of light and shadow? What is a wall but a continuous lighted surface, or a column but a plastic gradation from intense light to halftones and the dark shades of the shadow; and what are the volutes of cornices and the ornamental motifs of a work but a game of light and shadow? Even the internal spaces of architecture are of influence aesthetically because they provide light artistically; and, finally, any architectural structure badly lit inside and out becomes

lifeless: an example was the illuminating of the Acropolis at night. Bright and lifeless, the lights succeeded only in erasing every shadow: too much light freezes, and the buildings disappeared because they looked like layers of white cake. Only recently has this lighting been corrected.

Thus is light illuminated with the artistic shadows cast by the architectural forms; light shows where it is displayed; and as it reveals, it is disclosed. But light is also winged and volatile: when architecture exhibits light and is elevated by it, then one sees that in this elevation of the material the architecture has become possessed by forces vibrating through the agency of a musically composed pulse. These are true forces. Internal possession is made external and is displayed through the music of light.[2]

Basically, the entire spiritual jolt caused in the inner consciousness when we seem to rise like columns and, like them, seem to support, or feel we are lying like a beam and transporting its load, all these experiences are but an inaudible music, a harmony of silence, which is played within us as its appearance has become fixed. Made external through the play of light, architecture allows us also to go through the photo-vibrations of this musical experience which makes the surface whirl; and thus we hear it even more intensely within us. And we marvel at this exceptionally personal experience, and each art rejoices in it. So, in this light and shadow. which is not dependent directly upon the carrying and the carried, architecture again, externally, creates its transcendental internal harmony. Along such general lines is the beautiful expressed in architecture, as a static equilibrium of organized forces which create a universe and from within the lifeless material produce forms that are full of life and so perfect that they can only be divine. And even in Greek art, the gods too took on the form of man, and the forms of this architecture contain, stretch out, open up, compress, are compressed, and overflow, whirl, sit, and at other times are indifferent, while each and every one is illuminated by and illuminates the idea.

We can now well ask how the manner of expressing the beautiful in contemporary architecture differs from the old manner, and whether it is different or always the same.

As Schopenhauer has observed,[3] Greek architecture expresses better than any other the law of supporting and supported parts. But in the face of architecture, he himself admitted that this law could not account for its appearance because the horizontals which represent the supported parts recede, and only the verticals project. And thus there is only the expression of the supports, intensive and, in practical terms,

monotonous, since the arcs which transport the weight fulfill the work indirectly, and not directly, as do the beams. Hence, aesthetically speaking there is no other contrast to the verticals which move toward the infinite except the buttresses of the roofing, which move laterally and carry the thrusts (Fig. 27). In this Schopenhauer sees the aesthetic overcoming of weight through the rigidity of the material. I should say that this impression keeps the Gothic architectural structure from seeming about to collapse. But such a victory he deems "apparent" with "an ascertained deception." Yet from this is also derived the "mysterious and supernatural character" of Gothic architecture, which, rather than reflecting the rational, displays arbitrariness; and for this reason Schopenhauer defines the Gothic as the "negative pole of architecture" in relation to Greek classical art, and adds that if a Greek had looked at it, he would have called its builders barbarians.

I believe in all conscience that art succeeds in moving us not only through the parts carrying and those carried, but also through the overall function of forces balancing the work. Of course, the harmony of the support and the supported is the basic and simplest expression, is practically a requirement, of the harmony of the material, and for this reason it is the richest source of architectural creativity when it is emphasized artistically. Thanks to the convention of its logic, however, it is static, in contrast with the functional impulse of forces which act dynamically throughout the work. After all, every "becoming" is dynamic, and thus music is a dynamic art in comparison with architecture, which is static. But I have dwelt sufficiently on why and how the "being" cannot be expressed with the "becoming," and vice versa. That is why music contains architectural harmonies and architecture musical movement. Bach is an architect of music, whereas romantics like Wagner and Berlioz are dynamic. Ictinus was the architect of staticity, the Gothic architects were the architects of dynamism.

After all, it is natural that in certain periods the architect is influenced by the dynamism of the "becoming," especially when he is possessed by a mystical religious feeling, as he was in the Byzantine and Gothic ages. Every elevation of the soul from the depths almost abandons form because form, especially when it is to be exposed to everyone, goes from the external towards the internal, and stops the "becoming"; it shuts the internal within while it opens outward. Form requires measure and observation. And so dynamism turns to the analysis of forces more emphatically to express the "becoming"—that which is about to be—without limiting itself to austere forms. Hence the

unwinding of Gothic architecture into musical scales that "tune" the arbitrary—that is to say, the feeling that moves one, when he looks at the work, like a musical remembrance leading to the infinite (Fig. 27). Then architecture vibrates, as when it plays with light. But in the north, where light is lacking, people were forced to convey this vibration through intense plasticity and the analytical movement of the mass, a thing that could not be avoided in the light of Greece (Fig. 28). For this reason, Byzantine architecture, despite the music of its spheres and the dynamism of the religious exaltation which possessed it, remained a form of Greek theory which one regards with reason rather than with emotion (Fig. 10).

And so the climate and the character of a people determine the expression of dynamism when the spirit of the age demands it. Also critical are the material and the means at the disposal of the technician. For this reason, if they had not had the orchestra rich in infinite colors of sound, romantic musicians would have missed the target, just as, lacking the secret of the dome, the Byzantines would have failed, and without the system of buttressing, Gothic master builders could not have expressed their dynamism. Before dwelling on the spirit of the present era, therefore, to learn how it has influenced contemporary architecture, we should perhaps ask ourselves where the new materials and the new technology are leading us.

In Greece the new material, more than any other, is reinforced concrete, and here I shall deal with it alone. Perhaps for the first time in the history of architecture, reinforced concrete has made possible the realization of a single monolithic construction.[4] Thus its products truly have a single continuous character, and not in appearance only. All creatures of nature—it is of no consequence that they have parts separated by joints—have bodies consisting of sinews and tissues which make them unities, but, above all, they are also covered by a skin through which the inner continuity can be seen externally. This solidity of material, which even rocks possess, architecture has always endeavored to convey, thus the persistence and patience of the ancient Greeks in eliminating joints. They rejected all cohesive material and covered the surface of the marble with a fine colored coating which concealed the separation of parts. Then the parts of the work looked like its members. And later, wherever cohesive material was used, the architect exploited the joints aesthetically in the form of a decorative network for a covering of the architectural structure. In a word, this cohesion aimed everywhere and always to display on the surface, in

some way, what dominates every work of art—the unity of the variety of its members.

Reinforced concrete fulfills this aim completely. But, even more important, it permits the plastic overflow of material and the suspension of the members of the work to a degree never before attainable, as when the human body extends its arms when it either bends or stands on one foot (Fig. 29). The cantilevers and balconies, whether open or covered, are suspended; the framework bridges large open spaces; and entire masses are balanced on piles, as in the Swiss hostel by Le Corbusier at the Cité Universitaire in Paris (Fig. 30). This daring erection cannot be compared to the kinetic grace possessed by either Japanese or Chinese architecture[5] (Fig. 31). Here the works have a dynamism the purpose of which is the abolishment of the very meaning of architecture, since it has strayed into a movement with which the measure—that is, the equilibrium—of man conflicts. Compare the corresponding movements of the body to see how tortured they are and how, only after much effort, the body can balance itself. But, much like a dancer, art must move without straining. The dancer corresponds with Japanese architecture. As necessary movements, the arduous movements can be absorbed by the whole, but because they are gymnastic movements, they are not the prime characteristics of the work. They are technological possibilities but do not constitute the strength of art. Can it be that practices imposed upon us by the past hinder us in evaluating new movements?

I do not believe so because man accepts any creation that is beautiful, no matter how original it is. Although no one sees centaurs or satyrs or gorgons in nature, art has never been denied the right to present these unnatural creatures or spectators the right to admire them. But that which now surprises man is not a sudden and immeasurable dynamism but a certain misunderstanding. Possessing the means to create monolithic or massive edifices, contemporary architecture displayed them as massive solids: it did not articulate the members of these bodies. The Greeks, however, no matter how carefully they concealed the cohesive joints, articulated their works organically. Gothic architects, no matter how much they expressed their mysticism dynamically, also produced works the members of which were attached to the body. But the contemporary architecture of reinforced concrete deems dynamism to be the elimination of the members which make up the body, and therefore, rather than display a single unified body, it customarily molds a single mass. It thus emphasizes the possibilities of the continuity and flow of material which science has discovered. Wherever it wishes to

show the frame, it has denuded the body. But the frame is only a system and not an artistic structural form.

In a strange manner, contemporary architecture as a science nevertheless centers its attention on the living content of its work—man, and proclaims that it organizes its work functionally. It frees itself from convention and introduces the free plan. Rather than rejecting form which moves from the external to the internal, it remains indifferent to the concept. It reveals a free, liberated form. The "measure" does not weight the requirements of function with the requirements of form. Thus it leaves life itself unorganized, for it is not satisfied with what man wants: it is also concerned with what should be. And art molds as it uses all the important factors. At present, however, though it believes that it is conveying the truth, it also admits that it is organizing its work only for its practical aim—for temporary values—and not according to the eternal values which organize the world and embellish nature. Today, an architectural structure is not distinguished as a perfect creation from all the structures around it; rather than remain with the eternal values recognized by man in every age, it does not last, but vanishes along with the ephemeral needs which caused it to be created.

When the body lost its members, it also lost its plasticity. For this reason contemporary architecture reverted to openings for decorating bare surfaces. As a matter of fact, it examined its harmonious proportions,[6] but seemed to forget that every harmonious proportion can become ugly whenever the plastic details suppress or fail to emphasize it. It was satisfied only with the geometricity of proportions—that is, with an abstract and dubious harmony. Thus the monotony of the continuous rows of horizontal windows, admittedly a technical achievement made possible by the retreat of the supporting piles and placing of external partitions on cantilevers, cannot arouse any aesthetic interest. These windows do not subdivide the structure organically; they decorate the surface without being plastic.

Architecture recognizes decoration and ornamentation as only an auxiliary, not as a primary factor. Now, in the dwellings of folk art the continuous openings were horizontally and plastically subdivided and bordered, in such a way that the resulting contrasts of light and shade were not monotonous because they were used in moderation. The white buildings of the Greek islands, even with their monolithic appearance and the dynamism which characterizes them as graphically free structures, owe their grace to the smallness of their mass. If such structures were enlarged proportionately, they would lose much. They would no

longer be either simple, or beautiful, but fortresses.

Thus picturesqueness results not from abrupt and sudden movements, or from the embellishments of lines, but from the plastic articulation of members and from shading. Moreover, if the idea in itself is to take wing, the architecturally permanent structure, with its concentrated static equilibrium, should also be distinguishable from surrounding nature.

In connection with folk art, however, our demands for a monumental and intellectual organization of the work are fewer. Here we do not look for a composition emerging from an idea which suggests its form. Popular architecture owes its dynamism and its picturesqueness to the fact that it pursues needs in the absence of any prearranged idea, and thus each time acquires an originality of form, though also a fortuitous form. It is true that the folk master-builder is not indifferent to the end result of his work, but he is not concerned about whether the result looks like the creation of his imagination. In his imagination he sees that he also has to build, but the unity acquired by folk architecture is "from below," and not "from above," because such architecture has limited needs, never extreme or superfluous ones, since common sense determines the measure, and common sense will be served. Yet, for this reason such works do not possess the grace and the grandeur of the artificial or the exalted feeling which predisposes the architect in every intellectual work to create a form which, as Kant defined the beautiful, has its own purpose without one's discerning in it a representation of a certain purpose. This means not that the artist, or indeed the architect, denies the aim that the work possesses, but rather that the aim triumphs: a difficult triumph indeed, and one which the architect may fail to attain. But this is why praise is given to the inspired technician who succeeds in conveying the spirit of his age through ideas organized in immortal works. There are no such demands on popular art, and such a triumph in it would appear to be superfluous.

Influenced by the classical spirit of rationalism, the famous French architect Auguste Perret early in the century aesthetically shaped architectural works in reinforced concrete in accordance with the system of statically carrying and carried parts. He displayed beautifully the materials that filled in the spaces of the framework which he was attempting to mold plastically, and he gave to the whole work a skin which was artistically illuminated. Thus he rejected the dynamism which characterizes not only the potentialities of the new material but the universal spirit of the science of our age. In his hands even the belfry

of a church, like his Notre-Dame at Le Raincy, is not dynamic, despite the emphatic verticality it possesses. Instead, he confined architecture to its sources. He molded statically, but he created a varied plastic scheme. His work recalls the conception found in Notre-Dame in Paris, thanks to the horizontals he emphasizes, a practice contrary to the spirit of Gothic art. But this work, though not an original work of Gothic art, shows that the Latin races are distinguished by measure and rationality even in their dynamic expressions. Perret recognized as much and displayed these qualities. This we have found in Byzantine architecture also, and a modern Greek architecture in any case should and could not escape such a spirit.

Perret's way is certainly not the only way of expression in modern architecture, however; nor can any one deny the dynamism that universally characterizes the new spirit. From this entire study, however, I believe that certain facts emerge and that modern architecture must be wary of three pitfalls.

First, wherever the movements are serene and have become esoteric or internal, instead of abruptly exoteric or external, the dynamic overflow should be adjusted with moderation and proportion. Then the work will not cause surprises, but will attract admiration, which is the highest aesthetic feeling.

Second, whenever the work is articulated in a body which consists of members measured individually and in relation to the whole, the soul and spirit of the spectator reaches an equilibrium. But in it also the life the structure encloses is organized, as it should be and is worthy of being, but not merely for the reason that it is wanted so. That life acquires form.

Third, whenever the ancients rejected the nakedness of the outer layer or skin, not in order to make a show of richness and ornamentation, but to shape the architectural work plastically, light came to illuminate and to be illuminated by shadows. It thus gave vibration to the immobile creation which is every work of architecture, whether ancient or modern.

Contemporary architecture will eventually find its sources and its particular expression for the beautiful. We ask that contemporary architecture return not to the old morphology but to the eternal values, enriched by a new tone, that of dynamism, and a new potentiality, the monolithic structure. This is the way the theory goes; but the work falls into the realm of action.

13

the language of images in architecture

Erect a pillar in a landscape and you already have an architectural element, if not a monument, like the menhir of prehistoric ages. This element is an achievement of man, for erecting something which would naturally be lying on the ground is a technical achievement which at the same time can be an artistic one. Our pillar now expresses a victory over the force of gravity: it remains balanced in its erect position, either wedged into the ground or resting upon the small surface of its cross-section; it rises vertically in the landscape, opposing itself to the horizontality of the earth's surface. This monument is also an artificial, man-made image reminiscent of natural images—like the cypress tree, for instance, which also stands erect in the landscape and balances itself vertically in spite of the burden of its foliage, or like a horse which rears on its hind legs when frightened and manages to remain thus erect, if only for an instant, poised for flight, like another Pegasus; or, to make a final comparison, like man himself, standing on his own two feet.

Next, erect two pillars, or three—or four, or six—and, looking at them, you get an entirely new feeling: the feeling of *rhythm*. The repetitive element creates a rhythmical series, an alteration of masses and spaces. Naturally, the pillar element now falls back into second

place; it no longer constitutes a monument in itself because it has become subordinate to the whole; all the pillars together now constitute a *work,* a new architectural conquest, like the long rows of menhirs, or the sphinxes lining the road to an Egyptian temple.

Between the masses and the spaces, we now feel the vibration of space. In other words, the receiving vessel, the womb, has made its appearance: that which can contain both this and the other and anything else besides, so great and infinite is it. Space can embrace the whole world.

As our glance leaps from one pillar to another, we begin to feel that this rhythm may be perpetuated *ad infinitum.* And we feel a peculiar pleasure, as when we see a row of trees in a meadow, or animals following each other in a field. Here is not only the victory of the erection of a pillar, which is satisfactory in itself, but also the victory of order, which we can sense everywhere and which we seek everywhere, whether in the V-shaped flight of birds in the sky or in a thick forest where no order seems to exist. Order is victory over chaos. It is through order that the one begins to emerge from the many, and the many begin to become a pleasing whole, a rhythmical alignment, arrangement, and composition.

The pteron of ancient Greek temples is made of porticoes, which are no more, basically speaking, than a rhythmical alignment of columns in which masses alternate with spaces; for this reason we have the impression that the whole temple is in this way made lighter, that it has, in a sense, taken flight. It is as if the porticoes were the result not only of the cumulative alignment of columns but also of the voids which perforate a compact wall. We thus have a perforated body which is much lighter than the wall of the cella. This is particularly relevant in the case of the pteron of a Doric temple because connecting the columns is a high entablature and stylobate, which do not allow each column a free culmination or an individual base. Technically, of course, the trilithon of prehistoric times is the fundamental idea behind the principle of the lintel on posts, and it is undoubtedly an idea which our imagination can accept as the result of the perforation of a compact wall. We find this image quite frequently in nature, as in the opening of a cave or in the horizontal bodies of animals balanced upon vertical legs.

The element of the lintel on posts gives the impression of a gate. It separates the world behind it from the world before it, standing between the two not only as a partition (as in the case of a wall) but also as a connection. It invites us to go through it much more eloquently than two

isolated pillars could ever do because in passing through this elementary gate we will experience the pleasure of yet another conquest: the fact that the beam has been lifted and laid horizontally over an empty space, the fact that heavy, earth-bound matter is now suspended in the air. This explains the strange joy we feel when we step through a natural opening in a rock, or walk beneath two trees with their upper branches interlocked, or pass under a bridge.

Finally, if the pillars are arranged in a circular formation all around us, a rhythmical order results which is without beginning or end, but which nevertheless constitutes a single, closed form. It encloses a space which is sheltered above by the heavenly dome; like the line of the horizon, this circular formation unifies space and holds it together. Here again, the prehistoric cromlech is the protean prototype of this elementary and grandiose architectural form, which imitates the circle of the horizon girding the universe. This is why the space enclosed within this circular, perforated wall gives us the impression that it contains the entire world.

Now let us try to cover this circular shape with a conical roof, like those one finds on primitive huts made of leaves and twigs, or with a corbelled dome, as in the treasury of Atreus, or an ordinary dome, as in the Pantheon; thus we replace the natural firmament with a man-made one. An image of the universe in miniature, a world within a world, is before us. In prehistoric caves, primitive man, in an effort to recapture the outside world and surround himself with it, adorned the walls with paintings of animals and human beings. In later ages, the Egyptians decorated their ceilings with stars and vultures and painted the coffers blue, so as to bring the firmament to mind. Flat roofs and rectangular buildings do not basically alter this concept of space and the world around us, not just because such forms are also to be found in nature (caves, ravines) but because, being closed forms, they shut out the feeling of chaos, of immensity, and at the same time the feeling of constriction, imprisonment; they leave room for a free movement of the human spirit and body, provided that their composition has order and proportion.

Indeed, if we take each element separately, we shall see that we derive satisfaction not only from their position, but also from their intrinsic form: in other words, from their shape, proportions, and conformation. It is not enough for a pillar to stand erect; there are a number of other important factors: the pillar may be short, thick, slender, delicate; it may be an obelisk covered with symbolic inscriptions, a Roman

column decorated with carvings, or a North American Indian totem pole. It is nearly always a symbolic image which expresses the purpose for which it was erected, and it therefore means to our imagination something more than a mere pillar, even when we are unable to decipher the written signs which are part of it. But even if the pillar is bare, devoid of any inscriptions or representations, it will taper downward slightly, like the columns of the Kerameikos, or upward, like the classical column, or will show a very marked upward tapering, like the obelisk. Thus it may be reminiscent of the trunk of a tree or of the calf of a leg supporting a body.

Apart from tapering, there is also the factor of entasis. If the column is Doric, it will be crowned with the echinus, if Ionic, with volutes, and if Corinthian, with the basket of acanthus; in other words, with a capital which receives the architrave by means of the abacus. The shaft is usually fluted, as if multi-folded, and it has a base, just as the calf of the leg rests upon the sole of the foot or the tree on the node of its roots. The base, the shaft, the capital, the hypotrachelion, the annulets are all symbolic elements underlining the similarity of columns to human bodies. This correspondence is not merely a manner of speaking; it becomes concrete reality in the case of the anthropomorphic post, like the caryatids, the telamones, the titans, all products of an anthropomorphic vision.

Egyptian architecture, on the other hand, is dominated by phytomorphic forms and presents perfect renderings of the lotus and papyrus, in bud form or full-blown, complex, multi-folded or not, sometimes accompanied by bell-shaped capitals which seem to have a free, open-ended formation. In Greek architecture, phytomorphic forms, while not so prominent, under a purely tectonic dictate, merge into an exquisite amalgam with anthropomorphic forms. In other words, the component parts of this architecture become the tectonic elements first and foremost, in spite of their symbolic ornamentation and the language of imagery which they convey.

The figurative tendency is never quite absent, however, whether we turn to Byzantine, Gothic, or Renaissance art. It is the basis of any architectural formation of elements into a great style, not only in the columns, the beams, and the arches, but also in the various moldings, which, like leaves, guilloches, tori, projections, or recesses, decorate the mediating elements articulating construction and forms. Walls, too, can undergo diverse decorative treatment; they may be ornamented in imitation of carpets, or landscapes, or rough, rocky surfaces, as in

Baroque and Rococo architecture. Ceilings with coffers remind us of suspended spiders' webs, Byzantine domes are studded with stars like the sky, Gothic cross-vaults interlock their intricate ribbing like the branches of a tree, and the wide, colored ceilings of neoclassical buildings spread out like tents. By means of an ornamental rib, the corners of Egyptian pylons imitate the trunk of the palm tree, which once served as protection for earlier constructions made of sun-baked brick. Floors too are elaborately decorated, whether with geometrical motifs or representations of gardens and animals of land and sea, even to the point of imitating an unswept house, as in the famous floor at Pompeii.

But the outward features of buildings also suggest images from nature. Circular buildings, like the church of St. George in Thessalonika, imitate the ring of the horizon, and domed structures bring to mind the image of the celestial dome; tombs and pyramids recall towering mountains; the abrupt verticality of walls suggest steep, rocky cliffs. In the rocks and mountains of this world, one could easily find most of the stereometric forms in elementary guise: the prism, the cube, the cone, just as in the Meteora of Thessaly one can find the towers and skyscrapers of our man-made world.

Finally, even the predominant combinations and devices used in construction are echoed in images from nature; the spider's web, for instance, is reflected in metal latticework, the joints of the human body in hinges and pivots, the cage of the human thorax in stone ribbing, the eggshell or seashell in ferro-concrete shells, the branches of trees in the corbel, the snail's shell in spirals and propellers, not to mention the horn of animals, the filigree of leaves, and innumerable other forms which have not yet found their equivalent in the world of technology. And so it is that nothing will appear new to the man who studies nature.

The language of images is undoubtedly the source of any artistic creation because it is able directly to symbolize the tendencies, if not the intentions, which possess the creative artist while he is fashioning his work.

Architecture and music are usually classed as the two arts which make most use of abstraction and deal with abstract forms to achieve expression; neither of these arts imitates nature directly. Architecture, in particular, is believed to limit itself to the use of geometrical forms—that is to say, forms that are alien to nature, ideal forms—to fulfill its purposes. Furthermore, it is believed that the structural systems of architecture result from tectonic calculations concerning the resistance of mate-

rials and the law of gravity, without any relation to the structure of natural beings. Finally, there is also the belief that architectural beauty can dispense with all figurative memory—as opposed to painting, and sculpture in particular—because the harmonious proportions relating the geometrical forms to one another and to the whole are sufficient to arouse an aesthetic emotion. This is a conception which began to predominate with Andrea Palladio and G. B. da Vignola, the academicians of the Italian Renaissance, who cultivated a "white" architecture by depriving it totally of color so as to restrict themselves to the severe proportions of the five main orders which have since become standardized. The conception reached its extreme expression in modern architecture; there we find architecture projecting purposefulness in its arrangement of forms and technical truth in its construction, and rejecting any decorative elements, abolishing any figurative tendency. Thus, instead of freeing its products from the dead weight of superfluous decorative elements, it merely succeeded in devitalizing them under the tyranny of large, monotonous surfaces devoid of plastic members, sculptural ornamentation, moldings, animal and vegetal representations, and figurative elements in general. The cold proportional relationships we find in these architectural works are not sufficient to touch our inner, emotional world—a world which has never ceased to be rich in memories, associations, impressions, and feelings; and these can only be linked together by natural images familiar to the inner world because only images of this kind can serve as symbols of our multifarious spiritual urges, concepts, and even transcendental visions.

By abandoning the phytomorphic and anthropomorphic approach, architecture has moved into a new age, the iconoclastic age, I believe it should be called. Others may prefer to call it the geometrical age, recalling an analogous period in ancient Greek art, but the analogy does not quite apply, for in the Greek geometrical period, despite the schematic austerity of form and the angular contours and the basically geometrical technique of its craftsmen, the essential outlook remained figurative. The craftsmen of that age distorted and schematized natural shapes and decorative motifs, but they never renounced the language of images. Today, this language has been totally denied, and we have become iconoclasts not only in architecture, but also in sculpture and painting, as is witnessed by what is known as "abstract" art. It is frequently believed that painting and sculpture are simply striving to imitate architecture, which has always been an "abstract," geometrical art. This is a fallacy; one has only to remember that Muslim art, which

was iconoclastic, never completely gave up the language of images but persisted in expressing them through its arabesques, its stalactites, and its ornamentation in general. Therefore it would seem that there was a deeper reason for this development: the aim is not simply to imitate architecture—which, according to Plato, does not imitate illusory images, as does painting, for it is a science and makes things—but also to disown the representational symbols of the language of images and replace them with signs. Therefore we cannot properly say that contemporary art is asymbolic because there can be no art without symbols, but we may say that it is cryptosymbolic. Hence the great concern of the new aesthetics with symbolism and semantics. Hence the obstinate refusal of abstract art to express a definite theme or subject, even though many artists like to give their work a title a posteriori, like, for instance, "blue symphony" or "dot and circle." Artists may believe that "dot and circle" is not a theme, or that adding the title after the completion of the picture implies that the picture expresses far more than the prosaic combination of a dot and a circle. Perhaps they also believe that a work of art with a subject, like a portrait by Rembrandt, let us say, expresses only the object it depicts, and is therefore shallow in content because it embodies only a single meaning instead of a many-faceted one. But this again is a fallacy.

I shall not attempt to explain contemporary art by way of its negative positions, which are simply a reaction against the decadence of academic art; nor do I wish to show that, through its contradictions, it ends by denying its own denials and becoming even more subject-bound than are academic representations. But I do wish to make some observations about the surrealistic phase of modern art. In this particular phase, in which we see the overflowing of the whole automatism of the subconscious mind's dream imagery, we are really witnessing nothing other than a knitting together of various symbols with a purely subjective significance. The interpretation of these symbols poses an objectively insoluble problem—unless, of course, we have a "book of dreams" at hand. What remains is simply the joy of color combinations and proportions, and the imaginative exuberance which attempts to solve this cryptosymbolic language by divinatory means, by introducing its own meanings into the picture. Of course, it is not often that two personal emotions or experiences coincide (in the creator of the picture and in the beholder of the picture), and this lack of coincidence is something which must occur to many beholders whenever the artist expresses himself with immediacy and sincerity. But the happy coincidence is

becoming more and more difficult because the symbols have become secret, subjective, dream-like. Thus we each dream on our own, and we have now reached the dangerous point where being moved to intro-spection by a picture is considered an aesthetic joy—a communing with oneself. But no joy can be complete unless it embraces other human minds as well. There is, of course, a positive feature within this Babel of contemporary artistic symbols: the positive feature is Babel itself. And the suffering caused by this chaotic attraction between members di-vorced from society, by the tragic relationships among all these uncon-nected passions, tendencies, and actions, is revealed through the amal-gam of dream symbols, like a whirlwind of images in the confused head of humanity as it strives to impose order on chaos, and stretches out a hand to grasp an overhanging branch while it is being precipitated into the void.

But let us put aside the example of surrealistic painting into which we have digressed in order better to comprehend the great drama of art, and let us return to architecture, where we can get a clearer picture of it.

Modern architecture aims above all at serving our requirements as honestly and effectively as possible. It is first and foremost an expres-sion of purposefulness, of necessity, and for this reason it has a subject, a theme—more today than at any other time in history. This theme, of course, is not an abstract idea, like that of a memorializing monument, but something concrete and tangible; it is dictated by a particular need, and it is this need which determines the arrangement of space for the better accommodation of man. The arrangement of volumes proceeds as a consequence of the arrangement of space; the structure of forms is now a consequence of the system of construction; the modeling of shapes has become a process based on the nature of the material and on the projection of its texture, and lacks any ornamental intention. From an aesthetic point of view, then, all the elements converge in the harmonious proportions of geometrical forms, in lighting effects, and in the texture of materials.

This is how matters appear in theory. But in reality, man is not satisfied with the perfect proportions of petrified geometrical forms alone. The pyramid pleases the eye in the vast expanse of the desert because it replaces the missing hill or mountain, and also because it presents a strictly delineated form. But this pyramid does not stand alone; it is placed among sphinxes, mastabas, and smaller pyramids, which provide a scale against which it can be compared. Nature has

taught us to notice how light molds the plastic shapes around us, and how color infuses forms with a living content; and we expect the same things from art. Even if the intellect does not expect them, the imagination does; and it is the imagination to which art appeals, since it is the principal means by which art is created.

For this reason, contemporary architecture focuses all its attention on the functional arrangement of shapes and their aesthetics. Interior space is arranged so as to facilitate the movements of the inhabitants which the architecture aims to serve; it has ceased to be a series of box-like rooms. The rooms in a house now merge, grow into one another, and revolve around a continuous space, the partitions being only slight ones; or, in cases where the box-like arrangement persists, distances are reduced and the rooms are arranged functionally. A corner here, a recess there, a ledge further on, a diagonal opening, and various other curved, flexible forms appear, as if the house were a plastic, malleable material yielding at man's slightest pressure as he moves about in the space which organizes his needs. This has been made possible especially by the discovery of ferro-concrete, metallic constructions, plastic materials, plywood, and so forth. This is why the knowledge of modern architecture is acquired not merely through a consideration of an architectural work as a form in itself, as an objectively significant synthesis of component members into an entity, but through using it, walking through it, experiencing it as the receptacle of the needs of a particular function in a free plan. The beholder or the occupant then rejoices because the building serves him well as a school, or is convenient as a residence, or functions efficiently as a hospital; but if he just stands and looks at it, it often appears to his eyes as an incomprehensible complex, more often as a silent sign, conveying nothing.

The complex which as a rule emerges from a free plan rising up in the air by means of entirely new technical systems, so that even as regards height, the building blossoms out freely—an "open" form as opposed to the "closed" form of classical buildings—this can only be apprehended as an entity by an architect if he designs "from above." Thus seen, the building's complexity is elucidated, but in this way of looking at it, it is an abstraction which the ordinary beholder cannot easily achieve. That is why, in contrast to modern constructions, the Pantheon, St. Sophia, and the Parthenon stand before us like miracles of simplicity, easily comprehensible and inexhaustible in the diversity of their forms and picturesqueness. Conversely, modern buildings have

been reduced to their functional purposes—that of hospital, school, shop, and so forth—and leave nothing for the eyes, for the pleasure of the spirit, beyond the practical purpose of the building. The language of images has been ostracized. All that remains are certain pleasing proportions and occasional dramatic associations excited by the texture of the bare materials.

This is not to say, however, that symbols have also been ostracized from architecture—at least, those secret symbols, those signs we do not normally notice. The doorway of a building has never ceased to be a symbol of passage and separation between the outer and the inner world. The window is still a sign for the need for a view, and of the penetration of the outer world into the inner world, and vice versa. The wall remains a sign of support and partition. The floor, the roof, steps and staircases, and, above all, the column, the lintel, the corbel, the shell—in other words, all the elements which are architecturally and functionally necessary to a building—are signs of a structural and practical purpose. They could therefore be called tectonic and functional symbols.

These signs have always existed, but they did not in the past constitute a self-sufficient language in art, for they were not a poetical language. They were not a language of poetic metaphor, as was the Gate of Lions at Mycenae, where the lions guarding the entrance add meaning and content to the whole edifice. In other words, contemporary architecture has allowed its vocabulary to become impoverished because it does not base its power of suggestion on poetic imagery. Its poetic expression is prosaic, iconoclastic, and cryptosymbolic, as we have said. It does not speak with images or with representational symbols, but with prosaic meanings, with signs, like the letters of the alphabet, which once represented familiar objects and have now been reduced to combinations of certain lines which represent nothing and can be understood only by those who possess their secret. The language of modern architecture has therefore become secret. One has to learn it in order to read it, whereas in previous ages architecture had something to say to each beholder: it offered certain images he could associate with analogous representations or situations. It was the art of poetic metaphor. And it is this art, perhaps, which has been lost in modern art.

14

prefabrication and aesthetics

The application of aesthetics to the problem of prefabrication should not surprise anyone because, without the assistance of aesthetics, prefabrication by nature does not exist, even though in the course of its realization aesthetic principles are violated. Fabrication entails the application of principles and rules of aesthetics in a manner either good or bad.

Aesthetics concerns itself particularly with the artistic expression and accomplishment of the work. Prefabrication is concerned with the economic and technical improvement of the work. Aesthetics takes a purely intellectual interest in the work, whereas prefabrication is concerned with the social implications of a material and seeks to impose a means of facilitating and achieving its construction. Consequently aesthetics finds itself on a level different from that of prefabrication, and has another scope. Aesthetics has an idea of the economy of the composition of the work, whereas prefabrication simply has a rationalistic concern with the economy of expenditure and time in terms of the execution of the work. The aesthetic aim of the work is the aim of architecture, whereas prefabrication is the means. Thus aesthetics and prefabrication are distant from one another, but do not by necessity

disagree. On the contrary, the means can come to the aid of the end when both are used correctly—and this is precisely the problem: when will prefabrication be reconciled with the aesthetics of architecture? Certainly, aesthetics is not a contradiction of prefabrication, though it does impose limits in that it demands quality in the individual work.

Even in the past, prefabrication was not unknown in architecture; its use was limited, however, and it was carried out manually. Parts easily differentiated in construction and capable of being separated and reproduced (bricks, windows, doors, etc.) were prefabricated; their inclusion in the construction and their arrangement in larger elements (walls, drums, etc.) was carried out by hand labor. Today, however, industry goes so far as to become the means of organization, to the extent that this is possible, of the component parts which only a short time before had been made in a factory, the slightest possibility of individuality being absent, as, for example, in the prefabrications Pierluigi Nervi made of reinforced concrete (Fig. 32). The unsurpassable prototype of an entirely prefabricated industrial work is the Crystal Palace in London, built in 1851 by Joseph Paxton (Fig. 33). The entire industrial design of the project, as well as its structure, was envisaged in terms of prefabrication.

With the Crystal Palace one can precisely date the beginnings of prefabrication on a large scale, the date at which industrial development began to direct its efforts toward the construction of an entire building on the production line, as of factories producing a manufactured article—for example, the automobile. Industry certainly can and does turn out mass-produced articles according to a prearrangement, but every article thus produced is identical with every other, whereas what is esteemed in aesthetics is the difference and individuality of each one. Manufactured articles—antique vases, for example—even when produced one after the other so that they resemble one another, are, as a consequence of the interference of the human hand, individually slightly different and distinct and unique. The same is true in nature; all flowers of a species resemble one another, but each of them is a slight variation of the general type and is unique. There is a change and variation that makes the work tolerable and original.

It is therefore useful for us to consider the difference between mechanical repetition and type production, which are the basic elements of prefabrication, and rhythmical repetition and type production, which are the presuppositions of architectural composition. Initial planning and architecture seem to meet and to coexist on these princi-

ples of repetition and type production; yet it is at this point that they also separate if the mechanics of repetition and type production kill the rhythmical elements of style. For example, in the Parthenon, where the columns are repeated rhythmically according to an order, the triglyphs, the promoxthos, and stagones, even the walls of the cella are made of stones of equal dimensions repeated according to a determined rhythmical order. And yet the corner columns are thicker than the others, those on the sides of the axis are narrower at the top, all of the columns incline toward the cella, and the stylobates and cornices are curved at the bottom. Finally no one of the columns is exactly like another. The entire project becomes very elaborate, but it also appears to breathe and to conquer gravity by way of the mind. The thinning down of the form extends even to the cornice tiles, all of which have a turn toward the axis in a way symmetrical to one another, half of them to the right, half to the left. Today, however, such refinements are no longer feasible in architecture: we simply ask that repetition become mechanical, and this repetition determines the synthesis, so that prefabrication becomes an end rather than a means.

I have spoken of the antefixes as they are part of the marble tiles of the roof of the temple (Fig. 34) and as they, in my opinion, represent one of the masterpieces of prefabrication in classical architecture—especially if one looks closely at the perfection of their form and their ability to completely protect from rain. Byzes of Naxies (620 B.C.) was the first person to design marble tiles, and just for this reason was famous in antiquity; for he could have avoided the leaning of the antefixes because the temples had two pediments, whereas formerly they had one, and, as Romaios[1] has demonstrated, the bend of the antefixes was determined for reasons of design. The Greeks retained the turn for purely aesthetic reasons. The antefixes were more pleasing thus. Today what technician would think in this way? Unfortunately, our architects have become studio architects, and the studio is of no help in the realization of such details. The training of a technician has become primarily rationalistic and aesthetically indifferent—in fact, it deprecates sentiments of the aesthetic sort.

In classical and Renaissance architecture, division and the rhythmical repetition of elements are subordinate to the design, which divides the building into foundation, body, and head, in such a manner that it tends to be reduced towards the upper portion. When an elevation had successive orders, Doric was placed at the bottom, Ionic in the center, and Corinthian at the top. The theory was anthropomorphic, and

the composition of the work was analogous. If we consider a contemporary work like a skyscraper, however, we see that the windows seem to repeat themselves on every side and appear to terminate in infinity. There is no bottom, body, or head; rather, there is an inorganic crystal body made up of the sum total of parts repetitive and for all practical purposes purely mechanical. Aesthetic theory here becomes pragmatic and is conditioned upon the demands of the structure, which attempts within a limited, hollowed-out area to accommodate a crowd, a mass of people. In a skyscraper one can subtract or add floors without aesthetic effect, whereas nothing in a classical building can be changed: neither the foundation, nor the body, nor the head.

In classical architecture every structure belongs to an order; in other words, it belongs to one type which is repeated often, as is true of the Doric temple. In this order, all of the parts were formulated even to the smallest details, the temple conforming to an analogous rule that had the modulus as its measurement—that is to say, a rule determined from half the sum of the diameters of the columns. Thus all Doric temples seem to be the same, and yet each one differs from the other in detail, and is unique. Indeed, the perfection of the Doric temple is due precisely to this repetition, so that through successive approximations the remarkable structure of the Parthenon is finally arrived at. I say all of this about classical architecture to show that it is possible to relate it to the rationalism of prefabrication. Classical architecture had precision and order in composition, and its forms were rhythmically formulated. Determining the order of the temple and the modulus, the architect could immediately construct it since the rules of proportion for all temples, regardless of size, were theoretically the same. I say "theoretically" because each temple did not cease to be unique. For this reason Plato said that whatever is beautiful is not beyond measure, and Aristotle that the beautiful is within the limits of measure and order—thus all of these are details without which classical orders would have fallen from the state of art into the state of simple technique. The Romans did this when they rationalistically copied the external elements of Greek architecture and thus altered its beauty and the meaning of its orders. For example, they positioned the corner triglyphs according to the extremities of the columns, so that half of the metope is on the corner (Fig. 35).

At that time, as a reaction to these theories, the theory of Plotinus was formulated, which influenced all subsequent art up to that of the Byzantines. In opposition to Plato and Aristotle, Plotinus said that the

beauty of a work did not depend on its symmetry and variations—that is to say, on the diversification of its form—but on the idea motivating the work because this idea unites the parts. Thus, Plotinus transferred the burden from the form to the content. Space began to take on significance, and form became more and more picturesque. It is sufficient for me to point out that in a single colonnade, like one the church of St. Demetrius of Thessalonika (Fig. 36), each column has a different capital, something incompatible with the colonnades of a classical temple. Moreover, Byzantine walls do not have equally thick articulation or exactly regular shapes because if the arrangements are to be picturesque, the initiative and facility of the technician must be paramount in the formulation of the form. In a case like this, prefabrication is impossible because with its rationalism it denies the artisan any opportunity for freedom in execution. Also denied is chance or hazard, which has become a principle of contemporary art, of action painting, and especially of music, and appears as well even in some architectural works, like that by Le Corbusier at Chandigarh (Fig. 37), especially in the parapets, which can be characterized as jazz architecture. In contemporary art, as a consequence of the reaction against technocracy, there is a decree that the execution precludes reflection, as in action painting, a phenomenon, the meaning of which is that every denial of the initiative of the artisan is a suppression of the meaning of art.

The picturesqueness of form in Byzantine art did not prevent the design of rhythmical general varieties of churches and icons, which were then reproduced. When the donor of a church told the head workman that he wanted a four-columned church (that is to say, a church of the cross-inscribed-in-a-square type), they both knew what was meant (Fig. 38). Moreover, the chief workman also knew how to lay out this type, both in the ground plan and in the elevation, as has been made clear by Nikolas Moutsopoulos,[2] so that he could immediately set the limits of his measurements. That so much freedom was permitted in the execution indicates just how tightly allied church building was with the types, while never ceasing to develop and to render every one of its examples unique. Consequently, the isosceles triangle which is the basis of the diagram of Moutsopoulos (Fig. 39) is taller or shorter according to the historical period. The same is true of icons which are copies of models showing how one designs the Crucifixion, the Nativity, and all other images based on hagiography. The model was the type determined by and skillfully rendered by some master painter; it was determined to be the best and most perfect through its execution, as was Greek folk song as well.

The Renaissance and neoclassical periods, despite their copying of the classic form and its rationalism, produced no new element of an order other than a theory of numbers for the analogies of a work, and even this was restricted to a mimicry of arithmetical relations as taken from the Pythagorean theory of music. Perhaps one should expect that the modulus would have evolved as useful in construction; but the modulus became a measurement of the classical elements only, which Vignola organized into five orders: Doric, Ionic, Corinthian, Synthetic, and Tuscan. In essence, types of temples and types of palaces ceased to exist; types of religious images no longer existed. Everything was an individual composition, the inspiration being based on a naturalistic mimicry of nature in painting and in the mimicry of Greco-Roman orders in architecture. From the Renaissance onward the impression prevailed that the systems of harmonic designs had as their only ends the guarantee of sure proportions, whereas the truth is that they were the initial means of design of the work on the spot. No other system so guarantees the beauty of a work of art.

The foregoing historical digression pertains to works in which art controlled technique and aesthetics despite changes in taste, and was concerned with perfection of composition. Today, however, when technology crushes art and urges the need for complete prefabrication of architectural works, the architect will inevitably adopt an industrially oriented point of view, and his works will conform to the new industrial aesthetics. Industrial aesthetics has failed in our age, however, in artistically domesticating products produced in a series and looking exactly the same. In so doing, it has turned the products of industry in a direction far from its old mimicry of hand-made prototypes, so as to discover shapes having an internationally functional worth, a geometrical character, which would give value to the principle of the machine and its new materials. Because of this, industrial shapes finally became abstract, forbade mimicry and the adoption of old morphological shapes, and also harmonized with the turn in contemporary art toward this type of abstraction. Railway engines which once had chimneys in Doric or Corinthian orders now have aerodynamic forms. Assuredly, such creations of industry are designed by a staff of designers with specialized training, whose art at one time was known as "minor architecture."[3] Moreover, industrial aesthetics, insofar as it pertains to the mass of people, seeks to satisfy the needs of ordinary man. It is striking (for example, using brilliant colors) to attract attention and, generally, since it tries to be connected with an international·market, is commercial and serviceable and indifferent to aesthetic canons. It is

"international"—that is to say, it is not rooted in any place, climate, or tradition.

From these observations there arises the direct question: is it possible to reconcile the principles of industrial aesthetics with the principles followed heretofore in the creations of architecture, or should we perhaps search for some way to refine prefabricated works? A condensed answer to this question would be that prefabricated architecture must stop mimicing the shapes of the past and attempt to organize the structure of a work in keeping with industrial capabilities—in other words, it must innovate, as happened in the case of the automobile, which, ceasing to mimic the horse-drawn carriage, has become aerodynamic (Figs. 40–41). In the same way, we must wait for new forms of housing, like the Dymaxion of Buckminister Fuller (Fig. 42) or his earlier egg-shaped shell (Fig. 43). Naturally, architecture, if it is to be produced in the studio, must become an applied science according to which the architect creates designs of extreme accuracy. Actually, a board of architects and engineers should correlate designs in the way in which a board of industrial designers correlates the designs of an automobile, an aeroplane, and so forth. Finally, the executive must organize production scientifically, since a wide range of economic problems has to be considered.

To solve the problem in a more satisfactory way, however, one should analyze in detail the architectural forms the constituent parts of which are practical, technical, and artistic.

(1) The practical form of architecture in its contemporary development primarily selects whatever is of utility in a domestic area or structure as being highly rationalistic and consequently useful. Thus, its main concern is the basic satisfaction of the needs of a person's body; the satisfaction of those needs of the soul which require feeling and art are not grasped by the reason and are not measurable. The measurements of the soul of man giving form to a space are discovered only through the feeling and imagination of the architect. From the rational point of view, only the dimensions of the body can be measured—and for all people they are approximately the same; if we ask for economy, we must then take the minimum, putting things in order of importance, so that everything finds its own place, and moveable furniture and superfluous areas are avoided. A man therefore becomes a depersonalized digit, the bedroom, for example, being something in the order of a steamship cabin, with furniture attached to the walls and everything having its prescribed place. The needs of the masses who have little

money are satisfied with such spaces; an example is the Citrohan house of Le Corbusier (Fig. 44), in which it was finally revealed that identical rooms are acceptable for a few days but not for any significant length of time. When Le Corbusier created the Citrohan house, he called it "une maison comme un auto conçue et agencée comme un omnibus, ou une cabine de navire." Even if one enlarges the space a little and keeps the general orientation as it is, man is still deprived of the comforts his soul requires. It is well known that people suffer as a result of living in modern houses with small rooms. To put something new into a room, they must move something from its place, only to be left with that thing, which now has no place of its own, room for anything superfluous being non-existent. The director of a provincial museum which had been built without storage space for superfluous items once said to me: "A museum without storage space is in danger of becoming a storeroom in its entirety." In the same way a house with an excessive economy of space and areas rationalistically arranged in the end becomes intolerable and disorderly.

In other cases, the human body becomes a multiple standard of measurement. Le Corbusier, who wanted to give contemporary architecture a human scale based on human measurements universally applicable in the construction of both space and implements, took as his basis a man of the average European type with a height of 1.75 meters. Subsequently he found that these measurements did not conform to those of inhabitants of Anglo-Saxon countries, and he substituted for the first man a second one with a height of 1.83 meters (modulor 56). On the basis of this, he finally constructed the modulor, saying that it is better that objects so designed be a little larger than smaller, an observation completely arbitrary and illogical.

In Europe the decimal meter is used, which is completely unrelated to the human body. Anglo-Saxon countries use feet and the finger, as did the ancients, both of which have a relationship to the human body and conform to the dodecagic system that is divisible by the numerals 2, 3, 4, 6, etc., though certainly it complicates the arithmetical system. Le Corbusier wished to correlate the meter with the measurements of the human body—in much the same manner as one has a scale in music—and thus he created the modulor I have described. He did this hoping to establish an international scale to be used in the construction of every new building, and in particular of prefabricated ones. He found there was no response, however, The scale was used only by himself in an apartment building in Marseilles, and afterward it was forgotten because

the two Fibonacci series he created, when taken at the extremes, do not give the impression of continuity—only those that are closer to each other do. The rule of construction, a modulor, sometimes becomes the material itself, such as the brick, from which fact we have the expression one-and-a-half bricks or two bricks, and so forth. Occasionally one designs a grid of prescribed measurements, as did the Japanese in the tatami, a carpet which regulates all of the house. As the measurement of the grid we usually use a foundation of reinforced concrete, or axially aligned windows. The grid establishes a rhythmical step for the conclusion of the work as the ancients used it in temples which were in pyknostyle, diastyle, systyle, or araeostyle. In the end, all of these measurements accepted by Le Corbusier, even that of the modulor, do not guarantee harmonious relationships unless the architect has an eye and an imagination.

From the former we learn that, if it is to be habitable, it is enough that a room be 2.20 meters high. The question not considered is of whether or not the ceiling gives the impression of falling in on one. In other words, in contemporary architecture the most expensive and rare thing is space, despite the fact that in today's architecture the prime consideration, theoretically, is space and not beauty. For this reason American houses tend to avoid independent rooms and to combine the spaces into one large "living room," only the bathroom, which has a door with a lock, being separate. All the other spatial divisions are created by low and often temporary, movable partitions, so that the prevailing impression is one of a continuous, united large space (Fig. 45). The individual's loss of privacy and a place for reflection is a matter of indifference. The house becomes a living place for many people, and the individual is depersonalized as if he himself were the product of the production line. The modern architect often uses man badly, his main point being to demonstrate that in a small space he has managed to solve the problem of housing for the masses, with a planning arrangement maintaining light, air, and grass for communal purposes, as was evidently done by Le Corbusier in his apartment house in Marseilles, designed for sixteen hundred people (Fig. 46).

In it every apartment is prefabricated and, like a drawer, slides into a general frame which leaves the ground floor free. The arrangement of every apartment basically resembles the houses of Skyros, in which out of the right-angled area a platform is constructed at the rear upon which the family sleeps, the kitchen being located under the platform. The front section of the angular space remains free for daily use. Certainly a

presupposition is required that before people go to sleep on the platform to the rear, activity on the lower level has ceased, and this is only possible in patriarchically organized families, like those on Skyros. For this reason, many French people accused Le Corbusier of wanting to establish prototypes of collectivist housing according to his own liking. Naturally, it is difficult for everyone to have his own private house as he wants it to be. Furthermore, in the city most families rent houses the organization of which does accommodate their needs. Older houses which have no angular arrangement of specialized rooms and fixed furniture are more elastic in adapting themselves to the different uses of space. In any case, in an age of expanding technical development, the solution is not to be found in that way, and we all therefore seem to be wearing ready-made suits of clothes, not made-to-measure ones. And yet it would appear that prefabrication and pre-measurement represent the direction in which we are heading.

Certainly things would change if we were to transform our way of life and change the significance a house holds for us, as Americans have already done and as people in some European cities have been forced to do because domestic servants are expensive, if not unavailable, in a new society. If we change our way of life, it will be easy for all of us to end up, like nomads, in hotels or in trailers—built to the measure of the masses and easily manufactured. Radical changes in life are hardly easy, however, though in America one can observe the tendency to escape from the city into nature and the nomadic life, somthing which would be difficult in Europe, which has other traditions, and especially in Greece, where the love of private dwellings is prominent. Greek folk houses, though small, are relaxing primarily because of their inner courts, which augment their spaces.

(2) The rationalism of construction governs the technical aspect of architecture, which in different periods has established different systems of building: in classical architecture the architrave on columns, in the Byzantine period the dome, and in the Gothic period the tendency to devise a system of skeletal structure and non-supporting walls. In the classical period, there was open construction, and in the mediaeval, cohesive mass. Wooden and iron structures were latticed, and today, by means of reinforced concrete, we achieve monolithic unified structures which are completely self-supporting. Analogous, as well, were the systems of prefabrication which were devised in the past and which through distribution of means held the parts together lightly and conveniently. Others more specialized than myself have shown how many

239

ways prefabrication can be achieved today, though there are two basic systems: light prefabrication and heavy. The difference between light and heavy prefabrication will finally disappear when the use of plastic products, which are light by nature, is universal. Nonetheless, the basic character of the older prefabrication was its small scale, restricted and ultimately assimilated by the artistic form, which was not destroyed.

Today, however, when prefabrication is on a large and continually larger scale (so much so that houses emerge completely ready in a series), we are in danger of subordinating the artistic aspect of architecture to the mechanics of industrial products. If we suppose that eventually we will build ready-made houses and structures, in general and in a series, I should say that the future appearance of houses and cities will become non-human and monotonous. Unfortunately, such examples began to appear in workers' quarters in the beginning of the industrial period. To escape from this monotony, Gropius recommended the method of combining three-dimensional factors for composing space in a building, as with the wooden blocks of children. The idea, I believe, is an unfortunate one because the synthesizing of a work is not simply a joining together of inflexible parts. As soon as they change position and direction, the parts certainly give variety to the whole, but hardly give unity to the variety—which is the fundamental principle of every artistic creation. Another method is the unification of the units of the space according to the needs of the individual (Fig. 47). This method permits personal variation and the cooperation of the architect, who contributes his most valuable possession, imagination.

(3) The artistic form of architecture is first of all the product of the imagination of the architect, which should be protected from technology and especially from prefabrication, the rational motive of which threatens to become an end rather than a means. For this reason, I believe that prefabrication should be restricted to the area in which it can be assimilated by the artistic form. Thus, the engineer must think of the organization of the construction of the work in connection with its execution, as occurs in the work of Pierluigi Nervi, whom I consider an excellent example (Fig. 48). Another good example is the church of Royan, with V parts in reinforced concrete, invented by the engineer Lefaille and used especially by the architect Guillaume Gillet (Fig. 49). Here the tower has a height of 60 meters. By it I am reminded of the older lattice-worked windows of the churches of Auguste Perret, since they maintain classical cadenzas, whereas contemporary prefabricated parts are naked of rhythmic form.

Essential, therefore, in the decision to use any sort of prefabrication, either great or small, is the cooperation of the architect and the civil engineer. To create variety in the work, the architect knows how to use variations the possibilities of which exist in the plastic decoration of the walls. The art of transposition (permutations of Op art) is used today in the decoration of fabrics with designs taken from Op art, and thus every piece is different, a factor that pleases women to the extent that they want to wear cloth of a unique pattern. Manufacturers of fabrics attempt to adjust their production to this end; the same attitude must prevail with respect to construction.

Perhaps my observations about the maintenance of artistic form seem utopian in an age in which artists hold to the view that their creations should not be considered eternal and unique, but rather transient and passing. Today architecture too avoids monumentality and thinks that any one of its works which, possibly for economic reasons, can be discarded should make way for another. With prefabrication, moreover, a dwelling tends to cease representing a financial investment. The house will be reduced to the level of an automobile. It is only because life in a house is sacred and, also, because it is somewhat inconvenient to change houses often that we do not treat houses as we do automobiles.

Another misfortune is that the works of contemporary architecture are based on stylization. They do not yet have their own form. Either they fall to a mechanical level of repetition, as in the case of skyscrapers, or they exhibit an absence of form that comes from a tendency to demonstrate technical possibilities, or from an exaggerated emphasis on functional refinements, like, for example, Frank Lloyd Wright's Guggenheim Museum in New York.

Today we scrap 37 percent of our structures. Some people say that if the car were produced in the same manner as the house, its price would be 50 percent higher. Are these mundane economical considerations the only criteria for our finding out what we must do? Is it possible that man's need for beautiful form will vanish? Beauty is not produced mechanically, but one should not, for this reason, exclude prefabrication as a possible means of creating valuable architectural works, though it should not be permitted to become an end in itself. It should be allowed to cooperate in architecture only to the extent that it is assimilated into the artistic form, form having the right of a final veto. Architecture as an art should not be allowed to die. It should not die as a result of the architect's refusal to cooperate with industry and prefabrication, or

of the exclusion of architects, indifferent and uncooperative, from reality. There should be a great effort to find new acceptable forms for prefabrication. I should say that imaginative research is needed to change the present mentality and to build a spirit of research essential in our scientific age.

But we should keep in mind that industry has led us into a consumer civilization, a *prisunic* (cut-rate) civilization, the character of which has crushed the soul of man. I should think it prudent not to go too far in attributing this civilization to industry with its production lines because buildings belong to our immediate environment and within them men are born, live, and die. But as was once said, "It is easier to kill a man with an ugly building than with a gun."

One of the arguments for the necessity of prefabrication is the quick increase of the population of the earth, especially in the underdeveloped countries. Statistics indicate that by the end of the twentieth century the population of the earth will have doubled and that monstrous cities will have so multiplied that great building problems demanding a fundamental change in building methods and the structural syntheses of housing will be generated. A group of Japanese city planners has offered solutions in which upright skeletal structures would accommodate suspended houses made up of one or many prefabricated units having converting corridors, so that heavy and fast-moving traffic would be relegated to the ground level. I should say that the effect would be that of a tree with nests of houses instead of leaves. One successful such example was exhibited in Canada; though structurally it was without form, aesthetically I found it interesting.

In any case, I wish to add that statistical prophecies do not convince me because as life evolves, other factors, unseen and unaccounted for, play a part, factors which contradict the prophecies which take into consideration only quantitative growth and not qualitative changes and technical progress. Since the ancients did not have to take into consideration the possibilities of the wheel (buses, the subway) for communication, they would have been frightened had they been told that in the future cities would be made up of millions of inhabitants. One can foresee that after a time communication by means of the wheel will come to an end, and it is not an impossibility that tomorrow each of us will have an individual means of flying.

15

Greek popular architecture

When we speak of popular art, we do not usually associate it with artists; we think of it as impersonal—as a sort of product of the masses. This general attitude toward popular art has led folklorists, with their romantic outlook, to urge the educated artist to revive, if not exclusively to imitate, its forms, in the conviction that the folk arts alone express a nation's spirit. This view is one-sided, however, for the truly professional artist can no more be devoid of inspiration than popular art can be devoid of artists; he can no less help expressing the spirit of his country than can its popular native art. Unknown as folk artists may be, then, they are certainly *there*; anonymously they create forms which survive if they are good. And the professional artist is certainly refreshed if from time to time he drinks from that deep well, the soul of the folk.

In the country, people grow like trees, adapting themselves to its climate, its geographical position, and the possibilities of life it offers. This is why village dwellings, as they are made to conform to men's needs, are also adapted to climate and landscape. In towns, on the contrary, man is apt to forget natural conditions. In a sense, he lives out of place and time—in an artificial region, in which he often forgets where north and south lie; he is therefore quite likely to adapt not the

house to his needs, but his needs to the house. Such artificial environments naturally also affect the architect, who often for the sake of fashion imitates foreign architecture and sets up a formalistic modernism to which he may sacrifice the basic human necessities prevailing in his particular part of the world. Nowadays, we often see that our works proclaim functionality for its own sake; and, what is even worse, we do not always know the exact nature of any other functions than the structural one which form must obey—just as we often know the organic functions of the body, while psychological functions elude our understanding. Thus, it often happens that what yesterday was considered to be mainly functional may tomorrow seem utterly useless, irrational, and quite simply bad.

Popular art, on the contrary, has discovered certain basic forms which it repeats over and over again so long as they serve the same needs. This may suggest mass production in a factory except for one important difference: the products of popular art are never quite the same. Each one shows a slight variation; each is a small improvisation of the same type; each is unique. These differences give handicrafts their artistic value. Now, just as this individual touch is discovered in household articles and ornaments—such as vases, costumes, embroideries, or icons—it is found in the local dwelling, which even so does not depart from its set type; it may develop and become complex, but the basic idea is still there, as we shall attempt to show. The Doric temple is a good case in point. Basically, the same type of building was repeated over and over again, but the form was perfected further each time until it culminated in the Parthenon. In this way a style was produced which had its restrictions, but which gave the artist an artistic freedom once he succeeded in overcoming them. Today, on the contrary, we do not obey restrictions; novelty and innovation are pursued indiscriminately, so that, instead of being free, the artist is caught up in the meshes of his own freedom. Personal idiosyncracies must adapt themselves to impersonal criteria if they are to achieve artistic expression.

I know that our systems of production are different from those of the past. I know that handicrafts are dying out, and that we are overwhelmed by the machine which we ourselves have created. But the question still remains: should we not react more energetically to save at least certain values of the past and introduce them into modern life? The task is a difficult one, but the end is well worth striving for. And I propose to speak about Greek popular art because, quite unconsciously, it still keeps up a great tradition—a tradition worth studying for another reason

244

too: it shows us that the fundamental principles of art are eternal, and that though we may couch them in new terms and speak of functionalism, rationalism, or what you will, there is nothing very new about such things. All that is new are our needs and our techniques. Indeed, modern artists—men like Le Corbusier, Fernand Léger, Georges Braque, Marcel Breuer—who set out to rediscover the eternal principles of art, labeling them "functionalism," "rationalism," and so forth, were very much impressed by Greek popular art, which they praised as a perennial model.

Let us now take a look at Greek popular art, its architecture by no particular architect, its poetry by no particular poet, its sculpture without sculptors, its achievement the aggregate of anonymous artists.

Greece is a small piece of land in southeastern Europe, but while its northern section links it to central Europe, its southern islands are stepping stones to Asia Minor and Africa. The country thus acts as a bridge between Europe and the East. And indeed, we find that whenever in the past the East sought to extend its power westward, or vice versa, its passage always lay through Greece.

Now, important as its strategic uses may be, this bridge is of course no less important for its traffic of commerce and ideas. As early as the Minoan period, the influence of Egypt spread to Crete; and later, the influence of Persia and Asia Minor spread to Byzantium. On the other hand, in the days of Alexander the Great, ancient Greek civilization spread over the whole Mediterranean area and to the very shores of India, and Greek became the international language, whereas in the Byzantine period Coptic and Islamic art in the East and Russian and Romanesque art in the West came under the influence of Byzantine art until 1453, and the fall of Constantinople, when Greek scholars fled to Italy and paved the way for the Renaissance. Western European civilization may therefore be said to be founded on Greek art and thought.

The imperishable quality of that culture rests on an original conception of life and art derived from intellectual curiosity and clear reasoning, for it was the Greeks who first brought logic to bear upon thought. Philosophy is a Greek product, as are also idealism and rationalism in art. Think of the Egyptian and the Doric column, the one an imitation of a plant form, the other an ideal abstract form functionally conceived. Science, which in Egypt was a secret of the priests, became common property among the Greeks; in statecraft, they, in contrast to Eastern monarchisms, were the first to conceive of democracy and to offer it to the world. In religion, when they came to adopt Christianity,

the Greeks at once gave its dogma a philosophical background and brought to it sacred poetry, sacred music, and a sacred art—that of Byzantium.

I am not being a romantic in dwelling on the past, but I believe we cannot understand the present—cannot understand a contemporary country, a contemporary art, or contemporary thought—unless we know the past.

And the present Greek tradition, although it is called post-Byzantine, in fact also derives from the pagan world. To give an example: Easter, which is the main religious feast in Greece, is called "Brilliant Day." Why? Because, assimilated with pagan tradition, the Resurrection of Christ also symbolizes nature's revival in spring. In the imagination of this people, then, martyrs and saints live on side by side with satyrs and nymphs, and it is this mixture of pagan and Christian symbols which gives Greek tradition its originality. Now this fact proves another: that a people in all manifestations of life will unconsciously adapt new forms of beliefs or principles. Belief in resurrection is older than paganism itself; it is a belief inherent in man. So, too, art has its inherent principles, its eternal laws.

After the fall of Constantinople, memories of the past enabled the Greek people to stay together and, after the 1821 revolution, which liberated Greece, to begin a new life. Memories of the past are the spiritual heritage on which modern Greece was founded. It was a heritage her craftsmen—her icon painters, masons, embroiderers, potters—had guarded, the heritage which the dances, the music, and the poetry of the people had kept alive.

The country itself has not changed. Rocky and mountainous, it has always been poor. But its climate is mild, so that life in Greece has always been active and out of doors. The ancient agora, the meeting place where one could walk and discuss the affairs of the day and ideas, still goes by the same name and serves pretty much the same purpose, though in a different guise. Cafés sprawl along the squares of the city, even along the pavements of its streets; people sit there and discuss events. The house continued by a small portico extends outward as did the ancient megaron—a room extended outward by a prostylon in antae (Figs. 50–51). In front of the megaron bigger houses had a central court (atrium) with a peristyle, a form still existing today, despite variations. This basic traditional element of the Greek house, the prostylon, owes its design to the fact that the family needs a covered but nevertheless open space outside the house, a space where it can work, receive its guests,

and even sleep at night. Therefore these features still survive. The prostylon is the basic element of the native Greek house, as of the ancient Greek temple. The prostylon provides shade in the summer months and lets the sun stream in during winter, since the front of the house always faces south. This feature of the prostylon is also mentioned by the ancient Greek writer Xenophon. Nowadays, it is often over-looked in Greece, and some modern architects, trying to exhibit up-to-date ideas, give their houses large continuous windows facing south without a prostylon, and make the rooms behind them uninhabitable in the hot months from March to September.

The Greek landscape too as a rule is clearly defined by pure lines, since the mountains are for the most part bare. The golden light is everywhere diffused, and reveals every detail of the view. There is no mist to blur the outlines of objects. This clarity of contour everywhere leads to a love of plastic values and precision, both of which explain much of the physiognomy of ancient Greek art. But there is also a picturesque note in the Greek landscape, especially in the north; and it is not surprising that Byzantine and post-Byzantine monuments, which are unmistakably picturesque in style, blend harmoniously with ancient buildings. These two trends still survive in modern native archi-tecture—the plastic in "Aegean architecture," as it is called, and the picturesque in the architecture of the mainland, especially in the north of Greece.

Both have a common characteristic, however; there is no excess in any of the three dimensions. They display neither a pronounced vertical-ity, like the Gothic, nor a pronounced horizontality, like the Egyptian. Such emphasis would make a building ugly in the Greek landscape, which has no infinite expanse of desert or the vast mass of the valleys of central Europe to offset it. Around man, space, so to speak, is a finite infinity. In Greece, therefore, houses, temples, and churches in their three dimensions are small and balanced. There are other explanations, too, for this adherence to balance. Fear of exaggeration and therefore of appearing ludicrous is one good reason; indeed, many an ancient and modern Greek proverb warns against such exaggeration. Or it may be their love of criticism that impels Greeks to preserve measure; again, measure may be necessitated by the poverty of the country and its inhabitants. I should say that all are contributing factors.

The country's poverty has the further effect of making the people inventive, as well as leading them to aim for quality rather than quantity. The Greek equivalent of the saying "Necessity is the mother of inven-

tion" is, literally translated, "Poverty works out arts for itself." This constant need for economy should certainly be borne in mind as one tries to understand Greek art. Pericles, who built the Parthenon, took pride in saying: "We beautify with simple means," a practice still valued by the people.

Eighty-five years ago, a simple man on the island of Aegina built his own house on the flanks of a hill (Fig. 52). The main part is a bed-sitting room, and in the native house this room is called *to spiti,* the home. Then to this typical room, which is the house proper, other auxiliary rooms are added: the granary, the stable for the donkey, the wine cellar, and so forth. This main room is divided in two by floor level. The higher part provides the sleeping quarters, which serve for the bedroom (*pastos*) at night, and the lounge or sofa-room in the daytime. The lower part is the living room with the hearth (*stia*). (Both *pastos* and *stia* are Homeric words: *pastos, hestia.* Hestia is the goddess of the hearth.)

I pointed out previously that the Greek house still recalls the megaron through its prostylon and its hearth. There still exist some rare examples of houses in which the hearth is in the middle of the room; but in the course of evolution it has of necessity assumed its former position. Furthermore, the prostylon can be shifted to the long side of the house, if this side faces south. Today we distinguish narrow-front from wide-front houses. Finally, the prostylon can be replaced by a vineyard.

Near the hearth runs a long bench. Thus, the entire area, besides being serviceable throughout, since it includes sleeping and living accommodations, is also artistically laid out because of its different floor levels (Fig. 53). Furthermore, most of the furniture is built-in, and every useful object has its own place. Small open niches and small cantilevers complement the living facilities. And wherever the eye may pause, it is sure to find a pleasing simple carved ornament, an ornament which, though primitive perhaps, is sure to be interesting.

I can't think of a more effective arrangement for a room intended to serve as a home, particularly if two things are taken into consideration: first, the Greek peasant family's patriarchal way of life, and second, the fact that this room is extended outward, since it is continued by the courtyard, where much of the life of the house goes on. In this court, which is covered by a vineyard, the family works, receives guests, and often sleeps.

The courtyard is designed on the same principle (Fig. 54). The ground is on different levels, and access to it is indirect; its importance as a center is thus enhanced. The area is of course magnified by the

amphitheater-like arrangement of the secondary terraces, always full of flowers.

The distribution of the volumes, although it too conforms to the shape of the ground, is always clear and well balanced. The main room predominates, and wherever the eye is likely to pause, there are primitive sculptures. Have I convinced you that the pagan tradition still lives on in Greece (Fig. 55)? I hope you will also agree with me that, though this house is poor, in being self-sufficient it is rich; it is simple but wise, and its conception, like that of classical architecture (Fig. 56), is sculpturesque.

This house has a flat roof, a type common in the Aegean islands. On the mainland and on some of the islands where there is little wind, the houses for the most part have eagle or sloping roofs. The walls are made of stone and mortar; the stones are usually found nearby. The flat roof is made of timber beams and reeds covered with an insulating material of seaweed and clay. Every part is whitewashed, and the house looks like a white box. The inhabitants whitewash their homes every year.

On some islands with a volcanic soil, like Santorini, vaulted and domed roofs are not uncommon; the use of timber, which is scarce and costly, is thus avoided. Churches, however, are almost everywhere vaulted and domed (Fig. 57). And on those islands whole villages are made up of white cubes, one beside the other, growing organically like a symphony in white. Although there is uniformity of type, deviations are never absent from these dwellings, which bring much variety into the unity of the group. The landscape here is bare; the strong winds of the Aegean do not allow the trees to grow freely; they must be protected by walls, just as the houses have to be protected against these winds by flat roofs.

That symphony in white is made up of lines and geometrical stereometric forms; therefore, in principle, this architecture does not differ much, either externally or internally, from our modern architecture. Le Corbusier says proudly that in Marseilles he used the same type of bed-sitting room in his dwellings as is found on the island of Skyros. There is a similar one on Kos. It shows that the house in Skyros is really like that of Aegina, except that the sleeping quarters are higher, kitchen and storerooms being below. Figure 58 shows a larger house on Rhodes. All of these houses have wide fronts, however (whereas the original type has a narrow front, like the megaron), with entrances at the side, which also extend into the courtyards.

Let us now examine the house of peninsular Greece. Figures

59–61 show some houses in the north of Greece built in the eighteenth century for richer families. For protection, the basement has stone walls like a small fortress. In it are kitchen and storerooms. The house proper begins on the second floor and is built on a wooden frame filled in with bricks. Thus it can "step forward"; it can have bow windows, corner windows, and long continuous ones, as in the modern house. The plan has really grown around a hall facing south. This hall is the sitting and workroom (literally, "the sunny place"). In reality, it is the portico of the one-story house, for which reason the staircase is always built there. This hall, where it is partitioned off at one end, forms a sort of kiosk called the sofa-room, and is used as a special reception room (triclinos, or triclinum). The partitioning is done by wooden posts between which is a balustrade, and by the elevation of the floor level. Here the layout follows the same principle as does that of the Aegean house, and the impression of spaciousness and dignity is the same. Looking at the rooms carefully, one will notice that all of them are subdivided by two pillars, as if each one were extended by a prostylon, like the megaron; also noticeable is that the common prostylon of all those rooms is the hall of the house. I should like to emphasize this especially because here the evolution of the Greek house is clearly shown. A study of the various types of houses from the simplest to the most complex reveals that the features of the basic model, the megaron, are all preserved. Though the house grows as other rooms are added, the prostylon remains. It takes the form of an L or of a U, or it forms a peristyle with a courtyard between, as was the case with the ancient Greek house in Priene, or Pompeii.

Figure 62 shows an Athenian two-story house with its peristylon. This sort of peristylon is often closed with windows, and ultimately, in the north of Greece because of the severity of the climate, the courtyard was also enclosed and thus converted into an indoor hall. Open or closed, however, the prostylon or the peristylon of the Greek house is a basic element, the usefulness of which I hope I have suffi-ciently demonstrated. Figures 63 and 64 show its function and its clear construction.

I should like briefly to compare this ancient house in Olynthos with this modern counterpart of it, still existing in Athens, a comparison made by Professor Kriezis in Athens. It is clear what F. Oelmann meant when he said that "to understand the ancient Greek house, we must study its modern native counterpart in Greece." Let me add that such a comparison will show us the artistic value of the ancient model and,

indeed, of the Greek temple, in which we shall now recognize the pteron—the colonnade around the temple—as, in fact, a peristyle turned outward.

But let us return for a moment to the house in the north of Greece. Above the normal windows are some smaller ones; they let the light into the room when the blinds of the lower windows are drawn. Those skylights have no blinds but contain beautiful designs in the colored glass (Fig. 65). The same arrangement is found in the Byzantine houses of the fourteenth century on Mistra. As in the Aegean house, much of the furniture is built-in. The walls are whitewashed and the ceilings beautifully carved. The walls in the upper part often have frescoes, usually depicting Constantinople, and are the work of wandering painters. One of these painters, named Theophilos, died a few years ago, and his works, often exhibited, have become fashionable.

Here the sculptural decoration of the Aegean house is replaced by wood carving, which is everywhere in evidence. The chairs and the tables on many of the islands are made by the inhabitants on winter evenings; shipbuilders carve the mastheads of their boats (Fig. 66); and there are further wonderful examples of carving in the icon stands in the churches.

On the island of Tenos there is a marble quarry, and the families of a nearby village, who have been exploiting it, have produced generations of sculptors. Before the two world wars, the islanders used to travel in groups through Bulgaria, Romania, and Russia to decorate houses and churches in marble. Many of our best modern sculptors in Greece come from that island. Two examples of Greek folk sculpture in marble are in Figs. 67 and 68: a skylight (Fig. 67) and a low-relief statue of St. George (Fig. 68), both in the post-Byzantine tradition.

Before the two wars there still existed villages which produced generations of masons who, besides working at home, also wandered from place to place building houses and bridges. Figure 69 shows one such bridge, both functional and elegant, the most important such example being that of Arta. According to local folk poetry, the life of the master-builder's wife was the sacrifice demanded to make the foundation of the bridge solid. Figure 70 shows a dovecote built on Mykonos. Such elegant, graceful constructions persuade us that in Greek art two trends still coexist: Doric severity and Ionic grace.

After World War I the Greek families established in Asia Minor flocked to the Greek mainland from Ionia, where the industry of Turkish carpet-weaving had flourished under them. The important center of this

industry is now Athens. The carpet-makers now use chemical dyes instead of those they once made from plants or roots; they still use the designs—chiefly arabesques and Cufic letters—used also in Byzantine art, though they now occasionally experiment with modern designs as well.

The hand loom is still used in the villages. The girls prepare their "bottom drawer" and dowry—house linen, carpets, and so on—using bright colors and patterns not unlike those of Peru (Fig. 71). Modern materials like rayon, and variations of the older basic designs, are inevitably becoming popular.

Except at weddings and special celebrations, Greek costumes are unfortunately no longer in current use. Though every part of Greece has its own costume, the machine has virtually displaced what was expensive and took a long time to make. Embroidery is still done, and very beautiful examples of it are produced in which human beings, houses, dogs, trees, and so forth, are represented in geometrically shaped forms (Fig. 72).

Pottery still retains the basic forms of the simple Greek vase. In Crete I once met a wandering group of potters who were engaged in making large vases (Fig. 73), like those found in Cnossos of the Minoan period. Finally, Corfu and Jannina turn out exquisite silver hand-made jewelry.

Thus, Greek native architecture and crafts continue to reflect the forms of their ancient prototypes, but only in so far as the needs they serve are still the same and do not necessitate a change in technique. When needs and technical conditions change, craftsmen devise new forms but retain the principles that are unchanging. Here lies the real value of tradition: it does not allow art to become static. Tradition is impaired only by imitation of conventional forms. Certain manufacturers in Athens have attempted to imitate ancient pottery, or native hand-made furniture, but have failed sadly. The artisan is now beginning to come into his own again, and attempts are being made to give him a chance to earn his livelihood through his craft, selling his products in Athens, for the artisan alone can keep a country's tradition alive.

But why is the artisan the only person who can perpetuate tradition? First, because discrimination between art and craft is not made by ordinary folk, nor did they make it in ancient times. The Greek word *techné,* from which the English "technique" is derived, means both art and craft, art and technique. Second, because utility and beauty were interchangeable qualities in ancient times also. The word *kalón* in

Greek means both beautiful and serviceable, namely, fit for its purpose. Socrates uses the same word in its two-fold sense in his discourse on the beautiful, when, taking a ladle as an example, he points out that it would be beautiful if it were appropriate—in other words, serviceable. The artisan works at his craft in that spirit as he strives for both utility and beauty in his handiwork.

The identification of craft and art, or art and technique, and of utility and beauty means, then, not that the nature of form should be conceived as purely technical and functional, as we understand those terms today, but, on the contrary, that the technical and functional nature of form should at the same time be conceived artistically. The Doric column, for instance, expresses not merely the function of supporting the entablature but, through its artistic perfection—its diminution, its entasis, and its fluting—a spiritual achievement, the conquest of gravity. So too this poor house in Aegina is still a valuable possession because over and above the practical purpose it serves, it is artistically conceived and is worth seeing for its own sake.

That is why, in Greece, the art of making things is called poetry. The poet is a "maker" and every artistic inspiration is a poetic one. In Greece we speak of God as the poet of the universe, meaning that he is its Maker and its Creator.

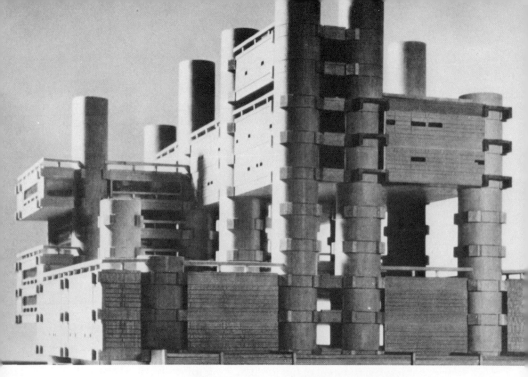

Fig. 1. Press and Conferences Building, Yamanachi. Architect: Kenzo Tange

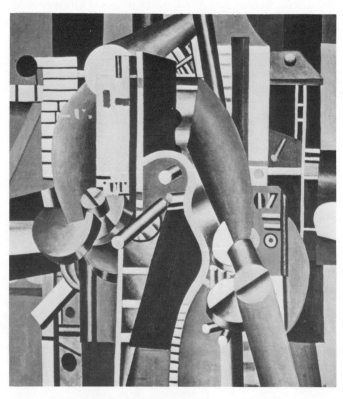

Fig. 2. Fernand Léger, *The Motor*, 1918

Fig. 3. Francis Picabia,
Love Parade, 1917

Fig. 4. Jean Tinguely, *Eureka*

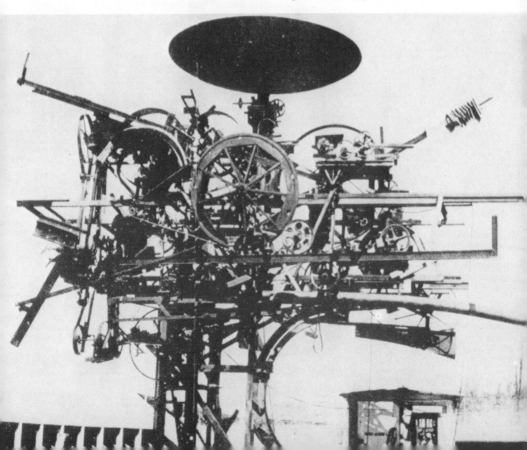

Fig. 6. Robert Rauschenberg,
Retroactive

Fig. 5. Pol Bury, *Erectile,* 1963

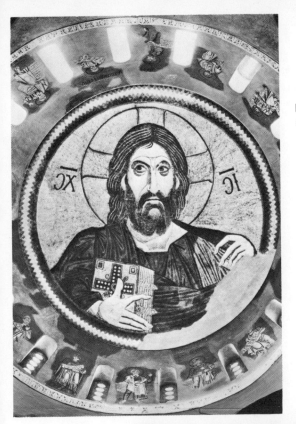

Fig. 7. Christ the Pantocrator,
monastery church, Daphne

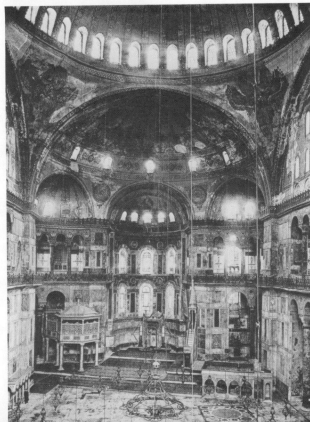

Fig. 8. Church
of St. Sophia, Istanbul

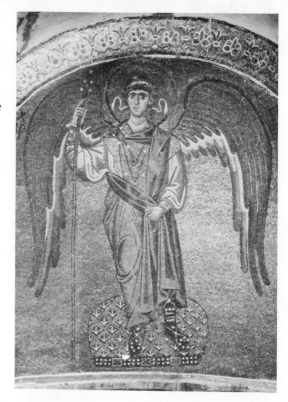

Fig. 9. Archangel Gabriel,
monastery church, Daphne

Fig. 10. Church
of St. Eleutherius, Athens

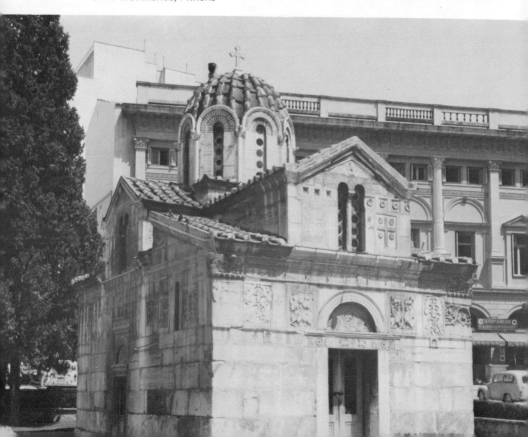

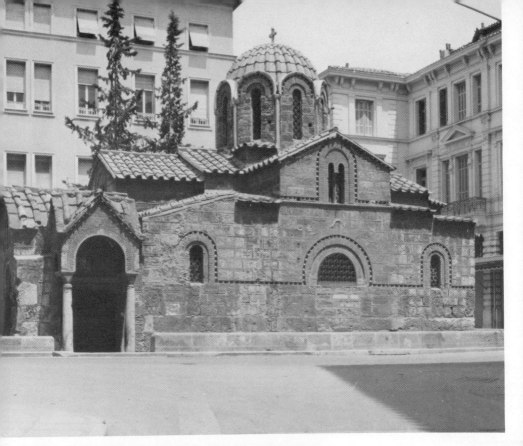

Fig. 12. The Capnikarea, Athens

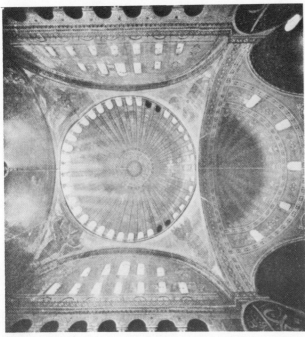

Fig. 11. Dome seen from below, Church of St. Sophia, Istanbul

Fig. 14. St. Demetrius of Thessalonika, Church of St. Demetrius

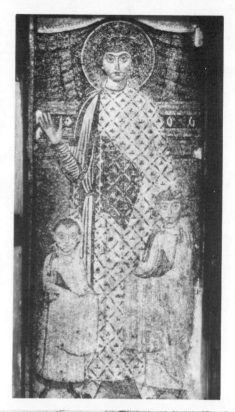

Fig. 13. Detail of Orpheus, Byzantine Museum, Athens

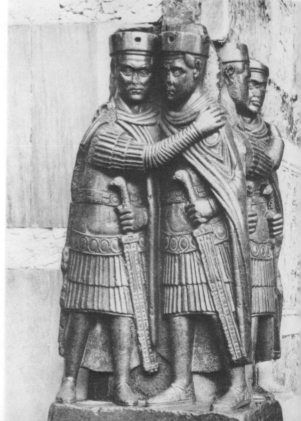

Fig. 15. The Four Moors of St. Mark, Venice

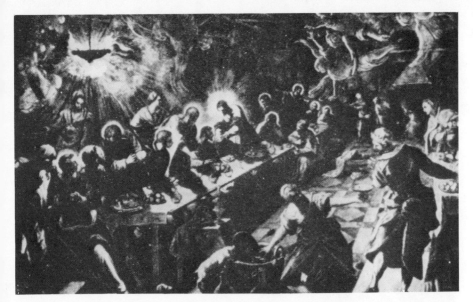

Fig. 16. Jacopo Tintoretto, *The Last Supper*, 1592–94

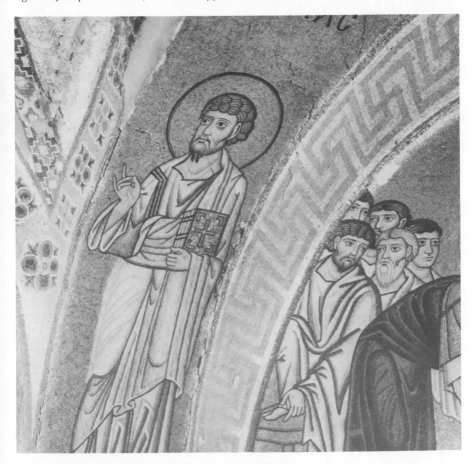

Fig. 17. Christ the Pantocrator, Monastery of St. Luke of
Stiris, Phocis

Fig. 18. Workmen's houses in nineteenth-century England,
built after passage of the Public Health Law of 1875

Fig. 19. Crystal Palace, Hyde Park, London, 1851.
Architect: Sir Joseph Paxton

Fig. 20. Reading room, Bibliothèque Nationale, Paris, 1862–68.
Architect: H.-P.-F. Labrouste

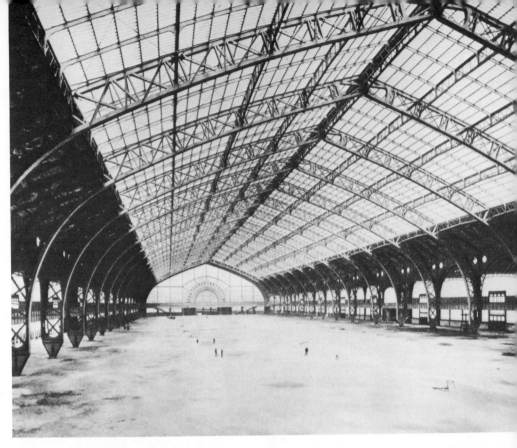

Fig. 21. Galerie des Machines, Paris Exhibition, 1889

Fig. 22. Red House of William Morris, Bexley Heath, Kent, 1859–60.
Architect: Sir Philip Webb

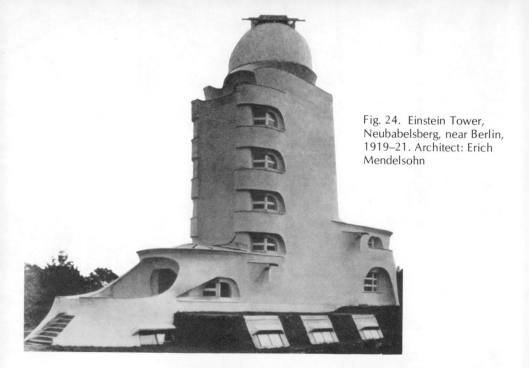

Fig. 24. Einstein Tower, Neubabelsberg, near Berlin, 1919–21. Architect: Erich Mendelsohn

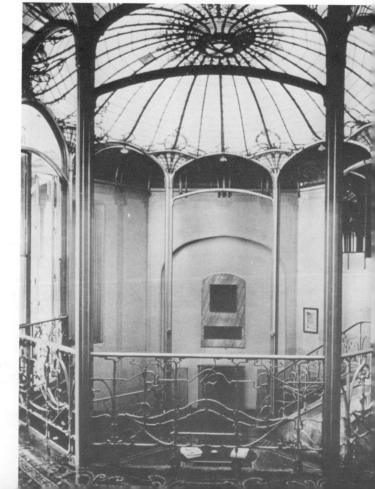

Fig. 23. Van Eetvelde house, Avenue Palmerston, Brussels, 1895. Architect: Viktor Horta

Fig. 25. Office hall, S. C. Johnson and Sons building, Racine, Wis., 1937–39. Architect: Frank Lloyd Wright

Fig. 26. "Falling Water," Kaufmann house, Bear Run, Pa., 1936. Architect: Frank Lloyd Wright

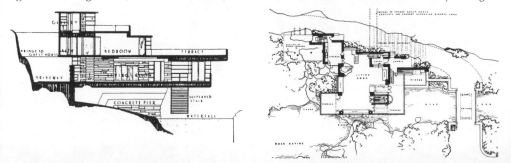

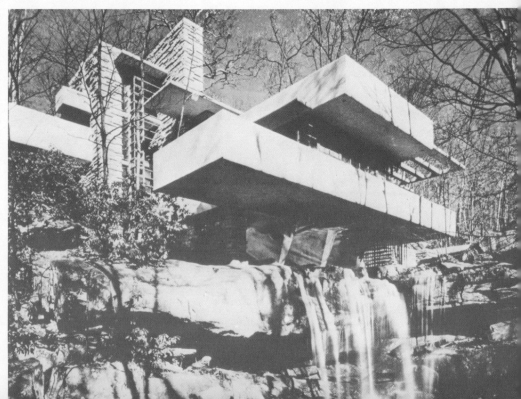

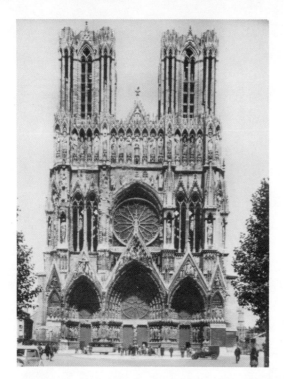

Fig. 27. Rheims
Cathedral

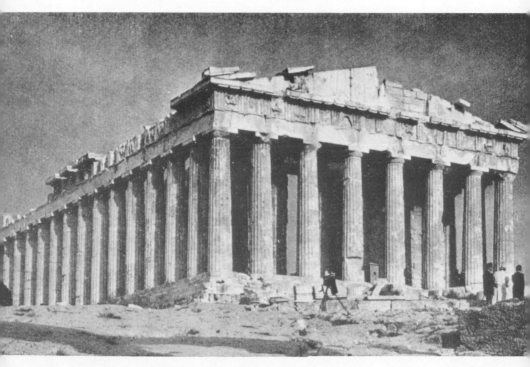

Fig. 28. The Parthenon

Fig. 31. Pagoda,
Yasaka, Japan, 1618

Fig. 29. Architectural
suspension illustrated through
analogy with human body

Fig. 30. Swiss Hotel, Cité
Universitaire, Paris,
1931–32. Architect: Le
Corbusier

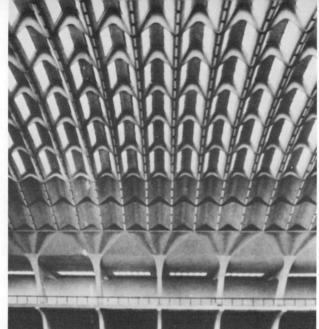

Fig. 32. Roof, Agnelli
building, Turin, 1948.
Engineer: Pierluigi Nervi

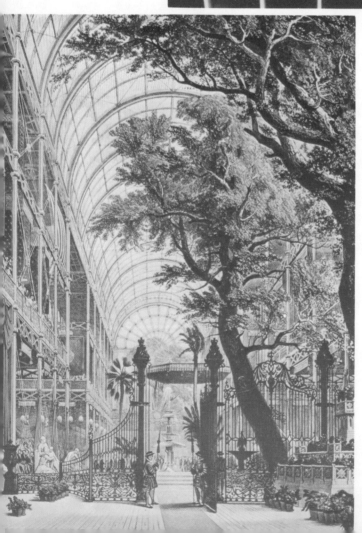

Fig. 33. Crystal Palace,
Hyde Park, London, 1851.
Architect: Sir Joseph Paxton

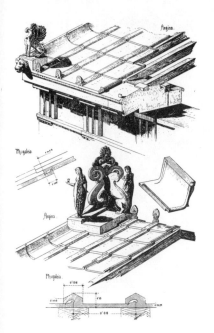

Fig. 34. Diagram of tile roof of classical temple

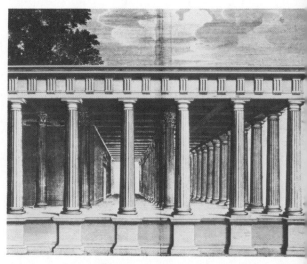

Fig. 35. Roman Doric colonnade

Fig. 36. Church of St. Demetrius of Thessalonika

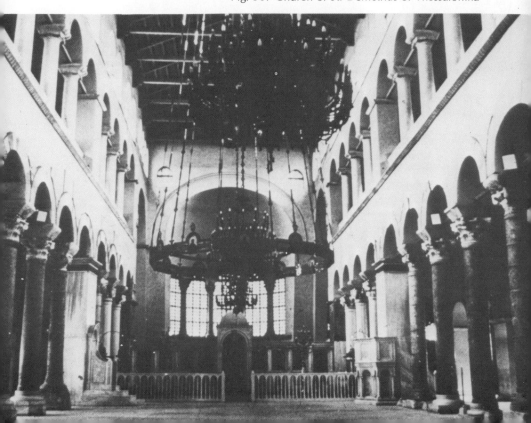

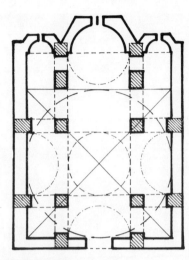

Fig. 38. Plan of temple
with four columns

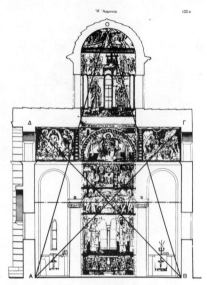

Fig. 39. Cross-section of Catholicon,
Kaisariani Monastery. Drawing after
Nikolas Moutsopoulos

Fig. 37. Building in Chandigarh, Punjab, India.
Architect: Le Corbusier

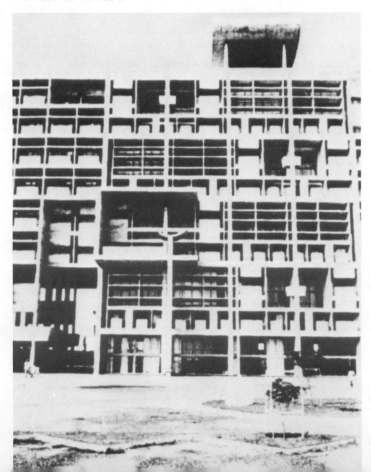

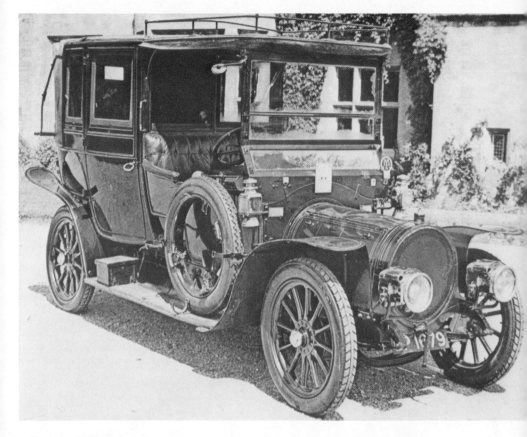

Fig. 40. Old automobile

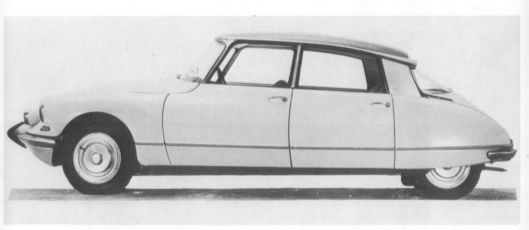

Fig. 41. New automobile

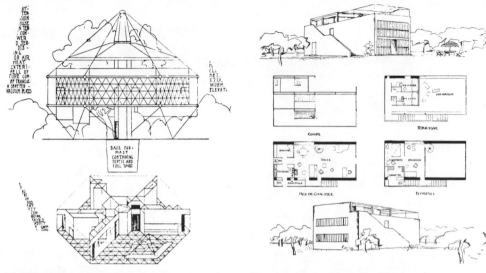

Fig. 42. Dymaxion house.
Engineer: R. Buckminster Fuller

Fig. 44. First project for Citrohan house,
1919–20. Architect: Le Corbusier

Fig. 43. Egg-shaped shell. Engineer: R. Buckminster Fuller

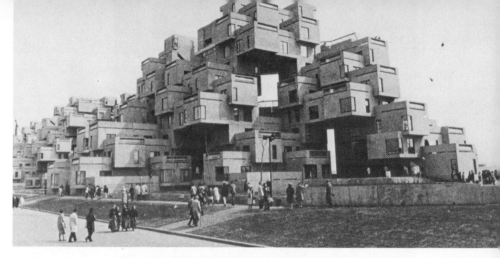

Fig. 47. "Habitat" houses, Montreal International Exhibition, Canada.

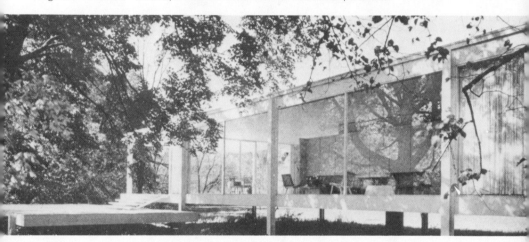

Fig. 45. Dr. Edith Farnsworth house, Plano, Ill., 1950. Architect: Mies van der Rohe

Fig. 46. Unité d'Habitation, Marseilles, 1946–52. Architect: Le Corbusier

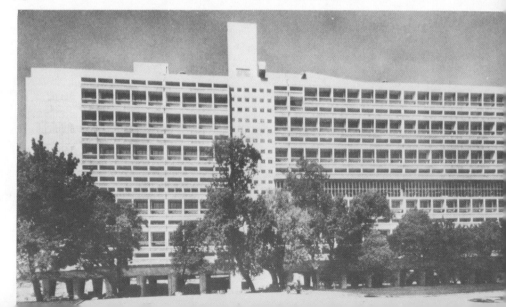

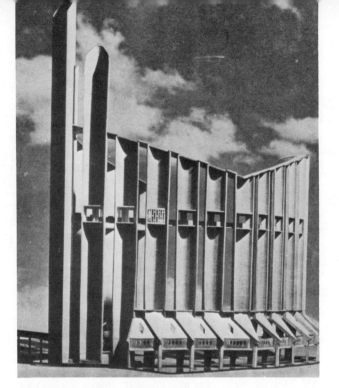

Fig. 49. Notre Dame de Royan, France.
Architect: Guillaume Gillet

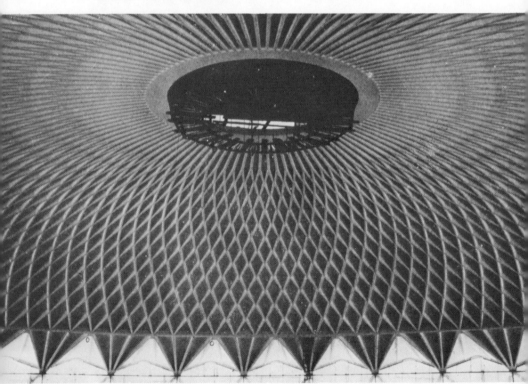

Fig. 48. Ceiling, Palazetto dello Sport, Rome.
Engineer: Pierluigi Nervi

Fig. 50. Megaron

Fig. 51. Popular house

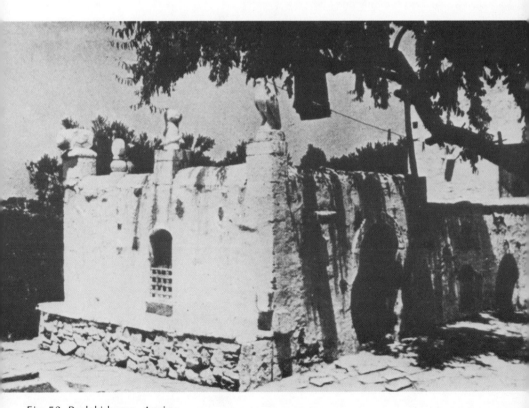

Fig. 52. Rodaki house, Aegina

Fig. 53. Sections, Rodaki house

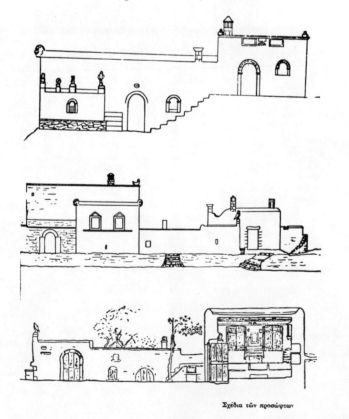

Σχέδια τῶν προσώψεων

Fig. 54. Facade and sections, Rodaki house

Fig. 56. Primitive sculpture, Rodaki house

Fig. 57. Santorini

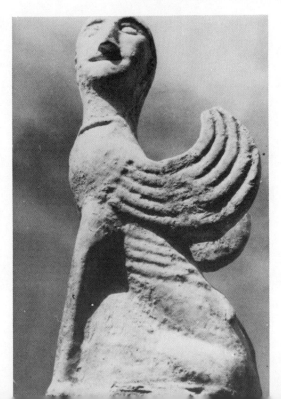

Fig. 55. Sculpture, Rodaki house

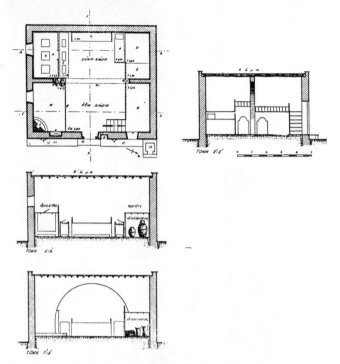

Fig. 58. Popular house, Rhodes. From G.
Megas, *Popular Dwelling in Dodecanissos*

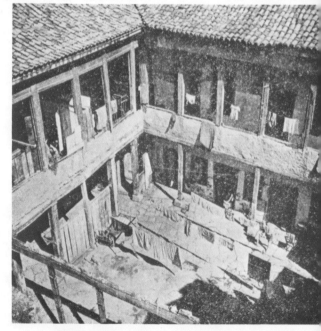

Fig. 62. Courtyard, two-story house, Athens.
Photograph and plan by Dr. Ares Constantinidis

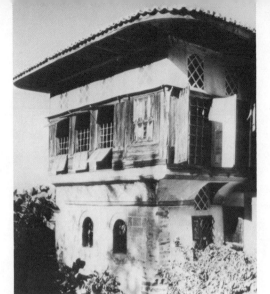

Figs. 59–61. Houses, northern
Greece

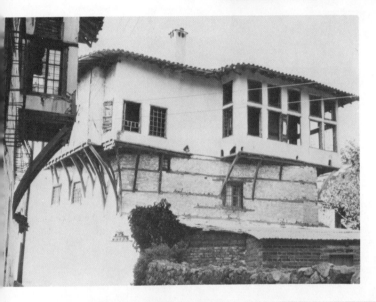

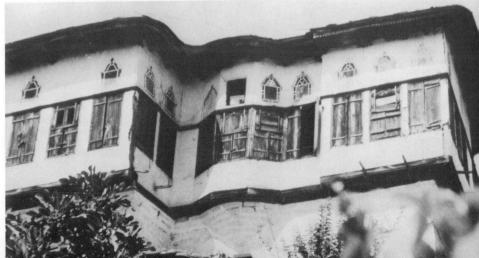

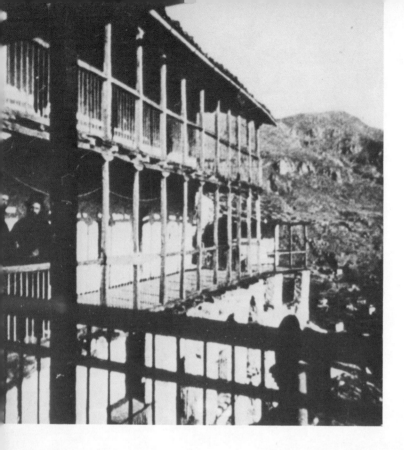

Figs. 63–64. Open colonnades

Fig. 66. Masthead

Fig. 67. Carved marble skylight

Fig. 65. Ceiling decoration

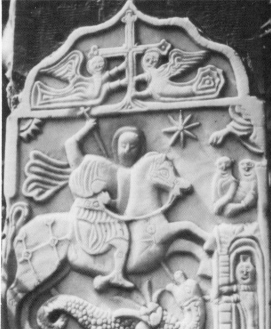

Fig. 68. St. George, popular relief

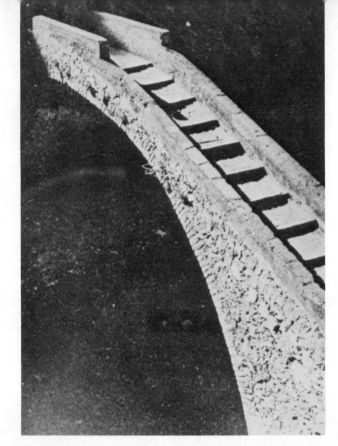

Fig. 69. Popular
bridge, Epirus

Fig. 70. Dovecote,
Mykonos

Fig. 73. Contemporary wandering potters, Crete

Fig. 72. Embroidery, Skyros

Fig. 71. Hand-woven carpet

notes

Chapter One

1. The Homeric question was first posed by the scholar Friedrich August Wolf (1759–1824), who based his contention on the theory of Herder concerning the folk genius, a theory originating with Giovanni Battista Vico (1668–1744), the first person to project the idea of the innate creative genius of the people.

2. K. A. Romaios, *Keramoi tis Kalydonos* [Tiles of Calydon]. *Symvoli eis Akrivesteran Theorisin tis Hellinikis Technis*, Library of the Archaeological Society No. 33 (Athens, 1951).

3. *Praktika tis Akadimias Athinon, Synedria 11 Maiou 1946* [Minutes of the Academy of Athens, meeting of May 11, 1946] (Athens, 1946), p. 148.

4. "The slanting of the antefixes responds to and reflects the technical attempt to cover the other of the sleeper tiles as much as possible" (Romaios, *Calydon*, p. 101). "Initially, therefore, and in conformity with the rigid logical structure of Greek architecture, the movement of the ornamental members was an accompanying result of the inner structure of the roofing, but it soon acquired an independence of its own and a great architectural importance. In the center, the two opposing directions were separated, and the two similar and differing series resulted in a rhythm which aesthetically emphasized the great length of the side" (ibid., p. 102).

5. See my article "I Aisthitiki tis Optikis Apatis Stin Architektoniki" [The aesthetic of optical illusion], *Technika Chronika,* 172 (1939), reprinted as "Optical Illusions and Corrections" in my *Architektoniki os Techni,* 2d ed. (Athens, 1951), pp. 247-80. It will become evident further in my review that, to interpret the optical corrections, I base my conclusions on the aesthetic mechanics of Theodor Lipps. According to him, optical illusion is due to an error of judgment because of our aesthetically psychological conditioning in evaluating the forces acting in the figures which have subjected us. But art deliberately deceives us so as to impose upon us, by means of the forms, the forces that are in harmony with the superior dispositions it wishes to express, as, for example, in the entasis of the column. Lipps has dealt only with the column, however, whereas I have extended my observations to cover the entire temple and have suggested that the respective rectifications of its members respond to the overall spirit of the work and, in substance, that they together comprise a single rectification or correction. In other words, I am supplementing the theory of empathy with the principle of unity in variety and the principle of ideal symbolization.

6. The ancients . . . would not have resigned themselves to the idea of curvature alone, but would have struggled between it and the straight line. It is for precisely this reason that they built so slight a curve that it almost approached the horizontal. There is no difference in the understanding of contemporary architects following their recognition of curvature because with the idea of rectilinearity the curve becomes united at the same time or at the very next moment. . . . A

composite rhythm then results. There follows the dynamism of the rhythm in which the components are mutually emphasized. The horizontal line no longer stands alone; nor is it faint or short when not sufficiently regarded; rather, in combination with the curve it is strengthened as a result of the contrast or comparison; it grows and holds the sight of the spectator who follows it to the end, thus acquiring an importance in extent. Moreover, with the contrast, its curvature is elevated, and the upward movement flows easily (Romaios, *Calydon*, p. 113).

7. "Despite the obvious observations made by the muscular senses of our vision, there are movements which escape the naked eye, as I have pointed out, such as 1) the frequent curvatures, 2) the slanting of the columns, 3) the bulging or entasis, 4) the movement resulting from proportion and morphology" (ibid., p. 108).

8. We are accustomed to accept rhythm as a repetition of two or more forms or images, but always independent of each other, and it would appear strange to find that rhythm exists in the lion's head. As I have pointed out, in each of the heads or the antefixes that make up a series, there were two contrasting figures— the law of impenetrability does not apply to our spiritual world—and despite the generally accepted precise frontal figure, there is also a separate figure representing much movement and facing a particular direction, and the latter does not eclipse the former. Because they approach each other as much as possible and because they possess a likeness despite their difference, they are linked closely, and one in fact helps to emphasize the other (ibid., p. 112).

9. "The co-existence of differentiated time movements is very possible in our inner spiritual world, and the help of older and newer movements has never meant a weakness; on the contrary, this help is of important aesthetic value. There are two successive postures in the *kouroi*, like and unlike, in rhythmic order when both members are exalted and the self-implied movement possesses duration" (ibid., p. 132).

10. Lalo argues in this example that "polyphony becomes cacophony without value" (*Notions d'esthétique* [Paris, 1948], p. 17, n. 1).

11. According to Professor John Kakrides in a lecture concerning anacolouthon in Greek poetry.

12. This theory recalls the views of Milontine Borissavliévitch, *Les Théories de l'architecture* (Paris, 1926).

13. Romaios, *Calydon*, p. 114.

14. The spindle-like swelling or entasis of the columns of the Renaissance is not cold and lifeless, as Romaios believes (ibid., p. 114), not because it did away with the other element of rectilinearity but because it passed beyond the creative moment and thus abolished the movement in the column. In actual fact, entasis is not a distortion of the column due to weight, as though its material were made of dough, a view which Romaios rightly rejects (p. 115). The theory of exactitude had never looked upon material in such a manner; on the contrary, it considered it to possess the quality of movement; consequently, it thought of the entasis of the column as a representative form of this movement.

15. The temple of Phigalia presents an emphasis on its northern flank—that is to say, the shafts of its columns are shorter and the height is balanced with the higher crowns of the columns. At the same time, the lower diameters of these columns are about 4 cm. larger, giving the impression of being more massive.

16. "The immobile and weak, the 'Egyptian,' statues in the museums are now elevated to the first rank of the works of the classical age, and since they lack the deceptive attraction of naturalism, they illuminate even more the essence of the Greek and of all other plastic arts" (ibid., p. 150).

17. William Henry Goodyear, *Greek Refinements: A Study in Temperamental Architecture* (Oxford, 1912).

18. Heinrich Wölfflin defines the art of the Renaissance as linear, in contrast with the

Baroque, which he calls picturesque (*malerisch*). But the distinction is purely morphological, and is unrelated to the spirit of the distinction which I make below. In my study of Byzantine art, I insisted that plasticity and not picturesqueness was the contrast to the linear of Wölfflin. I said, rejecting Alois Riegl's arguments, that picturesqueness is a product of the visual senses and not of the sense of touch, of which plasticity is a derivative. I also pointed out that these two qualities always coexist, irrespective of whether one or the other may at times be more pronounced. And finally, that they are subject to the aesthetic categories which are higher intellectual dispositions, innate to the artistic soul, one of which corresponds in each instance to the spirit of the period. Furthermore, that is why the picturesqueness of Byzantine art is manifest, whereas that of classical art is latent. See my *Aisthitiki Theorisi tis Vizantinis Technis* (Athens, 1946), p. 198, translated as *An Aesthetic Approach to Byzantine Art* (London, 1955).
19. Plotinus *Enneads* I.6,7.
20. William Henry Goodyear, "Architectural Refinements in Early Byzantine Churches and French Cathedrals," *Architectural Record,* 16 (1904), 116ff.
21. According to Professor Karatheodoris (Arch. Ephemeris, 1937), 120-24.
22. Aristotle *Metaphysics* II.998a (trans. W. D. Ross).
23. See my *Aisthitiki Theorisi tis Vizantinis Technis.*
24. The existence of a middle column in the long sides of the temple, when the number of columns was odd, does not emphasize the axis of these sides, as Romaios believes (*Calydon,* p. 77), because this column ceases to be distinguished when the number of columns exceeds six. Whenever it can be discerned, it disturbs. Thus, we do not have temples with five columns, but we do have temples containing nine columns.
25. François Auguste Rodin, *L'Art* (Paris, 1932).
26. See further also K. Romaios, *"Kinisi periorismeni kai Lanthanousa"* [Restricted movement and latent movement], *Nea Estia,* 670 (1955), 708-14; P. A. Michelis, "Graphikotita, Zognaphikotita Kai Kinisi" [The picturesque, the pictorial, and movement], *Nea Estia,* 678 (1955), 1274-79. From this article, a reply to the article of Professor Romaios, I quote some excerpts that, I believe, throw some light on the principles of movement, of the painterly, and of the picturesque in art.

Chapter Two
1. A distinction first made by Oswald Spengler in *The Decline of the West* (Munich, 1923), where he distinguishes civilization from culture.
2. Benedetto Croce, *Breviaire d'esthétique* (Paris, 1923), p. 50.
3. A term used by Spengler (*Decline of the West,* p. 105n), where he distinguishes the newer "Faustian" from the former "Apollonian" world. In the second part of.Goethe's *Faust,* the hero appears as a man of action who performs one task after another because in action he finds his salvation. As the poet says at the end of the tragedy, "Wer immer strebend sich bemüht, den können wir erlösen."
4. Alfred North Whitehead, *Science and the Modern World* (New York, 1947), p. 62.
5. Lewis Mumford, *Art and Technics* (New York, 1952), pp. 64-65.
6. Aristotle *Politics* I.4.1253b.
7. See my *Viomichaniki Aisthitiki kai Afimmeni Techni* [Industrial aesthetic and abstract art] (Athens, 1959).
8. Lewis Mumford, *Technics and Civilization* (London, 1934), p. 217; Mumford, *Art and Technics,* pp. 72-73; and Mumford, *The Condition of Man* (New York, 1944).
9. See n. 7 above.
10. "Space-Time and Contemporary Architecture," *Journal of Aesthetics and Art Criticism,* 8 (1949), 71-86.
11. Eugen Fink, "Techne und Technik, Platons Begriff der Chora, Hintergründe seiner

Metaphysik," in *Zur ontologisschen Frühgeschichte von Raum, Zeit und Bewegung* (The Hague, 1957), pp. 181-93.

12. *Prometheus Bound,* trans. Gryparis (Athens, 1930), pp. 77-78.

Chapter Three

1. *Politics* 1253b (trans. William Jowett).

2. Prisunic's, in Greece, is a bargain drugstore, rather like the American K-Mart and other discount stores (Ed.).

3. *Politics* 1253b.

Chapter Four

1. See my "Space-Time and Contemporary Architecture."

2. See my *Biomechanike Aesthetiki kai Aphereme Teckni* [Industrial aesthetics and abstract art] (Athens, 1959).

3. See my "Dialectics in Art," in *Actes des entretiens philosophiques d'Athènes,* 1955, pp. 135-42.

Chapter Seven

1. See my "Aesthetic Endurance," in *Atti del III Congresse Internazionale di Esthetica 1956* (Turin, 1957), pp. 286-90.

2. *Das Unvollendete als Künstlerische Form* (Bern, 1959), p. 83.

3. Gantner also reports that fifty years after Rembrandt's death, in 1718, a Dutchman, one Henbraken, denounced his works as being mere sketches, meaning that they were artistically imperfect, incomplete. See Gantner, *Schicksale des Menschenbildes* (Bern, 1958).

4. André Chastel, *Das Unvollendete als Künstlerische Form,* p. 87.

5. Quoted in ibid., p. 127.

6. Quoted in ibid., p. 132.

7. *Poetics* 1451a-b.

8. Quoted in *Das Unvollendete als Künstlerische Form,* p. 67.

9. Foçillon says that the portrait was born of the Gothic tombstones of the thirteenth century, whereas Gantner says that in Romanesque art the portrait has a "chameleonic" character, for there is a gap between *homo coelestis* and *homo terrenis (Schicksale des Menschenbildes).*

10. "Problems of the Finished and the Unfinished in Art," *Filosofia,* 12, suppl. 1 (1961), 641-65.

11. *Aisthitiki Theorisi tis Vizantinis Technis,* p. 41, and particularly my "Valeu du pittoresque dans l'art Byzantin," in *Proceedings of the IX International Byzantinology Congress of Salonica* (Salonica, 1954), vol. 1, p. 29.

12. "Le Non-fini dans l'art Byzantin," in *Proceedings of the XII International Byzantinology Congress of Ochris* (Ochris, 1961).

Chapter Eight

1. An approach to the history of art through aesthetic categories is what I call "an aesthetic approach to the history of art." The aesthetic categories are, after all, principles more basic than the "basic principles" *(Grundbegriffe)* of Wölfflin, which are morphological and with which some scholars have attempted unsuccessfully to interpret Byzantine

art. They are more basic than those of August Schmarsow, which are principles of content, since the aesthetic categories are always present in the artistic mind.

To reflect upon Byzantine art aesthetically, therefore, we must free ourselves from all historical preconceptions or biases and be attuned to the feeling of the sublime which it conveys to us. But this could not be brought about except during the Romantic age, when people felt a kinship with mediaeval art, when Goethe and Victor Hugo praised Gothic churches, when idealistic philosophy regarded Beauty as but a reflection of the divine. Kant, influenced by Burke, had placed the sublime alongside the beautiful as its aesthetic equal. Hegel maintained that Judaic verse was sublime, and Schelling said that "if ancient art enclose infinity in the past, then Christian art gives us an allegory of the infinite." See my *Aesthetic Approach to Byzantine Art.*

2. Concerning this magnificent structure, I have observed elsewhere that if one were to compare the actual size of St. Sophia with St. Peter's in Rome, he would notice how much larger the former looks, although it is actually smaller. Yet St. Peter's has errors in scale, whereas these mistakes do not exist in St. Sophia. The composition of the latter contributes to its grandeur. It is enough to visualize the church without the side partitions beneath the north and south large arches to see their aesthetic importance, since they have no static foundation. Without these the church would seem smaller, and the extensions of the transverse axis, which is now attractive and mysterious, would be lost. At the same time, these partitions emphasize the longitudinal axis and provide the scale for the space. See my *Aesthetics of Saint Sophia* (Faenza, 1963).

3. See "Refinements in Architecture," *Journal of Aesthetics and Art Criticism,* 14 (1955), 19-43.

4. To the classical Greeks the theory of imitation could not possibly have the meaning—that is, faithful reproduction—which was given to it later. The tendency to imitate or copy faithfully emerges in the Hellenistic period, when the individual appears on the scene. The portraits of Fayum are the forerunners of the turn inward which eventually was the root of Christianity, in which ugliness was not dreaded but was exploited to exalt the inner world.

5. It is for this reason, Demus contends, that in the classical Byzantine period the representations are drawn in apses so that the illusion of space is created. This theory, as it were, imprisons the pictures in the natural space of the church, eliminates the aesthetic distance between them and the spectator, and frustrates the imagination in envisioning the space of the painting in the depth of the panel because it is not depicted in an illusionistic fashion. In 1946 I pointed out that because the angel in the Annunciation panel of Daphne is painted in the apse, he for a moment seems to be passing through its space to approach the Virgin. But this means simply that the painting here exploits the curved surface of the apse, not that this impression must be generalized into a theory. See Demus, *Byzantine Mosaic Decoration* (London, 1947), and Chapter Ten below.

Chapter Nine

1. Demus, *Byzantine Mosaic Decoration,* p. 12.

2. See Chapter Ten below.

3. "Optical Illusions and Corrections." See also my "Refinements in Architecture," *Aesthetica Theoremata,* 1 (1962), 303-37 (in Greek), translated in *Journal of Aesthetics and Art Criticism,* 14 (1955), 19-43.

4. There are instances in which, instead of using an impost, the architect extended the abacus itself to act as a kind of obliquely cut square pier; thus it was made into a huge inverted truncated pyramid on which the arch rests directly.

5. See "Refinements in Architecture."

6. *Aisthitiki Theorisi tis Vizantinis Technis,* p. 220.

Chapter Ten

1. As quoted by Robert Zimmermann, *Aesthetik* (Vienna, 1865), p. xix.

2. Demus, *Byzantine Mosaic Decoration,* p. 44.

3. Quoted by Rudolf H. Lotze, *Geschichte der Aesthetik in Deutschland* (Munich, 1868), p. 394.

4. In England the continuity of Gothic art had not been interrupted throughout the seventeenth and eighteenth centuries.

5. G. W. F. Hegel, *Vorlesungen über die Aesthetik,* 3 vols. (Berlin and Stüttgart, 1842-1928), vol. 1, p. 494.

6. In this connection see Walter Passarge, *Die Philosophie der Kunstgeschichte* (Berlin, 1930).

7. Karl Groos, *Einleitung in die Aesthetik* (Giessen, 1892), pp. 46-51. See also V. Basch, *Essai critique sur l'esthétique de Kant* (Paris, 1927), pp. 556-57. On the objective significance of the aesthetic categories, see Raymond Bayer, *L'Esthétique de la grace,* 2 vols. (Paris, 1933), vol. 2, p. 433, and V. Feldman, *L'Esthétique française contemporaine* (Paris, 1936), pp. 107-10.

8. Michelis, *An Aesthetic Approach to Byzantine Art.*

9. Plotinus *Enneads* I.6, 8, 21.

10. Ibid., 6, 8, 41.

11. Ibid., V.8, 6, 2.

12. Ibid., I.8, 9, 1.

13. Ibid., 6, 9, 30.

14. Joseph H. Kuhn, *Upsos, Eine Untersuchung zur Entwicklungsgeschichte des aufschwunggedankens von Platon bis Poseidonios* (Stuttgart, 1941), pp. 72-111.

15. André Grabar, *Plotin et les origines de l'esthétique médiévale,* Cahiers Archéologiques No. 1 (Paris, 1945); Demus, *Byzantine Mosaic Decoration.*

16. Grabar, *Plotin,* p. 16.

17. Johannes Theodoracopoulos, *Plotins Metaphysik des Seins* (Baden, 1928), p. viii.

18. Robert Zimmermann, in his *Geschichte der Aesthetik* (Vienna, 1858), p. 127, writes that only the image made by the statue-maker can give an idea of the work of the creator. He too must have copied the archetype, for there is no question of a creator who first fashioned both archetype and its copy. Aristotle clearly asserts that form and matter are both equally eternal and uncreated.

19. Theodoracopoulos, *Plotins Metaphysik,* pp. 112-21.

20. Ibid., p. 118.

21. Ibid., p. 121.

22. Grabar, *Plotin,* p. 16.

23. Ibid., p. 30.

24. G. Rodenwaldt, "Zur Kunstgeschichte der Jahre 220-270," *Jahrbuch d. Deutsch. Arch. Inst.,* 51 (1936), 82; *Cambridge Ancient History,* vol. 12 (Cambridge, 1939), ch. 16, pp. 544, 563.

25. Grabar, *Plotin,* p. 16.

26. Ibid., p. 17.

27. Ibid., p. 18.

28. Ibid., p. 19.

29. In the Hippodrome of Constantinople, about A.D. 400.

30. Grabar, *Plotin,* pp. 32-33.

31. Ibid., p. 21.

32. Ibid.

33. The law of stability of sizes irrespective of distance is of primary importance to vision, "despite our idea that projective vision is an elementary and easy matter," says Egon Brunswik in his *Experimentelle Psychologie* (Vienna, 1935), p. 91.

34. A work of the fifth century, now in the museum of Dijon.

35. Grabar, *Plotin,* p. 33.

36. A miniature of Cosmas the Indicoplectus in the Vatican, a copy of the ninth century from the original of the sixth century in Alexandria.

37. Grabar, *Plotin,* p. 19.

38. Plotinus *Ennead* II. 4, 5, 4.

39. Ibid., I. 6, 3, 20.

40. Grabar, *Plotin,* p. 22.

41. A fresco of Palmyrian deities in Doura of the second century A.D.

42. Grabar, *Plotin,* pp. 32–34.

43. Ibid., pp. 24–25.

44. The quality of a work consists neither of happy color nor of symmetry, for then beauty would be composite and its parts in themselves would not be beautiful. In the work of art, the Idea unifies the composition; and when this is apparent we are charmed by beauty. Plotinus therefore is interested, not in *how* the work is presented, but in *what* appears there. And indeed, only this attitude to art can explain how the harmony of abstract classical beauty came to be replaced by characteristic beauty, so that highly emphasized contrasts and even the repulsive note of the ugly were later tolerated when it came to expressing exalted experiences. But these later developments had not even occurred to Plotinus, nor did he, in discarding "euchroia" and "symmetry," propose anything to take their place.

45. Theodoracopoulos (*Plotins Metaphysik,* pp. 95, 96, 98) adds that Kant's definition of critical taste is practically identical with Plotinus' definition of artistic understanding. Both attribute the capacity they define to a special spiritual faculty. They are again on common ground in making the enchantment of the soul a criterion of beauty—with this difference only, that Kant does not associate this enchantment with the Good and the True, as Plotinus does.

46. Demus, *Byzantine Mosaic Decoration,* p. 6.

47. Ibid.

48. Ibid., p. 43.

49. Ibid., p. 6.

50. Ibid., p. 43.

51. Ibid., pp. 6–7.

52. Ibid., p. 9.

53. Ibid., p. 4.

54. Ibid., p. 10.

55. Ibid., p. 4.

56. Michelis, *An Aesthetic Approach to Byzantine Art,* p. 125.

57. Demus, *Byzantine Mosaic Decoration,* p. 15.

58. Ibid., p. 30.

59. B. Tatakis in *Philosophie Byzantine* (from Bréhier's *Histoire de la Philosophie*) (Paris, 1949), p. 108, gives a lucid analysis of this point.

60. Bréhier's Preface to Tatakis, *Philosophie Byzantine,* p. vi.

61. Demus, *Byzantine Mosaic Decoration,* p. 16.

62. Ibid., p. 13.

63. Ibid., p. 12.

64. Michelis, *An Aesthetic Approach to Byzantine Art,* p. 55.

65. Demus, *Byzantine Mosaic Decoration,* p. 30.

66. J. Durm, "Die Baukunst der Renaissance in Italien," in *Handbuch der Baukunst* (Leipzig, 1914), p. 869.

67. The principle of the *perspective curieuse* emerges in Leonardo da Vinci's drawings, in which the artist seems to consider the walls and ceiling as glass, with the figures standing

upright behind them; and he reproduces them thus, as he sees them behind the transparent glass. As for the shape of the roof, the curved is preferred to the angular, but this concerns us little here.

68. Demus, *Byzantine Mosaic Decoration,* p. 35.
69. Ibid., p. 36.
70. Ibid., p. 37.
71. Ibid., p. 81.

Chapter Eleven

1. According to Alois Riegel, *Die Entstehung der Barockkunst in Rom.* (Vienna, 1908).
2. See Chapter Twelve below.
3. Carl Woermann, *Geschichte der Kunst aller Zeiten und Völker,* 2d ed., 6 vols. (Leipzig and Vienna, 1915–22).
4. Karl Otto Hartmann, *Die Baukunst in ihrer Entwicklung von der Urzeit bis zur Gegenwart,* 3 vols. (Leipzig, 1910–11), vol. 3.
5. Siegfried Giedion, *Space, Time and Architecture,* trans. Erwart Matthews (Cambridge, Mass., 1941).
6. For British architectural development, see James Maude Richards, *An Introduction to Modern Architecture* (Harmondsworth, 1940).
7. Quoted in Giedion, *Space, Time and Architecture.*
8. Quoted in Richards, *Modern Architecture.* For the New Movement in Germany see also Bruno Taut, *Die Neue Wohnung* (Leipzig, 1928).
9. Quoted in Taut, *Neue Wohnung.*
10. For a more detailed analysis of this chapter, see my *Architecture as Art,* pp. 303–26 (in Greek).
11. Le Corbusier, *Vers une architecture* (Paris, 1925), *Urbanisme* (Paris, 1925), and others.
12. See my "Space–Time and Contemporary Architecture."
13. See the brief entry on aesthetic theories in architecture in Wasmuth's *Lexikon der Baukunst,* 1929–32 ed., s.v. "Aesthetik," and Borissavliévitch, *Théories de l'architecture.*

Chapter Twelve

1. Borissavliévitch, *Théories de l'architecture,* p. 71.
2. For light in architecture, see also Arthur Schopenhauer, *The World as Will and Representation,* trans. E. F. J. Payne, 2 vols. (Indian Hills, Col., 1958), vol. 1, pp. 203, 216.
3. Ibid., pp. 214–16.
4. Monolithic structures exist also in Indian art, but in this instance in forms carved out of rock.
5. See Bayer, *L'Esthétique de la grâce.*
6. Le Corbusier, *Vers une architecture,* p. 49; Matila C. Ghyka [Ghika], *L'Esthétique des proportions dans la nature et dans les arts* (Paris, 1927).

Chapter Fourteen

1. Romaios, *Keramoi tis Kalydonos,* pp. 101–2.
2. Nikolas Moutsopoulos, "Morphologikes Paratereseis kai Harmonikes Haraksis stous Engerammenous Stavroeideis Naous" [Morphological observations and harmonious engravings of the churches in the style of the cruciform with a dome], *Chronika Aisthetikes,* 2 (1963).
3. See my *Biomechanike Aesthetiki kai Aphereme Teckni,* p. 1.

bibliography

The essays collected in this volume were first published as follows:

Chapter 1. *Latent Movement or the Latent Picturesque*
Nea Hestia, nos. 641 and 642 (1954), pp. 393–99 and 467–76; *Aesthetika Theoremata,* 1 (1962), 110–42 (in Greek).

Chapter 2. *Art and Technology*
Conference at the National Theater, Athens, 1961; *Twelve Conferences,* 1st ser., National Theater Library no. 1 (Athens, 1961), pp. 105–22; *Aesthetika Theoremata,* 1 (1962), 173–90 (in Greek).

Chapter 3. *Art and the Machine*
Conference at the National Association of Greek Literary Authors, Athens, 1966; *Chronika Aesthetikis (Annales d'Esthétique),* 3 (1972), 62–83 (in Greek).

Chapter 4. *Abstractionism in Contemporary Art*
Conference at the Philosophical Institute of the University of Brussels, Brussels, 1963; "L'astrattismo nell'arte contemporanea," *Rivista di Esthetica,* 3 (1965), 321–40; *Aesthetika Theoremata,* 2 (1965), 104–21 (in Greek).

Chapter 5. *The Beholder and the Work of Art*
Nea Hestia, 89 (1971), 145–50 (in Greek).

Chapter 6. *Art and Time*
Zygos, No. 3 (1956), p. 5; *Aesthetika Theoremata,* 1 (1962), 150–53 (in Greek).

Chapter 7. *The Artistic Principle of Non-Finito*
Conference at the Hellenic Society of Aesthetics, Athens, 1962; *Chronika Aesthetikis (Annales d'Esthétique),* 2 (1963), 51–63 (in Greek).

Chapter 8. *Reflections on Byzantine Art*
Conference of the Fondation Européenne de la Culture, Athens, 1964; *Aesthetika Theoremata,* 2 (1965), 69–88 (in Greek).

bibliography

Chapter 9. *The Grace of the Byzantine Column*
Bulletin of the Christian Archaeological Society, 4 (1964), 103–15; *Aesthetika Theoremata,* 2 (1965), 57–68 (in Greek).

Chapter 10. *Neo-Platonic Philosophy and Byzantine Art*
Journal of Aesthetics and Art Criticism, 11 (1952), 21–45 (in English); *Nea Hestia,* nos. 633–34 (1953), pp. 1–19; *Aesthetika Theoremata,* 2 (1965), 189–24 (in Greek).

Chapter 11. *The Revival of Architecture in the Twentieth Century*
Nea Hestia, no. 563 (1950), pp. 125–41; *Aesthetika Theoremata,* 1 (1962), 193–217 (in Greek).

Chapter 12. *Aesthetic Reflections on Contemporary Architecture*
Technika Chronika, no. 163 (1938), pp. 874–82; *Aesthetika Theoremata,* 1 (1962), 260–73 (in Greek).

Chapter 13. *The Language of Images in Architecture*
Charistirion to Anastasios C. Orlandos, (Athens, 1965), vol. 1, pp. 126–234; *Aesthetika Theoremata,* 2 (1965), 150–59 (in Greek); "El lenguaje de los imagenes en le Arquitectura," *Aesthesis* (Santiago, Chile), 4 (1969), 11–20 (in Portuguese).

Chapter 14. *Prefabrication and Aesthetics*
Conference on prefabrication held by the Technical Chamber of Greece, National Technical University, Athens, 1968; *Aesthetika Theoremata,* 3 (1972), 211–25 (in Greek); in press in the proceedings of the conference.

Chapter 15. *Greek Popular Architecture*
Conference at Syracuse University, Syracuse, N.Y., 1953, University of Uppsala, 1954; *Yearbook of the National Technical University of Athens, vol. 1, 1969–70* (Athens, 1972), pp. 81–92; *Aesthetika Theoremata,* 3 (1972), 231–43 (in Greek).

index of names

index of names

Panayotis A. Michelis (1903–1969) taught philosophy of art and architecture at the Polytechnic University, Athens, Greece. Most of the essays in this collection appeared originally in Greek journals devoted to aesthetics, architecture, and archaeology.

The manuscript was edited for publication by Herbert M. Schueller. The book was designed by Donald Ross. The typeface for the text is Mergenthaler's VIP Optima, based on an original design by Hermann Zapf about 1958; and the display face is Helvetica, designed in 1956 by Max Miedinger.

The text is printed on Bookmark paper and the book is bound in Columbia Mills' Triton cloth over binders' boards. Manufactured in the United States of America.